THE OFFICIAL

IDENTIFICATION AND PRICE GUIDE TO

AMERICAN FOLK·ART

ELTING MEMORIAL LIBRARY ··· NEW PALTZ, N.Y.

Ex Libris

GIVEN BY
WILLIAM HEIDGERD
IN MEMORY OF HIS MOTHER

THE OFFICIAL®
IDENTIFICATION AND PRICE GUIDE TO
'AMERICAN FOLK·ART

HENRY NIEMANN
HELAINE FENDELMAN

FIRST EDITION

54,835

House of Collectibles
New York, New York 10022

Cover folk art (swan) courtesy of Steve Miller, American Folk Art.

Published by: The House of Collectibles
201 East 50th Street
New York, New York 10022

Distributed by Ballantine Books, a division of Random House, Inc., New York and simultaneously in Canada by Random House of Canada Limited, Toronto.

Manufactured in the United States of America

ISBN: 0-876-37753-3

10 9 8 7 6 5 4 3 2 1

Table of Contents

Preface

What follows is an identification and price guide devoted to American "folk art," though what constitutes "folk art" has been the subject of rigorous—even hot-headed—debate over the past century. One field of scholarship dictates that folk art objects are handmade objects created by individuals, and those who adhere to this particular viewpoint distinguish between the utilitarian object and the decorative work, between the "craft" of the folk artisan and the "expression" of the unschooled—if not unskilled—individual.

In a strict use of the term, then, folk art would encompass painting, naive sculptures, and other works intended solely for decoration and illumination of the spirit, while baskets, bowls, quilts, etc., would fall under the domain of crafts. There are, of course, various gray areas in this. The functional object, such as the quilt, is not without decoration, and it is for the decorative quality of the piece that the object is now valued. And the supposition that the painting served a strictly decorative purpose is belied by the notion that the work of "art" was often created to establish in tangible form the wealth and authority of the individual portrayed.

Commercial and "popular" objects made in a workshop or factory and intended for indiscriminate distribution lack the uniqueness often attributed by scholars to the "folk art" object. The factory-made weather vanes and trade figures, Indian rugs, and pottery made for the tourist trade, "academic" paintings, and the wide variety of objects produced by young ladies attending the "Female Academies" in the nineteenth century fall into the realm of "crafts."

The issues that divide the folklore scholars in the matter of "folk art," then, seem to center on the question of creative intent and what the artist or artisan was trying to say in the making of the object—be it a painting or a chest of drawers—beyond establishing its immediate function (demonstrating an individual's prominence in the community or simply storing clothes). In recent years, academics and dealers alike have looked at the object as an expression at once of the *community* in which its maker lived, as well as of the *individuality* of the maker him- or herself. Thus, the folk art object—whether it is utilitarian or decorative—is prized, paradoxically, for the characteristics that reflect the place

and people among whom it was made, as well as for the particular traits that betray the hand of the individual maker. As a result, the "folk art" and the "folk crafts" have merged to include all "Americana"—not just the one-of-a-kind handmade object, but the commercially mass-produced, machine-manufactured item from an older age as well.

Whether the piece was handcrafted or machine-made, and regardless of whether it was intended to be a tool or a decoration, the object bears a legacy of decoration and implied symbolism that speaks louder than the object itself. Folk artists embued the decoration of their work with beliefs, ideals, and attitudes that determined how they handled their daily affairs—from references not only to their religious beliefs, but to their local legends and great myths as well. A weather vane may simply be a way of telling which way the wind was blowing, but when it was shaped in the form of Gabriel and his trumpet, it was a manifestation of a more primeval belief in the meaning of the winds. As such, these works bear the traditions and spirit of the communities and cultures from which the roots of our nation sprung forth.

The effort to distinguish American folk art from all other antiques and artifacts began in the early twentieth century in the course of the first wave of American folklore scholarship. Under the inspiration of Francis Child, the Harvard professor whose massive collection of folk ballads from the English-speaking world established a sense of the breadth and scope of the Anglo-American heritage, Americans began to look more closely at the "poetry" and, subsequently, the art prevailing in the landscape.

At roughly the same time, easier travel to Europe in the last quarter of the nineteenth century—sail was increasingly giving way to steam—put Americans in direct contact with the European scholars caught in the thralls of "primitive" indigenous art forms. Following the formidable lead established by Wilhelm and Jakob Grimm, collectors on both the continent and in the British Isles had been looking for the "soul of the nations" among the narratives, customs, and beliefs of the rural inhabitants, where age-old traditions survived intact, unspoiled by the rancours and sophistication of industrial civilization.

In 1916, artists affiliated with Hamilton Easter Field's School of Painting and Sculpture in Ogunquit, Maine—among them, Bernard Karfiol and Robert Laurent—began acquiring tin weather vanes, wood carvings, and oil paintings. In their turn, they interested such artists as William Zorach, Elie Nadelman, Yasuo Kuniyoshi, and Henry Schnackenberg in collecting as well. It was this second

group of enthusiasts that brought these survivals of the American past to the attention of Edith Gregor Halpert, owner of the Downtown Gallery in New York's Greenwich Village, who then assembled and displayed them as pieces of early American *art*. It was followed eight years later by the Whitney Studio Club's—the predecessor to the great museum—"folk art" exhibition. What was once functional among the early settlers and their descendants had become decorative objects in an increasingly urban culture. Where folk ideals and beliefs had formerly been passed down from the higher classes to the peasantry (from the lords of the manor, say, to their tenants), the peasants and rural gentry were now returning the favor by reminding the cultural (and social) elite of the exquisite forms of expression they had left behind.

However, none of this brings us any closer to defining "folk art," either from a scholar's or a collector's point of view. It is a term that was coined by a collecting elite somewhat after the fact, and where it once referred to the naive, even the sentimental, the only sure thing we can say about it is that "folk art" now describes any piece, utilitarian or decorative, that speaks in some way of our heritage as a nation, of the immigrant communities that settled in this land, or of the early moral and aesthetic vision from which we have now grown so distant. Regardless of their form and style, the objects and pieces that we now call "folk art" and collect as such are bridges with our past—touchstones (objects of "sympathetic magic," as Sir George Fraser would say in *The Golden Bough)* that bond us to the founding of our land. They provide a mirror in which our past is imperfectly reflected.

For our purposes in this guide, folk art is defined by the marketplace—a pragmatic Yankee solution—and what the community of collectors, dealers, auction houses, and museums have, simply by their interest, included as "folk art" in their collections and sales. The purpose of this book, then, is to guide the collector toward understanding, appreciating, and evaluating the various folk art forms prevailing among the American people.

Acknowledgments

The authors would like to acknowledge their grateful appreciation to the following dealers, private collectors, and auction houses, for without their cooperation this book could not have been written: America Hurrah, Kate and Joel Kopp; Marna Anderson; Aarne Anton; Bari and Phil Axelband; Butterfield & Butterfield; Kay Betts, Shoot the Chute; Robert Cargo; Christie's; Nancy and Jim Clokey; Nikki and Tom Deupree; Jeannine Dobbs; William Doyle Galleries; Jim Elkind; Sandy Elliot; Epstein Powell, M. Finkel & Daughter; Pat and Rich Garthoeffner; Guernsey's Auctions; Pat Guthman; Gary Guyette; Hillman/Gemini Antiques; Stephen and Carol Huber; Jay Johnson, America's Folk Heritage Gallery; Bill Ketchum, Jr.; Ron Korman, Muleskinner; Louanne LaRoche; Frank Miele, Hirschl and Adler Folk; Betty Mintz, All of Us Americans; Olde Hope Antiques; Sam Pennington, *The Maine Antique Digest*; Louis Picek, Main Street Antiques; Frank and Barbara Pollack; Roz and Harvey Pranian, Harvey Antiques; Sheila and Edwin Rideout; S.M. Rinehart; Marquerite Riordan; Stella Rubin; Kathy Schoemer; Robert W. Skinner Auction Gallery; Smith Gallery; Sotheby's; Sterling & Hunt; Isette Talpe, South Bay Auctions; Adam A. Weschler Auction Gallery; Thos. K. Woodard; and Shelly Zegart.

We would also like to thank the following *researchers*: Willa S. Rosenberg, coordinator; Sherry Kahn, coordinator of photography; Jacqueline Atkins; Sheila Brummel; Jeanne Carley; Edith Garshman; Alice Hoffman; Leanore Kogan; Jeanne Riger; Meg Smeal; and Maryann Sharky Warakomski.

Introduction

An Overview of American Folk Art

Painting

In Colonial America, painting—the Pennsylvania German fraktur tradition, for example—closely followed the artistic designs and aesthetics of the original European styles. After several generations, however, the native colonists began to incorporate motifs and symbols unique to the American consciousness and experience.

When the colonies gained their independence in 1776, they developed a host of new symbols and motifs that expressed the ideals of the new-found land—the eagle, the personification of Liberty, and George Washington, to name a few. Great events of the Revolution were faithfully—and sometimes fancifully—recorded on canvas or paper. Important historical sites, Mt. Vernon, for example, were depicted in commemoration and celebration.

But portrait painters—many of them itinerant, self-taught artists working the rural areas of the new nation—were most in demand. The developing middle class, comprised of men in the professions (doctors, lawyers, ministers), merchants, seafaring captains and a landed gentry, desired to have likenesses of themselves to demonstrate their wealth and provide proof of their social status for posterity. Of course, the rendering of the face was always most important to the sitter who commissioned the work, but the practice of portraiture in America at that time often included symbols of the sitter's trade—if it were a man—or of personal items when the sitter was a wife or child. The Ammi Phillips paired portraits of Dr. Isaac Everest and his wife Sarah Cornwall (executed around 1812), sold at Christie's in January 1988, show a man holding an open book, his finger marking his place on the page—the book, as well as the letter his wife is holding, connote literacy in an age when being able to read was a rare attribute and doctors were respected as men of learning. For women and children, these items would other times include the family pet, toys, and jewelry; for the captain, it would be a view of his ship, if not a picture of the ship itself. Lawyers, like doctors, were portrayed with their books.

3

While the freelance folk painter also painted such objects as signs and household objects, when the more accurate and less expensive daguerreotype was introduced to the American consumer in 1840, many folk painters, having lost the bulk of their portraiture market, were forced to learn the art of photography. The remainder turned to other types of decorative renderings to earn a living—among them: painting land- and seascapes, ship and house portraits, the overpainting of photographs, and wall murals.

During the nineteenth century, other popular, two-dimensional media were employed which are now appreciated as art forms in their own right. "School girl" or "Seminary" crafts of the early 1800s are now highly valued as much for the social documentation they provide as for their aesthetic qualities. Popular examples of these "arts" include theorems and memorial paintings, scherenschnitte, silhouettes, and still lifes. Those who perfected their skills might have progressed eventually to reverse paintings on glass, tinsel pictures, charcoal or pastel portraits, or landscapes on sandpaper, fraktur painting, and painting on jewelry—miniature watercolor or oil painting on lockets and pins.

As America passed through her industrial revolution in the late nineteenth century, the folk painter—once a member of the population's mainstream—became increasingly the artistically "unsophisticated" and isolated individual. Such artists during the first half of the twentieth century were usually rural dwellers who most often painted idealized "memory" scenes from a legendary American pastoral age.

After World War II, however, the contemporary artist began to incorporate a variety of new themes, motifs, and materials reflecting a society caught in the turmoil of global world tensions and overwhelming technological advances. The works produced during this time included fantasy paintings based on either childhood tales or embellished "memories," personal religious revelations, extraterrestrial phenomena, or such social movements as the sexual revolution, women's liberation, or the emergence of minorities attempting to recapture their lost heritage—most notably, Hispanics, Afro-Americans, and native Americans.

Sculpture

Three-dimensional religious figures—Bultos—date from the sixteenth century when gold-seeking Spanish explorers and missionaries settled in the southwest, conquering the land and converting the native population to Catholicism. The settlers in New England

from northern Europe and the British Isles, for their part, developed such sculptural forms as gravestones, weather vanes and, as commerce grew, shop and trade signs.

The first American artisans working in three-dimensional forms were the gravestone carvers whose iconography reflected anthropomorphic images of death. But during the eighteenth century, as the tenets of Puritanism became more relaxed, these carvers began creating likenesses of the deceased on the stones.

The livelihood of most colonists centered around agricultural pursuits, thus, weather vanes were important as tools, as well as decorative objects. In an era where survival itself could depend on knowing which way the wind blew—as well as what kind of weather it would bring—the weather vane was an important part of the farmer's prognosticatory repertoire. (Readers of Middleton's excellent *Foxfire* series know that the crystal bearers of the New Age are no match to the farmers of the late eighteenth century when it comes to the real significance of stargazing.) While the initial motifs on the early weather vanes were rife with Biblical references (the cockerel, for example, or Gabriel), later design patterns manifested the increasingly secular concerns of life in the new world. Gabriel would rejoin the heavenly host as weather vanes sported the landholder's name (bannerettes or banner vanes) or reflected one's commercial interests (ship, fish), the advancement in transportation (horses, cars, trains), or favored real or mythological animals (seahorses, cows).

Shop and trade signs were initially three-dimensional carvings created to capture the public's attention at a time when most people could not read, and alerted them to the nature of the trade being transacted (barber poles, teeth, boots). Freestanding figures—the cigar store figure (primarily Indians), for instance—were also popular during the nineteenth century. As spelling was standardized in America during the 1820s and literacy became more prevalent, the less cumbersome, more refined two-dimensional shop sign, typically containing a terse message, rose to prominence.

From this point on, almost to the end of the century, multifaceted carvers, first in cottage industries and later in "factories" of a sort, produced ship figureheads, carousel figures, and circus wagons, while the blacksmith turned his talents to producing wrought-iron pieces intended to serve the consumer's every need (kitchen implements, household utensils, weather vanes, bootscrapers, and windmill weights).

Nonprofessional and unschooled individuals also found three-

dimensional outlets for their creativity. Whalers carved scrimshaw from whale teeth, bone, and ivory to create utilitarian and decorative objects. Hunters carved the likenesses of fish, waterfowl, and birds to serve as decoys, while whittlers devised whirligigs and other whimsical pieces that are still being made today.

Other "handmade" curiosities extant in American folk art collections (many of which were actually mass produced in various media) include chalkware (plaster of Paris figurines), metal doorstops, shooting gallery targets, and wooden carousel animals, to name but a few. Today, such varied objects as architectural ornaments and flag pole finials are virtually all machine-manufactured, having all but given way to the increased standardization of our culture. Yet innovative "self-taught artists" continue to produce interesting, aesthetically beautiful, one-of-a-kind, decorative objects.

Textiles

Since harsh New England weather demanded heavy clothing, the settlers considered all material precious. And if survival in the bitter winters of the new world were not enough incentive to make full use of whatever textiles were on hand, the fact that the greater part of cloth in the colonies was imported made it precious from a monetary standpoint. Every usable scrap of fabric was saved from worn-out garments, and when enough pieces were collected, they were recycled in rugs, quilts, and other textile objects.

As colonists prospered in the course of the eighteenth century, they began to produce their own fabrics on a commercial scale—primarily woolens, linens, and cottons. Only the affluent continued to use the fashionable, imported textiles that came from Europe, England, and even India. By the time of the American Revolution, however, such notable manufacturers as John Hewson of Philadelphia were producing fine, printed fabrics for the upper classes.

A girl of upper social status underwent training for womanhood in the "seminary schools" or "female academies" (what would later be thought of as finishing schools) from the start of the early eighteenth century on. Refined skills and a substantial dowry provided the promise of a good match and a comfortable life. Along with learning to play musical instruments, these girls made samplers—so-called because they included samples of the varying sewing stitches—and needlework pictures, often taken from printed sources. These crafts had begun as a home-taught art that was

later taught in the schools, until these seminaries and academies entered their decline in the first half of the nineteenth century.

Among the typical thematic sampler classifications are alphabet/verse, pictorial, family records, and maps.

Embroidery skills were essential to the ways of life at the turn of the nineteenth century. Marking fabrics with names signified ownership in a less materialistic time. Woolen bed rugs and embroidered bedcovers served as bedspreads and provided warmth in colonial America. Linsey-woolseys were popular woolen and linen spreads, sometimes glazed with egg white or by rubbing a stone over them to achieve a glossy sheen.

Later, women produced embroidered work for more aesthetic reasons. During the second quarter of the nineteenth century, developments in bed linen also included the candlewick spread—"whitework" made from coarse candlewick thread—and the stencilled spread.

Coverlets, made from wool for warmth and cotton for strength, were constructed on hand looms in strips. Two or three of these strips were then sewn together and featured geometric patterns. Typically the nomenclature reflected the weaving process, either overshot, double weave, or "summer and winter." By the 1820s, the Jacquard attachment permitted professional itinerant American weavers to use as many as forty looms to create intricate rosette patterns and pictorial borders.

Quilts, whether pieced, appliqued, or pieced and appliqued, consist of three layers: the quilt top, usually made from scrap fabrics, the filling, and the backing. The craftsmanship of the stitching on the quilt top, as well as its design formation in holding the three layers together, contribute as much to a quilt's raison d'être as its overall color pattern. While many designs bear standard names (Log Cabin, Album), categorization of specific quilt patterns is often confusing, for a single design that was devised and executed simultaneously in various regions of the country bears different regional names.

Rugs, initially used only on top of tables because they were rare and valuable, eventually found their way to the floor during the nineteenth century. Generally, these handcrafted specimens reflect four distinct techniques of rug making: hooked, yarn-sewn, shirred, and braided. The pile in hooked rugs is fashioned by pulling narrow strips of fabric (often wool) through a foundation fabric (usually burlap) with a hooking device similar to that used by whalers for fastening rope. Yarn-sewn rugs (usually homespun) differ from the hooked rug in that the maker uses a needle as

opposed to a hook. Shirred rugs are constructed with long strips of fabric stitched down the center, gathered, and applied to a foundation. Braided rugs require no foundation material. Pieces of fabric are cut and sewn into tubes, braided, and then sewn together to form generally circular or oblong pieces.

Country Furniture

American furniture was initially produced as purely functional pieces—lift-top boxes and simple, six-board storage chests—to hold the household's utensils. The predominant styles followed already established European forms. These were modified somewhat by what the carpenter or cabinetmaker knew, as well as by the types of woods and tools available when the piece was made. American country furniture styles emulated the high style of both its European and American counterparts. Awareness of this tendency to parody—in the strictest sense of the word—is important in gaining a better understanding of American country and decorative folk arts.

Essentially, formal American furniture styles can be classified into periods or styles. the Pilgrim period, circa 1640–1700, evolved from the English Elizabethan and Jacobean styles. The primary woods were oak and pine. Usually joined together by a mortise and tenon, the ornamentation of these pieces consisted of turnings on a lathe, and carving and ebonizing the woods. Other decorations included applied bosses and spindles, carved geometric panels, turned feet, and finials.

The William and Mary period also followed the English traditions closely. Dark woods, such as walnut with burlwood, and veneered surfaces were favored. Popular from 1700–1725, the preferred stylistic features were trumpet shaped and spiral legs with ball feet. Scroll motifs in C and S forms were carved and applied as decorative elements.

Styles during the Queen Anne period, circa 1720–1755, were basically curvilinear. The most distinguishing characteristic was the cabriole leg, which usually terminated in a pad-shaped foot. The primary woods were walnut, mahogany, cherry, and maple. Wood graining and veneering were important. The rise of regional centers of cabinetmaking with their own highly individualized stylistic elements was a development of the eighteenth century. With the opening of travel to the Far East, Oriental design motifs became part of the cabinetmaker's vocabulary.

The Chippendale period, circa 1755–1790, grew out of the

English publication entitled *The Gentleman and Cabinet-Makers's Director* by Thomas Chippendale. Mahogany was the principal wood. Gothic, Rococo, or Chinese design elements predominated with scrolls, finials, shells, and acanthus leaves as decoration. Legs were cabriole or blocked, often terminating in ball and claw feet.

Two important English source books which influenced the Federal Style, circa 1785–1820, were Geoge Hepplewhite's *The Cabinet Maker's and Upholsterer's Guide* and Thomas Sheraton's *The Cabinet Maker and Upholsterer's Drawing Book*. During this period, mahogany was complemented by using wood graining, satin wood inlaid motifs, and shallow carving. Legs were straight, slim, and tapering, being either turned and reeded or ending with the splayed French foot. Decorative motifs were drapery, swags, urns, medallions, sheaves of wheat, the Prince of Wales feather, the eagle, and the shield.

During the Empire period, circa 1810–1840, mahogany, cherry, and maple predominated. Here the emphasis was on classical motifs with heavy, ornate carving in naturalistic forms. Feet were often large animals' legs with decorated paws. The pieces also featured carved leafage and scrolls. Cast brass or ormalu, sometimes in combination with marble, complemented carved friezes and pilasters. Ogee columns often flanked chests of drawers and cupboards. Decorative elements were the lyre, the eagle, leaves, grain, and fruit forms.

The years from approximately 1840–1900, known as the Victorian era, have often been called a "century of revivals" because they featured a return of interest to earlier styles of furniture and architecture. These include Gothic Revival, circa 1840–1865, inspired by medieval designs; this group of furniture used trefoils and pointed arches for design sources. Walnut, mahogany, and rosewood were the preferred woods.

In the Elizabethan Revival style, circa 1840–1870, furniture was produced for the first time using machine lathing. Posts, rails, legs, and spindles have spool, ball, or spiral turned features. This was the first time that there was mass-produced furniture in maple, cherry, and birch. Painted pine cottage furniture, usually made in sets, was also introduced at this time.

The process of laminating wood was developed during the Rococo Revival period, circa 1845–1870. Entire suites of furniture, in either rosewood or walnut, intended mostly for the parlor, were produced. Decorations were in shell, fruit, flower, and bird form with marble sometimes complementing the tops of tables and chests.

Turned, carved, and applied ornaments were popular on Renaissance Revival furniture, circa 1850–1875. Mahogany, rosewood, walnut, and satinwood were most often used. During the Egyptian Revival period, circa 1850–1900, decorative motifs included winged figures, animal forelegs, hairy paw feet, sphinx, and numerous combinations of animal and human forms.

The Eastlake style, circa 1870–1890, grew out of a book describing household tastes in furniture and upholstery by Charles E. Eastlake. The furniture is rectilinear and has shallow carving and framed paneling, and often used a variety of inexpensive woods, among them ash, pine, and hickory.

Country styles tended to reflect the more formal stylistic periods cited above. The design elements were generally pared down and diminished in size, though not as an aspect of the design. Oftentimes the country forms lagged the high style periods by as much as a decade.

Painted pieces form an important aspect of American furniture. They are extant in both formal and country forms. Painting was applied in freehand manner or with stencils and brush with several purposes in mind: to preserve the wood, to hide lesser-quality woods, to simulate more formal woods, and for decorative appeal.

The Folk Art Market

The Art of Collecting

There are a few basic guidelines that every individual should follow in starting a collection of American folk art. It is important to study pieces of American decorative arts hands-on for at least six months. Go to museums; visit dealers and auction houses. "Book learning" may be essential for knowledge, but touching the pieces and questioning those who are already familiar with your field of interest are essential to wisdom. Antique shows and auctions, for their part, will clue you in on what is available in the marketplace. Many of the most serious collectors agree that only this kind of personal experience teaches you how to judge the best from the lesser quality items before you even think of making that first important purchase.

Many collectors also agree that as you begin to collect, it is a good idea to try to develop a focus for your collection. However, this is a natural part of the collecting process, and it is not unusual to move from one realm of objects to another, as your knowledge becomes more honed and your sensibility in what curries your interest in the objects becomes more precise. Among the diversity of folk art, some people collect objects found in different types of material (kitchen tin or treenware), others with a specific function (decoys), while still others prefer to collect items that call to mind a particular period in American life (early nineteenth century) or theme (political items).

Perhaps one of the most celebrated of the American folk art collectors is Barbara Johnson, whose personal collection was without equal. An interest in whaling that evolved during time spent on Nantucket first led her to collect scrimshaw. As she became familiar with the pieces, she became interested in their provenance and began to research their origins—who were the people who carved them? What was the life on the sea? Many of the pieces she collected had been passed down from generation to generation in the family, an heirloom of heritage.

It is here that we discover the true wonder of folk art collecting—the way in which one transcends the typical categories in order to know and understand more about a type of piece. In Barbara Johnson's case, a curiosity about scrimshaw led to a profound involvement in uncovering the history of whaling. She ended up a kind of

anthropologist of a lost trade, collecting whaling prints from all around the world, log books from the great ships, maps of the ports that served as the homes of the whalers. Her collection boasted tools from the ships—winches and doctor's kits, models in miniature, family portraits of the boat owners, and their captains.

Most touching of all about her collection is the description of her thoughts as she prepared the catalogs for the four-part Sotheby's sale between 1981 and 1983. "Eighteen years after I had my child I was ready to wean her and send her into the world. I have similar feelings about the collection," she wrote in the introduction to the first catalog (Sotheby's, December 1981). "It is ready to go into the world. It is finished."

The point here is that above all else, one *nurtures* a collection. These objects, far from being mere things, become the reminders of a people and a way of life. At the very least, you should look for satisfaction in the objects you collect, but as Barbara Johnson so wonderfully demonstrates, it is not only the collection that is so rewarding, it is the knowledge it can provide, the amazing voyages of discovery that it can lead you on.

Just as this famous collector did, then, you should become familiar with the collectors, curators, and dealers in your area of collecting. This is the best way to share information, stories, and even objects. Antique shows and flea markets, museum exhibitions, and lectures are essential, not merely for learning about your field, but for meeting others involved in it. At the shows and lectures, you will probably be able to touch and feel the objects and ask questions about the pieces that interest you. In doing so you will begin to educate your eye to distinguish form and color, to separate the real from the fake, the repaired, and restored. Inconsistencies will not seem elusive because you will gradually build a storehouse of knowledge. You will even begin to learn to trust your common sense. Books, newspapers, magazines, and even exhibition catalogs are obviously important. To understand the market today, one should be versed on what was on the market years ago and for what prices. The more you know, the more aware you will be. You may hear stories about great coups—legends on the proverb "Nothing ventured, nothing gained"—but erring on the side of caution is not a mistake.

You should always be aware of the possibility that there is a better or more significant example in the marketplace than what you currently own. Therefore, you should not be afraid to upgrade your collection. Dealers can be particularly helpful by sharing their expertise and providing avenues for making purchases. They can

help sell your pieces for the highest market value. It is a very good idea to establish a network among them.

And do not be afraid of making a mistake with them. Most dealers are honorable people and may well exchange your purchase for another. Always obtain a written receipt from the seller which explains in as much detail as possible the entire nature of the piece, as well as its provenance. This safeguard, though occasionally time-consuming, will stand you in good stead should any problem arise in the future, either in cases of theft, questions of authenticity, claiming a refund, or in obtaining a tax deduction should you have an occasion in the future to donate or will the piece to a museum or friend.

Maintaining adequate insurance on your collection is optional and should be dictated by one's financial abilities. However, while insurance is costly in some instances, fire and/or water damage can devastate any work of art—as well as its value. Having insurance coverage would allow you, should the dreadful need arise, to begin afresh.

Proper care is essential for maintaining the value of your pieces. Placing objects in direct sunlight near a window without a protective ultraviolet covering causes fading, particularly if the material is fugitive. Proper care must also be exercised when displaying items. One should avoid overly humid and hot conditions. The installation of anti-theft devices is also recommended.

Market Value

There are a number of factors which come to bear upon market values of pieces passing through hands at public auction or private sales. With some exceptions, the general considerations that determine in great part the prices paid for folk art are aesthetic appeal, provenance, and documentation. Other more specific considerations which affect price structure are restoration, condition, and uniqueness because of color, age, craftsmanship, utilitarian function, size, rarity, and/or form.

Aesthetic Considerations

Probably the single most important consideration of any work of American folk art is that it be aesthetically pleasing. No object will increase in price to any significant extent if it is neither beautiful to look at nor "charmingly disarming." Its artistic qualities must predominate.

Provenance

With few exceptions, past ownership of any item is important. Pieces auctioned or sold from a well-known or recognized individual or authority in the field (distinguished writer, collector, or as part of a museum deaccession) bring greater acceptance than comparable pieces with little or no "track record." Those works which have been cited in books or articles, or have appeared in museum inventories or exhibitions, also invariably command higher prices.

Documentation

The last major constant bearing upon any object's value is the amount of verified documentation connected with it. Pieces which possess accompanying information answering the "5 Ws" (who, what, where, when, and why) command higher values. The extent to which a buyer or seller has researched a specific work and knows where the object was made, the name of the maker, that artist's standing within the field, the personal history of the maker, the object itself, and the social reasons or individual motivations behind its creation, will bear heavily upon value. Signed, stamped, and/or dated pieces are especially sought after.

Restoration

Folk art in its original condition will retain or increase in value more than an altered piece. Occasionally repairs are recommended. Those necessary to allow the continued use of the piece and executed as if the original maker had done them are the most acceptable. In addition, repairs which do not offend the eye or taste are preferable.

Restorations are another matter. They are repairs with new parts added so that the piece can be used and enjoyed for the future. Most restorations can be readily detectable with the aid of a "black" or ultraviolet light and x-ray machine if they are not otherwise readily noticeable. Those which are readily recognizable seem to have a more detrimental effect upon value than disguised restorations. The extent of restoration also bears upon value. If the piece has lost its "integrity," then its value decreases. Generally, conservation (repairs that would normally be done through the years due to daily use) is not as deleterious to value as those restorations which replace functional parts or major design patterns. A piece totally made from old wood is a new piece and has

the corresponding value of a new piece. Sometimes the words "repair" or "restoration" are used when two old pieces are put together to form one old "new" piece. This is called a "marriage" and has less value. A reproduction is a replica, copy, or facsimile. Of course, it will not have the value of the original piece.

Condition

An object possessing its original condition (exceptional color and/or pristine condition) is always desirable. Yet, certain objects such as painted furniture, weather vanes and outdoor pieces still possess value if their paint or wooden parts are appropriately "worn" through years of use. Other objects, such as textiles or pottery, decrease in value if unduly worn because of daily use or improper care. Other factors of condition that decrease value are fading resulting from improper washing or cleaning, cracking, flaking, foxing, chipping, or staining. Tears or missing pieces also affect value.

Uniqueness/Rarity

An object may be considered unique from several vantage points—if the object, for example, possesses exceptional color, form, craftsmanship, age, unusual size, or form. With some utilitarian objects such as decoys, value depends on whether or not the piece was ever used for the purpose for which it was intended. Hence, working decoys and pieces of furniture generally bring higher prices than those which haven't been used.

But rarity is a double-edged sword. A limited availability of objects generally increases price. However, there must be a significant number of similar pieces to stimulate collecting interest in the first place. It is rare that a one-of-a-kind piece will command a high price, while the best among several most likely will.

Historically, American works of art have been treasured by museums. For the last two decades, however, individuals—collectors and dealers alike—are reaping the benefits of an apparently new-found source of pride and self-expression in illuminating the "American Experience." Currently, the American folk art market is extremely "hot" with seemingly no end to collector interest in sight.

Fakes

The following guidelines were prepared by Sam Pennington, editor of *The Maine Antique Digest,* for the exhibition, "April Fool," presented in conjunction with the MAFA at Hirschl and Adler in New York City in April 1988. We have mentioned several of these in passing, but as the proverb goes, "Repetition is the mother of memory," the reader would be well advised to heed Mr. Pennington's words.

Collectors can protect themselves from expensive mistakes by following some simple rules.

1. Deal with reputable dealers. The old axiom is, "If you don't know your antiques, know your antiques dealer."
2. Get a written guarantee as to what you are buying. The guarantee should specify the age, culture, and other pertinent information and offer a cash refund if the object turns out to be significantly other than as described. Remember that auction purchases are often "as is."
3. If you see something at auction that catches your fancy, you may be able to commission a good dealer to buy it for you, unless he already has an interest or a commission. For maybe an extra 10%, you get not only his guarantee, but his expert advice as to whether the object of your desire is a suitable purchase and whether it's been offered around the trade.
4. Do your homework. Read, go to museums, study, study, study. Collecting is a field that rewards knowledge.
5. Ask yourself, could this piece really have been done when and where the seller says it was? Does it have the proper tool marks? Check out things like ships' names.
6. Avoid the "just like." If what you are offered is illustrated somewhere, check out where the original is. Ask yourself, what are the chances of another turning up?
7. Look at a portrait as art. The best folk portraits were done quickly and freely by real artists. The faces may be stylized, but they have a vitality and look like real people. Copies are much more laborious and they often show it.
8. Always look for provenance. Where did the object come from? Who owned it? It's no accident that the biggest prices at auction come when the family history is known.

9. Be very wary of dirty, rusty, or excessively stained things, especially art on paper. Family records, portraits, or silhouettes should have gotten good care. Learn the difference between tea stains and water stains.
10. Consult a restorer before making an expensive purchase. Restoration may be too expensive and a restorer can often spot fakery or previous restoration.
11. Be wary of bargains unless you know exactly what you are doing. If it's too good to be true, it probably is.
12. Buy something and try to sell it for more than you paid for it. You'll learn more than any of us can ever teach you.

One last word. Fakes are not all bad. They add a certain spice to the quest for the antique. I am indebted to Charles Hamilton, the rare documents expert, for the thought that if everything was as it purported to be, collecting would be a pretty dull sport.

How to Use
This Price Guide

Owing to reasons of space, the following listings cannot be as detailed as we would like. As a result, we have resorted to a variety of shorthand in our listings. Beyond a brief description of the object itself, we try in a word or two to explain why a piece, in comparison with others similar to it, should have an unusual price. Thus, a single word—"craftsmanship," for example, or "provenance"—speaks of a distinguishing factor in the piece described. It may also refer to the condition. As we mentioned previously, there are many factors that determine the value of a piece, let alone the final bid made on it at auction. Craftsmanship, provenance, and condition are important to the long-term value of the object.

Should any of the individual items interest you enough, then you can turn to the actual auction catalogs themselves. Generally, you can purchase a copy of the catalog directly from the auction house (remember to refer to the date of the sale; the addresses are listed in the back), or you might be able to look it up at a local research institution—a university, for example. As always, your library is a good place to start.

1. Subjects are listed alphabetically.
2. Entries are listed alphabetically by artist where possible. Pieces unidentified by an artist/maker are arranged according to date of sale, the earliest sale being the first entry, if not listed alphabetically by object. Where many of the same objects were sold at the same sale, their arrangement appears in ascending price order.
3. Where available, all dimensions are in inches unless otherwise so noted. Single dimensions are qualified with one of the following letters: H = height, L = length, W = width, D = depth, Dia = diameter. Double dimensions are qualified if possible. Triple dimensions always signify H, L or W, and D respectively.
4. The condition of the pieces is noted where possible and identifiable attributes or faults are likewise noted. If there are no descriptive comments concerning condition, it is assumed to

be typically representative of similar available pieces in the marketplace.
5. A complete listing of auction houses and addresses appears in the *Resources* section at the back of the book.

American Folk Art
at Auction

Andirons

Andirons, metal supports for logs in a fireplace, are commonly made of brass, wrought, or cast iron. Usually found with ball, urn or steeple finials, ball, snake, or ball and claw feet, and cabriole legs, they reflected the furniture and architectural styles of the period in which they were made.

Ball finial andirons, probably Rhode Island, 18th century, wrought iron, penny feet. H 18¼″

Skinner 1/85 **$300**

Gooseneck, wrought iron, penny feet, faceted finials, pitted, primitive. H 16″

Garth 2/87 **$150**

Brass pair, 18th century, small, iron feet on one have braized repair. H 14½″

Garth 2/87 **$195**

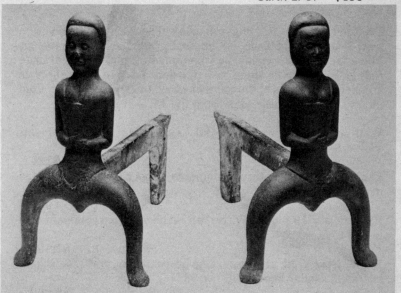

Pair of late 19th-century New England cast-iron andirons, 12″ height. *(Photo courtesy of American Primitive)*

Knife blades, 18th century, wrought iron, penny feet, brass urn finials. Good brass detail at base of stem, old patina, back feet: one deteriorated, other restored. H 19½"

Garth 2/87 **$575**

Serpents, 19th century, wrought iron, craftsmanship, unusual form. H 16¼"

Sotheby's 6/87 **$3,750**

Baseball players, c. 1900, cast iron, polychrome, provenance, rare. H 19½"

Sotheby's 6/87 **$6,000**

Architectural Ornaments

Typically, exterior building ornaments reflect either patriotic symbols, fleur-de-lis patterns, or unusual grotesque faces or beings. These facade embellishments were made from a variety of materials including wood, stone, iron, tin, and concrete, and reflect the architectural trends of the times in which they were created. Commonly, most specimens date from the 1875–1925 period.

Wall sconces, a pair, early 19th century, tin house ornaments. 13" × 8¼"

Skinner 5/86 **$225**

Eagle, mid-19th century, hammered copper, gilded, illustrated, damaged. L 48"

Skinner 6/86 **$900**

Eagle, early 19th century, carved mahogany, exceptional condition. 44" × 50"

Phillips 5/87 **$2,100**

Eagle, New York, cast bronze, good condition, craftsmanship, illustrated, similar known. 36" × 98"

Phillips 5/87 **$9,000**

Late 19th-century New England tin architectural ornament in the form of a bird with reddish patina, 13″ height. (*Photo courtesy of Sterling & Hunt*)

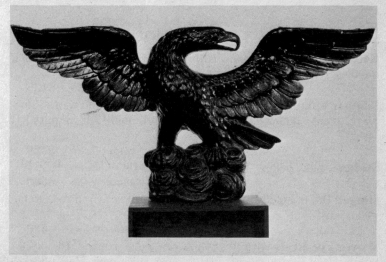

Mid-19th-century New York cast-iron architectural ornament in the form of an eagle with outspread wings, 30″ height × 64″ width. (*Photo courtesy of Lost City Arts*)

Baskets

Baskets served many utilitarian purposes in American life, both in the home and on the farm. Baskets were commonly made from found materials such as split woods (ash, hickory, or oak), sweet grasses, willow rods, or wicker. Shapes included ovals, rounds, or squares with center or side handles depending upon need. Purposes ranged from gathering, storing, and transporting foods and light objects to trapping eel.

Berry

Pair, split wood. H 5 1/2″

<div align="right">

Garth 2/87 **$20**
</div>

Small, pierced and curved wooden sides, tin rims around lip and base. Early. Minor damage. H 3 7/8″ × D 4 1/2″

<div align="right">

Garth 2/87 **$60**
</div>

Cheese

Woven splint, brown varnish finish, damaged. H 8 1/2″ × D 12″

<div align="right">

Garth 3/87 **$45**
</div>

Covered/Lidded

Rectangular, plain, plaited with potato stamp decoration, small handles, New England, 19th century. H 12 1/2″

<div align="right">

Skinner 1/86 **$125**
</div>

Feather splint, cover slitted to slide handle up and down, blue-black paint, Initials J.C., New England, mid-19th century. H 10 1/2″

<div align="right">

Skinner 1/86 **$220**
</div>

Storage, blue, yellow, red, New England, 19th century. H 13″

<div align="right">

Skinner 1/86 **$600**
</div>

Hinged lid, double bentwood handles, floral design in red, green, yellow. L 13″

<div align="right">

Garth 5/86 **$20**
</div>

Woven rye straw with lid, oval, worn, edge damage. 16″ × 20″

<div align="right">

Garth 5/86 **$30**
</div>

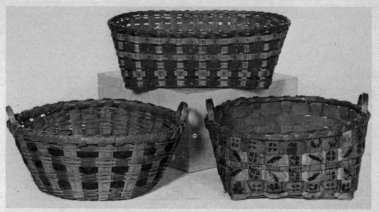

Group of early 19th-century New England Indian splint baskets, two with painted decoration and one with potato-stamped and painted decoration. (*Photo courtesy of Olde Hope Antiques, Inc.*)

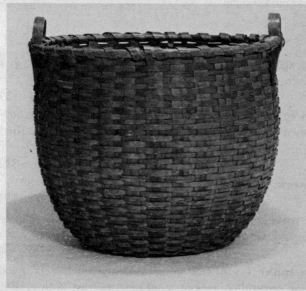

Mid-19th-century New England splint basket with wooden handles, 15″ height. (*Photo courtesy of Muleskinner Antiques*)

Shaker, woven, red ribbon, hinged lid, probably New England, damaged, wear. 5½″

Sotheby's 10/86 **$15**

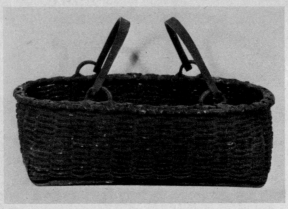

Early 19th-century New England splint basket having the wooden runners on the bottom woven into the basket and up the sides with original red-painted finish, 7″ height × 21″ length × 11″ width. (*Photo courtesy of Bari and Phil Axelband*)

Egg

Woven splint, wide bentwood handle, good age, color, some damage, restoration. 7 1/2″ × 12 1/2″ × 13 1/2″

<div align="right">

Garth 2/86 **$70**
</div>

Woven splint, red design painted at eye of God on handle and down median ribs, age, good color, minor wear. 6″ × 10 1/2″ × 11″

<div align="right">

Garth 2/86 **$135**
</div>

Wire work, probably Pennsylvania, 19th century. H 18″

<div align="right">

Sotheby's 1/87 **$350**
</div>

Large woven splint, bentwood handle, radiating ribs design, damage, old, worn white paint. 10 1/2″ × 17″ × 20″

<div align="right">

Garth 3/87 **$55**
</div>

Woven splint, eye of God detail at bentwood handle, good age and color, several courses of splint missing from bottom. 8 1/2″ × 15″ × 17″ plus handle.

<div align="right">

Garth 3/87 **$45**
</div>

Miniature woven 'one-egg' type, good detail, several layers of paint partially removed. 3 3/4″ × 4 1/2″

<div align="right">

Garth 3/87 **$240**
</div>

Fish

Eel basket, woven splint. H 31″

Skinner 1/87 **$175**

Wooden top, bait tray, splint, R.A. Drayer, York, Pennsylvania, good condition, signed, unusual design.

Oliver 7/87 **$90**

Laundry

Splint, double rim, double wrap, open checkerboard bottom, New England, 19th century. H 11″

Skinner 1/86 **$175**

Woven splint, sturdy bentwood rim handles, wooden runner-type feet, age, color, some damage. L 28½″

Garth 2/86 **$55**

Miniature

Woven splint, bentwood handle, good construction, some damage. 1¾″

Garth 5/86 **$25**

Woven splint, bentwood swivel handle, handle has break as does one attachment ear. H 3″ × D 4½″

Garth 2/87 **$50**

Miscellaneous

Buttocks type, woven splint, woven handle, good age, color, some wear, damage. 5¼″ × 9½″ × 10½″

Garth 5/86 **$70**

Buttocks type, woven splint, some damage, lopsided. H 6″

Garth 5/86 **$165**

Buttocks type, woven splint, eye of God design, some damage. 8″ × 17″ × 19″

Garth 7/86 **$110**

Buttocks type, woven splint, plaited diamond at handles, wear and damage. 4″ × 7″ × 7¼″

Garth 2/87 **$40**

Circular, woven, low, Nantucket, Massachusetts, 19th century, provenance, condition, handle missing. D 9¾″

Bourne 2/87 **$300**

Half basket, woven splint, eye of God design, good construction. H 5½″ × W 10½″

Garth 5/86 **$135**

Half basket, woven splint, some damage. W 7¼″

Garth 2/87 **$55**

Large oval woven splint, bentwood rim handles, good age and color, some damage. 13½″ × 24½″ × 30″

Garth 3/87 **$45**

Large woven splint, bentwood handle, good laced rim, good age, colors, some damage, holes. 9″ × 17½″ × 28″

Garth 7/86 **$55**

Lightship type, woven, Nantucket, Massachusetts, 19th century, provenance, good condition. D 6″

Bourne 2/87 **$500**

Lightship type, three, woven splints, ash, willow, circular pine board bases, all marked, R. A. Folger, Nantucket, Massachusetts, 19th century, provenance. 4½″ to 9¼″

Sotheby's 6/87 **$3,250**

Loom basket, woven splint, white overpaint, good design. W 9″

Garth 5/86 **$85**

Mellon rib, woven splint, round, bentwood handle, eye of God design. H 5½″ × D 12″

Garth 5/86 **$125**

Mellon rib, woven splint, bentwood handle, eye of God design, good construction. H 5¼″ × D 9″

Garth 5/86 **$145**

Mellon rib, woven splint, small, round, bentwood handle. H 4½″ × D 7½″

Garth 3/87 **$35**

Nantucket basket, signed: Jose Ramoso Reyes, Massachusetts, early 20th century, damage. H 7½″

Skinner 1/85 **$600**

Nest of ten graduated splint baskets, c. 1920, minor damage. L of smallest ¾″

Skinner 1/85 **$600**

Oval covered rye straw, worn. L 24″

Garth 2/86 **$55**

Oval splint, bentwood handle, good age and color. 7½″ including handle × 12″ × 17″

Garth 3/87 **$55**

Rectangular woven splint, well-shaped bentwood handle with median brace, some wear and damage, rim has string-wrapped repair. 8″ × 14″ × 25 1/2″

Garth 2/87 **$55**

Rectangular woven splint, bentwood handle, green paint, minor wear. 6″ × 10″ × 15 1/2″

Garth 3/87 **$25**

Round bentwood basket, well-shaped handle, good construction, old dark patina. H 6 1/2″ × D 9 1/2″

Garth 5/86 **$175**

Round rim, shaped double handles, turned wooden base, incised line decoration, Nantucket, Massachusetts, early 20th century, rim replaced. H 3 1/4″

Skinner 3/85 **$275**

Shaker, woven splint, good construction, bentwood handle, some wear, damage. H 5 3/4″

Garth 5/86 **$60**

Splint, woven, bentwood handle. 7 1/2″ × 15 1/2″ × 19 3/4″

Garth 2/86 **$30**

Splint, woven, carved bentwood handle, good age, color, craftsmanship, some damage. H 8 1/2″ × D 14 3/4″

Garth 2/86 **$45**

Splint, woven, oval, blue and white repaint. 4″ × 6 3/4″ × 8 1/2″

Garth 5/86 **$205**

Splint, woven, oval, carved bentwood rim handles, red, black, natural woven design, good color, some damage. 11 1/2″ × 15 1/2″

Garth 5/86 **$175**

Splint, woven, radiating ribs, good patina, minor damage. 9″ × 15 1/2″ × 16″

Garth 5/86 **$85**

Splint, woven, radiating ribs, black woven design with eye of God, some damage. 4 1/4″ × 8″ × 9″

Garth 5/86 **$175**

Splint, woven, round, carved handle, good construction. H 7 1/4″ × D 11 1/2″

Garth 5/86 **$175**

Splint, woven, ring handles, worn white paint. H 8 1/2″

Garth 7/86 **$10**

Splint, woven, round, bentwood handle, contemporary. H 9 1/2″

Garth 7/86 **$25**

Splint, woven, round, bentwood handle, some damage. H 8″ × D 14″

<div align="right">

Garth 7/86 **$30**
</div>

Splint, woven, radiating ribs, eye of God design, some wear, damage. 7″ × 14″ × 15″

<div align="right">

Garth 7/86 **$65**
</div>

Splint, woven, small oval, old yellow paint. H 5½″ × D 7″

<div align="right">

Garth 7/86 **$85**
</div>

Splint, woven, round, bentwood handle. H 7¼″ × D 13″

<div align="right">

Garth 7/86 **$125**
</div>

Splint, woven, round, bentwood handle, old red paint. H 9½″ × D 15″

<div align="right">

Garth 7/86 **$175**
</div>

Splint, woven, low circular, painted blue, 19th century. H 3¾″

<div align="right">

Sotheby's 10/86 **$605**
</div>

Splint, woven, ash handle, oval, painted red with heart-shaped stationary, 19th century. H 11½″

<div align="right">

Sotheby's 10/86 **$1,100**
</div>

Splint, woven, bentwood handle. 5½″ × 10″ × 15″

<div align="right">

Garth 3/87 **$50**
</div>

Splint, woven, round, minor damage. H 4½″ × D 9¼″

<div align="right">

Garth 3/87 **$145**
</div>

Splint and bark, woven, oval, eye of God design. H 7″

<div align="right">

Garth 5/86 **$55**
</div>

Splint and cane, woven, round. H 7″ × D 12¾″

<div align="right">

Garth 7/86 **$55**
</div>

Three, woven reed and splint, all oval, smallest has bentwood handle, some damage. 16″ × 28″

<div align="right">

Garth 3/87 **$90**
</div>

Two, (A) New buttocks type. L 9½″ (B) Old basket with tapered sides, minor damage. H 8″(with handles) × D 9″

<div align="right">

Garth 2/86 **$80**
</div>

Two, (A) Woven grass with lid. D 5″ (B) Woven splint egg basket, radiating ribs, old worn white paint, some wear. H 3¼″

<div align="right">

Garth 5/86 **$80**
</div>

Two, woven splint buttocks types: (A) Good age but worn, holes in bottom. 10½″ × 12½″ (B) Later, minor wear, weathered gray finish. 10″ × 10″

<div align="right">

Garth 3/87 **$75**
</div>

Two, woven splint: (A) Large oval with mellon ribs and rim band holds. 23″ × 24″ (B) Rectangular, faded bands of red, well-shaped bentwood handle. 12″ × 20″. Both have some wear and damage.

<div align="right">

Garth 3/87 **$90**
</div>

Two, woven splint: (A) Small and round. H 2″ × D 7¼″ (B) Oval with lid, rectangular base, bentwood swivel handle, brown varnish finish. 7″ × 9½″ Ends of handles loose.

Garth 2/87 **$55**

Washing cage, all wooden, used for vegetables. 17″ × 24½″

Garth 2/87 **$175**

Wire, three: One boat-shaped. L 28″; one oval with handle, hinged lid with hand hole. 10″ × 12½″; one roughly in the shape of a round gazebo. D 10″

Garth 3/87 **$65**

Woven, painted with alternating yellow and red splints, potato stamp decoration, Indian, early 19th century. H 10″

Sotheby's 10/86 **$475**

Sewing

Nantucket Lightship type, Massachusetts, 19th century, rim damage. H 3¾″ × W 11″

Skinner 1/85 **$450**

Rye, circular opening, interlocked, felted. H 3¼″

Skinner 1/87 **$200**

Shaker, Enfield, Connecticut, 19th century, splint, two handles. Dia 15½″

Christie's 5/87 **$800**

Splint, rectangular with handles, red paint, two smaller baskets fastened to interior, possibly Shaker, 19th century, illustrated. H 6¼″ × L 14″

Skinner 6/86 **$425**

Swing/Swivel-Handled

Splint, plain plaiting, double cross-bound rim, demijohn base, signed Angie Davis, c. 1825, possibly Shaker. H 6″

Skinner 5/85 **$400**

Shallow bowl, turned wooden bottom, copper pin, Nantucket, Massachusetts, late 19th century, small break. H 4″

Skinner 5/85 **$500**

Shallow bowl, turned three-ring wooden bottom, chamfered edges, copper hinge, possibly Capt. Thomas James, South Shoal Lightship, Nantucket, Massachusetts, late 19th century. H 4½″

Skinner 5/85 **$600**

Splint, woven, round, well-shaped carved swivel handle, good construction, reinforced staves, some damage, rim incomplete. H 9″ × D 12″

Garth 5/86 **$150**

Woven reed and splint, bentwood swivel handle. 9¼″ × 14″ × 16″

Garth 5/86 **$75**

Woven splint with lid, swivel handle, old black paint, minor damage. L 15½″

Garth 7/86 **$125**

Woven splint, painted blue, 19th century. H 9″

Sotheby's 10/86 **$1,200**

Cylindrical, Nantucket, Massachusetts, 19th century. H 7¾″

Skinner 11/86 **$1,100**

Lightship type, carved handle and ears, copper rivet, Nantucket, Massachusetts, 19th century, handle cracked. H 8″

Skinner 11/86 **$1,400**

Lightship type, carved handle and ears, copper rivet, Nantucket, Massachusetts, 19th century, rattan broken. H 8″

Skinner 11/86 **$1,500**

Oval, Nantucket, Massachusetts, 19th century, some damage. H 5½″

Skinner 11/86 **$500**

Bound rim, straight sides, turned wooden bottom, possible Mitchell Ray, Nantucket, Massachusetts, late 19th century, illustrated, paper label missing. H 5″

Skinner 8/87 **$550**

Utility

Splint compote type, gallery atop double rim, New England, 19th century. H 7″

Skinner 1/86 **$50**

Splint, double rim, handled, signed Mary A. Tyler, New England, 19th century. H 10″

Skinner 1/86 **$175**

Woven splint gathering basket. H 16″ × W 22″

Garth 7/86 **$45**

Double melon wall pocket type, two flat back baskets on a single frame, late 19th century, illustrated. H 27½″ × W 11½″

Skinner 8/87 **$1,100**

Beds

Country bed designs, following formal furniture fashion with simpler lines, include both high and the more favored low post styles. Rope bed construction, found in both formal and country styles, employs pegs or holes drilled into the framework with ropes wrapped around them to form the platform for the mattress. Trundle beds were prevalent country forms where space was limited. Graining, stencilling, and/or freehand painting with or without hand carvings individualize many of these pieces.

Red and brown grain painted maple, scrolled headboard, turned posts, probably Pennsylvania, c. 1830. H 39″ × W 52″

Skinner 3/85 **$200**

Federal style, orange and black grain painted maple, New England. 29 1/2″ × 77″ × 49 1/2″

Sotheby's 1/87 **$2,200**

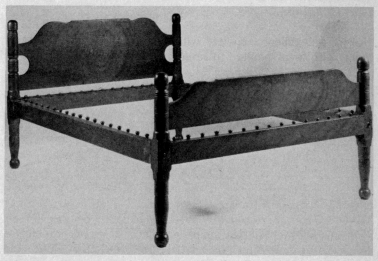

Early 19th-century New England paint-decorated rope bed with turned posts and acorn-shaped finials. (*Photo courtesy of Sotheby's, New York*)

Federal style painted and decorated maple, New England, c. 1820. 54½″ × 78″

<div align="right">

Sotheby's 1/87 **$2,300**
</div>

Painted and decorated maple, elaborately turned headposts, craftsmanship. 77¼″ × 52¼″

<div align="right">

Sotheby's 6/87 **$2,250**
</div>

Bootscrapers

Bootscrapers were attached outside at the doorstep and used to clean dirt from shoes. Cast-iron examples date from the late nineteenth century, though they were probably in use earlier.

Cat silhouette, cast iron, old black paint, good paint, leg repair. H 9½″

<div align="right">

Garth 2/86 **$125**
</div>

Horse, full-bodied, complete with brushes, cast iron, old black paint, with horse painted to resemble a palomino, good paint. H 14″

<div align="right">

Garth 2/86 **$100**
</div>

Boxes

Wooden boxes are particularly appealing to collect because of their endless assortment of size, shape, and decoration. Decoration was in carved or incised and/or painted form. Boxes that were hung commonly held combs, tableware, spices, or candles. Those that sat or stacked on tables stored other household necessities. Shapes were round, oval, or square. Sometimes the boxes were left plain, but more often their form lent to the decorative whims of the maker. Grain-painted boxes were popular, but the endless variety also included painted scenes, floral decorations,

and personal inscriptions. Bible boxes (1700–1835) were primarily found throughout New England and Pennsylvania. The Bible box sports a flat or slanted top intended for use on tables or benches and held the Bible or other valuables. Slanted tops were used for writing. Oak or pine were used most often.

Candle

Dovetailed pine and poplar, sliding lid, refinished. L 14″
Garth 2/87 **$65**

Painted, Lancaster County, Pennsylvania, 1800–1850. 3¼″ × 5″ × 7″
Sotheby's 1/87 **$1,500**

Painted and decorated pine, probably Unicorn artist, Berks County, Pennsylvania, provenance, published, publicity, rare, beautiful. 7¼″ × 16″ × 9¼″
Christie's 1/87 **$56,000**

Painted and decorated wood, Pennsylvania, early 19th century, provenance. 4½″ × 12⅝″ × 5½″
Sotheby's 10/86 **$1,800**

Painted and stencilled pine, probably Pennsylvania, 19th century. 6″ × 10¾″ × 6″
Sotheby's 1/87 **$500**

Pine, blue paint, red geometric designs, shaped crest. L 11″
Garth 7/86 **$250**

Primitive hanging type, pine with peaked crest, square nail construction, dark finish, some edge damage, age cracks. L 12½″
Garth 2/87 **$130**

Primitive hanging type, pine, poplar, square nail construction, worn old red paint. L 12″
Garth 2/87 **$150**

Carved

Bible, pine, New England, c. 1700, retangular, compass work carvings, refinished, front patched. H 9″
Skinner 6/86 **$400**

Ditty box for sailor, chip-carved, wooden, fitted cover, ingenious locking device, chip-carved decoration, "Samuel Cason" cut into cover, provenance. 6½″ × 5½″ × 9½″
Skinner 6/87 **$425**

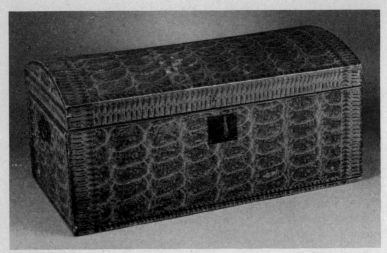

Early 19th-century New England paint-decorated, domed lid, lift-top box. (*Photo courtesy of Sotheby's, New York*)

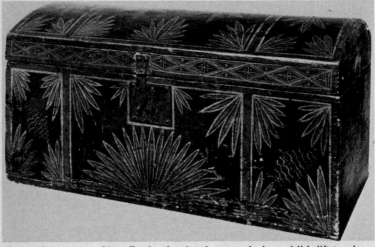

Early 19th-century New England paint-decorated, domed lid, lift-top box from Worcester, Massachusetts, area, 12″ height × 24″ width × 12½″ depth. (*Photo courtesy of Marna Anderson/American Folk Art*)

Freizan carved, cigar box bottom, small, lid flange is damaged. L 7⅞″

Garth 2/87 **$10**

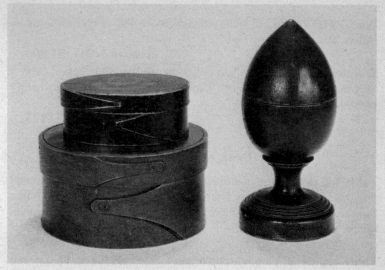

Mid-19th-century New England wooden boxes, possibly Shaker, having lap closures, together with a wooden darning egg. *(Photo courtesy of Muleskinner Antiques)*

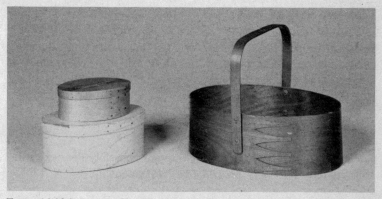

Two mid-19th-century New England Shaker boxes (one 5½″ length, second 7¼″ length) with lap closures, together with an early 20th-century cherry wood sewing basket (11″ length) from the Shaker community in Sabbath Day Lake, Maine. *(Photo courtesy of Christie's, New York)*

Freizan carved, almond-shaped snuff box, good color, detail, glued repair in lid. L 4″

Garth 3/87 **$190**

Pine, c.1800, slide lid, relief-carved pinwheels, polychrome decoration. 10″ × 4″

Skinner 6/86 **$1,200**

Wooden, joke book with serpent, 19th century, slide cover, carved decoration, vase of flowers, slide cover reveals spotted snake's head, tongue removed. 3½″ × 4½″ × 1¼″ thick.

Skinner 6/87 **$225**

Desk and Writing

Table top desk, poplar, dovetailed case, nailed drawer, lift-top lid and interior pigeon holes, old red paint with some old added white repaint, some nailed repairs to lid. 15¾″ × 26″ × 26″ plus dovetailed gallery

Garth 2/87 **$100**

Table top desk, pine with dovetailed case, old black repaint, red molding, yellow stencilled floral design, interior pigeon holes added, paint has some touch-up repair, found in southern Pennsylvania. 9″ × 30″ × 21¾″

Garth 3/87 **$150**

Table top writing, oak, made from an early Bible box. L 24½″

Garth 2/87 **$120**

Writing, walnut, fitted interior, original finish with gold stencilled decoration, including swan in center of lid, some wear, lock is missing. L 11¼″

Garth 3/87 **$70**

Document

Carved and painted pine, Peter Glawson, possibly Pennsylvania, 1863, dated, inscribed, provenance, workmanship. 6″ × 13″ × 7¼″

Christie's 1/87 **$2,000**

Painted black grain on red, carved wood, New Hampshire, 1831. 10″ × 24″ × 11″

Christie's 10/87 **$400**

Painted, stylized leaf and floral motifs, probably Pennsylvania, 19th century. 5½″ × 16¼″ × 8″

Sotheby's 1/87 **$500**

Tin, probably Connecticut, early 19th century, domed top, yellow decoration, red stylized flowers, small dent, handle missing. 6″ × 9½″ × 6″

Skinner 6/86 **$300**

Tin, probably Connecticut, early 19th century, domed top, ring handle, green, yellow decoration, red flowers, birds, leaves. 7½″ × 10″ × 6½″

Skinner 6/86 **$450**

Tole, c. 1830, domed lid, yellow strokes, scalloped drape form, minor paint wear.

Skinner 11/86 **$325**

Dome Top

Crude drawings and stylized flowers, trees, Pennsylvania, c. 1830, inscription. H 4″

Sotheby's 10/86 **$4,000**

Decorated, c.1830, yellow, red, dark green ground, hinges replaced. H 8″

Skinner 8/87 **$900**

Decorated pine, original red vinegar graining, iron lock, old tin patch over hasp, some edge damage, age cracks. L 23¾″

Garth 3/87 **$95**

Decorated and dovetailed pine, original red and black flame graining, wrought iron lock, hasp. L 18½″

Garth 2/87 **$195**

Decorated and dovetailed pine, original mahogany flame graining, good color, original brass bale handle, some wear. L 16¼″

Garth 2/87 **$350**

Dovetailed pine, worn old yellow paint, smoked decoration, iron lock is missing hasp, edge wear, age cracks. L 24″

Garth 2/87 **$65**

Painted and decorated pine, probably Rochester, New York, c. 1830, design unusual, initialed inscription R.R. on bottom. L 13½″

Sotheby's 10/86 **$2,000**

Pine, worn floral wallpaper covering. L 21″

Garth 7/86 **$50**

Pine, green paint. L 27½″

Garth 7/86 **$95**

Poplar, brass lock, hasp, green paint. L 15″

Garth 7/86 **$95**

Table chest, painted pine, tulip decoration on black ground, Pennsylvania, 19th century. 5 1/2″ × 12 1/4″ × 7 1/2″

Sotheby's 1/87 **$700**

Two, both small: (A) Wallpaper-covered wood with homemade tin hinges, hasp, red, blue paper worn. L 4 1/4″ (B) Tole with worn brown japanning. L 3″

Garth 3/87 **$65**

Vigorous loose circles of green concentric stripes and red and green brushwork, New England, c. 1830, exhibited.

Sotheby's 10/86 **$6,000**

Grain-painted

Decorated pine, early 19th century, dovetail construction, handles, lift lid, iron hasp, dark green, black, red on yellow ground, illustrated. H 12″

Skinner 6/86 **$700**

Dovetailed poplar, old olive-brown graining, lid replaced. L 23 3/4″

Garth 2/86 **$25**

Original brown graining on a pale salmon ground, stencilled label Goodspeed & Wyman, Winchester, Massachusetts, original brass bale handle, provenance, some edge wear. L 19 1/2″

Garth 2/86 **$75**

Pine, 19th century, lid above ornate metal escutcheon, four small turned feet, olive brown ground. H 12″

Skinner 6/86 **$250**

Rectangular box, mid-19th century, paint simulates various woods, gilt stencilled decoration, back grained, wallpaper lined, some paint wear. 9 1/2″ × 14 1/4″ × 9 1/2″

Skinner 8/87 **$250**

Square, pine, cover with molded edges, rosewood grain painting, dated 1820. H 10″

Skinner 5/85 **$200**

Miniature

Dome top, hinged, slate blue ground, escutcheon, tin and punchwork heart, Lancaster County, Pennsylvania, 1800–1850, incised, provenance, similar pieces exhibited. 5″ × 7″

Sotheby's 10/86 **$3,500**

Pantry box, circular, fitted lid, painted black flowers with yellow leaves on red ground, Pennsylvania, c. 1840. H 2³/₄″ × D 3¹/₄″

Sotheby's 10/86 **$3,000**

Set of two: Sliding lids, painted, decorated with figure of dog and busts of stag, Lancaster County, Pennsylvania, c. 1870, exhibited, provenance, signed.

Sotheby's 10/86 **$3,000**

Miscellaneous

Band, oval cardboard, wallpaper covered, "View of Providence River" on top, sides titled "Al Fresco Lunch," 1830, rim broken, paper faded, published. H 11″

Skinner 5/85 **$425**

Band, oval, wallpaper covered, "View of Providence River", c. 1830, similar examples published.

Skinner 5/86 **$375**

Band, oval carboard, covered, ship "Prosperity to Our Commerce & Manufacturers," c. 1830, similar published, some wear. H 11¹/₂″

Skinner 5/86 **$500**

Band, oval, wallpaper covered, old, faded olive-brown and white with red paper showing beneath, wear, but interesting design. L 22″

Garth 2/87 **$250**

Bentwood, oval, finger construction, copper tacks, scrubbed finish, some damage. L 9″

Garth 7/86 **$65**

Bentwood, oval, single finger construction, old dark patina. D 5³/₄″

Garth 7/86 **$115**

Bentwood, oval, single finger construction, old green paint, dark patina. L 6³/₈″

Gath 7/86 **$135**

Bentwood, oval, small, stained. L 4⁵/₈″

Garth 7/86 **$75**

Bentwood, round, single finger construction, worn blue paint. D 7″

Garth 5/86 **$145**

Bentwood, round, gray paint, minor wear. D 10¹/₂″

Garth 5/86 **$155**

Bentwood, round, worn green paint. D 7″

Garth 7/86 **$85**

Bentwood, round, wire bale, wooden handle, repainted, worn. L 6 1/2 ″

> *Garth 7/86* **$130**

Bentwood, round, wire bale, wooden handle, old white paint, lid loose. H 6 1/2 ″ × D 11 1/4 ″

> *Garth 7/86* **$175**

Bentwood, round, wire bale, wooden handle, olive-colored paint. D 9 1/2 ″

> *Garth 7/86* **$185**

Bentwood, round, wire bale, wooden handles, worn blue paint. H 6 ″

> *Garth 7/86* **$195**

Bentwood, round, wire bale, wooden handle, blue paint, signed, weight of box cover 9/16 lbs. H 5 1/4 ″ × D 9 1/4 ″

> *Garth 7/86* **$200**

Bentwood, round, pencil inscription, old gray paint. D 7 ″

> *Garth 7/86* **$65**

Bonnet, painted and decorated wood, inscribed. 12 ″ × 14 ″ × 12 ″

> *Sotheby's 1/87* **$1,000**

Book shape, cover inlaid with metal and whale ivory in forms of ships and whales, 19th century, good condition, craftsmanship. 16 ″ × 13 3/4 ″ × 4 1/2 ″

> *Bourne 2/87* **$500**

Cheese-butter, painted staved wood, c. 1830, possibly Shaker, round cover, dark green, tapered laps, carved initials, "MR." H 6 1/2 ″

> *Skinner 5/85* **$275**

Cheese-butter, painted staved wood, possibly Shaker, c. 1830, round cover, blue, buttonhole on eyelet hoops, carved initials, "ATW," illustrated. H 6 1/2 ″

> *Skinner 5/85* **$475**

Covered box, pine, punched tin, floral design in red, green. 16 3/4 ″ × 28 1/4 ″ × 18 1/2 ″

> *Garth 5/86* **$500**

Dovetailed pine, two compartments with single sliding lid, good old dark patina. L 10 ″

> *Garth 2/87* **$225**

Dove top pine, worn wallpaper covering, replacements. L 9 1/2 ″

> *Garth 7/86* **$55**

Early pine and poplar with square nail construction, scrolled crest, rim, one dovetailed drawer, old worn black paint shows brown finish beneath, front board has age cracks, some late re-nailing, age crack in crest at hanging hole. 15″ × 6″ × 4″

Garth 2/87 **$1,050**

Hat, wallpaper covered, early 19th century, top titled "Wind Mill & Railroad," sides with squirrels, loose top and bottom, illustrated. H 13″

Skinner 6/86 **$800**

Hat, painted and stencilled, New England, c. 1840, provenance, fine condition.

Sotheby's 1/87 **$2,900**

Immigrant's chest, small, dovetailed pine, applied moldings, decorated, worn red paint, flowers, replacements. 13³/₄″ × 39″ × 18¹/₄″

Garth 5/86 **$250**

Oval, small, wallpaper covered, original floral paper is pink, green, brown on gray ground, some wear. L 8¹/₄″

Garth 2/87 **$145**

Pine, floral wallpaper covering, lined with 1855 newspaper from Lowell, Massachusetts, paper worn, stained, casters added. L 23″

Garth 7/86 **$45**

Pine with sliding lid, small, square nail construction, worn bluish-green paint. L 7¹/₂″

Garth 2/87 **$40**

Pipe box, New England, early 19th century, maple, scrolled sides, single molded drawer, craftsmanship. 19″ × 5″ × 4″

Sotheby's 6/87 **$2,000**

Primitive dovetailed boxes, two, pine, refinished larger has fitted interior and brass nameplate E. Hayles. (A) L 9¹/₂″, (B) L 12″

Garth 3/87 **$60**

Ribbon, Berks County, Pennsylvania, c. 1800. L 14¹/₄″

Sotheby's 1/87 **$400**

Ribbon, probably Pennsylvania, 18th century, bentwood, covered and laid paper, painted, stylized tulips, vines. 6″ × 16³/₄″

Sotheby's 1/87 **$750**

Slant front lift lid, pine, original brown paint with white striping, good design. L 12″

Garth 2/86 **$85**

Spice, butternut, c. 1840, six graduated drawers, turned wooden knobs, natural color. H 14″

Skinner 6/86 **$700**

Spice, with hanging shelf, box, four-part interior, shelf carved with scalloped trim and aplied star, painted yellow and brown, damaged. 8″ × 9″ × 11³/₄″

<div align="right">

Garth 2/86 **$75**

</div>

Tea, wood, 19th century, red, inscribed "Maracaibo." H 33″

<div align="right">

Skinner 6/86 **$275**

</div>

Turned footed box, spire finial on lid, good detail, walnut and ash, old varnish finish has good color, minor age crack. H 10¹/₄″

<div align="right">

Garth 3/87 **$50**

</div>

Painted and Decorated

Bentwood, fine painted and decorated, probably Pennsylvania, c. 1840, two peaches on top, dot and vine borders. 4¹/₂″ × 11″

<div align="right">

Sotheby's 1/87 **$2,000**

</div>

Bentwood bride's, oval, laced seams, floral designs, faded pink ground, some wear, age crack in lid glued. L 16³/₄″

<div align="right">

Garth 5/86 **$425**

</div>

Bentwood, round, overall floral design in raised gesso, worn brown, white paint, some wear. H 3″ × D 12¹/₂″

<div align="right">

Garth 7/86 **$50**

</div>

Bentwood, round, laced seam, hinged lid, bentwood handle, floral decoration in red, green, yellow, white, some wear. L 13″

<div align="right">

Garth 7/86 **$100**

</div>

Book, painted and decorated, Midwest, 1870–1880, unusual design, exhibited. 13″ × 9¹/₄″ × 2³/₄″

<div align="right">

Sotheby's 10/86 **$800**

</div>

Bride's, Pennsylvania, late 18th century, oval, wood, fitted cover, stylized floral decoration, lady and gentleman on cover, illegible legend at base, Dove of Peace beneath, paint loss. H 8¹/₂″

<div align="right">

Skinner 11/85 **$375**

</div>

Bucher, Berks or Lancaster County, Pennsylvania, c. 1800, oval, painted and decorated bentwood, provenance, damaged. 2¹/₂″ × 11³/₄″

<div align="right">

Christie's 1/87 **$1,200**

</div>

Bucher, painted with tulips and initials "MA," possibly Pennsylvania. 3″ × 9³/₄″ × 8¹/₄″

<div align="right">

Sotheby's 1/87 **$900**

</div>

Bucher, H.W., Berks or Lancaster County, Pennsylvania, c. 1800, square, painted and decorated, signed. 3″ × 9″ × 8″

<div align="right">

Christie's 1/87 **$2,100**

</div>

Bucher, painted with tulips and initials "HW," Pennsylvania, c. 1800. 3″ × 9″ × 8″

Sotheby's 1/87 **$2,100**

Covered wooden pantry, 19th century, dark green ground, "Sugar" painted in yellow, scrolling freehand in red, cover split, minor paint loss. H 7¼″ × Dia 12″

Skinner 1/86 **$850**

Decorated, dovetailed pine, sliding lid, original olive-brown paint, floral decoration in red, black, white. One side has wreath with initials, other side has date of 1828. Urns on ends, heart-shaped design on lid. Top edges have been broken and reattached, with old blue overpaint around top edge. Lid has minor damage, restored beveled edge. L 22½″

Garth 2/87 **$500**

Decorated, dovetailed poplar, original red paint with blue and yellow striping, gilt stencilled floral designs, interior has green repaint, some wear, age cracks. L 11″

Garth 3/87 **$45**

Decorated pine, worn brown paint, yellow, black striping, scroll work. L 10″

Garth 5/86 **$40**

Decorated pine, block graining, wrought lock, hasp, repainted. L 21″

Garth 7/86 **$145**

Decorated, sliding lid, poplar, worn red paint, black brushed graining, age is questionable. L 9″

Garth 2/87 **$85**

Decorated, sliding lid, made from one piece of wood, small, old red paint with black sponging, some edge damage, replaced nail latch in lid. L 6″

Garth 3/87 **$20**

Decorated wood, Boston area, early 19th century, painted and decorated pine, scenic shell, floral and fruit decoration, yellow ground, four small brass ball feet, wear, color loss. H 4″ × L 12″

Skinner 3/85 **$800**

Decorated wood, c. 1820, polychrome freehand decoration, design of compote with fruit, basket with strawberries, stylized flowers, all on yellow ground, drab green striping, minor paint wear, top split, detached. 5″ × 10″ × 5″

Skinner 6/87 **$1,500**

Dovetailed pine, sliding beveled edge lid, old green paint. L 7″

Garth 5/86 **$75**

Dovetailed pine, wire hinges, wrought iron lock, hasp, old green repaint, black striping, floral decoration. L 12 1/2 ″

Garth 5/86 **$85**

Jewelry, 19th century, lift top, decorated scenes on sides, gilt work, minor restoration. 5 3/8 ″ × 11 ″ × 6 5/8 ″

Christie's 5/85 **$3,000**

Match box, painted pine, peacock design, hanging box, Yates Newsom, Vermont, 1806, dated, repaired. H 7 1/2 ″

Sotheby's 6/87 **$1,700**

Oval bonnet, painted and decorated wood, Pennsylvania, late 18th century, exhibited.

Sotheby's 10/86 **$5,250**

Painted and decorated, slate blue, sliding lid, incised compass design, Lancaster County, Pennsylvania, 1800–1850, exceptional color, provenance. H 2 1/2 ″ × L 8 ″

Sotheby's 6/87 **$2,600**

Painted pine, brass handles, nail-constructed, dark green paint, New England, c. 1820. H 9 3/4 ″

Skinner 1/85 **$125**

Painted wood, five-finger construction decorated with yellow, green, black foliage, good design, color, damage, replaced lid, wear. L 11 ″

Garth 2/86 **$75**

Pine, painted and decorated, exhibited, provenance. 4 1/2 ″ × 12 ″ × 10 1/4 ″

Sotheby's 10/86 **$825**

Pine, stencilled, c. 1830, polychrome repeating rope and pineapple decoration, interior has blocked wallpaper. H 8 ″

Skinner 6/86 **$650**

Pine, stylized pine cones, tole-like decorative leaves in yellow, probably New England, c. 1830. 5 3/8 ″

Sotheby's 10/86 **$1,800**

Polychrome decoupage, c. 1825, lift top, single drawer, divided interior, vibrantly painted, squares, rectangles, decoupage borders front and sides, pink, green, yellow, paint in excellent condition, one sectional divider missing. 6 1/2 ″ × 10 3/4 ″ × 10 1/2 ″

Skinner 11/86 **$2,100**

Yellow paint, black printed transfer designs, Greek key border. L 17 3/4 ″

Garth 7/86 **$100**

Pantry

Painted and decorated, "Launch or Clipper Ship Staffordshire, 1857" on lid, 1850–1875, exhibited, stamp on bottom, 10 1/2 ″

Sotheby's 10/86 **$2,300**

Vinegar-grained, simulating bird's-eye maple on salmon pink ground, New England, c. 1830. H 5 1/2 ″ × D 8 1/4 ″

Sotheby's 10/86 **$1,600**

Vinegar-grained, felted top, Midwest, 19th century, cracked badly. H 13 ″ × D 11 ″

Sotheby's 10/86 **$700**

Sewing

Painted and decorated pine and velvet, signed Jos. (Long) Lehn, Lancaster County, Pennsylvania, c. 1860, provenance. 13 1/2 ″ × 10 ″ × 7 1/2 ″

Sotheby's 1/87 **$3,500**

Painted fruit decoration, c. 1835, hinged cover, broken. 2 ″ × 5 ″ × 3 1/2 ″

Skinner 1/85 **$225**

Sliding cover, village scene, floral vines on sides, crazed top, 19th century. 3 ″ × 7 1/4 ″ × 10 ″

Skinner 8/87 **$950**

Shaker

Covered oval, mid-19th century, four fingers, old red paint partially cleaned. H 6 3/8 ″

Skinner 1/86 **$285**

Cylindrical, natural finish, 19th century, double tapering fingers, fitted cover, twenty Shaker spools, some with salmon paint.

Skinner 11/86 **$3,500**

Four boxes, single fingered, copper tacks, green over dark gray, red, New England, 19th century, broken. L 4 ″ to 5 3/4 ″

Skinner 5/85 **$1,000**

Oval carrier, Sabbathday Lake, Maine, late 19th century, four tapering fingers, bentwood copper riveted swinging handle, light blue fitted interior, sewing accessories. H 3 1/2 ″

Skinner 3/85 **$225**

Oval, c. 1840, red paint, four tapering fingers, small, some damage. H 2 ″ × L 5 1/4 ″

Skinner 3/85 **$150**

Oval, 19th century, one finger fitted cover, four finger cherry box, small crack. 5 1/2 ″ × 9 1/2 ″ × 13 1/2 ″

Skinner 1/86 **$450**

Pine, New England, 19th century, fine dovetailing, applied moldings, brass handles, interior till, initials "AG." H 12 1/2 ″

Skinner 3/85 **$485**

Sewing, covered, round, 19th century, brass tacks, swing handle, interior lined, moth damage, contains pin cushion, needle holder, small emery, illustrated. H 3 3/4 ″

Skinner 6/86 **$110**

Sewing, mahogany, other hard wood, drawer, pointed finials, ivory eyelets for thread, worn maroon silk covering on pin cushion finial, old finish, minor edge damage, small repairs. H 7 1/4 ″

Garth 2/87 **$135**

Sieves, set of nine, graduated circular ash, c. 1850, various sizes, provenance.

Sotheby's 6/86 **$3,250**

Stack of five oval boxes, red paint, some wear. L 6 1/2 ″ to 17 ″

Skinner 6/87 **$1,700**

Stack of six oval boxes, 19th century, fitted covers, copper tacks, finger construction, natural finish, illustrated. L 8 ″ to 15 ″

Skinner 6/86 **$4,300**

Stack of three boxes, fitted lids, four tapering fingers, some wear. L 8 3/4 ″ × D 11 1/2 ″

Skinner 6/87 **$2,500**

Storage, J. Dyer, Shaker, 19th century, wood, fitted lid, stave and hoop construction, signed. 7 ″ × Dia 15 1/2 ″

Christie's 5/85 **$260**

Utility, oval, 19th century, maple, fitted lid, two fingers. L 5 1/4 ″

Christie's 5/85 **$350**

Utility, oval, 19th century, fitted lid, four tapered fingers, yellow, excellent condition, illustrated. H 4 1/4 ″ × L 13 1/2 ″

Skinner 1/87 **$3,500**

Storage

Bentwood, round, single finger construction, old dark green paint, bottom loose. D 7 ″

Garth 5/86 **$85**

Bentwood, round, single finger construction, old blue paint. D 7 ″

Garth 5/86 **$200**

Carved and inlaid wood, heart motif, birds, masonic motif. H 19″ × W 7″

Sotheby's 1/84 **$900**

Fitted cover, copper nails, four fingers, 19th century, rim cracked. 5 1/2″ × 9 1/2″ × 13 1/2″

Skinner 5/86 **$450**

Hinged top, dovetail construction, burnt sienna decoration on poplar, New England, c. 1830, fine condition, minor paint loss. 11″ × 26″ × 14″

Skinner 5/86 **$200**

Putty decoration, poplar, hinged top, dovetail construction, New England, c. 1830, good condition, minor paint loss. 11″ × 26″ × 14″

Skinner 1/86 **$200**

Rectangular, red, yellow, initialed "WHB," New England 19th century. 4 1/2″ × 28″ × 9 1/4″

Skinner 5/86 **$425**

Rectangular wooden vinegar grained, yellow, umber, c. 1840. 8 1/4″ × 20″ × 9 3/4″

Skinner 5/86 **$325**

Round, wood, old worn blue paint over white, D 6 3/4″

Garth 5/86 **$65**

Stencilled and decorated, Ransom Cook attribution, probably New York, mid-19th century, poor condition. 10 1/4″ × 15 1/2″ × 17 3/4″

Skinner 5/86 **$100**

Stencilled and grained decoration, floral, leaf pattern, attributed to Ransom Cook, probably New York State, mid-19th century, needs repair. 10 1/4″ × 15 1/2″ × 17 3/4″

Skinner 1/86 **$100**

Vinegar grained, yellow, umber, c. 1840. 8 1/4″ × 20″ × 9 3/4″

Skinner 1/86 **$325**

Wood, domed top, c. 1840, vinegar grained decoration, burnt sienna, yellow ground, broken, crazing. H 12 1/2″

Skinner 5/85 **$100**

Tramp Art

Box. L 14 1/4″

Garth 7/86 **$85**

Wood, cigar box label inside, damage, hinge broken. L 9 3/4″

Garth 2/86 **$60**

Trinket

Painted pine, probably Connecticut, mid-18th century, cover, molded edge, cotter pin hinges, wire loop handle, incised initials "J.D.," dovetail corners, leaf design, worn gray paint, interior lined with 1771 Hartford newspaper, illustrated. 4³/₄″ × 7¹/₂″ × 4³/₄″

Skinner 11/85 **$1,900**

Utility

Dough, poplar, corner post construction, mortised and pinned stiles, raised panels, lift lid, two-section interior with sliding bread board and paddle, good craftsmanship, lid damaged, one hinge reset, stripped. 36³/₄″ × 38″ × 25″

Garth 2/86 **$175**

Scouring box, poplar, hangs, square nail construction, worn old brown patina. 9″ × 16″

Garth 2/87 **$155**

Knife, inlaid mahogany, c. 1850, two sections, scrolled, pierced handhold inlaid with an ivory spoon, knife, and fork, initials, old repairs. H 5¹/₂″

Skinner 6/86 **$200**

Knife, mahogany, dovetailed, turned handle, worn finish. 13¹/₂″ × 9¹/₄″

Garth 7/86 **$75**

Knife, painted pine, crown, paint loss. 14³/₄″ × 8¹/₄″ × 5″

Skinner 3/87 **$1,200**

Two: Wall and knife, country pine, 19th century, painted, applied circular medallions, knife box inlaid, stained red. H 13″ and H 12″

Skinner 6/86 **$165**

Wall Boxes

Comb box, pine, early 19th century, backboard cut in scroll design, painted finial, wooden pins hold front, dark green, illustrated. H 7¹/₄″

Skinner 5/85 **$600**

Comb case, Harwinton, Connecticut, 18th century, shaped crest, hanging hole, illegible paper label. H 7³/₄″ × W 6″

Skinner 3/85 **$1,100**

Hanging, carved, painted, pine, shaped crest, scalloped sides, heart cut-out, carved flowers, blue, green, brown, early 19th century, illustrated, imperfections. H 8 1/4"

Skinner 1/86 **$1,500**

Hanging, decorative scalloped crest, late with brown-grained repaint over gray. H 11"

Garth 2/87 **$85**

Hanging, pine, early 19th century, high arched backboard, curved sides, red paint, cracked. H 20 3/8"

Skinner 6/86 **$200**

Hanging, pine, scalloped rim, crest, divided interior, worn original red paint, black edge striping, splits in crest have nailed braces. W 11"

Garth 3/87 **$190**

Hanging, poplar, two sections, square nail construction, gray finish, traces of old paint, age cracks in crest. 10 3/4" × 17 3/4"

Garth 2/87 **$250**

Painted wood, two tiers, yellow over green, 19th century. 11" × 12" × 4"

Skinner 5/86 **$375**

Two-tier, probably Connecticut, c. 1790, carved pine, polychrome, elaborately carved eagle, flowers, rosettes, fine original condition and paint, illustrated, rare. 22 3/4" × 12 1/2" × 6"

Skinner 6/87 **$187,000**

Buckets

Fire bucket, William Otis, early 19th century, painted leather, inscription, strap missing, some repainting.

Christie's 5/85 **$400**

Calligraphic Drawings

Calligraphic pictures are pen and ink sketches of birds, animals, flora, and fauna which are sometimes colored. They flourished in the nineteenth century and developed from the teaching of penmanship as a school subject. Ornamental writing became more than a utilitarian skill to meet the demands of commerce and grew into a modest art form. The concentric curvilinear strokes were called flourishes because they were executed in very rapid succession.

Neilson, Joseph Ralstan, "Andrew Jackson," West Chester, Pennsylvania, c. 1848, pen and ink on paper, inscribed, signed. 21½″ × 15¾″

Christie's 1/84 **$500**

Unknown, profile: "Two Horses," 19th century, pen and ink on board. 21″ × 27″

Christie's 1/84 **$260**

Canes/Walking Sticks

Canes or walking sticks are practical, fashionable wooden items which were primarily made from 1850–1900, typically fashioned from sturdy domestic hickory, ash, spruce, or imported mahogany. Country craftsmen and amateurs alike personalized canes with paint, root handles, carved figures, incised decoration, bone, and/or ivory. Canes were especially popular in the southern part of the United States.

Abstract design, "Bally," probably Pennsylvania, 19th century, carved wood, unusual. L 35″

Sotheby's 1/87 **$600**

Abstract design, Simmons, probably Pennsylvania, 19th century, unusual. L 37½″

Sotheby's 1/87 **$1,200**

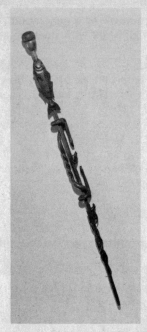

Late 19th-century New England carved wooden cane. (*Photo courtesy of Sotheby's, New York*)

Animals, snakes, dogs, men's heads, etc., Masonic emblem on knob, age crack. L 36½″

Garth 7/86 **$265**

Black boy, hatchet, alligator, carved, primitive, shaft damaged. L 14″

Garth 5/86 **$50**

Bone handle, carved ebony. L 35″

Garth 2/86 **$25**

Duck head handle and brass tip, carved, segmented bone, 19th century. L 38″

Skinner 11/85 **$500**

Eagle, shields, birds, anchor, pocket knife, etc., carved, "folk art" craftsmanship, design, uniqueness, top replaced. L 35″

Garth 2/86 **$135**

Ebony, tooled gilt handle with presentation engraving dated "1882," good craftsmanship, dated, design. L 34½″

Garth 2/86 **$75**

Figural natural formation of a gentleman, frock coat, left arm extended holding a ball, shoe with stocking at end, 19th century, carved. L 40″

Skinner 7/86 **$275**

Leg, bone handle, with buttoned riding breeches and boot, belt and buckle, probably American, late 19th century, carved wood and bone, chipped. L 34½″

Skinner 1/86 **$185**

Horn handle, wear. L 34½″

Garth 2/86 **$25**

Horse heads (3), crook handle, snake head, primitive, some wear, damages. L 38″

Garth 7/86 **$45**

Ivory knob, cracks. L 35½″

Garth 2/86 **$45**

Serpents cornering bullfrog, probably southern, late 19th century, carved pine. L 37″

Sotheby's 6/87 **$3,400**

Snake, carved and painted wood, 19th century, glass eyes, ochre, umber diamonds, tip missing. L 34″

Skinner 1/86 **$220**

Sword shaped, ivory knob, good design, cracks. L 35″

Garth 2/86 **$135**

Whale bone, ivory, 19th century, turned ivory knob head, diamond-shaped inserts of abalone, missing pieces. L 31½″

Skinner 11/85 **$385**

Woman bare breasted in top hat with serpent, wood, carved and painted wood, probably Tennessee, 19th century.

Skinner 1/86 **$4,400**

Carousel Figures

Carousel figures, crafted in a dozen or more northern east coast shops, were popular from 1875 to 1925. Amusement park and country fair carousels primarily sported carved and painted wooden horses and menagerie animals. Though some were relief carvings, a majority were carved in the round. Dentzel, Looff,

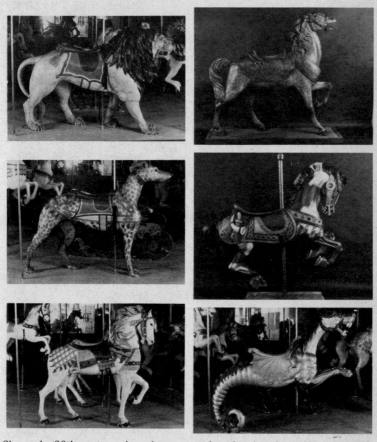

Six early 20th-century American carved and painted wooden carousel animals, including a lion, three horses, a greyhound, and a sea horse. (*Photo courtesy of Guernsey's*)

Stein & Golstein, Herschell-Spellman, and Illions are among the principal carousel carvers. Highly treasured for their sculptural quality, condition, original paint, and structural soundness, it appears that tasteful, skillful restoration does not significantly lessen an animal's value.

Camel, Allan Herschell, 1922, jumper, carved and painted wood, excellent, color, condition, craftsmanship, design.

Phillips 5/87 **$1,500**

Chariot, Herschell-Spellman, 1920, carved and painted scrolls, very fine condition, craftsmanship.

Phillips 5/87 **$1,600**

Goat, Gustav Dentzel, prancer, carved and painted wood, excellent craftsmanship, design, documentation, replacements.

Phillips 5/87 **$11,000**

Greyhound, Charles Looff, 1895, carved and painted wood, jeweled, excellent, color, condition, craftsmanship, unusual design, rare, provenance.

Phillips 5/87 **$54,000**

Horse, Charles Looff: attribution, c. 1885, carved, painted wood, stander, fine condition, published, illustrated. 60 1/2" × 58" × 13"

Skinner 3/85 **$8,500**

Horse, Charles Looff, 1910, carved, decorated, gilded and painted wood, horse hair tail, excellent, color, condition, craftsmanship, provenance.

Phillips 5/87 **$15,000**

Horse, Charles Illions, 1912, jumper, carved and painted wood, very fine craftsmanship, similar pieces known.

Phillips 5/87 **$3,600**

Horse, Stein & Goldstein, 1910, jumper, carved and painted wood, color, condition, craftsmanship, design.

Phillips 5/87 **$10,500**

Horse, Charles Looff, 20th century, stander, jeweled, carved and painted, 57" × 65"

Phillips 5/86 **$16,000**

Mule, carved, painted pine, stylized. 47" × 47"

Sotheby's 1/87 **$2,800**

Panel, eagle and flag design, oval in yellow and black, c. 1880. 36" × 47"

Skinner 3/85 **$1,300**

Panel, painted pine, gilt scroll motif frame surrounding oil on canvas child's portrait, late 19th century. 81" × 40"

Skinner 3/85 **$325**

Seahorse (hippocanthus), Dare, 1890, carved and painted wood, excellent condition, rare, exhibited, published, similar museum pieces known, provenance. 56" × 60"

Phillips 5/87 **$20,000**

Tiger, Charles Looff, 20th century, jeweled, rosettes, fierce expression, carved, painted, and decorated, excellent color, condition, craftsmanship. 47″ × 89″

<div align="right">

Phillips 5/86 **$32,000**
</div>

Tiger, Muller-Dentzel, 1895, stalking pose, carved and painted wood, excellent condition, craftsmanship, design.

<div align="right">

Phillips 5/87 **$12,000**
</div>

Zebra, Herschell-Spellman attribution, c. 1880, carved, painted wood, glass eyes, illustrated. 33″ × 48″

<div align="right">

Skinner 11/85 **$3,400**
</div>

Zebra, Gustav Dentzel, 1895, carved and painted pine, excellent color, condition, craftsmanship, design.

<div align="right">

Phillips 5/87 **$23,000**
</div>

Chairs (Benches/Settees)

Chair styles follow the furniture styles described in the Introduction. Additional information about Hitchcock, Shaker, and Windsor chairs and chair tables will help you identify and price these American country chairs.

Hitchcock 1820-1860

Named for Connecticut manufacturer Lambert Hitchcock who produced and popularized them, these painted and decorated chairs had open backs and plank, cane, or rush seats. Factory produced, the decoration on these chairs reflected the use of multiple stencils culminating in a variety of design patterns.

Shaker 1800-1900

New England and New York State Shaker communities produced chairs and other furniture as early as the late nineteenth century, originally for their own use but later for the "world." The design of all of their furniture reflected the simplicity and purity of their religion. Woven seats were of tape, splint, or rush. Chairs usually had a delicately shaped finial. The wood was commonly maple, ash, or birch.

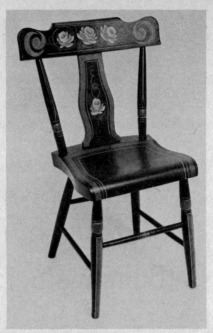

Late 19th-century Pennsylvania paint-decorated side chair with plank bottom and shaped back, and crest rail. (*Photo courtesy of Olde Hope Antiques, Inc.*)

Windsor 1750-1920

Though starting in eighteenth-century Philadelphia, American craftsmen throughout the colonies developed their own versions of the English Windsor chair. Windsors, originally used as garden seating, are spindle-backed chairs, settees, and benches made of plank-molded seats and turned, splayed legs met by turned stretchers. The names reflected the designs of their backs: comb, fan, bow, arch, loop, rod, and low-back. Windsor writing and children's chairs were also produced. Windsor chairs (and tables) were made from a combination of woods most often unified by paint.

Chair Table 1675-1700

This armchair contains a hinged back which may be lowered to serve as a table top. The back and arms of the chair serve as supports for the table top when lowered. Typically composed

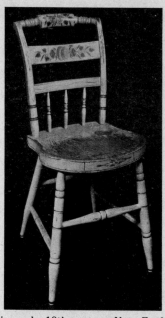

One from a set of six early 19th-century New England paint-decorated side chairs in various woods, with pillow back, 34″ height. (*Photo courtesy of Barbara and Frank Pollack*)

of two boards, the top may appear square, round, or oblong. The dual function was most helpful in conserving valuable space in small homes. Primarily a New England form, the chair table often sported a pine top and oak base and was painted red, black, or green to unify it.

Adirondack stick, New York, 19th century, straight crest, sloping arms, dark green, imperfections. H 30¼″

Skinner 11/85 **$150**

Armchair, New England, 18th century, painted and turned wood, three slats, worn blue paint, cut-down legs. H 22″

Skinner 5/86 **$175**

Armchair, 18th century, maple and ash, knob and ring turned finials, three splats, refinished, modified. H 47″

Skinner 5/86 **$400**

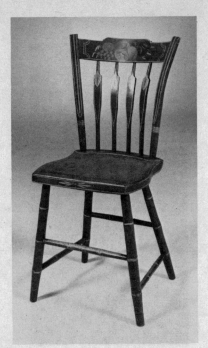

Early 19th-century New England paint-decorated side chair with back splats in arrow form. (*Photo courtesy of Sotheby's, New York*)

Baltimore-type side, pair, fancy, good turnings, balloon seats, rabbit ear ladder-backs, worn original yellow paint, red striping and black panels on crest slats, foliage, seashells in faded gold, yellow, white, and red, some splits in back posts, replaced paper rush seats, one seat worn.

Garth 3/87 **$200**

Child's armchair, c. 1830, smoke grained, ochre, green, white, and black striping, rush seat, some repair. H 18¾"

Skinner 1/85 **$300**

Child's chair, possibly E. Oliver, New York City or Albany, New York, c. 1825, painted, elaborate acanthus leaf decoration, rush seat, inscription.

Sotheby's 6/87 **$500**

Child's potty, probably Pennsylvania, 1750–1800, green paint, restored.

Sotheby's 1/87 **$800**

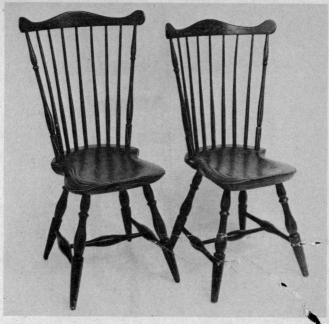

Pair of late 18th-century New England fan-back side chairs with 19th-century brown paint over original green paint. (*Photo courtesy of Olde Hope Antiques, Inc.*)

Child's side chair, Pennsylvania, c. 1845, plank seat, painted, decorated with floral and leaf motifs, polychromed, gilt, shaped crest, vase splat, turned legs, stretchers.

Sotheby's 10/86 **$600**

Child's slat-back armchair, New England, 1750, splint seat, green with red striping, original seat. H 20″

Skinner 6/86 **$150**

Country Chippendale side, walnut, square legs, molded corner and inside chamfer, wooden seat, "H" stretcher, pierced splat, shaped crest, good old dark finish.

Garth 2/87 **$500**

Country corner, turned legs, bentwood rail, old refinishing, replaced woven splint seat.

Garth 3/87 **$65**

Country ladder-back side, red repaint, yellow striping, small flowers, replacements, seat damage.

Garth 5/86 **$55**

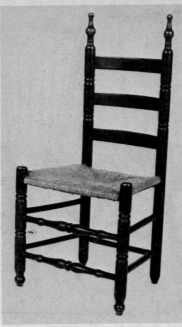

Early 19th-century Bergen County, New Jersey, child's size ladder-back side chair, made by Cornelius Abraham Demerest, in hickory and chest-nut, 31″ height. (*Photo courtesy of Bari and Phil Axelband*)

Country ladder-back side, set of four, worn old red paint, re-placed woven splint seats.

<div align="right">

Garth 3/87 **$400**

</div>

Country ladder-back side, three curved slats, finials, woven splint seat, old worn black paint, some edge damage.

<div align="right">

Garth 3/87 **$90**

</div>

Country ladder-back side, three slats, turned finials, splint seat, old worn dark finish.

<div align="right">

Garth 2/87 **$45**

</div>

Country ladder-back rabbit ear side, two slats, refinished, new splint seat.

<div align="right">

Garth 2/87 **$45**

</div>

Country Queen Anne side, turned legs, posts and front stretcher, vase splat, yoke crest, worn old green repaint, crest cracked as one side is mounted lower on post than other, new paper rush seat.

<div align="right">

Garth 2/87 **$300**

</div>

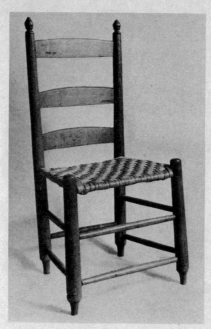

Mid-19th-century Selma, Alabama, ladder-back side chair in various woods, with replaced splint seat, 36″ height. (*Photo courtesy of Robert Cargo Folk Art Gallery*)

Decorated balloon-back side, set of five, original dark brown paint, polychrome stencilled fruit, floral decoration, well-turned legs, decoration is faint, paint worn, one slat has damage on back edge, one crest is reattached.

Garth 3/87 **$425**

Decorated ladder-back side, old dark red repaint with yellow striping, stencilled floral slats, slats appear to have been reshaped at one time, new rush seat.

Garth 2/87 **$65**

Decorated side, pair, plank seats, half-spindle rabbit ear backs, worn original black graining over red with blue, yellow striping, floral decoration on crests.

Garth 2/87 **$300**

Decorated side, set of six, original red and black graining, yellow, green striping, stencilled decoration, including foliage and compotes of fruit on crest, some wear, fading.

Garth 3/87 **$750**

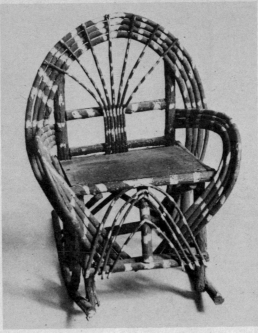

Early 20th-century northwestern Alabama child's size twig rocking arm-chair with painted decoration, 24″ height. *(Photo courtesy of Robert Cargo Folk Art Gallery)*

Decorated side, set of six, plank seats, half-spindle backs, original green paint, black, yellow striping, stencilled fruit, foliage on crests, very good color, minor wear, one crest reattached.

Garth 2/87 **$2,100**

"Great" chair, New England, c. 1720, four arched slats, sloping arms, black paint, repairs.

Skinner 5/86 **$450**

Hepplewhite side, set of six, mahogany, square tapered legs, "H" stretchers, pierced splats, old finish, corner braces added to inside of seat frames, slip seats reupholstered in pale lemon yellow, some small repairs.

Garth 2/87 **$1,950**

Highchair, northern New England, c. 1800, ash, old rush seat, two slats. H 32″

Skinner 5/86 **$150**

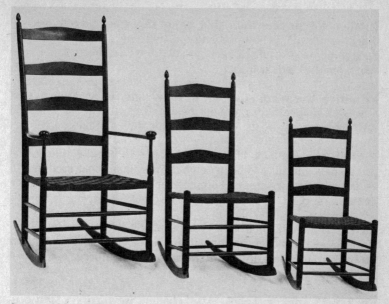

Group of three late 19th-, early 20th-century Shaker rocking chairs, including two side chairs and one armchair with mushroom-shaped knobs at arms, and all three with acorn-shaped finials. (*Photo courtesy of Adam A. Weschler & Son, Inc.*)

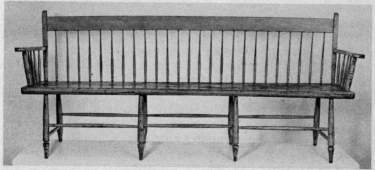

Mid-19th-century American Windsor settee with old, gray/white paint, probably from New York State. (*Photo courtesy of Muleskinner Antiques*)

Highchair, decorated, turned legs, captain's chair back, turned spindles, bentwood crest, worn old black paint, traces of striping and decoration. H 28½″

Garth 2/87 **$275**

Hitchcock-type Sheraton side, set of three decorated, original black paint with yellow striping, polychrome gilt, stencilled foliage, compote of fruit, some wear, two have replaced paper rush seats, one has old rush seat.

Garth 2/87 **$300**

Primitive Moravian side, set of four, pine, splayed pencil post legs, well-shaped backs, cut-out hearts, worn finish, traces of old red, age cracks in seats and backs, some added braces.

Garth 3/87 **$740**

Primitive wing-back chair, pine, iron side handles, possibly a potty chair, but lid has been rehinged and inner seat modified to rectangular opening, open compartment in base, old finish, some age cracks. H 46″

Garth 3/87 **$210**

Shaker armchair rocker, very faint stencilled "Mt. Lebanon, New York" label on rocker, impressed size mark, number "6," appears on back of top slat, original dark finish is alligatored, old woven tape seat.

Garth 3/87 **$975**

Shaker #3 rocker, Label: "Mt. Lebanon, New York," 19th century, turned finials, three slats, olive green tap seat. H 34¼″

Skinner 11/86 **$325**

Shaker side, probably Alfred, Maine, c. 1850, maple, three slats, tape seat, red wash, replacements. H 40¾″

Skinner 11/86 **$500**

Sheraton: pair of country ladder-back side chairs, worn original red, black graining, green and yellow striping and traces of stencilled decoration, replaced rush seats.

Garth 3/87 **$250**

Sheraton youth-size side chair, turned legs and rails, original dark paint, faded striping, stencilled decoration on wide slat, rush seat is very worn, one side of seat trim damaged. H 15″ seat

Garth 3/87 **$45**

Sheraton: set of three country side chairs, maple, with bird's-eye and curly, old finish has very good color, a few age cracks, one splat has glued split, replaced cane seats.

Garth 3/87 **$210**

Side chair, probably Massachusetts, c. 1720, bannister back, "C" scrolls on crest, four splats, turned feet, some repairs. H 52″

Skinner 5/86 **$2,500**

Side, Massachusetts, c. 1770, Chippendale, carved and painted maple, rush seat, provenance, repainted.

Sotheby's 1/87 **$2,800**

Side, New England, c. 1780, Chippendale, carved and painted maple, rush seat, provenance.

Sotheby's 1/87 **$3,250**

Side, New England, c. 1790, Federal style, carved, painted and decorated maple, rush seat.

Christie's 1/87 **$4,800**

Side, New England, c.1790, painted and decorated, rush seat.

Sotheby's 1/87 **$4,750**

Side: a pair, New England, c. 1830, Federal style pine, tablet crest rail, four spindles, plank seat, turned legs, provenance.

Weschler 9/86 **$100**

Side, Pennsylvania, c. 1845, plank seat, painted, decorated floral motifs.

Sotheby's 10/86 **$275**

Side chairs, Pennsylvania, c. 1835, maple, painted, decorated with apple, cherry motifs, rush seats.

Sotheby's 10/86 **$5,250**

Side, Long Island, New York, c. 1750, Queen Anne style country piece, repainted in 19th century, yolk crest rail, rush seat, old repairs. H 41 1/2″

Skinner 5/86 **$400**

Side, New York, c. 1770, Queen Anne, maple, rush seat, provenance.

Sotheby's 1/87 **$2,600**

Side: set of eight, possibly Maryland, c. 1825, Federal style wooden, gilt stencilled painted fruit and vine decoration, caned seat.

Weschler 9/86 **$1,700**

Transitional Chippendale to Hepplewhite armchair, mahogany, square tapered legs, "H" stretcher, shaped arms, pierced splat, scrolled crest, seat upholstered in slate blue, fine white, brown figure, old finish, repaired split in one arm.

Garth 2/87 **$950**

Two decorated balloon-back side chairs, original dark brown paint, yellow striping, polychromed floral, fruit, shell decoration, paint worn but good color.

Garth 3/87 **$280**

Two decorated side chairs, plank seats, half-arrow backs, wide crests, worn original red graining, gold, black and white striping, Greek key-like design on crests, similar, but not an exact match.

Garth 3/87 **$150**

William and Mary style, c. 1700, wooden bannister back, painted, split reed seat, turned legs, provenance.

Weschler 5/87 **$400**

Windsor armchair, Nantucket, 1770–1790, painted, braced fanback, rarity.

Sotheby's 1/84 **$3,500**

Windsor armchair, Philadelphia, Pennsylvania, c. 1785, painted, turned, carved lowback, some restoration.

Sotheby's 1/84 **$7,000**

Windsor armchair, c. 1810, painted and grained combback, two drawers, provenance, publicity.

Christie's 1/87 **$9,500**

Windsor armchair: a pair, Pennsylvania, c. 1800, painted, turned wood, provenance, publicity.

Christie's 1/87 **$37,500**

Windsor bamboo armchair rocker, refinished, small repairs, one arm post has metal brace.

Garth 3/87 **$225**

Windsor bamboo side, five-spindle back with medallion, refinished, plugged knothole in seat. H 17¾″ seat

Garth 2/87 **$80**

Windsor bamboo side, splayed base with "H" stretcher, old, worn refinishing, well-executed patch in seat. H 17½″ seat

Garth 3/87 **$120**

Windsor bamboo side, splayed legs, "H" stretcher, shaped seat, cage-like back, repairs, replacements, refinished. H 16½″ seat

Garth 3/87 **$150**

Windsor birdcage rocker, New England, c. 1810, seven spindles and bamboo turned stiles on shaped seat, refinished. H 39½″

Skinner 5/86 **$400**

Windsor bowback armchair, New England, c. 1810, J. Beal, Jr., painted brown over green, signed, repairs.

Skinner 5/86 **$425**

Windsor bowback side, splayed base, turned legs, "H" stretcher, saddle seat, seven-spindle back, old finish has very good dark brown color, split in bow, base is old replacement. H 18″ seat

Garth 3/87 **$125**

Windsor, child's, Pennsylvania, c. 1800, stamped J. J. Waten (?), pink, yellow, and green. H 17″

Skinner 6/86 **$700**

Windsor, child's, "H Cate," painted wood, green-stamped sackback, armchair. H 27¼″

Christie's 1/87 **$7,500**

Windsor child's highchair, New England, c. 1780, splayed bamboo turned stiles, saddle seat, black paint, yellow striping, worn. H 33″

Skinner 11/86 **$650**

Windsor combback rocker, New England, c. 1800, color illustration, provenance.

Sotheby's 1/87 **$8,000**

Windsor combback writing armchair, c. 1810, painted and grained.

Sotheby's 1/87 **$10,450**

Windsor country bamboo side, branded "Willer," traces of old yellow paint, crest is old replacement. H 17½″ seat

Garth 2/87 **$50**

Windsor country fanback side, pair, splayed legs, "H" stretchers, saddle seats, seven-spindle backs, turned posts, shaped crests, repairs, replacements, refinished. H 18″ seat.

Garth 3/87 **$390**

Windsor country low-back armchair, refinished late. H 18″ seat

Garth 3/87 **$125**

Windsor fanback, Connecticut, 1770–1790, green, seven spindles, saddle seat.

Skinner 5/86 **$2,600**

Windsor fanback, New England, c. 1780, maple and ash, bowed crest rail above seven spindles, saddle seat, old stain refinish.

Skinner 5/86 **$800**

Windsor highchair, New England, c. 1810, brown, green, turned thumbback style, five spindles. H 33½″

Skinner 5/86 **$400**

Windsor kitchen side (two), similar, bamboo turned legs, plank seats, four-spindle backs, rabbit ear posts, refinished.

Garth 3/87 **$110**

Windsor rocker, possibly Connecticut, c. 1780, maple, pine, and ash, saddle seat, splayed vase and ring turned legs, four spindles. H 48″

Skinner 5/86 **$1,300**

Windsor sackback: pair, Pennsylvania, c. 1800, painted and decorated dark green, yellow highlights.

Sotheby's 1/87 **$37,500**

Windsor side, probably Connecticut, c. 1800, fanback, green over blue, craftsmanship, good condition.

Sotheby's 6/87 **$3,100**

Windsor side, New England, c. 1810, painted, decorated, fanback.

Sotheby's 10/86 **$2,100**

Windsor side, New England, c. 1795, painted, carved, turned, combback, some restoration.

Sotheby's 10/86 **$4,000**

Windsor side, New England, c. 1800, saddle seat, bamboo turned legs. H 37″

Skinner 3/85 **$950**

Windsor slipper, Nantucket, 1770–1790, painted, braced fanback, good condition, documentation, provenance.

Sotheby's 1/84 **$7,000**

Windsor triple-back, Massachusetts or Connecticut, c. 1780, maple, pine, and ash, saddle seat, splayed vase and ring turned legs, repairs, refinished. H 46″

Skinner 5/86 **$800**

Windsor youth's rodback chair, Maine, c. 1840, shaped crest, green, ochre striping, five spindles.

Skinner 1/86 **$350**

Multiple Seating Pieces

Bench, primitive, old alligatored yellow, green paint. 16″ × 12″ × 34″

Garth 7/86 **$70**

Bench, Pennsylvania, c. 1830, painted and decorated yellow, green, and black. H 32½″ × L 76″

Skinner 6/87 **$2,400**

Settee, miniature, Pennsylvania, c. 1840, plank seat, painted, decorated wood, rarity.

Sotheby's 10/86 **$2,700**

Chalkware

Popularly made in Pennsylvania, and consisting of processed gypsum or plaster of Paris and water, chalkware was factory cast into molds to fashion ornaments resembling more expensive

pottery and porcelain figures. The white plaster of Paris, hollow-bodied objects, commercially produced in quantity between 1850 and 1890, were sized and hand painted in both oil and watercolor. Brightly colored, the unglazed images often depicted animals and birds (cats, roosters, sheep, parrots), fruit forms, busts of famous people, and churches.

Canary, Pennsylvania, mid-19th century. H 6″
<div align="right">

Sotheby's 1/87 **$400**
</div>

Cat, 19th century, painted, some chipping. H 6½″
<div align="right">

Skinner 1/85 **$275**
</div>

Cat on all four legs.
<div align="right">

Sotheby's 1/87 **$550**
</div>

Cat, Pennsylvania, mid-19th century, oversized, yellow, red collar, crack, small hole.
<div align="right">

Sotheby's 6/87 **$1,400**
</div>

Cats: a pair, Pennsylvania, mid-19th century, painted and decorated, oversized, rare, condition. H 16⅛″
<div align="right">

Christie's 1/87 **$38,500**
</div>

Distel fink, Pennsylvania, mid-19th century. H 6″
<div align="right">

Sotheby's 1/87 **$2,100**
</div>

Eagle, Pennsylvania, mid-19th century. H 8½″
<div align="right">

Sotheby's 1/87 **$450**
</div>

Fruit in urn, Pennsylvania, mid-19th century, painted, hollow. 9¼″ × 12″
<div align="right">

Christie's 1/87 **$1,800**
</div>

Fruit, Pennsylvania, mid-19th century, provenance.
<div align="right">

Sotheby's 1/87 **$1,980**
</div>

Hen bank, Pennsylvania, mid-19th century. H 6½″
<div align="right">

Sotheby's 1/87 **$650**
</div>

Kissing doves, Pennsylvania, mid-19th century. H 4¾″
<div align="right">

Sotheby's 1/87 **$800**
</div>

Kissing roosters, Pennsylvania, mid-19th century. H 4″ × L 5¼″
<div align="right">

Sotheby's 1/87 **$1,100**
</div>

Parakeet, Pennsylvania, mid-19th century. H 4½″
<div align="right">

Sotheby's 1/87 **$500**
</div>

Reclining stag, yellow with red, black, and green, chipped. 10″ × 8½″
<div align="right">

Sotheby's 1/87 **$1,400**
</div>

Rooster, Pennsylvania, mid-19th century, yellow, polychrome markings. 5½″ × 3¼″
<div align="right">

Sotheby's 1/87 **$500**
</div>

Rooster, Pennsylvania, mid-19th century. H 7″
Sotheby's 1/87 **$700**

Rooster, Pennsylvania, mid-19th century, painted, oversized. 7″ × 6″
Sotheby's 1/87 **$12,000**

Seated cat, Pennsylvania, mid-19th century, painted black stripes. H 5½″
Sotheby's 1/87 **$500**

Squirrel, Pennsylvania, mid-19th century. H 7″
Sotheby's 1/87 **$850**

Watch holder, Pennsylvania, mid-19th century, bird, flaking. 12″ × 8″
Sotheby's 1/87 **$1,300**

Chests

Found in the seventeenth, eighteenth, and nineteenth centuries, in their simplest form chests were boxlike, with hinged lid covering the storage area, sometimes with one or two drawers at the bottom. By the nineteenth century, the blanket chest often was hidden behind false drawer fronts to pass as an ordinary chest of drawers. Trunks, traditionally dome topped, frequently housed smaller interior side compartments.

Historically connected with the Pennsylvania German settlers, the dower chest served as a repository for the belongings a young girl would take with her as a bride. Vivid polychrome decorations on the facade reflected the fraktur tradition. Favorite motifs included tulips, birds, stars, geometrics, hearts, and carnations, each with its own symbolic significance. Pine, poplar, and tulip woods were often used.

Grain-Painted Blanket Chests

Brown, New England, c. 1840, yellow putty, pine, nail construction.
Skinner 3/85 **$300**

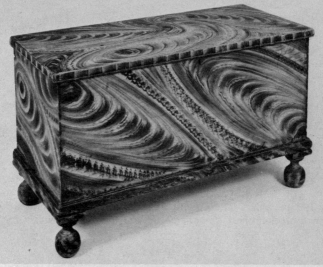

Early 19th-century New England paint-decorated lift-top blanket chest on ball feet. (*Photo courtesy of Sotheby's, New York*)

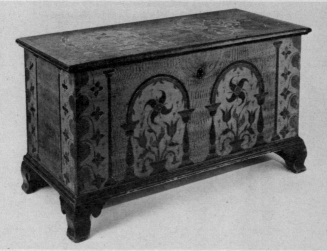

Late 18th-century Lebanon County, Pennsylvania, paint-decorated lift-top dower or blanket chest. (*Photo courtesy of Olde Hope Antiques, Inc.*)

Burnt sienna, c. 1840, pine, dovetailing, damage. 21″ × 43″ × 23″

Skinner 1/87 **$250**

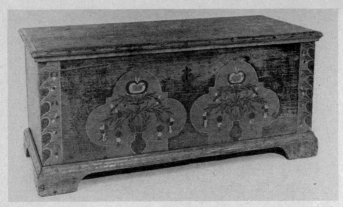

Early 19th-century Center County, Pennsylvania, paint-decorated lift-top dower or blanket chest. (*Photo courtesy of Olde Hope Antiques, Inc.*)

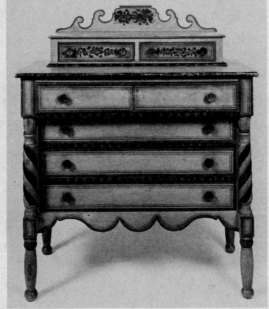

Early 19th-century New England paint-decorated Empire chest of drawers, with scrolled back splash and turned posts. (*Private collection*)

Chippendale style, Pennsylvania, late 18th century, wood. 23″ × 49″

Christie's 10/84 **$2,000**

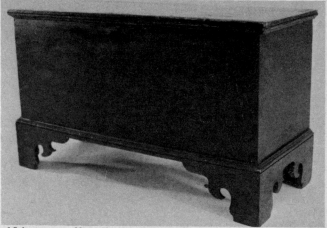

Late 18th-century New England painted, six-board or blanket chest on scrolled bracket base, 37″ height × 21½″ width × 16″ depth. (*Photo courtesy of Litchfield Auction Gallery*)

Federal style, possibly Pennsylvania, c. 1800, red on brown graining, floral rosettes, bracket feet. 29″ × 56″ × 28″

 Weschler 9/85 **$250**

Lift top, New England, c. 1740, interior till, two drawers, ring pulls, illustrated. 40″ × 39″ × 17″

 Skinner 6/86 **$2,500**

Lift top, New England, c. 1810, mustard yellow, pine, brass pulls, illustrated. 27″ × 36″ × 17″

 Skinner 11/85 **$1,500**

Lift top, Albany County, New York, c. 1840, orange-red mahogany graining, yellow stencilled cabbage rose, two drawers, "E.P.": Eliphalet Nott, fine condition, published. 45″ × 41″ × 17″

 Skinner 11/86 **$9,000**

Lift top, New England, c. 1820, painted mahagony graining, minor flaking. 38″ × 38″ × 18″

 Skinner 6/87 **$1,250**

Pine, New England, c. 1830, dovetail construction, bracket feet. H 22″

 Skinner 1/85 **$350**

Pine, dovetailed case, well-shaped turned feet, worn original red graining, hinged lid has braced split, pieced edge repair, minor age cracks in feet. 23¾″ × 36¾″ × 18¾″

 Garth 3/87 **$150**

Pine, dovetailed, till with two dovetailed drawers, old brown-grained repaint, ball feet are old additions, braces added to inside of lid, over strap hinges. 21 1/2″ × 40″ × D 22″

Garth 3/87 **$200**

Pine, dovetailed case, base and lid molding, high turned feet, till, original dark brown graining, minor wear, pieced repair in lid edge molding and lock.

Garth 3/87 **$275**

Pine, New England, c. 1830, nail construction, mustard brown decoration, repaired. 23″ × 37″ × 18″

Skinner 1/85 **$850**

Poplar, dovetailed construction, turned feet, till, yellow graining. 24″ × 39 1/2″ × 20 3/4″

Garth 7/86 **$225**

Poplar, till, old worn graining, mismatched feet are replacements, hinges broken. 23 3/4″ × 36 1/2″ × 19 1/4″

Garth 7/86 **$100**

Pine, Connecticut, c. 1780, red and black paint. 24″ × 48″ × 18″

Skinner 1/86 **$950**

Six-board pine, till, small, small cutout feet, applied base molding, worn salmon-colored paint, smoked graining, some edge damage. 19 1/4″ × 37″ × 14″

Garth 7/86 **$235**

Smoke-grained pine, New England, c. 1800, dovetailed box, iron handles. 19″ × 44″ × 20″

Skinner 1/86 **$200**

Pine, William and Mary, c. 1720, provenance, repairs, replacements. 37″ × 36″ × 18″

Skinner 5/86 **$1,400**

Tulip wood, small, original brown graining on yellow ground, original lock with brass keyhole cover, hasp missing, minor edge wear. L 29 1/2″

Garth 3/87 **$325**

William and Mary style, New England, c. 1740, three working drawers, illustrated, replacements, repairs. 48″ × 38″ × 18″

Skinner 3/85 **$700**

Wood, New England, early 19th century, one long drawer with sunburst decoration. 34″ × 40″ × 19 1/2″

Christie's 5/87 **$3,500**

Miniature Blanket Chests

Pine, decorated, Pennsylvania, 1800–1850, fine, rare, piece incomplete, scratched. 16″ × 26½″ × 13½″

Christie's 10/85 **$22,000**

Walnut, Pennsylvania, late 18th century, carved, decorated, incised and inlaid, provenance, rare. 7″ × 15¾″ × 8″

Christie's 1/87 **$16,500**

Wood, Pennsylvania, late 19th century, carved, red painted decoration, inscribed "Sarah," craftsmanship. 6¼″ × 12¾″ × 6½″

Christie's 6/84 **$24,000**

Federal style, inlaid and painted cherry wood, inscribed: Maria Seigrift, 1807. 8″ × 11″

Sotheby's 1/87 **$1,900**

Pine, New England, c. 1840, grain and sponge decorated and carved, two drawers. 12″ × 10¼″ × 6″

Christie's 1/87 **$2,500**

Pine, probably New England, c. 1840, green on red and yellow grain and sponge painted.

Sotheby's 1/87 **$2,500**

Painted, decorated wood, Shenandoah, Virginia, c. 1850, Jacob Stalwart, exhibited, published.

Sotheby's 10/86 **$9,075**

Painted, decorated, Lancaster County, Pennsylvania, 1840–1850, Jacob Weber.

Sotheby's 1/87 **$13,000**

Painted, early 19th century, grained, hinged top, applied edges, bracket legs. H 9″

Skinner 6/87 **$275**

Pine, New England, c. 1830, sponge painted. 9¼″ × 24″ × 12″

Sotheby's 1/84 **$880**

Poplar, six board, cutout feet, base, lid moldings, old green paint over earlier black. L 13¼″

Garth 3/87 **$450**

Sponge painted wood, 13½″ × 25¼″ × 12¾″

Sotheby's 1/84 **$1,320**

Walnut, Pennsylvania, 19th century, internal music box. 9″ × 15¾″ × 9″

Sotheby's 1/87 **$3,300**

Pine, yellow painted, Lancaster County, Pennsylvania, c. 1845, Jacob Weber, fine, rare. $4\,1/4''\times7''\times4''$

<div align="right">

Christie's 1/87 **$13,000**

</div>

Miscellaneous Blanket Chests

Child's, possibly New Jersey, c. 1820, molded lift top, single drawer, opaque red wash, illustrated, original condition. $12\,1/2''\times11\,1/4''\times5\,1/2''$

<div align="right">

Skinner 6/86 **$2,000**

</div>

Chippendale, New Hampshire, c. 1770, molded lift top, three working drawers, bracket feet, fine original brasses, escutcheons. $54''\times34''\times18\,3/4''$

<div align="right">

Skinner 5/86 **$1,700**

</div>

Chippendale, New England, c. 1780, pine, blue paint, dovetail construction. $21\,1/2''\times43''\times16''$

<div align="right">

Skinner 1/87 **$600**

</div>

Chippendale style, New England, c. 1760, lift top, old brown paint, three faux drawers over two working drawers. $41''\times38''\times19''$

<div align="right">

Skinner 1/85 **$600**

</div>

Chippendale style country piece, c. 1780, lift top, two thumb-molded drawers, pine, good condition, original Queen Anne brasses. $40''\times38''\times19''$

<div align="right">

Skinner 5/86 **$900**

</div>

Country pine, blue paint, lift top, single drawer, original brasses. $33''\times40''\times17''$

<div align="right">

Skinner 1/86 **$1,600**

</div>

Pine, dovetailed, small, with till, wrought iron strap hinges, old finish, good color, hinges reset. L $33''$

<div align="right">

Garth 7/86 **$360**

</div>

Pine, New England, c. 1780, cut-out ends, repaired. $42''\times42''\times18''$

<div align="right">

Skinner 3/85 **$425**

</div>

Shaker, New England, c. 1800, two thumb-molded drawers, dovetail construction, illustrated, refinished, repairs. $38''\times36''\times18\,1/2''$

<div align="right">

Skinner 7/86 **$1,800**

</div>

Walnut, dovetailed bracket feet, till, wrought iron strap hinges, good scrolled detail, feet repaired. $22\,1/2''\times46''\times17\,1/2''$

<div align="right">

Garth 7/86 **$600**

</div>

Painted, Decorated Blanket Chests

Child's, possibly New York State, c. 1830, polychrome pine, nail constructed box, decorated compass work, illustrated, fine condition, recently varnished, minor wear, imperfections. 17″ × 20½″ × 11½″

Skinner 6/87 **$13,000**

Chippendale style, Pennsylvania, 1785, pine, blue paint, interior signed in chalk, Dubois (?). 23⅝″ × 49¾″ × 20¼″

Christie's 1/84 **$800**

Chippendale style, pine, Bern and Tulpehocken Townships, Pennsylvania, c. 1790, Himmelberger shop: attribution, similar pieces known. 51″ × 24½″

Christie's 1/87 **$10,000**

Dower, Pennsylvania, dated 1829, red and black painted pine, lift top, dovetail construction, initials: "ABM," illustrated. 30½″ × 47″ × 23″

Skinner 11/85 **$850**

Dower, Pennsylvania, c. 1770, blue, white, yellow, and red painted pine and poplar, dovetail construction, illustrated, imperfections. 23″ × 51″ × 22″

Skinner 1/87 **$3,000**

Federal style, 1800–1850, carved and painted poplar, tree of life design, possibly Connecticut, published, color plate. 25″ × 50″ × 21″

Christie's 10/87 **$6,000**

Federal style pine, 19th century, painted and decorated, three arched vignettes, three drawers, bracket feet. 25″ × 51″ × 23″

Weschler 2/87 **$2,100**

Floral decoration, Center City, Pennsylvania, early 19th century, publicity.

Sotheby's 10/86 **$19,800**

Lift top, checker decoration, pine, Page County, Virginia, 1822, illustrated, inscription inside lid. 25″ × 45″ × 18½″

Skinner 1/85 **$1,500**

Lift top, New England, c. 1830, four drawers, mahogany-like painted veneer, illustrated, minor damage, replacements. 38″ × 38½″ × 17″

Skinner 3/85 **$600**

Lift top, probably Manheim, Pennsylvania, dated 1784, painted, carved, flower decoration, grained moldings. 20″ × 50″ × 24″

Sotheby's 1/87 **$11,000**

Painted, 19th century, beautiful paint, color illustration. 23 1/2 ″ × 50 ″ × 22 1/4 ″

Sotheby's 1/87 **$42,900**

Painted, decorated pine, Center City, Pennsylvania, early 19th century, similar one by Johannes Spitler published. 22 1/4 ″ × 47 ″

Sotheby's 10/86 **$14,300**

Painted, decorated pine, Pennsylvania, c. 1780, lacks feet. 21 ″ × 50 1/2 ″ × 22 ″

Sotheby's 1/87 **$5,250**

Painted, decorated pine, Shenandoah Valley, Pennsylvania, c. 1840, Johannes Spitler.

Sotheby's 1/87 **$60,000**

Painted, grained, New England, early 19th century, provenance, restoration, hinge broken. 21 ″ × 37 ″ × 16 ″

Sotheby's 1/87 **$5,500**

Painted, marbleized wood, mat stick molding, probably Maine, 1790–1810, similar pieces known from Cushing, Maine. 24 3/4 ″ × 44 ″ × 18 3/4 ″

Sotheby's 1/84 **$8,800**

Painted red, two drawers, Brattleboro, Vermont, 1836, F.W. Spooner. 39 ″ × 42 ″ × 18 ″

Christie's 10/87 **$600**

Painted wood, Center City, Pennsylvania, c.1820, "Flat Tulip" artist, attributed to Dancel Otto, documentation, publicity, similar pieces published. 24 3/4 ″ × 48 ″ × 23 ″

Sotheby's 10/86 **$27,500**

Pine, bracket feet, wide one-board sides and ends mortised into square corner posts and pinned, old refinishing has good color, repairs, replacements, small piece of one foot missing. 22 1/4 ″ × 42 1/4 ″ × 21 3/4 ″

Garth 3/87 **$140**

Pine, carved and painted, two secret drawers, decorated with flowers, vines, initials "CA" and "STO." 25 ″ × 50 ″ × 20 ″

Christie's 10/87 **$3,000**

Pine, dovetailed, bracket feet, till, lock and key, end handles, old worn brown graining over earlier black paint, feet appear to be old additions to a flat-bottom chest, one side bracket in old replacement, edge damage to one end of lid. 21 1/2 ″ × 42 1/2 ″ × 19 1/2 ″

Garth 3/87 **$275**

Pine, dovetailed, small, base and lid moldings, till with two dovetailed overlapping drawers beneath, cleaned down to old blue, lid has some edge damage, repair at one hinge. $16^{1}/_{2}'' \times 32'' \times 15''$

Garth 3/87 **$350**

Pine, dovetailed case, small, turned feet, till with lid, original brown vinegar painting, black trim, minor wear, a little edge damage. $20^{1}/_{4}'' \times 43'' \times 15^{1}/_{4}''$

Garth 3/87 **$2,500**

Pine, painted and decorated, probably "Unicorn" artist, Berks County, Pennsylvania, rare, provenance, similar pieces known, published, publicity. $23^{1}/_{2}'' \times 50'' \times 22^{1}/_{4}''$

Christie's 1/87 **$39,000**

Pine, Shenandoah Valley, Pennsylvania, dated 1800, painted and decorated, Johannes Spitler: attribution, provenance, publicity, inscribed. $25^{1}/_{2}'' \times 50'' \times 23''$

Christie's 1/87 **$60,000**

Pine, dated 1815, small square tapered feet, dovetailed case, red, green with white, yellow, and black decoration, inscription in center flanked by compass stars, flowers, good color, wear, molding incomplete. $22^{1}/_{2}'' \times 48^{1}/_{2}'' \times 24^{1}/_{2}''$

Garth 7/86 **$1,150**

Pine, square legs and posts, mortised and pinned sides, till, applied base and lid molding, dark blue-green, damaged, wear. $25^{1}/_{2}'' \times 17^{1}/_{4}'' \times 22^{1}/_{2}''$

Garth 2/86 **$150**

Polychrome green, black and red floral design, New England, c. 1820. $24'' \times 34'' \times 17''$

Skinner 1/85 **$1,900**

Polychrome, two birds above "Lydia Heberling," Pennsylvania, early 19th century. $21'' \times 37'' \times 18''$

Sotheby's 1/87 **$8,000**

Poplar, dovetailed case, small, bracket feet and till, old worn brown finish, painted decoration with two stylized horses (foliage is a late addition), one foot broken, repaired using original pieces, edge damage, lid needs reattachment. $22^{1}/_{4}'' \times 34'' \times 18^{3}/_{4}''$

Garth 3/87 **$350**

Putty-painted pine, five-board construction, red-orange, yellow decoration, New England, late 18th century, illustrated. $24'' \times 47'' \times 19''$

Skinner 3/87 **$1,700**

Red, black paint, Pennsylvania, c. 1830, rectangular hinged top, dovetailing. $15'' \times 39'' \times 15''$

Skinner 3/85 **$325**

Six-board pine, bootjack ends, old red, good color, till missing, some edge damage, wear. 23 1/2″ × 43 1/4″ × 16 1/4″

Garth 7/86 **$475**

Country Type Chests

Chippendale, well-shaped bracket feet, dovetailed case, five dovetailed, overlapping drawers, refinished southern pine has good dark color, chestnut secondary wood, original brasses, feet have some repairs but no replacements. 39 3/4″ × 37″ × 17 3/4″

Garth 3/87 **$1,350**

Hepplewhite, cherry, simple banded inlay around top edge and base, line inlay or stringing around drawer edges, scrolled apron, cut-out feet, four dovetailed drawers, repairs, replacements, refinished, some wear, replaced brasses. 33 1/2″ × 43 1/2″ × 18 1/4″

Garth 3/87 **$1,000**

Hepplewhite mule type, refinished walnut, single wide board ends, cut-out feet, simple scrolled apron, two dovetailed drawers, hinged lid, replaced brasses, some repairs. 43″ × 42″ × 17″

Garth 3/87 **$600**

Hepplewhite, pine, high cut-out feet, scrolled apron, four dovetailed drawers, one-board ends, old worn refinishing, replaced brasses, some repaired breaks in foot brackets, nailed top is loose. 39″ × 40 1/2″ × 19″

Garth 3/87 **$650**

Pine, turned feet, four dovetailed drawers, refinished, replaced brasses, old repairs, replacements. 37″ × 41 1/4″ × 16 1/2″

Garth 3/87 **$450**

Queen Anne mule type, pine, single-board ends, cut-out feet, two overlapping drawers, wide, early dovetails, four false drawers, blanket chest top, fine old dark patina, lid has age cracks, old added underside cleats with replaced butt hinges, brasses, small repairs. 45 1/2″ × 38 3/4″ × 17 1/2″

Garth 2/87 **$1,650**

Sheraton, cherry, turned feet, four dovetailed beaded drawers with clear lacy pulls, refinished, rich dark color. 42 1/2″ × 41 3/4″ × 19 1/4″

Garth 2/87 **$600**

Miscellaneous Chests

Apothecary, mahogany facade, pine, dovetailed case, 46 dovetailed drawers, four paneled doors, old finish, drawers have old gilt, black labels, wood on bottom doors does not match rest of facade, doors are not latched, plywood back, base molding added as case was originally built in. $50^{1}/_{4}'' \times 75^{3}/_{4}'' \times 9^{3}/_{4}''$

<div align="right">

Garth 2/87 **$1,650**

</div>

Immigrant's, pine, small, wrought iron strap hinges, worn original brown paint, red edging, white painted label addressed to "North Pepin, Wisconsin," lid has age crack, ends of lid are missing. L 29″

<div align="right">

Garth 3/87 **$90**

</div>

Immigrant's, pine, dome top, iron bound, worn original black paint, hand-lettered label for destination of Chicago via Baltimore. L 37″

<div align="right">

Garth 3/87 **$65**

</div>

Miniature, four drawers, poplar, masonite, plywood, cute, not too old, worn soft brown finish. H $14^{1}/_{2}'' \times$ W $13^{3}/_{4}''$

<div align="right">

Garth 3/87 **$55**

</div>

Sheraton, cherry, high turned feet, reeded posts, scalloped skirt, reeded edge top, four dovetailed drawers with bird's-eye veneer, walnut edging and edge beading, small repairs, top reattached, refinished. $41^{1}/_{2}'' \times 43^{1}/_{2}'' \times 20^{1}/_{2}''$

<div align="right">

Garth 2/87 **$575**

</div>

Sheraton bow front, mahogany, high turned feet, reeded columns, biscuit corners, cross-banded inlay along top edge, four dovetailed drawers with applied beading and matched flame veneer, old finish with good color, minor edge, veneer damage, replaced brasses. $40^{3}/_{4}'' \times 46^{1}/_{4}'' \times 24^{1}/_{4}''$

<div align="right">

Garth 2/87 **$750**

</div>

Sheraton bow front, birch, matched mahogany flame veneer drawer fronts, high turned feet, four drawers, applied edge beading, beaded edge top, old worn refinishing, replaced brasses, age cracks in ends. $41^{3}/_{4}'' \times 41^{1}/_{4}'' \times 24^{1}/_{4}''$

<div align="right">

Garth 3/87 **$600**

</div>

Small, turned legs shaped like a stack of books, hinged lid, interior till, antiqued polychrome paint with worn decal decoration, some edge damage, worm holes in base, 20th century. $19'' \times 13^{1}/_{2}'' \times 17''$

<div align="right">

Garth 3/87 **$250**

</div>

Chests of Drawers

Chests of drawers were an outgrowth of chests, which in turn evolved from boxes. They were used for storing clothes and linens. Typically they have four to eight drawers.

Chippendale, cherry wood, New England, c. 1780, four graduated drawers, refinished, replacements. 35″ × 39″ × 18″
Skinner 5/86 **$4,750**

Chippendale style chest of drawers, New England, late 18th century, blue-painted maple, six graduated drawers, bracket feet, molded cornice, restored. 49 1/2″ × 41 1/2″
Christie's 10/86 **$5,000**

Child's chest of drawers, New England, c. 1820, Empire style, stencil decorated, four drawers, replacements, minor repairs. 13 1/4″ × 18″ × 13″
Skinner 11/86 **$950**

Country Sheraton, walnut, turned feet, square corner posts, reeding, five dovetailed drawers, applied edge beading, refinished, minor repairs, drawer beading restored. 43 1/2″ × 40 3/4″ × 20 3/8″
Garth 2/87 **$625**

Empire, painted, New England, c. 1825, three drawers, mahogany umber graining, brass pulls, illustrated, some damage. 53″ × 41″ × 20″
Skinner 1/86 **$3,000**

Miniature, Rhode Island, early 19th century, three drawers, red, black, ochre decoration, broken legs. 10 1/2″ × 4 1/4″ × 6″
Skinner 7/86 **$375**

Miniature, possibly New England, c. 1840, painted, chamfered edges, scalloped top, pine exhibited, similar piece known, scallop top chipped.
Sotheby's 10/86 **$8,250**

Miniature Sheraton, cherry, turned feet, freestanding turned rope-carved columns, four dovetailed beaded-edge drawers, beautifully made, good age and condition. H 18 1/2″ × 9 3/4″ × 14 3/4″
Garth 3/87 **$1,450**

Vinegar, painted, decorated, shaped splashboard. 39″ × 47″
Sotheby's 10/86 **$7,500**

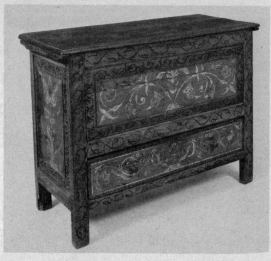

Early 18th-century New England oak and pine lift-top blanket chest, with single drawer having original floral and vine painted decorations. (*Photo courtesy of Sotheby's, New York*)

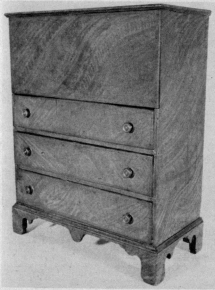

Late 18th-century New England three-drawer, paint-decorated lift-top blanket chest, with drop at apron and on bracket base. (*Photo courtesy of Litchfield Auction Gallery*)

William and Mary chest of drawers, New England, c. 1725, maple, provenance, restored. 36½" × 37½" × 20½"

Sotheby's 1/87 **$9,250**

William and Mary style chest of drawers, c. 1725, painted maple, five drawers, provenance, restored. 36½" × 37½" × 20½"

Christie's 1/87 **$9,250**

Clocks

The earliest clocks were public examples used by one entire town. Clock making gained popularity in New England where tall case clocks were most common, then spread to Pennsylvania and other colonies. By the 1840s clocks were being mass produced. (For specifics on period characteristics see: "Introduction: Country Furniture.")

Confederate soldier clock, carved and painted wood, Kohler, New York, gilding restored.

Sotheby's 6/86 **$25,000**

Federal style, Waterbury, Connecticut, c. 1835, mahogany, eglomise, pillar and scroll, Mark Leavenworth, replacements, restoration.

Sotheby's 1/84 **$700**

Hepplewhite grandfather type, cherry, old dark finish, tall, slender, cut-out feet, chamfered corners, fluting, wide molding between sections. Bonnet has freestanding turned columns, broken arch pediment. Face has scene of castle in arch, floral decorated spandrels, two parrots, "Bradford, Enniskillen" on dial (Nathaniel Bradford worked in Enniskillen, Northern Ireland, in 1824). With weights, pendulum. Brass works, painted metal face are old replacements, some age cracks in case, some old repairs and replacements. H 93½"

Garth 2/87 **$1,550**

Tall case, Connecticut, c. 1830, tiger maple grain painted, gilt painted dial, floral spandrels, inscribed, missing glass panel. H 85″
Skinner 3/85 **$1,000**

Tall case, Connecticut, c. 1830, pine polychromed, hood with scrolled fretwork, inscribed: "R. Whiting Winchester," illustrated, extensively decorated.
Skinner 5/85 **$5,200**

Tall case, Riley Whiting, Winchester, Connecticut, c. 1830, Federal decorated country piece, gilt stencilled floral design, wooden dial, published, provenance. H 85″
Skinner 5/86 **$200**

Tall case, Shenandoah County, Virginia, 1801, painted wood, Johannes Spitler, publicity, published, similar pieces in museums.
Sotheby's 10/86 **$203,500**

Pillar and scroll, mahogany case, wood works, original paper label: "Bishop & Bradley, Watertown, Conn.," brass finials, pendulum and key, wooden face has redrilled winding holes, replaced spring, hands and reverse painted glass are replacements, one gooseneck scroll is ended out. H 31½″
Garth 2/87 **$750**

Coverlets

Woven coverlets are bedcoverings usually made of wool and cotton and include overshot, summer/winter, double-weave, Jacquard, and Biederwand types. These geometric and curvilinear designed bedcovers were useful and popular in the eighteenth and nineteenth centuries. Professional itinerant male weavers travelled from town to town with their looms seeking orders during the mid and late nineteenth century.

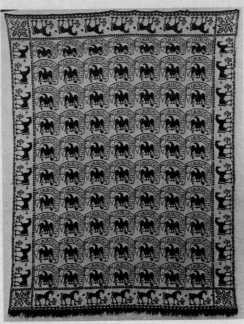

Mid-19th-century Pennsylvania double-woven wool and cotton coverlet, with extremely rare horse border, 87″ × 71″. (*Photo courtesy of America Hurrah Antiques, New York*)

Candlewick

Spread, 1828, basket of berries, worked on linen, J. Morrison, stains, repairs, worn. 104″ × 98″

Skinner 8/87 **$950**

Double-Weave

Checkerboard, 1800–1850, wool, madder red, indigo, minor wear, holes. 74″ × 79″

Skinner 1/86 **$330**

Pine tree border surrounding grid of squares, wool, 1800–1850, blue and red, minor wear and holes. 72″ × 84″

Skinner 5/86 **$300**

Two-piece, blue, white optical pattern, some moth damage, repairs, fringe added. 72″ × 80″

Garth 3/87 **$200**

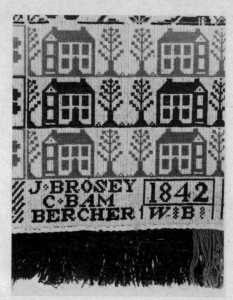

Mid-19th-century wool coverlet from Manheim, Pennsylvania (Lancaster County), and made by John Brosey, Jr., 1842. (*Photo courtesy of Olde Hope Antiques, Inc.*)

Homespun

Peacock and flowers, probably New York, 1840, red, navy, and green. 72″ × 108″

Skinner 3/85 **$300**

Two-piece wool blanket, blue and natural, wear, repaired. 72″ × 86″

Garth 5/86 **$125**

Two-piece wool blanket, natural white, grayish-brown plaid, hand-hemmed, minor wear, small patches. 70″ × 72″

Garth 2/87 **$225**

Jacquard

Blue and white, c. 1846, floral border, Washington Capitol building, stained, shortened. 90″ × 76″

Christie's 1/86 **$800**

Double-weave, Cortland Village, New York, 1842, Jacob Impson, Lady's Fancy, blue and white, soiled. 80″ × 88″

Skinner 8/87 **$385**

Double-weave, probably Ohio, c. 1845, buildings and Boston town border, red wool, white cotton, published, minor wear. 70″ × 88″

Skinner 1/87 **$2,100**

Double-weave, one-piece, blue, white, central repeated design: peacock, tree, eagle, Liberty, worn, stains. 69″ × 80″

Garth 5/86 **$325**

Double-weave, Jefferson County, New York, c. 1830, Harry Tyler, snowflake design, blue and white, documentation, small tear. 86″ × 76″

Sotheby's 6/87 **$2,100**

Double-weave, two-piece, blue, tomato red, intricate design: peacocks, turkeys, oriental building order, wear, some fading, small holes. 72″ × 80″

Garth 5/86 **$400**

Double-weave, two-piece, navy blue, white pine tree, snowflake pattern, some stains, minor wear. 76″ × 92″

Garth 2/87 **$375**

Double-weave, two-piece, stylized floral medallions in tomato red, navy blue, natural white, some overall and edge wear. 68″ × 86″

Garth 3/87 **$150**

Double-weave, two-piece, birds, roses, bird borders, four houses in corners, good rich colors of red, blue, pale green, edges are flayed, some wear, small holes. 74″ × 82″

Garth 3/87 **$425**

Double-weave, c. 1840, urn with flowers, architectural border, minor damage. 72″ × 82″

Skinner 1/86 **$375**

Floral medallions, buildings, and birds, c. 1840, blue and natural. 76″ × 84″

Skinner 5/86 **$385**

Floral medallions, Womelsdorf, Pennsylvania, c. 1840, red, blue, olive, and natural wool, fringed on three sides, Henry Oberly.

Skinner 3/87 **$300**

Geometric and stylized floral pattern, Trexlertown, Pennsylvania, 1846, tan, green, red, dark blue, fringe, S. Hausman, some damage. 78″ × 96″

Skinner 1/86 **$330**

One-piece, blue, white, inscription, published, wear, stains. 74″ × 95″

Garth 5/86 **$495**

Polychrome wool and natural cotton, mid-19th century, discolored. 96″ × 76″

Christie's 6/84 **$325**

Single-weave, inscription: "H. Ender's coverlet weaver Sidney, O.," made in 1857, one-piece, wear, cut down, border reattached.

Garth 2/86 **$125**

Single-weave, one-piece, blue, green-brown, maroon, white, domed building, inscribed borders, good colors. 80″ × 82″

Garth 7/86 **$200**

Single-weave, border label: "Made by H. Sager, Mount Joy, Lancaster Co., Pa. Fast Color No. 1," one-piece, floral medallion with vines, eagles, bird corners, red, olive-green, orange, and natural white, tassel border and border label, minor wear, some fringe missing. 75″ × 78″

Garth 2/87 **$500**

Single-weave, two-piece blue, white, red, gold, floral medallions, signed, dated 1839, very worn. 70″ × 72″

Garth 5/86 **$85**

Single-weave, signed "John B. Welty," Boonsboro, Washington County, Maryland, 1840, two-piece, red, gold, blue, white, floral medallion center, worn. 80″ × 90″

Garth 5/86 **$150**

Single-weave, two-piece, red, white, blue, floral medallion center, vintage, some wear, fading, wool worn. 73″ × 79″

Garth 5/86 **$200**

Single-weave, two-piece, blue, white, floral medallions, border roses, eagles, inscription. 68″ × 82″

Garth 5/86 **$325**

Single-weave, Hamburg, Pennsylvania, dated 1838, two-piece, blue, red, natural white, floral medallions, bird borders, signed "C. Lochman," worn, faded. 82″ × 102″

Garth 7/86 **$195**

Single-weave, E. Hempfield Township, 1839, two-piece, red, blue, olive-green, roses, J. Lutz, good color, wear, minor stains. 82″ × 90″

Garth 7/86 **$200**

Single-weave, Findlay, Hancock County, Ohio, 1861, two-piece, red, blue, green, natural white, William Fleck, publicized, some minor wear. 72″ × 90″

Garth 7/86 **$475**

Single-weave, two-piece, floral design with building borders and eagle corners, deep red, ivory, and natural white, some wear, fading. 72″ × 76″

<div align="right">

Garth 2/87 **$375**

</div>

Summer/winter, 1842, fruit and flower pattern, red, blue, natural, repairs, stains, worn. 74″ × 78″

<div align="right">

Skinner 3/87 **$300**

</div>

Miscellaneous Bedcovers

Bed rug, inscribed "H H–1770. probably CT," flowers, scrolling vines, blue, yellow, and gold, illustrated, missing section, yarn loss. 54″ × 82″

<div align="right">

Skinner 1/85 **$3,500**

</div>

Bed rug, Hannah Baldwin, Canterbury, CT, dated 1741, cut and uncut pile, wool, vine and floral motifs, documentation, exhibited, published, similar pieces known, color plate. 85″ × 79″

<div align="right">

Christie's 1/86 **$18,000**

</div>

Blanket: counterpane, New York State, 1800–1850, embroidered, woven indigo blue, geometric motifs, illustrated, tiny holes. 86½″ × 72″

<div align="right">

Sotheby's 1/87 **$800**

</div>

Blanket, 1800–1825, embroidered, striped, ivory and blue, vine border. 72″ × 84″

<div align="right">

Skinner 11/85 **$400**

</div>

Blanket, probably New York, 1831, floral design, handspun wool yarns, blue, red, yellow fringe, Lucretia Brush (?), illustrated, some provenance. 76″ × 88″

<div align="right">

Skinner 1/86 **$6,380**

</div>

Calamanco, Kingston, New Hampshire, 18th century, flowers and vine leaves, blue, wool, Miss Clark, holes. 82″ × 82″

<div align="right">

Sotheby's 1/86 **$3,600**

</div>

Geometric, 19th century, red, blue, blue-green, initialed, worn. 56″ × 74″

<div align="right">

Skinner 5/85 **$55**

</div>

Linsey-woolsey, late 18th century, calamanco, floral vines, glazed linen and wool, good condition, craftsmanship, unusual design. 88″ × 88″

<div align="right">

Sotheby's 1/87 **$2,200**

</div>

Linsey-woolsey, c. 1800, cream and blue, edges frayed. 88″ × 82″

<div align="right">

Skinner 1/85 **$150**

</div>

Summer/winter, inscribed "Lydia Mullener," c. 1840, floral medallion, border of Masonic symbols, natural and blue. 80″ × 98″
Skinner 1/85 **$550**

Summer/winter, Palmyra, New York, 1852, Ira Hadsell, patriotic design, blue and white, minor staining. 76″ × 84″
Skinner 11/86 **$800**

White on white, late 18th century, American eagle motif, stars, embroidered cotton, restored, discolored. 80″ × 95″
Christie's 10/86 **$1,100**

Wool, Marthaham, Pennsylvania, 1837, homespun fringe. 100″ × 102″

Sotheby's 1/87 **$2,100**

Overshot

Geometric, c. 1835, three sections in blue and natural wool on cotton, repairs, 99″ × 100″
Skinner 1/87 **$220**

Three-piece, unusual colors of pink, brown, natural white in plaid pattern, minor wear, machine-sewn seams. 82″ × 96″
Garth 2/87 **$80**

Two-piece, blue, white, some wear. 72″ × 50″
Garth 7/86 **$125**

Two-piece pair, star and diamond pattern in red, white, worn and faded. 66″ × 80″ and 68″ × 84″
Garth 2/87 **$70**

Two-piece, optical design in navy blue, red, green, natural white, sewn-on fringe, minor wear. 76″ × 94″
Garth 2/87 **$350**

Two-piece, five star pattern in tomato red, olive-yellow, natural white, some wear. 72″ × 94″
Garth 3/87 **$60**

Two-piece, blue and white, some wear. 62″ × 96″
Garth 3/87 **$125**

Two-piece, optical design in red, blue, natural white, good color, repair. 68″ × 78″
Garth 3/87 **$150**

Single-Weave

Two-piece, blue, white, some wear, damage. 74″ × 91″
Garth 7/86 **$100**

Two-piece, blue, white plaid. 76″ × 86″

Garth 7/86 **$265**

Single-weave, Hampton, Adams County, Pennsylvania, 1851, cotton, flowers in red, green, blue, grapevine border, Jacob C. Schriver, faded, some wear.

Skinner 3/85 **$135**

Single-weave, dated 1840, cobalt blue and cream colors, flowers and patriotic motifs, inscribed, signed "E.S. Cooper," exceptional color, condition, craftsmanship, unusual design. 93″ × 77″

Phillips 5/87 **$200**

Cupboards

Appearing first in the seventeenth century, cupboards lasted for two centuries and were originally cup boards: shelves built to hold cups and dishes. As shelves were added, they were placed in an open frame or enclosed by doors. The two typical variations, the corner cupboard (triangular in form) and a flatback cupboard, were either placed against or built into a wall. Those in two sections, the popular form, were designed for display above and storage below. Freestanding cupboards were traditionally in two parts, made from regional woods, and covered with painted decoration to unify them.

Jelly cupboards, essentially food stores made for the kitchen, are one-piece cupboards, usually housing a drawer or two at the top where valuables such as tea and sugar might be kept locked. Lower shelves were enclosed by doors. Woods included walnut, pine, cherry, or poplar with some examples then being painted. Found primarily in Pennsylvania, examples were made nationwide.

Brown painted pine, Pennsylvania, c. 1780, tombstone panels, shelved interior. 77″ × 54″ × 20½″

Skinner 3/85 **$5,800**

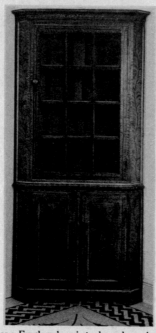

Early 19th-century New England painted and grained corner cupboard, with glazed paneled doors on bracket base. (*Photo courtesy of Sotheby's, New York*)

Corner, Massachusetts, c. 1820, carved and painted, fluted columns, flowers, hearts, and the sun, Peter Hunt. 65½" × 33" × 13"

Skinner 1/86 **$550**

Corner, Pennsylvania, c. 1820, Federal style, grain painted red and brown, fine condition. 84" × 44" × 21"

Skinner 5/86 **$3,250**

Corner, one-piece, cherry, scrolled apron, paneled doors below, double eight-pane doors above, unusual cut-out and molded cornice, refinished. 85½" × 58"

Garth 3/87 **$2,200**

Corner, two-piece, bracket feet, paneled doors set in a beaded frame, top doors each have six panes of old wavy glass, molded cornice, painted light blue interior, top shelves are serpentine with

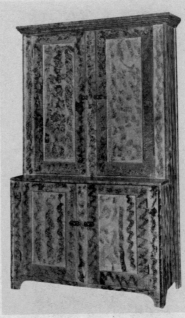

Late 19th-century paint-decorated stepback cupboard, with four single-paneled doors from upper New York State. (*Private collection*)

cut-outs for spoons, good craftsmanship, detail, color, worn feet, cracked glass, refinished, repairs.

Garth 2/86 **$1,100**

Corner two-piece, cherry, with pine, poplar secondary woods, good small size, bracket feet, paneled doors, top has single door, twelve panes of old glass, molded cornice, good reeded detail, old finish, feet have lost some height, replaced brasses, repaired latches. 81″ × 43½″

Garth 3/87 **$3,000**

Corner, small, one-piece, cut-out feet, paneled doors, crown molded cornice, old but not original blue paint with minimal traces of green overpaint, iron thumb latch with brass knob on top door, bottom door has had interior lock removed, minor wear, edge damage. 77″ × 44″

Garth 3/87 **$1,600**

Corner, wood, molded cornice, two dovetail drawers, double top doors with beading, eight glass panes, good detail, finish, pane broken, minor edge damage. W 52″

Garth 2/86 **$2,000**

Country jelly, poplar, two-board, batten doors, nailed drawer, old brown grained repaint. 49″ × 41″ × 17″

Garth 7/86 **$350**

Country, one-piece open wall type, pine, sturdily constructed, two dovetailed nailed drawers, old worn tan paint shows blue and other colors beneath, shelf in base is replaced, wrought iron shelf hooks are additions. 77½″ × 48″ × 19½″

Garth 3/87 **$400**

Country wall type, two-piece, poplar, original dark brown finish, brushed graining on panels, drawer fronts, original cast iron and brass hardware, two nailed drawers. 85″ × 51″ × 20″

Garth 7/86 **$650**

English country hanging corner type, pine, raised panel door, scalloped bracket, two small shelves, refinished, minor repairs, small sections of molding replaced. H 46½″ × W 27″

Garth 3/87 **$275**

English country with open top, pine, post feet, front brackets, paneled end, paneled doors, four dovetailed drawers in base, old dark finish, replaced brasses, one back foot replaced, the other is ended out, small repairs. 85½″ × 65″ × 18″

Garth 2/87 **$1,350**

Gray-painted pine, New England, c. 1780, four-shelf interior, HL hinges original. 83″ × 39″ × 20″

Skinner 6/86 **$1,400**

Green-painted pine, New England, c. 1830, four raised panel doors, shelved interior, worn. 74″ × 44″ × 18″

Skinner 6/87 **$750**

Hanging corner, Lancaster County, Pennsylvania, early 19th century, painted and decorated pine, good condition, similar ones exhibited, published, or in museum collections, restoration. 34½″ × 29½″ × 18″

Sotheby's 10/86 **$19,000**

Hanging corner, pine, red flame graining, one dovetailed drawer, raised panel door, molded cornice, damaged, repairs, rebuilt drawer. H 42½″ × L 29″

Garth 2/86 **$400**

Hanging open type, good architectural detail, turned columns, arches, old green paint with paper-covered interior painted yellow, portion of a larger unit of more arches, some edge damage. 22³/₄″ × 43¹/₂″ × 10″

Garth 3/87 **$300**

Hutch, Pennsylvania, c. 1800, Chippendale style, carved walnut. 84″ × 53″ × 22″

Sotheby's 1/84 **$3,750**

Jelly, pine, painted and decorated, brown and tan on white ground, turned feet, chamfered corners, paneled doors, two dovetailed overlapping drawers, reeded edge top. 47³/₄″ × L 42³/₄″ × 17″

Garth 2/86 **$300**

Mahogany, small, with two doors flanked by 12 small drawers, old finish, late wire nail construction, old repairs. L 20³/₄″

Garth 3/87 **$1,000**

Painted, decorated, abstract optical configuration, wood, has provenance, publicity. 77¹/₂″ × 44″ × 15¹/₂″

Sotheby's 10/86 **$115,500**

Pewter, birch and butternut, one-board ends, one-board door in base, truncated top has shelves with plate bars, pine backboard, refinished. 78¹/₂″ × 34¹/₂″ × 17¹/₄″

Garth 2/86 **$850**

Pewter, two-piece, cherry, paneled doors in base, open shelves in top, scalloped ends and molded cornice, reconstructed. 82¹/₂″ × 42″ × 16″

Garth 2/86 **$650**

Pine, double doors, solid panels in bottom, glass panes in top, porcelain knobs, worn white, brown graining over reddish stain, scalloped base added, iron latches missing. 65″ × 44″ × 14″

Garth 7/86 **$195**

Pine top, paneled door, old worn gray paint. 49³/₄″ × 37¹/₂″ × 11″

Garth 3/87 **$125**

Pine, raised panel door, early, good old reddish-brown finish, H and HL hinges and top replaced, door sags. 40¹/₂″ × 36″ × 18¹/₂″

Garth 3/87 **$275**

Pine, small, raised panel door from earlier cupboard, worn yellow repaint, red trim. 41″ × 22″ × 16″

Garth 3/87 **$215**

Poplar, scalloped feet, paneled doors, removable cornice, narrow interior horizontal dividers, yellow graining over dark original finish. 82″ × 38½″ × 16½″

Garth 7/86 **$375**

One-piece wall type, pine, very good architectural detail, raised panel doors, applied moldings, fluted pilaster, butterfly shelves, molded cornice, orginally built-in, repairs, replacements, refinished. 94″ × 21½″ × 47¼″

Garth 2/87 **$1,500**

Wall, two-piece decorated, pine and poplar, turned feet, paneled doors, three dovetailed drawers in base, top has pie shelf, double doors, old glass, molded cornice, old worn brownish-yellow graining over earlier red, edge damage, replacements, restoration. 83½″ × 52″ × 19¾″

Garth 2/87 **$1,800**

Wall two-piece, walnut, pine secondary wood, applied base molding, flush panel doors, edge-beaded detail, three dovetailed drawers in base, stepback top has double doors in beaded frames, six panes of old glass, wide molded cornice, top shelves have cut-out for spoons, old worn finish, good color, replaced brasses, some wear, repair, bottom has good wear. 83½″ × 61½″ × 22″

Garth 3/87 **$4,600**

Wardrobes

Decorated kas, pine, dovetailed case and drawer in base, original wrought iron lock, rat-tail hinges, original blue paint, red side panels, black, foliage decorated door panel, minor wear, some worm holes, divided through center, rejoined pieces, removable cornice. H 69½″ × W 44″

Garth 3/87 **$1,200**

Light brown and mustard grain-painted pine, two doors each with six recessed panels, probably Pennsylvania, c. 1840. 79″ × 54″ × 16½″

Skinner 3/85 **$2,100**

Primitive, poplar, base, cornice molding, four-panel door, one shelf, wooden clothes hooks, old cherry-colored finish, brushed gaining, found in Medina, Ohio. H 79½″ × W 46″

Garth 3/87 **$350**

Poplar, small, cut-out feet, unusual molded stiles, cornice, paneled door, worn original red flame graining, found in eastern Pennsylvania, some edge damage, age cracks. H 71″ × W 30″

Garth 3/87 **$400**

Decoys

Originally used by the Indians, bird decoys reached the height of their popularity in the late nineteenth century and early twentieth century. There are distinct regional characteristics that make identification possible. Categorically, decoys are waterfowl (floaters) and shore birds (stick-ups). Floaters such as mallards, pintails, canvasbacks, mergansers, scooters, and eiders ride the waters of bays, marshes, lakes, inlets, and oceans. Shore birds, i.e., sandpipers, yellowlegs, curlews, and pipers, are mounted on sticks set into the ground.

Another important decoy category includes those not hunted for food. Crows were hunted as pests or for sport. Owls were used to bait their natural enemy, the crow. Gulls and swans were used as confidence decoys signaling safety and food to other birds.

Fish decoy making reached its height during the 1830s. Unlike bird decoys, they do not have to represent specific species to be effective. As a result, fish decoys are often painted in a whimsical fashion. Made with an appropriate lead weight inset underneath, their length can vary from 3 to 48 inches. Pine is favored because it carves and floats easily. Individualistic carving often identifies age, region, and maker. Other forms of decoys include frogs, turtles, muskrats, and mice. Plastic, rubber, and metal versions notwithstanding, most fish decoys are handmade.

Fish

Bait, Riley Haskell, Painesville, Ohio, c. 1860, silver-plated metal, excellent condition, documentation, inscribed, similar pieces known, provenance, craftsmanship. L 4″
Oliver 7/87 **$8,400**

Codfish plug, unknown maker, early 19th century, whalebone, lead, beads, good condition. L 3½″
Oliver 7/87 **$425**

Flying helgramite, Harry Comstock, Fulton, New York, c. 1883, metal, glass eyes, piece missing. L 2⅓″
Oliver 7/87 **$2,100**

Frog, Lou Rhead, c. 1917, handmade lure, carved and painted wood, good condition, rare.
Oliver 7/87 **$600**

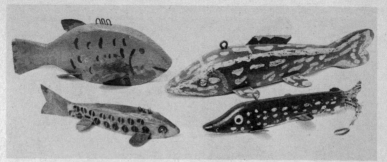

Four early 20th-century American carved and painted wooden ice fishing decoys with tin fins, probably from Michigan, 6″ to 11″ length. (*Photo courtesy of Louis Picek, Main Street Antiques*)

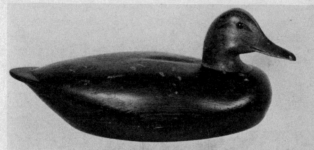

Early 20th-century carved and painted wooden black duck decoy by Charles "Shang" Wheeler, Stratford, Connecticut. (*Photo courtesy of James Julia/Gary Guyette Inc.*)

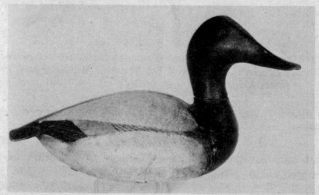

Early 20th-century carved and painted wooden canvasback drake decoy, by the Ward Brothers, Crisfield, Maryland. (*Photo courtesy of James Julia/Gary Guyette Inc.*)

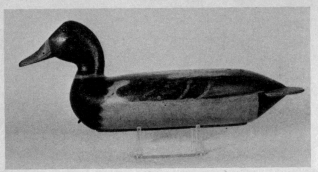

Early 20th-century carved and painted wooden mallard drake decoy by Roger Elliston, Bureau, Illinois. (*Photo courtesy of James Julia/Gary Guyette Inc.*)

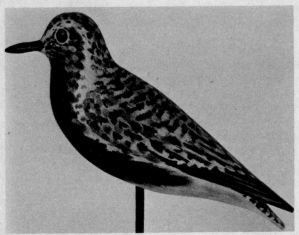

Early 20th-century carved and painted wooden black-breasted plover decoy with tack eye, by Elmer Crowell, East Harwich, Massachusetts. (*Photo courtesy of James Julia/Gary Guyette Inc.*)

Frog, Pflueger, Akron, Ohio, green rubber, good condition, unusual design.

Oliver 7/87 **$80**

Green trout, Jess Ramey, Cadillac, Michigan, 20th century, carved and painted wood, good condition, rare. L 6½″

Oliver 7/87 **$600**

Primitive, Mel Aaserude, Cass Lake, Michigan, wood, tack eyes, copper, brass. L 8″

Oliver 7/87 **$165**

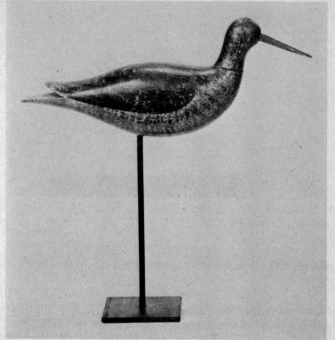

Late 19th-century carved and painted wooden greater yellowlegs decoy from Long Island, New York. (*Photo courtesy of James Julia/Gary Guyette Inc.*)

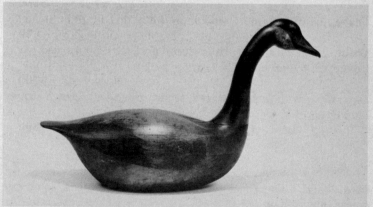

Early 20th-century Canadian carved and painted wooden goose decoy. (*Photo courtesy of Sotheby's, New York*)

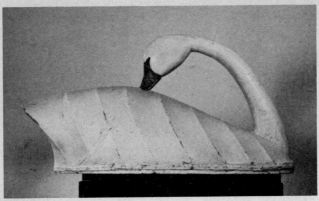

Early 20th-century New England preening swan decoy with wood, wire, and canvas construction, 26″ length × 15″ height. (*Photo courtesy of Sterling & Hunt*)

Primitive, unknown, wood, tin painted red, white, and black, good condition. L 6″

<div align="right">

Oliver 7/87 **$15**
</div>

Red-spotted trout, Jess Ramey, Cadillac, Michigan, 20th century, carved and painted wood, copper, brass, good condition, rare.

<div align="right">

Oliver 7/87 **$1,900**
</div>

Smallmouth bass, Bob Beebe, Seymour, Tennessee, 20th century, copper, wood, glass, unusual form, published, signed. L 10″

<div align="right">

Oliver 7/87 **$180**
</div>

Three, primitive, wood with sheet metal fins, brightly painted.

<div align="right">

Garth 7/86 **$60**
</div>

Trout, unknown maker, Lake Huron area, c. 1980, carved wood, glass eyes, oversized. L 25″

<div align="right">

Oliver 7/87 **$100**
</div>

Two, wood with metal fins, red, white, green with brown stripes. L 6¼″ and 6½″

<div align="right">

Garth 7/86 **$90**
</div>

Waterfowl

Bird, black, white repainted, green head, glass eyes, some age cracks, glue repair. L 13″

<div align="right">

Garth 5/86 **$65**
</div>

Black-breasted plover, wood, only one tack eye.

<div align="right">

Sotheby's 10/86 **$1,400**
</div>

Black-bellied plover, Parker Hall, Massachusetts, carved and painted wood, original paint, documentation, flaking, worn.

Oliver 7/87 **$475**

Black-bellied plover, Obediah Verity, Seaford, New York, c. 1875, carved and painted wood, good condition, repainted.

Oliver 7/87 **$2,500**

Black duck, probably Cobbs Island, Virgina area, original condition.

Skinner 3/85 **$110**

Black duck, glass eyes, line and weight, old worn repaint, minor cracks.

Garth 2/86 **$75**

Black duck, glass eyes, wood, age, cracked neck, repainted, wear. L 14½"

Garth 2/86 **$10**

Black duck, glass eyes, wood, age, some damage, repainted, shot scars. L 15½"

Garth 2/86 **$30**

Black duck, standard grade with old repaint, glass eyes, provenance: Mason, repainted. L 15½"

Garth 2/86 **$75**

Black duck, cork, carved head, one glass eye, old worn paint. L 14½"

Garth 7/86 **$30**

Black duck, bottom inscription "R.A. Peteson, Yar. 1967," cork body, wooden base, head, tail, original paint, glass eyes. L 19"

Garth 2/87 **$45**

Black duck, balsa body, wooden head, glass eyes, worn old paint. L 15"

Garth 3/87 **$40**

Black duck, unknown maker, New Jersey, carved and painted wood, hollow, flaked, worn.

Oliver 7/87 **$100**

Black duck, oversized, carved and painted wood, Edson Gray, Ocean View, Delaware, c. 1935.

Oliver 7/87 **$325**

Bluebill, Delaware, tack eye, excellent original paint, solid body, "Water Works" on base.

Skinner 5/85 **$385**

Bluebill, primitive, old worn paint, thumbtack eyes, one is rusted. L 14¼"

Garth 3/87 **$30**

Bluebill drake, Bob Snow, Marcette, Michigan, original paint, glass eyes, wear. L 13¾″

<div align="right">

Garth 2/86 **$35**
</div>

Bluebill drake, Mason's shaped body, turned head, glass eyes, old worn paint. L 13¼″

<div align="right">

Garth 7/86 **$60**
</div>

Bluebill drake, mid-20th century working decoy, cork body, wooden head, glass eyes, original paint, chipped. D 14¼″

<div align="right">

Garth 2/87 **$25**
</div>

Bluebill drake, glass eyes, good old repaint, minor age cracks, old neck repair. L 13″

<div align="right">

Garth 2/87 **$85**
</div>

Bluebill drake, well carved, good bill detail, turned head, old, well-executed repaint has some minor wear. L 12¼″

<div align="right">

Garth 3/87 **$115**
</div>

Bluebill drakes, two, balsa, wood heads, glass eyes, worn old paint, one head glued. L 12½″

<div align="right">

Garth 3/87 **$95**
</div>

Bluebill drake, Rowley Horner, West Creek, New Jersey, c. 1930, carved and painted wood, excellent condition.

<div align="right">

Oliver 7/87 **$1,400**
</div>

Bluebill hen, Bob Willoughby, Battle Creek, Michigan, hollow, canvas bottom, painted. L 12¼″

<div align="right">

Garth 2/86 **$25**
</div>

Bluebill hen, Bob Snow, Marcette, Michigan, original paint, glass eyes, similar pieces known, wear. L 13¼″

<div align="right">

Garth 2/86 **$35**
</div>

Bluebill hen, Dave Hodgman, Niles, Michigan, branded "D. W. H.," original paint, glass eyes. L 12½″

<div align="right">

Garth 2/86 **$105**
</div>

Bluebill hen, glass eyes, good head, old working repaint, shot scars, wear, damage, age cracks. L 13½″

<div align="right">

Garth 7/86 **$45**
</div>

Bluebill hen, Rowley Horner, West Creek, New Jersey, c. 1930, carved and painted wood, chipped, cracked, repainted, flaking.

<div align="right">

Oliver 7/87 **$350**
</div>

Blue heron, New Jersey, cedar, hollow, original paint, natural condition, cracked.

<div align="right">

Sotheby's 1/84 **$200**
</div>

Blue heron confidence decoy, well-shaped cedar body, whittle marks, original gray paint, yellow beak, stamped Mackey Collection, reglued, minor damage. H 24″ × L 30″

<div align="right">

Garth 3/87 **$675**
</div>

Blue wing teal hen, Mason Decoy Factory, Detroit, Michigan, 1924, carved and painted wood, glass eye, craftsmanship, stamped, flaking.

Oliver 7/87 **$1,200**

Brant, two, unknown maker, probably New Jersey, hollow carved, excellent original paint, tack eye, illustrated.

Skinner 5/85 **$4,000**

Brant, primitive, two-piece head, old paint, minor age cracks. H 16¾"

Garth 7/86 **$125**

Brant, primitive, two-piece head, weighted, old paint, minor age cracks. L 17½"

Garth 7/86 **$85**

Brant, William Bowman, Lawrence, New York, c. 1900, carved and painted wood, rare, publicity, cracked.

Oliver 7/87 **$700**

Broadbill drake, mismatched glass eyes, old worn paint. L 14½"

Garth 7/86 **$75**

Broadbill, primitive, wood, painted canvas covering, glass eyes. L 12"

Garth 7/86 **$20**

Bufflehead hen, attributed to Alvin Gunner Meckins, primitive, old paint, tack eyes. L 10¾"

Garth 2/87 **$155**

Bufflehead drake, Alvin Gunner Meckins, primitive, old paint, tack eyes. L 10"

Garth 2/87 **$185**

Bufflehead, laminated cork body, old worn paint. H 11½"

Garth 7/86 **$50**

Canada geese stick-ups, five pieces, sheet metal, primitive, iron stakes, good age, paint. H approximately 30" each

Garth 2/86 **$75**

Canada geese, two, unknown makers, late 19th century, both with painted decoration. L 20" and L 23"

Skinner 6/86 **$600**

Canada goose, canvas, wooden frame, carved head, tack eyes, original paint. L 15½"

Garth 2/86 **$95**

Canada goose, worn paint, replacements, age cracks. L 27"

Garth 5/86 **$65**

Canada goose, canvas-covered wire, wood frame, carved wooden head, worn paint initialed "C.B.," age cracks, repaired. L 24½″
Garth 5/86 **$75**

Canada goose, carved and painted wood. 18″ × 30″
Sotheby's 1/87 **$450**

Canada goose, stick-up field type, primitive, wood, wire nail construction, old worn paint, old age cracks, bill incomplete. H 27″
Garth 2/87 **$45**

Canvasback, possibly Joseph Seiger, Wisconsin, late 19th century, c. 1900, similar museum pieces known.
Sotheby's 10/86 **$3,750**

Canvasback drake, balsa body, wooden head with glass eyes, worn, repainted, provenance. L 18¾″
Garth 2/86 **$35**

Canvasback drake, balsa body, wooden head, glass eyes, initialed "F.C.H." L 16″
Garth 7/86 **$55**

Canvasback drake, glass eyes, old worn paint, shot scars, split. L 17½″
Garth 7/86 **$80**

Canvasback drake, glass eyes, worn old paint, age cracks, shot scars. L 16″
Garth 2/87 **$80**

Canvasback drake, signed "L. Travis Ward, Sr.," Crisfield, Maryland, 1917, carved and painted wood, documentation.
Oliver 7/87 **$650**

Canvasback drake, Lem and Lee Dudley, Knotts Island, North Carolina, c. 1890, carved and painted wood, inscribed "L.D."
Oliver 7/87 **$8,000**

Dove, unknown maker, possibly Chesapeake Bay, Maryland, c. 1940, carved and painted wood, excellent original condition, documentation.
Oliver 7/87 **$150**

Eider drake, unknown maker, repainted. L 19¼″
Garth 7/86 **$95**

Eider, possibly C.F. Jacobs, Maine, c. 1915, oversized.
Sotheby's 10/86 **$1,900**

Eskimo curlew, unknown maker, North Carolina, carved and painted wood, provenance, rare.
Oliver 7/87 **$600**

Goldeneye drake, Elmer Crowell, East Harwich, Massachusetts, early 20th century, carved and painted wood, craftsmanship, over-sized, unusual design.

Oliver 7/87 **$45,000**

Goldeneye: a pair, hen and drake, George Boyd, Seabrook, Massachusetts, carved and painted wood, rare, original paint.

Oliver 7/87 **$5,500**

Golden plover, Massachusetts, spring plumage, fine original paint, split tail has the Mackey Collection stamp, small head bruise, prov-enance.

Skinner 6/87 **$700**

Goose root head, wood, paint, good age, condition, original paint, unique design. L 34″

Garth 2/86 **$240**

Great horned owl, carved, wood, glass eyes, feathered ear tufts, worn original paint. H 15 1/2″

Skinner 5/85 **$600**

Green-winged teal drake swimmer, beautifully painted, glass eyes, decorative decoy, minor wear, poorly repaired chip, stamped label, Decoy Shop. L 13 1/4″

Garth 2/87 **$30**

Hollow-bodied bird, glass eyes, worn repaint. L 17 1/2″

Garth 7/86 **$45**

Hudsonian curlew, Daniel Leeds, Pleasantville, New Jersey, c. 1890, carved and painted wood, good condition, documentation, published.

Oliver 7/87 **$4,500**

Mallard, Mason Factory, painted by Elmer Crowell, tack-eye duck, minor splitting, good condition of paint, very minor flaking.

Skinner 5/85 **$500**

Mallard drake, cork, wooden head, tack eyes, signed and dated: "Forrest Murphy, Marshall Texas, 1936," repainted, wear. L 13 1/4″

Garth 2/86 **$35**

Mallard drake, Miles Smith, Marine City, Michigan, original paint, glass eyes, some wear. L 18 1/4″

Garth 2/86 **$45**

Mallard drake, primitive, tack eyes, shot scars, repainted, wear. L 15 3/4″

Garth 2/86 **$50**

Mallard drakes, two, both rough-sawn factory finish, glass eyes, old paint, some edge damage.

Garth 7/86 **$20**

Mallard drake, unknown maker, cork body, adjustable wooden head, glass eyes, old worn paint. L 20″

Garth 7/86 **$35**

Mallard drake, initialed "C.J.S.," worn old paint, head repaired. H 15³/₄″

Garth 7/86 **$95**

Mallard drake, unknown maker, primitive, good stylized carving, old paint. L 12″

Garth 7/86 **$95**

Mallard drake, Evans, hollow body, glass eyes, worn repaint. L 15¹/₂″

Garth 7/86 **$125**

Mallard drake, 20th-century working decoy, glass eyes, original paint, marked "A.B.Y." L 16¹/₄″

Garth 2/87 **$100**

Mallard drake, Gus Wilson, Portland, Maine, carved and painted wood, original paint, patina, splits, damaged.

Oliver 7/87 **$4,250**

Mallard drake, unknown, possibly Delaware River area, carved and painted wood, unusual design and form.

Oliver 7/87 **$7,000**

Mallard drake and Bluebill hen, glass eyes, worn old paint. 21″ × 14″.

Garth 7/86 **$65**

Mallard hen and drake, cork-bodied, glass eyes, worn paint. L 14″

Garth 7/86 **$45**

Mallard hen, Forrest Murphy, Marshall, Texas, 1936, cork, wooden head, tack eyes, signed, dated, repainted, missing pieces, wear. L 13¹/₂″

Garth 2/86 **$35**

Mallard hen, primitive carving, old paint, tack eyes, wear. L 15¹/₄″

Garth 2/86 **$45**

Mallard hen, glass eyes, turned head, branded "W.E.B.," working repaint. L 16¹/₂″

Garth 7/86 **$55**

Mallard hen, Lem Ward, Crisfield, Maryland, standing, carved and painted wood, craftsmanship, dated, unusual design, documentation, similar pieces known, damaged.

Oliver 7/87 **$4,500**

Mallards, pair, miniature, Elmer Crowell, Cape Cod, Massachusetts, carved and painted wood, good condition, inscribed.

Oliver 7/87 **$2,800**

Mallard sleepers, pair, hollow bodies, original paint, glass eyes, mid-20th century, some wear. L 17³/₄″

Garth 2/87 **$200**

Mason's Bluebill, old working repaint, replaced tack eyes. L 12³/₄″

Garth 7/86 **$65**

Mason's Merganser, tack eyes, worn old paint. L 16″

Garth 7/86 **$95**

Mason's Merganser drake, glass eyes, old worn repaint, some edge damage, shot scars. L 15¹/₄″

Garth 7/86 **$75**

Merganser, contemporary carving, glass eyes. L 14¹/₂″

Garth 5/86 **$100**

Merganser drake, Nate Frazer, Tuckerton, New Jersey, hollow red breasted, original paint, published, similar pieces known.

Oliver 7/87 **$1,400**

Merganser drake, Dodge Decoy Factory, carved and painted wood, provenance, stamped, damaged.

Oliver 7/87 **$4,250**

Merganser drake and hen, pair, Lothrop Holmes, Kingston, Massachusetts, 1850–1900, painted wood, rare, published, signed, similar pieces known, publicity.

Christie's 10/85 **$93,500**

Mergansers, pair, Mason Decoy Factory, Detroit, Michigan, 1924, carved and painted wood, original paint, provenance, flaking, missing eye.

Oliver 7/87 **$4,000**

Miniature, old paint, glass eyes, initialed "F. F." (Fabre Firch, Elton, Louisiana), cracked eye. L 9¹/₄″

Garth 2/86 **$95**

Owl, Swisher & Soules Decoy Co., Decatur, Illinois, c. 1930, painted metal, published, rare, stamped with patent number.

Oliver 7/87 **$400**

Pair, old worn orange paint, wear. L 10¹/₂″ and L 11″

Garth 2/86 **$70**

Papier-mâché, two, (A) Pintail, labeled "H.C. Higgins Life-Likem," (B) Black duck, labeled "General Fibre Co." Both have original paint with minor wear, glass eyes. 14″ × 16¹/₂″

Garth 2/87 **$20**

Pigeon, confidence, screw eyes, original paint, driftwood base, good age, paint, minor repair. L 13½″

Garth 2/86 **$105**

Pigeon, hand-painted papier-mâché, paper label, "The Burbo Nesting Pigeon Decoy," mass produced: Pat. No. 449, 712. L 13½″

Garth 2/86 **$65**

Pintail drake, glass eyes, original paint, textured feathers, 20th century, some age. L 19″

Garth 2/86 **$55**

Pintail or Sprig drake, hollow body, initialed "J.W.RE.," worn repaint. L 13¾″

Garth 7/86 **$95**

Pintail drake, mid-20th century, well-shaped bulbous body, slightly turned head, worn original paint, glass eyes. L 21½″

Garth 2/87 **$155**

Pintail drake, Bob McGaw, Havre de Grace, Maryland, c. 1930, carved and painted wood, hairline crack.

Oliver 7/87 **$650**

Pintail hen, A.E. Crowell, East Harwich, Massachusetts, unmarked, carved wood, written on base "The Pintail," in Crowell's hand, mint condition, miniature, illustrated.

Skinner 1/87 **$700**

Plover, small, black spotted sides, red breast, painted eye, some wear.

Skinner 5/85 **$375**

Plover, small, black wings, red breast, painted eye, bill pegged through head, original paint, worn.

Skinner 5/85 **$225**

Plovers, two, oversized, black breast, New England, hollow, two-piece construction, spring and fall plumage.

Skinner 1/87 **$3,500**

Primitive, detail on wings, tail, old repaint, repairs, replacements. L 12¾″

Garth 5/86 **$65**

Primitive, painted wood, four pieces. L 10″ to 14″

Garth 2/86 **$105**

Primitive, three, 20th century, wood, brightly painted, some age cracks, worm holes in clocks. L 12½″

Garth 2/87 **$45**

Primitive, two, (A) Mallard hen, tin, tack eyes, worn old paint, signed "F. Haas." L 11¾" (B) Bird, good carving, traces of white, black paint, damage, age cracks, replaced head. L 12"
<div align="right">*Garth 5/86* **$45**</div>

Primitive, two, both have lines, lead weights, damaged. L 14"
<div align="right">*Garth 2/87* **$20**</div>

Redhead, unknown maker, North Carolina, c. 1915, painted cast iron, rusting.
<div align="right">*Oliver 7/87* **$200**</div>

Redhead drake, good profile, old worn working repaint. L 12½"
<div align="right">*Garth 7/86* **$85**</div>

Redhead drake, A.E. Crowell & Son, East Harwich, Massachusetts, paper label, mint condition, miniature, illustrated.
<div align="right">*Skinner 1/87* **$800**</div>

Redhead drake, old paint, age crack. L 18½"
<div align="right">*Garth 2/87* **$45**</div>

Rig of seven, wood, six painted as mallards, all have old spark plug weights. L 14"
<div align="right">*Garth 2/87* **$175**</div>

Robin snipe, Long Island, New York, stick-up, wood, one shoe-button eye, good workmanship, cracked.
<div align="right">*Sotheby's 10/86* **$1,100**</div>

Shore bird, carved and painted, c. 1900, initialed "F.F.H." H 9"
<div align="right">*Skinner 6/86* **$1,100**</div>

Shore bird, whittled, yellow legs, contemporary. H 9½"
<div align="right">*Garth 7/86* **$35**</div>

Shore bird, carved and painted stick-up, brown and black spotted. 11" × 22½"
<div align="right">*Christie's 5/87* **$400**</div>

Silhouette, primitive carving, black paint, repairs.
<div align="right">*Garth 2/86* **$40**</div>

Silhouette crows, two, folding tin, old worn black paint, springs fastened. L 15"
<div align="right">*Garth 7/86* **$50**</div>

Six working decoys, a couple are probably by Mason, repaired.
<div align="right">*Garth 2/86* **$125**</div>

Six mallards and pintail, all painted wood, initialed "F.F" (Fabre Firch, Elton, Louisiana), wear. L approximately 15" each
<div align="right">*Garth 2/86* **$300**</div>

Stick-ups: eight pieces, marked, dated: "Copy 1949 by Herter's, Inc., Waseca, Minn., U.S.A.," cardboard, lithographically reproduced, heavy damage, wear. L 29″

Garth 2/86 **$25**

Stuffed canvas Canada goose and Brant, primitive, old worn black, white paint. L 14″ and 20″

Garth 7/86 **$40**

Stuffed canvas pair, bluebills, glass eyes, old paint.

Garth 3/87 **$165**

Swan, New Jersey, cedar, hollow, original paint, natural condition.

Sotheby's 1/84 **$850**

Swan, J.P. Hand, New Jersey, cedar, hollow, original paint.

Sotheby's 1/84 **$850**

Swan, Frank Finney, Pungo, Virginia, carved and painted wood, hollow, good condition.

Oliver 7/87 **$475**

Swan, Dorchester County, Maryland, 19th century, carved and painted wood, documentation, cracked, worn.

Oliver 7/87 **$500**

Swan, Samuel T. Barnes, Havre de Grace, Maryland, c. 1890, carved and painted wood, rare, similar pieces known, cracked, worn, repairs.

Oliver 7/87 **$60,000**

Two pieces, unknown makers, painted wood. L 13″ and 14″

Garth 2/86 **$100**

Whistler drake, inset head, relief carved detail, glass eyes, old paint, shot scars. L 14″

Garth 7/86 **$95**

White wing scoter, Joseph Lincoln, Accord, Massachusetts, carved and painted wood, excellent condition.

Oliver 7/87 **$3,700**

Willett, Mason Decoy Factory, Detroit, Michigan, 1924, carved and painted wood, tack eye.

Oliver 7/87 **$475**

Willet, Mason Decoy Factory, Detroit, Michigan, 1924, carved and painted wood, tack eye, excellent original paint and condition.

Oliver 7/87 **$750**

Yellowlegs, William Southard, Bellmore, Long Island, New York, original paint, bill broken, fine S-curved wings, rare.

Skinner 3/87 **$1,500**

Yellowlegs, William Southard, Bellmore, Long Island, New York, original paint, worn.

Skinner 3/87 **$1,760**

Yellowlegs, carved and painted balsa wood, George Ross Starr, Virginia, original paint, stamped, repairs.

Oliver 7/87 **$475**

Yellowlegs, John Lee Baldwin, Babylon, New York, c. 1920, carved and painted wood, good condition.

Oliver 7/87 **$575**

Yellowlegs: rig of twelve, Strater & Sohler Co., Boston, Massachusetts, painted tin, rusting.

Oliver 7/87 **$650**

Yellowlegs: four, stamped "Stratters Pat Oct 27, 1874," folding tin, sticks, original paint, excellent condition.

Skinner 6/87 **$350**

Desks

The bureau desk, developed during the William and Mary period, combined the slant-top box with a lower chest of drawers. Bottom hinges were designed to enable the lid to open into a writing surface. Pull-out slides gave additional support to an opened lid. Interiors were often fitted with small drawers and compartments. The front of the desk, its feet, and hardware reflected the time, region, and style in which it was made. For instance, forms in the Chippendale period sport the bombe shape and the block front styles. The Chippendale kneehole desk sported a central hole for legs flanked by vertical drawers.

Secretary, C.E. Littlefield, probably Pennsylvania, 1896, Tramp art, chromolithograph panel on door.

Sotheby's 1/84 **$3,500**

Light blue-green and ivory sponge decoration, square tapering legs, Vermont, c. 1800, worn. 33″ × 25″ × 19″

Skinner 1/85 **$1,200**

Ship's, New Bedford, c. 1850, sailor-made, six graduated drawers, whalebone pulls, various exotic woods, provenance. 42″ × 23 1/2″ × 25 1/2″

Skinner 11/85 **$2,000**

Country slant top, New England, c. 1790, Chippendale style, bracket feet, original brasses, old refinish, minor lid damage. 42 1/2″ × 35 3/4″ × 17 1/2″

Skinner 5/86 **$3,000**

Country Queen Anne on frame with turned legs, stretcher base, one dovetailed drawer is an expertly constructed replacement, old wood, top has slant lid. 42 1/2″ × 22″ × 22 3/4″

Garth 2/87 **$1,050**

Dolls

Cloth and rag dolls, among the most popular type of dolls, were the simplest to make. Scrap material and some stuffing—straw or cotton—sufficed. Cloth doll features were either painted or embroidered; and the hair was made from threads, yarn, animal, or human hair. It was also common for a father, uncle, or brother to carve a piece of wood into a facsimile for the child, boy or girl, in the family. Frequently painted and/or clothed as the recipient desired, dolls considered to be folk art are one of a kind. Included within this category are handmade marionettes and other carved wooden figures such as balancing and jump toys.

Articulated wood, primitively carved features, old red, green paint. H 10″

Garth 5/86 **$135**

Beggar's dummy, articulated, M. R. Crandall, American, carved and painted wood, fabric, documentation. H 52″

Sotheby's 1/84 **$6,050**

Black, painted composition and fabric. H 39 1/2″

Sotheby's 1/84 **$550**

Black, set of three: chain-gang member, farmer, laundress, American, 20th century. H 9″ each

Sotheby's 1/84 **$650**

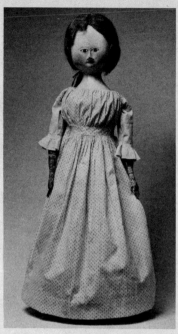

Late 18th-, early 19th-century New England Queen Anne style doll, constructed with a painted wooden face, glass eyes, and human hair, leather arms and a fabric dress, 28″ height. (*Photo courtesy of Barbara and Frank Pollack*)

Black child, stuffed cloth, embroidered, applique face, button eyes, some wear, feet recovered. H 18¹/₂″

Garth 5/86 **$30**

Black cloth, Julia Beecher, Elmira, New York, c. 1893–1910, sculptured black rayon face, olive material, oil cloth slipper, illustrated, fabric worn, hole in leg. H 20¹/₂″

Skinner 1/87 **$2,300**

Black mammy, 19th century, cloth, cotton-stuffed body and head, embroidered eyes, material faded, hand damaged. H 21¹/₂″

Skinner 11/86 **$300**

Black man, c. 1900, cloth, excelsior stuffed doll, sewn features, white linen suit, fine condition, missing piece. H 14″

Skinner 11/85 **$300**

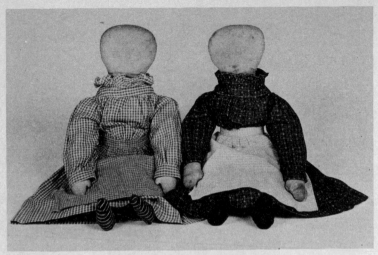

Two late 19th-century Pennsylvania cotton rag dolls, probably Mennonite, 23″ height. (*Photo courtesy of Kathy Schoemer*)

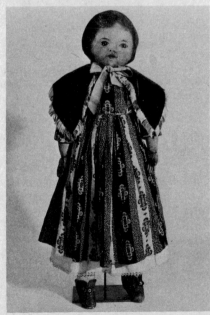

Late 19th-century American rag doll with painted face, 26″ height. (*Photo courtesy of Olde Hope Antiques, Inc.*)

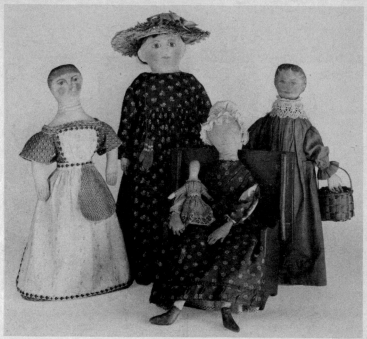

Group of late 19th-century American rag dolls with painted faces. (*Photo by Bill Finney; courtesy of Sandy Elliott*)

Black woman and baby, primitive stuffed cloth, bead eyes, old cloth costume, good detail. H 11 1/2″

Garth 5/86 **$200**

Clown on head stick, wood, laminated construction, brightly colored, repainted black, red, pink, and white, unusual design, repainted. L 36 3/4″

Garth 2/86 **$85**

Figure: bearded man, American, carved wood, primitive, no provenance. H 9 3/4″

Garth 2/86 **$25**

Figure: man, carved wood, band uniform, bright original yellow and orange paint with black and flesh color, tin base, good paint. H 5 1/2″

Garth 2/86 **$55**

Mammy, fabric. H 21 1/4″

Sotheby's 1/84 **$325**

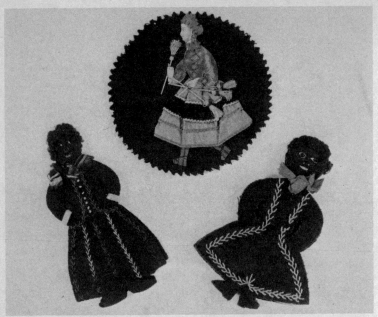

Three early 20th-century American felt pen wipes in figural form. (*Photo courtesy of Jeannine Dobbs*)

Marionette, American, carved wood, detailed shoes, hands, and face and articulated body and limbs, clothes and wig missing, modern metal standard, craftsmanship, missing pieces. H 22 1/2 ″

Garth 2/86 **$145**

Primitive figures: two, American, (A) carved and painted wood, articulated arms, legs, metal stand, poor condition, paint. H 10 1/4 ″ (B) Dancing figure with hole in neck for rod. H 11 ″

Garth 2/86 **$50**

Primitive stuffed cloth, worn pen and ink face, faded colors. H 9 1/4 ″

Garth 5/86 **$65**

Primitive, wood, minimal carving, worn original paint, worn costume. H 10 ″

Garth 5/86 **$95**

Rag dolls: three, Amish, Holmes County, Ohio, machine sewn, provenance, stains, minor wear. H 13 ″ to 18 ″

Garth 2/86 **$135**

Stuffed cloth, embroidered face, some wear. H 23 ″

Garth 5/86 **$40**

Stuffed cloth, faceless Amish baby, faded pink, white dress, bonnet. H 16″

Garth 5/86 **$25**

Stuffed cloth, faceless Amish baby, purple dress. H 16½″

Garth 5/86 **$30**

Three: (A) Black marionette, painted composition and fabric. H 32″ (B) Mammy, c. 1940. (C) Marionette, possibly Pinocchio, painted wood and fabric, c. 1940.

Sotheby's 1/84 **$325**

Topsy-turvy, cloth, 1850–1900, painted features, cotton printed fabric, worn, fading. H 16″

Skinner 5/85 **$55**

Uncle Sam, 20th century, nylon, blue felt hat and coat, good color, condition. H 16½″

Phillips 5/87 **$180**

Doll Furniture

Decorated wooden dresser, three drawers, mirrored top, green striping, gold trim, polychrome floral detail. H 11¾″

Garth 5/86 **$95**

Ladder-back chair with rush seat, unidentified maker, early 19th century, painted and turned maple, rarity. H 15¼″

Sotheby's 10/86 **$925**

Doorstops

Doorstops fashioned of cast iron became popular in the last half of the nineteenth century. An English tradition, their designs range from baskets of flowers to human and animal forms. While the images are identical, they frequently appear individualistic because of their many different colors. Their sizes range from between 6 to 12 inches in height.

Airedale, cast iron, worn paint. H 8½″

Garth 7/86 **$95**

Angelfish, cast iron, traces of black paint. H 6″
<div align="right">

Garth 5/86　**$40**
</div>

Art Deco sailor, cast iron, good color. H 11½″
<div align="right">

Garth 7/86　**$575**
</div>

Aunt Jemima, cast iron, polychrome repaint. H 12″
<div align="right">

Garth 5/86　**$105**
</div>

Aunt Jemima, cast iron, polychrome paint, white repainted, some wear, chips. H 13¼″
<div align="right">

Garth 7/86　**$70**
</div>

Baby shoe, cast iron, original white, blue paint, wear. L 5″
<div align="right">

Garth 2/86　**$30**
</div>

Basket of flowers, cast iron, polychromed, repainted. H 8½″
<div align="right">

Garth 2/86　**$50**
</div>

Basket of flowers, cast iron, painted, repainted. H 10½″
<div align="right">

Garth 2/86　**$50**
</div>

Basket of flowers, cast iron, polychromed, good paint, minor wear. H 5½″
<div align="right">

Garth 2/86　**$60**
</div>

Basket of flowers, cast iron, dark metallic finish, good paint. H 12″
<div align="right">

Garth 2/86　**$65**
</div>

Basket of flowers, cast iron, colorful polychrome paint. H 7″
<div align="right">

Garth 5/86　**$30**
</div>

Basket of flowers, cast iron, polychrome paint, some wear. H 5⅝″
<div align="right">

Garth 5/86　**$50**
</div>

Basket of flowers, cast iron, polychrome repaint. H 9¾″
<div align="right">

Garth 5/86　**$55**
</div>

Basket of flowers, cast iron, polychrome repaint. H 8″
<div align="right">

Garth 5/86　**$55**
</div>

Basket of flowers, cast iron, polychrome paint, some wear, rust. H 10½″
<div align="right">

Garth 5/86　**$55**
</div>

Basket of flowers, cast iron, polychrome paint. 7¼″
<div align="right">

Garth 5/86　**$55**
</div>

Basket of flowers, cast iron, polychrome repaint. H 2¾″
<div align="right">

Garth 5/86　**$75**
</div>

Basket of flowers, cast iron, pastel paint, minor wear. H 11″
<div align="right">

Garth 7/86　**$155**
</div>

Basket of flowers, cast iron, worn old polychrome paint. L 8″
<div align="right">

Garth 3/87　**$75**
</div>

Basket of fruit with bow, cast iron, polychromed, good paint, size, flaking, chipped, rust. H 16$\frac{1}{2}$"

Garth 2/86 **$125**

Basket of fruit, cast iron, old polychrome paint. H 15$\frac{1}{2}$"

Garth 5/86 **$195**

Basket of fruit, cast iron, polychrome paint, worn, good color. H 10$\frac{1}{2}$"

Garth 7/86 **$65**

Basket of fruit, cast iron, handle is broken, old worn polychrome repaint. H 10"

Garth 3/87 **$55**

Basket of tulips, cast iron, painted, good color. H 8$\frac{3}{8}$"

Garth 2/86 **$90**

Basket of tulips, cast iron, polychrome repaint. H 8$\frac{3}{8}$"

Garth 5/86 **$80**

Begging dachshund, cast iron, old worn black paint. H 10$\frac{3}{4}$"

Garth 7/86 **$75**

Boston bulldog, cast iron, painted realistically, worn. H 9"

Garth 2/86 **$50**

Boston bulldog, cast iron, old worn black, white paint. H 9$\frac{1}{2}$"

Garth 5/86 **$40**

Boston bulldog, cast iron, worn black, white paint. H 10$\frac{3}{8}$"

Garth 5/86 **$65**

Boston bulldog, cast iron, old worn polychrome repaint. H 8$\frac{1}{2}$"

Garth 7/86 **$25**

Bowl of fruit and flowers, cast iron, painted, repainted. H 7"

Garth 2/86 **$50**

Bulldog, cast iron, black, white repaint. H 6$\frac{1}{4}$"

Garth 7/86 **$35**

Cat, cast iron, original white, gray, and pink paint, full figure, details, wear, chipped. H 8$\frac{1}{2}$"

Garth 2/86 **$75**

Cat, cast iron, old white repaint. H 8$\frac{1}{4}$"

Garth 5/86 **$55**

Child, naked and yawning, cast iron, polychrome paint, marked, 1931. H 8$\frac{3}{8}$"

Garth 7/86 **$105**

Children playing "Guess Who?", cast iron, painted, repainted. H 5$\frac{3}{4}$"

Garth 2/86 **$70**

Cockatoo, cast iron, colorful polychrome paint, some wear. H 8$\frac{1}{4}$"

Garth 5/86 **$40**

Cockatoo, cast iron, bright repaint, worn. H 11³/₄″
Garth 5/86 **$55**

Collie, cast iron, polychrome paint, wear. H 7¹/₂″
Garth 7/86 **$115**

Cottage with flowers, cast iron, polychromed, repainted. H 5³/₄″
Garth 2/86 **$65**

Cottage, cast iron, polychrome paint. H 5″
Garth 7/86 **$70**

Dwarf with lantern and keys, cast iron, original paint, full figure, good design, size, wear. H 9³/₄″
Garth 2/86 **$155**

Elephant with raised trunk, cast iron, red repaint, black highlights. H 7¹/₄″
Garth 7/86 **$20**

Full figure cast, cast iron, old black paint, blue eyes, good paint. H 6³/₄″
Garth 2/86 **$105**

Geisha girl with string instrument, cast iron, worn polychrome paint. H 6³/₄″
Garth 7/86 **$85**

Girl curtsying, cast iron, black, white repaint. H 9″
Garth 7/86 **$45**

Girl with fan, cast iron, polychrome paint, wear. H 9″
Garth 7/86 **$155**

Golfer, cast iron, polychrome paint worn. H 8³/₈″
Garth 7/86 **$300**

Goose spreading wings, cast iron, brass finish, full figure. H 6³/₄″
Garth 2/86 **$55**

Greyhound, cast iron, signed, old green, bronze metallic paint. L 11⁷/₈″
Garth 5/86 **$35**

Horse with saddle, cast iron, polychromed, wear, repainted. H 4³/₄″
Garth 2/86 **$55**

Iris, cast iron, polychrome paint, minor wear. H 10¹/₂″
Garth 7/86 **$200**

Lady Liberty, cast iron, black paint, gold highlights. H 9³/₈″
Garth 5/86 **$30**

London mail coach, cast iron, old polychrome repaint. L 12″
Garth 5/86 **$50**

Oriental child, cast iron, wear, polychrome repaint. H 5 1/4 ″
<div align="right">

Garth 7/86 **$25**
</div>

Pair of pots of flowers, cast iron, polychrome metallic paint, H 9 3/4 ″
<div align="right">

Garth 7/86 **$200**
</div>

Old sailor, cast iron, painted, full figure, wear. H 6 1/2 ″
<div align="right">

Garth 2/86 **$75**
</div>

Parrot, cast iron, original painted, good paint. H 7 3/4 ″
<div align="right">

Garth 2/86 **$90**
</div>

Parrot in a circle, cast iron, polychrome, gold ring, good paint. H 8 ″
<div align="right">

Garth 2/86 **$75**
</div>

Parrot on oval perch, cast iron, polychrome, metallic paint, full figure, details, size. H 13 1/2 ″
<div align="right">

Garth 2/86 **$80**
</div>

Parrot, cast iron, polychrome paint, some wear, piece missing. H 7 3/4 ″
<div align="right">

Garth 5/86 **$55**
</div>

Parrot on a stump, cast iron, polychrome repaint. H 7 1/4 ″
<div align="right">

Garth 5/86 **$55**
</div>

Parrot, cast iron, polychrome paint, marked Albany. H 12 1/4 ″
<div align="right">

Garth 7/86 **$40**
</div>

Peacock and urn, cast iron, polychrome repaint. H 7 5/8 ″
<div align="right">

Garth 5/86 **$25**
</div>

Police dog, cast iron, old bronze paint. H 12 1/2 ″
<div align="right">

Garth 5/86 **$55**
</div>

Rabbit, cast iron, polychrome paint. H 6 ″
<div align="right">

Garth 7/86 **$225**
</div>

Roses in a cornucopia, cast iron, polychrome paint, minor wear. H 10 ″
<div align="right">

Garth 5/86 **$70**
</div>

Sailing ship, cast iron, polychrome paint. H 9 1/2 ″
<div align="right">

Garth 5/86 **$65**
</div>

Sailing ship, bronze, painted. H 9 ″
<div align="right">

Garth 2/86 **$65**
</div>

Sailor, cast iron, worn original bronze finish. H 11 1/4 ″
<div align="right">

Garth 7/86 **$35**
</div>

Scottie with good detail, cast iron, flaking turquoise repaint. H 8 ″
<div align="right">

Garth 5/86 **$55**
</div>

Seated cat, cast iron, white and green paint, full figure, size, wear. H 10 1/8 ″
<div align="right">

Garth 2/86 **$105**
</div>

Seated police dog, cast iron, painted, wear. H 6¹/₂″
Garth 2/86 **$10**

Southern belle, cast iron, polychrome, repainted. H 11¹/₈″
Garth 2/86 **$75**

Southern belle, hoop skirts, cast iron, polychrome repaint. H 8″
Garth 5/86 **$35**

Southern belle, cast iron, polychrome paint, wear, some rust. H 6″
Garth 5/86 **$65**

Spaniel, cast iron, black, white paint, wear. H 6⁷/₈″
Garth 7/86 **$65**

Standing police dog, cast iron, painted realistically, full figure, good paint, size, repaint. H 9¹/₄″
Garth 2/86 **$75**

Sunbonnet baby, cast iron, painted, full figure, good paint. H 5³/₄″
Garth 2/86 **$50**

Three-masted ship, cast iron, brass plated. H 10¹/₂″
Garth 7/86 **$10**

Two scotties, cast iron, old black paint. H 6″
Garth 7/86 **$45**

Vase of flowers, cast iron, polychrome, poor color, wear. H 11⁵/₈″
Garth 2/86 **$85**

Vase of poppies, cast iron, red, white, green paint, minor wear. H 10³/₄″
Garth 7/86 **$75**

Viking ship, cast iron, inscription, polychrome paint. H 7″
Garth 5/86 **$30**

Dry Sinks and Washstands

The dry sink served as the kitchen sink before indoor plumbing. Most dishes were cleaned in the well, which sometimes came equipped with a drainage system and zinc lining. Commonly, there

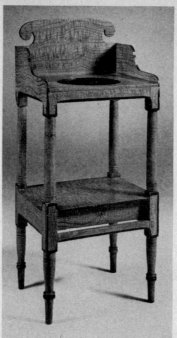

Early 19th-century New England paint-decorated washstand. (*Photo courtesy of Sotheby's, New York*)

existed a one- or two-door compartment below the well. Made throughout the United States from pine, poplar, and other soft woods, they were usually also painted.

Washstands accommodated washbowls, glasses, and soap dishes. Sometimes cut-out tops were provided for these items. Others had flat tops backed by splashboards or galleries with an open shelf below for storage.

Dry sink, poplar, one drawer, paneled doors, old brown, yellow graining, some wear, edge damage, drawer later addition. $34^{3}/_{4}''$ × $42^{1}/_{2}''$ × $18''$

Garth 7/86 **$355**

Dry sink, poplar and pine, paneled doors, one small nailed drawer, age crack, refinished. $34''$ × $62^{1}/_{2}''$ × $19^{3}/_{4}''$

Garth 2/87 **$700**

Washstand, pine, painted, decorated, turned legs and posts, one dovetailed drawer and scrolled crest, repairs, wear. H 28 1/2 ″ × L 17 ″ × D 14 ″

Garth 2/86 **$50**

Washstand, pine, painted, decorated, c. 1835. 38 ″ × 17 ″ × 14 ″

Sotheby's 1/87 **$600**

Fireboards and Firescreens

Fireboards, usually fashioned from wide wooden boards joined by battens, provided decorative baffling for fireplaces unused during summer. They also kept soot, birds, and other creatures from entering the room via the chimney. Fireboards, occasionally possessing canvas fronts, were for the most part painted by the same artist who decorated the room. Some were freestanding, while others were fitted over andirons or attached to the fireplace by a turnbuckle. Subjects were often trompe l'oeil designs of landscapes or floral motifs.

The firescreen, usually made with a wooden frame and inset with canvas or muslin, was first used in America in the eighteenth century and functioned as a shield for the sitter against heat and sparks from the fireplace. Serving a decorative purpose as well, the screen displayed elaborate pieces of needlework, theorems, and watercolors on paper or velvet, and was often worked by the homeowner's wife. Polescreens on a tripod base could be raised and lowered. Fancy needlework firescreens served as symbols of gentility among the middle class citizenry.

Painted, probably Massachusetts, early 19th century, pine, tree border, green, blue, white, circles, squares, surrounding vase of flowers, good condition, provenance, illustrated, minor abrasions. H 27⅝″ × W 38″

Skinner 5/85 **$9,500**

Painted, pine, c. 1820, landscape, minor scratches. H 27″ × W 31″

Skinner 6/86 **$3,400**

Painted, pine, c. 1820, landscape. H 27″ × W 32″

Skinner 6/86 **$2,800**

Painted vase of flowers, probably Massachusetts, early 19th century, provenance, published.

Skinner 5/86 **$9,500**

Oil on panel, c. 1825, provenance, museum deaccession. 29″ × 25″

Sotheby's 1/87 **$7,750**

Early 19th-century New England paint-decorated wooden fireboard, depicting a pot of flowers with horse below. (*Photo courtesy of Sotheby's, New York*)

Still life on pine, possibly central Massachusetts, c. 1815, published. 30″ × 37½″

Skinner 1/85 **$10,000**

Wallpaper covered, early 19th century, pine boards, cleats, mural scene, people, manor house, paper loss. 31″ × 42″

Skinner 5/85 **$250**

Screen, with theorem, New England, c. 1830, watercolor basket of fruit on velvet, cabriole legs.

Sotheby's 1/87 **$4,250**

Footstools

Footstools, also known as "crickets," vary widely in shape and materials. Tops are commonly made of wood, woven rush, splint, leather, or fabric. Legs are straight or curved, turned, and varied in height. Sometimes the entire footstool assumed painted animal forms such as frogs and turtles. Animal footstool kits and/or

instructions for making these animal footstools were widely distributed in the early part of the twentieth century.

Country Windsor, oval, bamboo turnings, worn old blue, green paint, replacements. $10^{1/4}'' \times 10^{1/2}'' \times 13''$
Garth 2/87 **$75**

Country Windsor, splayed tapered legs, bench edge top, old dark finish, chipped. $6^{3/4}'' \times 7'' \times 13^{3/4}''$
Garth 2/87 **$65**

Country Windsor, splayed legs, refinished, traces of green paint. $7'' \times 12''$
Garth 2/87 **$70**

Pine legs mortised through long rounded corner top, refinished. $7^{1/2} \times 7'' \times 17''$
Garth 3/87 **$75**

Primitive, pine, age cracks, nailed repairs, refinished. $6^{1/2}'' \times 9'' \times 17^{1/2}''$
Garth 3/87 **$65**

Primitive, wood, original white paint with stylized floral designs of green, red, yellow, brown, folk art pedestal. L 5″
Garth 3/87 **$25**

Thick top, inscribed "Sarah M. Murphy," dated 1874, red and black paint, American flag, shields. $7'' \times 6^{1/2}'' \times 19''$
Skinner 6/87 **$1,000**

Turned, splayed legs, good color, old refinishing. $7'' \times 13''$
Garth 3/87 **$35**

Walnut ottoman, scrolled feet, acanthus carved knees, brown velvet reupholstery, late 19th century, repairs. $18'' \times 24'' \times 27''$
Garth 2/87 **$85**

Windsor, oval top, turned legs, colorful needlework checkerboard design covering on top, old varnish finish, needlework has some wear. $9'' \times 11''$
Garth 2/87 **$55**

Fraktur

Rooted in a medieval style of lettering, frakturs (literally meaning "broken writing") were stylized, decorative watercolor pictures painted by hand and, later, mass produced by printing. They were created by Pennsylvania German-Americans between 1750 and 1850 to record important events and depict spiritual subjects. Among the wide range of fraktur were birth, baptismal, and wedding certificates, house blessings, family registers, and rewards of merit. The heart, tulip, and distelfink were popular motifs. Highest prices are paid for handcrafted fraktur by identified artists.

Known Artists

Berholtzen, Jacob O., attribution, covered booklet, probably Pennsylvania, c. 1785, bird, heart, inscription, water stains, illustrated. 8″ × 6½″

Skinner 1/86　**$1,400**

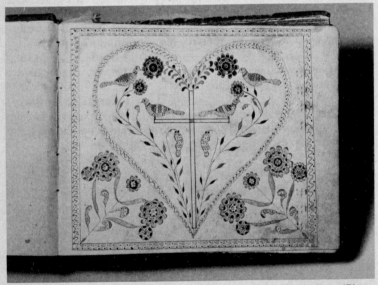

Early 19th-century Pennsylvania watercolor on paper bookplate. (*Photo courtesy of Sotheby's, New York*)

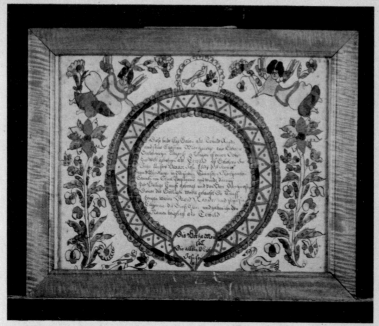

Early 19th-century Pennsylvania watercolor and ink fraktur drawing, 12½″ height × 26½″ width. (*Photo courtesy of Christie's, New York*)

Billmeyer, Michael, "Bookplate," Germantown, Pennsylvania, 1790, watercolor, printed "Michael Billmeyer," poor condition, some paper loss. 5½″ × 3½″

Sotheby's 1/84 **$300**

"Blowsy Angel" artist, Geburtz und taufschein, Northampton County, Pennsylvania, 1801, watercolor on paper. 12¾″ × 15½″

Sotheby's 1/87 **$900**

Brechall, Martin, Geburtz und taufschein, Berks County, Pennsylvania, watercolor on paper, calligraphy. 13″ × 9″

Christie's 1/87 **$750**

Brechall, Martin, Geburtz und taufschein, Berks County, Pennsylvania, 1804. 13¼″ × 9½″

Sotheby's 1/87 **$825**

Eyer, Johann Adam, "Bookmark: Reward of Merit," Montgomery County, Pennsylvania, 1761, dated, documentation.

Sotheby's 10/86 **$1,500**

Eyer, Adam, attribution, drawing: two angels, Montgomery County, Pennsylvania, 1875–1900, watercolor on paper, original frame, discolored, stained. 8″ × 8″
Sotheby's 1/87 **$13,500**

Eyer, Johann Adam, attribution, pictorial record, Montgomery County, Pennsylvania, late 18th century, watercolor on paper, documentation, discolored, stained. 8½″ × 8″
Christie's 1/87 **$13,500**

Fake(?), Peter, "Family Record," dated 1822, watercolor, pen, ink on paper, documentation, provenance, signed. 15⅝″ × 12½″
Sotheby's 10/86 **$4,000**

Krebs, Frederich, Geburtz und taufschein, Bucks County, Pennsylvania, 1810, heart border, stains, creases.
Sotheby's 1/87 **$850**

Scherg, Jacob, "Man in Coat Smoking Cigar," Lancaster County, Pennsylvania, c. 1811, watercolor, ink on paper, exhibited, provenance, published. 9″ × 6¾″
Christie's 1/87 **$7,500**

"Stony Creek" artist, "Taufschein for George Miller," Shenandoah County, Virginia, 1786, attribution, inscription in German, poor condition, some paper loss on borders, small tear. 12⅛″ × 14¼″
Sotheby's 10/86 **$1,850**

Stover, J., Geburtz und taufschein, Lebanon County, Pennsylvania, 1797, watercolor on paper. 13″ × 16″
Sotheby's 1/87 **$500**

Strickler, Jacob, Shenandoah County, Virginia, 1803, watercolor on paper, dated, documentation, similar pieces known, poor condition: stain, paper loss, strickle.
Sotheby's 10/86 **$6,250**

Walker, J.B., "Family Record for J.J. Metzger Family," probably Pennsylvania, dated 1894, cutwork, unusual design. 22″ × 27″
Sotheby's 10/86 **$3,600**

Young, Rev. Henry, "Birth and Baptismal Certificate for Franklin Riechley," Center County, Pennsylvania, dated 1859, watercolor on paper, design unusual, poor condition: creases, paper loss, some discoloration. 15½″ × 12¼″
Sotheby's 1/84 **$325**

Young, Rev. Henry, attribution, "Birth Certificate for Miss Emily Ann Rockey," Center County, Pennsylvania, 1845, watercolor on paper, exhibited, published, similar pieces known, stained, creases, foxing. 9¼″ × 7¼″
Christie's 1/87 **$2,700**

Birth and baptism, Center County, Pennsylvania, man and lady under inscription, creases, stains, foxing. $9\,^1/_4'' \times 7\,^1/_4''$

<div align="right">

Sotheby's 1/87 **$2,700**

</div>

Unknown Artists

"Baptismal of Ewald Arader," Northampton County, Pennsylvania, 1804, ink and watercolor on paper. $12\,^1/_2'' \times 26\,^1/_2''$

<div align="right">

Christie's 5/87 **$2,000**

</div>

Birth and baptism, unusual watercolor, cutwork, probably Pennsylvania, 1816, provenance.

<div align="right">

Sotheby's 1/87 **$1,400**

</div>

Birth certificate for Johannes Heller, possibly Columbia County, Pennsylvania, 1816, watercolor on paper, documentation, unusual cutwork design. $7\,^1/_4'' \times 12\,^1/_4''$

<div align="right">

Christie's 1/87 **$1,400**

</div>

Drawing: couple under bird arbor, c. 1800, watercolor, pen on paper, exhibited, published, period frame.

<div align="right">

Sotheby's 1/87 **$25,000**

</div>

Drawings, Pennsylvania, watercolor on paper, original frame. $4\,^1/_2'' \times 3\,^1/_2''$

<div align="right">

Sotheby's 1/87 **$1,900**

</div>

Family record, early 19th century, watercolor on paper, classical arch, figure of Hope, mother and child, bird with young, record of the Joshua family, tears, fading. $16\,^1/_2'' \times 13''$

<div align="right">

Skinner 5/85 **$500**

</div>

Family record, watercolor, 1800–1850, period frame, stains. $19\,^1/_2'' \times 15\,^1/_2''$

<div align="right">

Skinner 6/86 **$125**

</div>

Family record, 1825–1850, watercolor, two columns, floral arch, borders, period frame under glass, stains. $19\,^1/_2'' \times 14\,^1/_2''$

<div align="right">

Skinner 6/86 **$200**

</div>

Family record, probably Rhode Island, mid 19th century, geneological register, two men, spread eagle, animals, watercolor on paper, illustrated, torn corner. $9'' \times 14''$

<div align="right">

Skinner 7/86 **$425**

</div>

Family record, watercolor on paper, provenance, published, similar known. $18'' \times 12''$

<div align="right">

Skinner 1/87 **$2,500**

</div>

Floral wreath, c. 1795, watercolor on paper, inscribed. $7'' \times 6''$

<div align="right">

Weschler 9/86 **$200**

</div>

Geburtz und taufschein, 19th century, watercolor, pen, ink on paper. 10 1/4″ × 8″

Skinner 1/86 **$3,600**

Geburtz und taufschein, hand-colored, printed, 1809, good color, tears, repaired, framed. 12 1/2″ × 15 1/4″

Garth 5/86 **$12**

Geburtz und taufschein for Elizabeth Schiffer, "C.M.," Lancaster County, Pennsylvania, 1796, watercolor on paper, foxing, creases. 12 1/2″ × 15 1/2″

Sotheby's 1/87 **$6,000**

Geburtz und taufschein, "C.M.," Lancaster County, Pennsylvania, 1796, watercolor on paper, original frame, similar pieces known, published, stained, foxing, creases. 12 1/2″ × 15 1/2″

Christie's 1/87 **$6,000**

Genre scene: a couple, arbor, and birds, c. 1800, watercolor, ink on paper, exhibited, published, publicity. 12 1/4″ × 14″

Christie's 1/87 **$25,000**

German Bible with fraktur bookplate, American, dated 1790, black and brown ink, good craftsmanship, some wear and damage, fading, page missing. 3 1/2″ × 5 5/8″

Garth 2/86 **$25**

Illuminated manuscript: book, Snow Hill Cloister, Franklin County, Pennsylvania, dated 1852, published.

Sotheby's 1/87 **$21,000**

"Man Smoking Cigar," watercolor, ink on paper, exhibited, published, provenance.

Sotheby's 1/87 **$7,500**

Miniature, 19th century, framed, watercolor on paper, tulips, blue, red, yellow, provenance, damage to frame. 5″ × 3 1/2″

Skinner 1/87 **$150**

Miniature, framed, 19th century, watercolor on paper, tulips, blue, red, yellow, provenance. 5″ × 3 1/2″

Skinner 7/86 **$300**

Parrot, Pennsylvania, 19th century, 9 3/4″ × 7″

Sotheby's 1/87 **$800**

Parrot, watercolor, c. 1800, framed, some discoloration.

Sotheby's 1/87 **$1,100**

Property of Frederick and Mary Habbert, Pennsylvania, watercolor, June 1850, yellow lovebirds with religious text.

Sotheby's 1/87 **$400**

Signature fraktur, watercolor, possibly Maine, 19th century, William Hoois (?), Jr., in brown, red, yellow, heart, signature of artist removed, old culy maple frame. 2 1/2 " × 4 1/4 "

Skinner 6/87 **$325**

Taufschein for Johannes Schenct, Dauphin County, Pennsylvania, 1788, watercolor on paper, inscription in German, poor condition: paper frames loose at edges with some discoloration. 16 1/4 " × 12 1/4 "

Sotheby's 1/84 **$800**

Valentine, cutwork paper, New England, c.1840, hearts, pinprick outlines, birds, butterflies, verse. Dia 9 3/4 "

Skinner 5/85 **$400**

Valentine, Christian Strenge, late 18th century, watercolor, pen, ink on paper. L 13 3/4 "

Skinner 1/86 **$16,000**

Valentine, paper and cloth cutwork, New England, c. 1830, black painted rectangular shadowbox frame, cutwork flowers, bird, trees, illustrated. 9 " × 11 "

Skinner 6/86 **$1,300**

Valentine, early 19th century, watercolor, verse, paper loss. 13 " × 13 "

Sotheby's 1/87 **$850**

Vorschrift, Pennsylvania, 1866, watercolor on paper, discolored, fading, paper loss.

Sotheby's 1/87 **$700**

Vorschrift, Lancaster County, Pennsylvania, 1795, calligraphy flanked by birds, flowers, and vines, minor stain, foxing.

Sotheby's 1/87 **$2,700**

Games/Gameboards

Games were a favorite American pastime before the invention of the phonograph, radio, and television. Games included checkers, parcheesi, darts, and backgammon. Gameboards were made by both skilled and unskilled craftsmen. They possess vast appeal in their vibrantly painted surfaces and designs.

Board, pine, old worn black, white paint, edge damage. 12 3/4 " × 19 1/2 "

<div align="right">

Garth 5/86 **$125**

</div>

Board, wooden, relief-carved pattern with 64 squares on one side, 144 on the other, old black paint, varnish finish, minor age cracks. 17 " × 26 "

<div align="right">

Garth 2/87 **$250**

</div>

Bowling game, ten turned wooden pins, two balls, wooden pins. H 8 "

<div align="right">

Garth 5/86 **$30**

</div>

Checkerboard/backgammon, 19th century, painted, black and white. 20 " × 20 1/4 "

<div align="right">

Skinner 3/85 **$225**

</div>

Checkerboard, 19th century, painted red, black, deep frame. 17 " × 24 "

<div align="right">

Skinner 3/85 **$225**

</div>

Checkerboard, Virginia, c. 1860, Civil War relic, inscribed "Picked up on Winchester (Virginia) Battlefield, June 1863," age, design unusual, provenance, worn, weathered. 12 1/2 " × 13 1/2 "

<div align="right">

Garth 2/86 **$300**

</div>

Checkerboard, natural pine, black, some damage, wear. 18 1/4 " × 26 1/2 "

<div align="right">

Garth 7/86 **$100**

</div>

Checkerboard, natural pine, primitive, worn red paint, some damage. 17 " × 23 1/2 "

<div align="right">

Garth 7/86 **$65**

</div>

Checkerboard, painted and decorated wood, similar piece exhibited.

<div align="right">

Sotheby's 10/86 **$3,700**

</div>

Checkerboard, painted and decorated wood, publicity, inscription "R" on back. 18 1/2 " × 21 "

<div align="right">

Sotheby's 10/86 **$4,250**

</div>

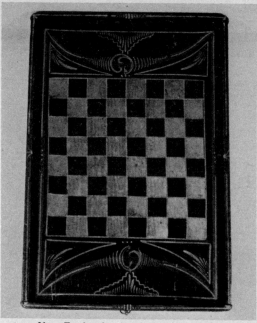

Late 19th-century New England paint-decorated gameboard. (*Photo courtesy of Bari and Phil Axelband*)

Checkerboard, 19th century, painted and decorated red and black wood panel. 14″ × 19½″

Christie's 1/87 **$3,500**

Checkerboard, pine, natural varnish finish, red squares, age cracks, two edge strips are old replacements. 19¼″ × 27½″

Garth 3/87 **$150**

Checkerboard, painted red and black with green molded frame, 19th century, some damage. 19″ × 23½″

Skinner 6/87 **$385**

Checker and parcheesi board, Pennsylvania, 1860–1880, painted and decorated bold pattern of green and white squares and red and green sawtooth border, incised wood, unusual design. 23″ × 23″

Sotheby's 10/86 **$4,000**

Checker and parcheesi board, c. 1870, painted and decorated wood, publicity. 21″ × 20¾″

Sotheby's 10/86 **$4,000**

Parcheesi board, American, c. 1870, painted and decorated wood. 16″ × 16″

<div align="right">

Sotheby's 10/86 **$2,900**
</div>

Slate, worn painted surface, one corner chipped. 20″ × 20″

<div align="right">

Garth 2/87 **$90**
</div>

Three pieces, (A) Cribbage board, worn brown graining. L 12⅝″ (B) Box of checkers. L 6¼″ (C) Marble board and box, edge chips. L 8¾″

<div align="right">

Garth 5/86 **$95**
</div>

Household Items

Household items encompass all utilitarian objects, among them: firkins, chandeliers, bird cages, and banks. The earliest children's banks, encouraging thrift, had no moving parts. They were made from pottery, wood, and tinned sheet metal. Cast-iron banks in the shape of mailboxes, houses, animals, and cartoon characters received wide popularity in the last quarter of the nineteenth century.

Probably the most collectible group of household objects remains the kitchen implements. Such utilitarian devices as molds for various foods, butters, or cookies, were often made from tin or carved wood and etched with distinctive designs. Initially, the designs marked the owner; but, later in the nineteenth century, emblems and nationalistic themes such as eagles, animals, or floral rosettes appeared.

Among other much appreciated kitchen items are pieces of woodenware including bowls, spoons, and wall boxes. Their simplistic forms and patina provide the aesthetic quality. Also included are redware and stoneware pottery found variously as jugs, crocks, and pitchers. Cast iron and other metal items used for cooking, such as toasters and pots, are also collected today.

Bank, novelty, 19th century, cast iron, painted building, good condition. H 7″

Skinner 3/85 **$500**

Bank, painted tin, gilt gingerbread ornamented cottage, repainted. H 6¹/₄″

Skinner 3/85 **$90**

Bellows: turtle back, possibly Rhode Island, c. 1830, polychome scene of house in landscape.

Skinner 3/85 **$1,600**

Birdcage, 19th century, painted wood, wire. H 21″

Skinner 1/86 **$400**

Chandeliers, early 19th century, tin, two tiers. H 24″ × Dia 22″

Skinner 1/86 **$1,000**

Cradle, New England, c. 1780, flat-top hood, canted sides, cut-out hand grips, original red and blue paint, illustrated. 26″ × 43″

Skinner 6/86 **$425**

Early 20th-century New England iron and wooden coat tree. (*Photo courtesy of Muleskinner Antiques*)

Doll's cradle, c. 1840, putty color, grain painted, hooded, minor damage. 11" × 19"

Skinner 8/87 **$275**

Eagle flag holder, embossed brass, tin back has holders for spray of five small flags, minor battering, similar published, wing span. 32 1/2"

Garth 2/87 **$300**

Firkin, carved wood, inscribed "Elizabeth," New England, 19th century. H 21"

Skinner 6/87 **$250**

Firkin, blue paint, Hingham, Massachusetts, early 19th century, minor cracks. H 14 1/4" × Dia 14"

Skinner 6/87 **$400**

Foot warmer, cherry wood, wire handle, E.P., dated 1776, illustrated, missing pan. 6" × 9 1/4" × 7"

Skinner 3/85 **$325**

Foot warmer, decorated wood, tin, 19th century. 6″ × 17″ × 9″

Skinner 1/86 **$250**

Foot warmer, Pennsylvania, c. 1830, red, yellow floral decorated pine, cracked. 11″ × 12″

Sotheby's 1/87 **$600**

Foot warmer, turned corner posts, double size, inscription, damage. 9 1/4″ × 12 1/2″ × 6″

Skinner 3/87 **$1,500**

Mantel, probably Pennsylvania, c. 1830, painted pine, faux marble, blue, gray, and black paint, flaking. 55″ × 71″ × 9″

Skinner 3/85 **$600**

Mantel, New England, c. 1830, pine, valance and frieze over straight beaded edge, white and gray marble painted surface, piece missing. 52″ × 63″

Skinner 5/86 **$150**

Match holder with eagle, cast brass, good detail. H 7 1/4″

Garth 2/87 **$150**

Pin cushion, shoe, Pennsylvania, c. 1860, carved and painted wood, velvet.

Sotheby's 10/86 **$450**

Pin cushion, "Make Do," Amish, Pennsylvania, c. 1900, fabric, wood, strawberry design.

Sotheby's 10/86 **$500**

Swift with clamp, wood, damaged. H 25″

Garth 2/86 **$45**

Tea caddy, pear-shaped, hinged lid, decorative steel escutcheon, stem missing. H 6 1/4″

Garth 2/87 **$650**

Tray with fruit, 19th century, velvet fruit on wood tray, fabric bird on handle, stone peach and pear, twenty pieces.

Sotheby's 10/86 **$3,000**

Watch hutch, probably Maine, 19th century, scrolled frame, carved eagle crest, gilt-painted shield, old brown varnish finish.

Skinner 11/85 **$950**

Wool winder and measuring reel, Pennsylvania, c. 1820, carved, painted, and decorated maple and oak, rare, superior craftsmanship. 36 1/4″ × 24″

Christie's 1/87 **$15,000**

Iron Objects
(Cast, Wrought)

Cast and wrought iron figures were among the most ubiquitous types of objects found during the last half of the nineteenth century. The images were molded and hence were produced in multiples, though their paint often personalized them. Among the kinds of objects found which are sought after by today's collectors, aside from decorative mantel pieces, are shooting gallery targets, doorstops, nutcrackers, bootscrapers and bootjacks, mill weights, hitching post finials, andirons, kitchen utensils, irons, flower holders, and various molds used for food.

It is very rare to find old cast or wrought iron forms that are not weathered or worn (pitted), since many pieces functioned both outdoors and indoors and were subject to much use.

Cast Iron

Fishing spear, Lake St. Helen, Michigan, c. 1920, cast iron and wood, two threaded removable heads, unusual design. L 45″
Oliver 7/87 **$100**

Eagle snow birds, four, one has repair, broken wing, pitted. Wing span 6 1/2″
Garth 3/87 **$120**

Garden urns: pair, similar but not a pair, larger has mounting holes in foot. H 10″
Garth 3/87 **$100**

Stove plates, two, (A) "Temptation," dated 1749, cast iron. 24 1/2″ × 26″ (B) From Mary Ann Furnace, cast iron, molded in relief, decorated and double canopy, wheat shaft, tulips, various names, published, inscription. 19 3/4″ × 21 1/2″
Sotheby's 10/86 **$900**

Wrought Iron

Two pieces, primitive, (A) Candlestick with three feet. L 10 1/2″ (B) Triangular trivet with simple shoe feet. H 8″
Garth 2/87 **$90**

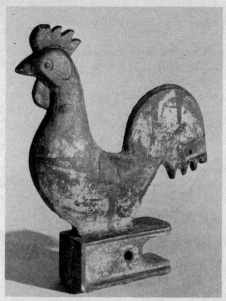

Early 20th-century Midwestern cast-iron rooster mill weight. (*Photo courtesy of Harvey Antiques*)

Four pieces, primitive, two forks, tongs, and scissors. L 15″
Garth 3/87 **$25**

Fireplace crane, primitive, modern mounting brackets. L 39″
Garth 2/87 **$20**

Betty lamp, decorative crest has tooled date of 1791, font lid and pack missing. H 3³/₄″ plus hanger
Garth 2/87 **$100**

Betty lamp, hinged lid H 4″ plus twisted hanger
Garth 2/87 **$45**

Lighting device, adjustable pan, scrolled spring clip, feet, battered, rusted. H 18¹/₄″
Garth 2/87 **$250**

Four fishing spear heads. L7″ to 16″
Garth 3/87 **$60**

Five early farm tools with wooden handles, four sickles, small adze.
Garth 3/87 **$45**

Decorative hanging ornament, with scroll work, bird crest, old black patina. 10 1/2" × 12"

Garth 3/87 **$135**

Pair surface mounted door latches, brass knobs, sliding bolts, replacements, lock repairs. L 5 1/4"

Garth 2/87 **$330**

Fireplace crane, good simple detail. 25 1/2" × 43"

Garth 3/87 **$85**

Two pieces: (A) Boot scraper with gooseneck posts. (B) Chain link trammel. L 43"

Garth 2/87 **$50**

Sawtooth trammel, pitted. Adjusts from L 25"

Garth 2/87 **$40**

Shooting Gallery Targets

Bear, cast iron, drips of orange paint, pitted, paint. W 9 1/2"

Garth 2/86 **$50**

Bear, cast iron, pitted, W 5 1/4"

Garth 2/86 **$85**

Bull, cast iron, pitted. W 6"

Garth 2/86 **$50**

Double bird and duck, cast iron, pitted, missing duck bill. L 9"

Garth 2/86 **$35**

Double cat and dog, cast iron, pitted, repainted. L 10 1/2"

Garth 2/86 **$45**

Duck, cast iron, white paint, worn. W 7 3/4"

Garth 2/86 **$45**

Elephant, cast iron, cracked, pitted. W 9"

Garth 2/86 **$95**

Five small figures: bear, two birds, turkey, clover leaf, cast iron, worn yellow paint, shot scars, battered.

Garth 3/87 **$175**

Four figures: fox, squirrel, ox, duck, cast iron, worn yellow paint, shot scars. L 9"

Garth 3/87 **$187**

Jumping fox, cast iron, pitted. L 9 3/4"

Garth 2/86 **$70**

Man on horseback, cast iron, J. Smith & Co., American, signed, cracked, pitted. W 6"

Garth 2/86 **$50**

Running rabbit, cast iron, pitted. W 11 1/4"

Garth 2/86 **$60**

Small clover leaf or club, cast iron. H 4 1/2 ″

Garth 2/86 **$30**

Three figures: elephant, polar bear, rabbit, cast iron, worn yellow paint, shot scars. L 9 ″

Garth 3/87 **$295**

Three small figures: rooster, bear, bird, cast iron, good condition, dark finish. 5 1/2 ″

Garth 3/87 **$140**

Three figures: star, bird, and flag, cast iron, pitted. 3 1/2 ″ to 5 1/4 ″

Garth 2/86 **$45**

Two figures: cat and dog, bird and duck, cast iron, worn orange, yellow paint, shot scars. L 11 ″

Garth 3/87 **$145**

Two ducks on spring mount with trigger, cast iron, good design, dents. W 10 ″

Garth 2/86 **$105**

Two small birds, no paint. H 2 1/2 ″

Garth 3/87 **$45**

Two spring-loaded birds, no paint. L 10 1/4 ″

Garth 3/87 **$95**

Jewelry (Mourning)

During Victorian times, families of means—including their servants—were expected to wear mourning jewelry for a prolonged period after a member of the household died. Popular pieces featured black enamel, or white if a child or young person had died. Rings and pins contained ivory-painted miniatures of the deceased or allegories of death such as the funerary urn, tombstone, weeping willow, or mourning figures. Seed pearls symbolizing tears were sometimes set into pieces. Common also were lockets enclosing photographs, miniatures, or a lock of the deceased's hair. Opal and jet, occasionally set in silver, were also favored.

Mourning brooch, woman, tomb, willow, black, brown on ivory, inscription, minor edge wear, gold-colored case, enclosed hair. $1\,7/8'' \times 2\,1/4''$

Garth 5/86 **$350**

Mourning earrings, two, carved cameos, woman, tomb, one cracked, one incomplete. L 1″

Garth 5/86 **$65**

Mourning pins, two, enameled black, white tomb, willow, one with hair. $3/4'' \times 7/8''$ and $1/2'' \times 3/4''$

Garth 5/86 **$115**

Mourning ring, dated 1793, gold, woman at tomb, black enameled border, worn.

Garth 5/86 **$175**

Kitchen Items

Among the variety of personally embellished articles used and made in the home were jagging wheels, mortar and pestles, and scoops. Most cooking utensils were iron or copper, while eating utensils were primarily of wood. Butter molds and cookie cutters were primarily used for decorating foodstuffs, and their designs often reflected their regional heritage, such as the tulip and heart motifs executed by the Pennsylvania Germans (see "Molds").

Bowls were typically made from wood. Frequently incised, their function dictated size and shape. Many early examples can still be found in the marketplace (see Treenware, following Other Items, below).

Bowls

Burl, late 18th century, turned, rolled rim. H 6 1/2 "
Skinner 1/85 **$700**

Burl, ovoid, handle at one end, dated 1747. 5 1/2 " × 16 "
Skinner 6/86 **$3,600**

Burl, turned, incised line decoration, late 18th century, excellent condition, illustrated. H 8 " × Dia 22 1/2 "
Skinner 6/86 **$1,200**

Burl, turned, oval, 19th century, repairs, rough surface. H 6 1/2 " × Dia 18 1/2 "
Skinner 6/86 **$325**

Burl, early 19th century. D 5 1/4 "
Sotheby's 10/86 **$1,600**

Butter paddle and bowl, wood, good design, craftsmanship, cracked. L 9 "
Garth 2/86 **$150**

Burl, footed, late 19th century. H 3 3/4 " × D 6 1/2 "
Garth 2/87 **$50**

Burl, large, very good ash burl throughout, good wear and color, minor two-inch edge crack. H 6 1/4 " × D 6 1/2 "
Garth 3/87 **$1,750**

Mortar, burl, with turned bands, good figure and color, age cracks, surface imperfections, pine pestle very worn. H 6 1/2 "
Garth 3/87 **$195**

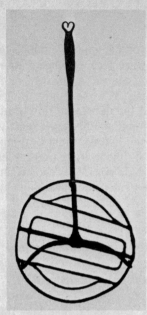

Early 18th-century New England wrought-iron broiler, with the handle in heart form. (*Photo courtesy of Pat Guthman*)

Mortar and pestle, turned wood, butter print with flower, handle missing, both refinished. H 7 1/2 ″ × D 3 1/2 ″

Garth 3/87 **$30**

Mortar and pestle, turned wood, refinished, minor age crack, finial damaged. H 7 1/2 ″

Garth 3/87 **$30**

Oblong, wood, good wear, tool marks, worn reddish stain. 3 3/4 ″ × 10 1/2 ″ × 18 ″

Garth 3/87 **$75**

Pine, primitive, iron reinforcing straps, scrubbed finish, large size. 25 ″ × 58 ″

Garth 2/86 **$155**

Rectangular, 19th century. 6 ″ × 15 3/4 ″

Sotheby's 1/84 **$900**

Trencher, wood, good wear. D 8 3/4 ″

Garth 2/87 **$225**

Turned wood, good old brown finish. 16 ″ × 17 ″

Garth 2/87 **$45**

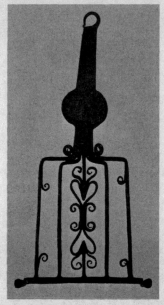

Turn-of-the-19th-century New England wrought-iron gridiron, with the handle in rat-tail form. (*Photo courtesy of Pat Guthman*)

Turned wood, painted buff and blue, 19th century. Dia 19 1/2 "
Skinner 3/85 **$300**

Two, wood: (A) Oblong wooden bowl, good wear, tool marks, scrubbed finish, bottom branded "Holliday." H 5 " × 14 " × 24 " (B) Butter paddle, refinished. L 10 "
Garth 3/87 **$50**

Wood, hanging hole, good age, color, wear, cracks, 16 1/4 " × 17 1/4 "
Garth 2/86 **$30**

Wood, primitive, oblong, four whittled-out feet, good design. 15 " × 31 "
Garth 2/86 **$45**

Other Items

Buckets: two sugar, wooden bands and handles, old brown paint, chipped. L 14 " and L 12 "
Garth 2/86 **$100**

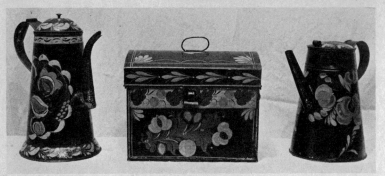

Group of early 19th-century Pennsylvania and New England paint-decorated tinware. (*Private collection*)

Mid-19th-century New England wooden canister, probably originally used for flour or sugar. (*Photo courtesy of Old Hope Antiques, Inc.*)

Butter churn, Winchendon, Massachusetts, 19th century, cylindrical, crank handle, minor paint wear. H 16″ × L 14″

Skinner 8/87 **$150**

Butter paddle and bowl, unidentified maker, curly maple, chipped. L 8″

Garth 2/86 **$145**

Cake board, attributed to J. Conger, Massachusetts (?), early 19th century, carved mahogany, similar pieces in museums with provenance and published. 15 1/2″ × 26 3/4″
Sotheby's 10/86 **$11,000**

Cake board, carved mahogany, J. Conger: attribution, early 19th century. 10 1/4″ × 14″
Sotheby's 1/87 **$900**

Charger, unidentified maker, redware, greenish clear glaze, pattern of dark wavy lines where slip has worn away, coggled edge, poor condition, repaired. D 12 1/4″
Garth 2/86 **$40**

Chocolate mold, tin, two-piece, deer. H 6 1/4″
Garth 3/87 **$90**

Cup, treen, beautifully carved, well-shaped handle. H 2 3/4″
Garth 5/86 **$175**

Dogs: two seated, unidentified maker, Ohio, white clay, molded and hand-tooled features with amber and blue dots of running glaze, design, provenance, chipped, craftsmanship, flanking. H 8 1/4″ and H 9 1/4″
Garth 2/86 **$765**

Grater: nutmeg, turned wood, brass trim, good craftsmanship, minor damage. L 7 3/4″
Garth 2/86 **$155**

Graters: nutmeg, nine, tin, some with wooden parts, two incomplete, damage.
Garth 2/86 **$95**

Graters: nutmeg, three, two with wooden handles, one with spring wire handle, good design.
Garth 2/86 **$235**

Graters: nutmeg, two, "The Edgar," MTE & Co., tin, wooden handles, crank, provenance.
Garth 2/86 **$80**

Kraut cutter, unidentified maker, wood, red paint. L 17 1/2″
Garth 2/86 **$65**

Ladle, 19th century, carved and painted wood, damage. L 16″
Skinner 1/86 **$100**

Muffin pans, five round or oblong, one marked "R&E Mfg. Co.," cast iron, each makes 6 to 12.
Garth 2/87 **$75**

Mug, unidentified maker, redware, three applied handles with elaborate detail, dark brown glaze, good design, cracks. H 6 1/2″
Garth 2/86 **$30**

Pastry roller, floral design, turned handle, "J. Conger," age cracks. L 11½″

Garth 5/86 **$375**

Peel, unidentified maker, curly maple, rare. L 13″

Garth 2/86 **$150**

Rolling pin, unidentified maker, curly maple, dark finish, stains. L 15¾″

Garth 2/86 **$145**

Scoop and horn short flask, unidentified maker, wood, primitive carving, chipped. L 14″ scoop and L 7″ flask

Garth 2/86 **$40**

Spoon, curly maple, long handle, good design. L 14½″

Garth 2/86 **$100**

Spoon, carved maple, handle with hook on end, good design. L 9¼″

Garth 2/86 **$125**

Tool: multipurpose, unidentified maker, tin, cylindrical shaker with two size graters, brass wheel pastry cutter and crimped circle cookie cutter, good design, worn brown japanning. H 5″

Garth 2/86 **$100**

Two scalloped muffin pans, cast iron, one makes 6, the other 12.

Garth 2/87 **$30**

Utensils: five, unidentified maker, wrought iron, three spatulas, one with copper blade, two brass-bowled skimmers, wear, minor damage. L 16″ to 20″

Garth 2/86 **$95**

Utensils: four, can opener, lid opener, scissors, curling iron.

Garth 2/86 **$15**

Utensils: four, curly maple, conical pestle, narrow paddle, spatula and spoon. L 11″

Garth 2/86 **$90**

Utensils: three, unidentified maker, curly maple, two pestles, rolling pin. L 11″

Garth 2/86 **$40**

Utensils: two, curly maple, spoon and rolling pin, cracked, damage. L 17″ and L 22½″

Garth 2/86 **$40**

Treenware

Treenware is woodenware usually associated with kitchen objects.

Four pieces: (A) Keg-shaped jar. H 5½″ (B) Three darners.

Garth 3/87 **$30**

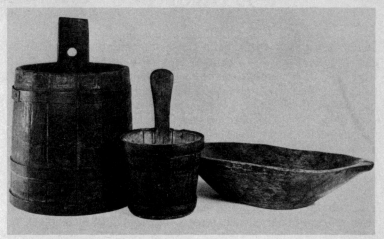

Three pieces of early 19th-century New England kitchen utensils in wood.
(*Photo courtesy of Pat Guthman*)

Four pieces: (A) Oblong bowl, age crack. L 17³/₄″ (B) Turned
plate, worn holes, glued edge chip. (C-D) Scoop and spatula with
age crack. All refinished.

Garth 3/87 **$55**

Primitive cup, one piece of walnut, good wear, patina. H 2⁷/₈″

Garth 3/87 **$75**

Spoon, well-shaped burl handle with chip, chips, hairline cracks.
L 6¹/₄″

Garth 2/87 **$15**

Two pieces: (A) Twined gavel, original paint, yellow striping on
brown ground, crossed flags and inscription. L 12″ (B) Turned
wooden bowl, worn red finish, black trim, age crack, minor dam-
age. H 4¹/₂″ × D 11¹/₂″

Garth 2/87 **$200**

Three pieces: (A) Two jars with screw-on lids, smaller has age
crack. H 5³/₄″ × 4¹/₄″ (B) Small well-shaped wrought iron spat-
ula. L 12¹/₂″

Garth 2/87 **$30**

Three pieces: (A) Octagonal mahogany tea caddy, simple inlay.
H 3³/₄″ (B) Small round box. D 2¹/₄″ (C) Footed jar with lid. H
3³/₄″. All have old dark finish.

Garth 3/87 **$85**

Lanterns

Lanterns of tinned sheet metal alternating with panes of translucent horn and housing a candle were early lighting forms. They were used in America from the early settlements through at least two succeeding centuries. Other shapes and forms, most popularly the pierced tin cylindrical type, which was misnamed a Paul Revere type, commonly used around farms, were dictated by their function. Additional materials used in making lanterns ranged from pewter, aluminum, galvanized iron and steel, brass, and bronze. They housed either a candle or oil with a wick to provide lighting for modes of transport such as ships, railroads, and coaches.

Tin, tubular square lamp, patent dates 1867–1878, embossed brass label, original burner, repairs, replacements, incomplete. H 20 1/2 ″

> *Garth 2/86* **$85**

Tin candle type, half round punched with glazed door, pierced top, minor rust, with ring handle. H 14 ″

> *Garth 2/87* **$100**

Tin candle type, pierced pyramidal top, old repairs, rust, slightly cracked, with ring handle. H 11 1/2 ″

> *Garth 2/87* **$115**

Tin candle type, original black paint, yellow striping, stenciled label "Clark's Astronomical Lantern, Boston," two sockets, worn. H 9 1/2 ″

> *Garth 2/87* **$240**

Tin, glazed opening protected by crossed wire, pierced cupola top, hinged door, rust damage, age. H 11 1/2 ″

> *Garth 2/87* **$65**

Tin, large, original black paint, stenciled label "C.T. Ham Mfg. Co's New No. 8 Tubular Square Lamp. Label Registered 1886," mercury reflector and original kerosene burner. H 24 1/2 ″

> *Garth 3/87* **$175**

Wooden barn type, glassed four sides, hinged door, some damage, tip wired. H 11 ″

> *Garth 3/87* **$145**

Memorials and Mourning Pictures

Popular during the early nineteenth century, memorials were often created by girls in "female academies." Watercolor or embroidered motifs were executed on silk, paper, ivory, and velvet. Death was not feared, but was celebrated and eulogized in jewelry, engravings, and china through symbols such as the weeping willow, headstone, funeral urn, and/or mourning figures.

Unknown, mourning picture, inscription, watercolor on paper, c. 1822, very fine condition, dated, unusual design. 10 1/2" × 9"

Phillips 4/85 **$150**

Unknown, "Mr. John Wallen Taber," watercolor, Providence, Rhode Island, c. 1826, stains, contemporary frame and mat. 12" × 16"

Skinner 1/86 **$600**

Unknown, "Memorial of Young Lady," watercolor, C. 1816, unframed, crude inscription. 8 1/2" × 7"

Skinner 11/86 **$300**

H.P.H. "Alexr W. Archer," cut paper silhouette, New England, dated 1833, fabric loss, breaks in darkened paper. 19" × 15"

Skinner 8/87 **$500**

Family tomb, Massachusetts, c. 1830, watercolor, period frame, discoloration. 8 1/4" × 10 1/2"

Skinner 1/85 **$1,600**

Primitive watercolor, paper memorial, tomb, inscription, dated 1810, matted, gilt frame. 5 3/4" × 5 3/4"

Garth 5/86 **$45**

Primitive watercolor, pen, ink, house, Abraham P. Smith, 1842, stained, creases, damage, framed. 8 3/8" × 10 3/8"

Garth 5/86 **$275**

Primitive watercolor mourning picture, woman, tomb, willow, pen, ink, inscription, 1825, Eliza Dalrymple, Malborrough [sic], Massachusetts, good detail, green, blue, gray, black, stained, old gilt frame. 18 1/4" × 23 1/4"

Garth 5/86 **$850**

Small memorial, abalone shell, watercolor, applied straw, paper, willow, tomb, inscription in German, black lacquered frame. 3³/₈″ × 4¹/₄″

Garth 5/86 **$35**

Mirrors

Initially available only to the elite, domestically produced mirrors became available during the second quarter of the nineteenth century, when the Industrial Revolution made glass accessible to the rural populace and urban middle class. In simple country households, silvered glass mirrors became widespread. Before glass, polished, tin sheet metal was used for both wall and hand examples. Glass hand and wall mirrors, that are framed with grain-painted decoration, stencilled or painted freehand design or carvings, are typically considered "folk art" objects.

Gilt split banister type, rosette corner blocks, c. 1835, flaking of gold leaf. 38¹/₂″ × 18″

Skinner 5/86 **$325**

Shaving mirror, beautifully carved animals, human-like faces, posts of potted plants with woman's head finials, relief-carved frame, repairs, old varnish finish. H 7³/₄″

Garth 5/86 **$500**

Painted and decorated, red, yellow, New England or Pennsylvania, c. 1830. 8″ × 6″

Skinner 1/87 **$1,600**

Empire, turned posts, corner blocks, old ebony, gilt finish, embossed brass rosettes, plywood back replaced. 16³/₄″ × 26³/₄″

Garth 2/87 **$95**

Two-part country Empire, turned column frame, corner blocks, old gold repaint, reverse painting of house, rookery, trees. 12″ × 24″

Garth 2/87 **$185**

Country Queen Anne, refinished, replacements. 11″ × 13″

Garth 3/87 **$325**

Two-part Empire, half-turnings, corner blocks, worn old finish, traces of gilt, colorful reverse painting, minor flaking, replaced mirror, glass. 17 1/2 ″ × 34 ″

Garth 3/87 **$400**

Decorated, molded poplar frame, unusual scrolled crest, original yellow paint, black, green striping, polka dots on crest, repaired, replaced mirror, glass. 14 ″ × 20 1/2 ″

Garth 3/87 **$700**

Molds

Carved utilitarian household objects include wooden marzipan boards, as well as cookie and butter molds. Intaglio-carved, rectangular marzipan boards were often made of mahogany and were 14 to 30 inches long. Cookie and cake molds followed a long European tradition. A type of German cookie mold called *springerle boards* closely follow German models. Cakes were made in molds for special celebrations and in commemoration of historical events. Outstanding examples of these molds seem to have originated in Pennsylvania.

Butter was molded and decorated on top. The molds usually were made out of wood and came in various sizes and shapes. Early butter molds were handmade, designed, and carved. By the last half of the nineteenth century, butter molds were factory made and the designs were cut by machines. Some popular design motifs found on butter molds are various flowers, leaves, fruits, eagles, and animals. Molds for chocolate and ice cream were also commonly used.

Butter Molds

Mold, unusual turned curly maple case, lever-activated plunger, changeable print in lid, "Prince of Wales" feather design, L. & A. Campbell, Glasgow, worm holes. H 9 1/2 ″

Garth 7/86 **$900**

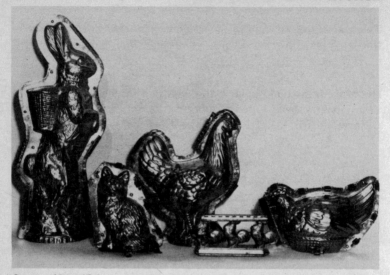

Group of late 19th-century American tin chocolate molds in animal forms. (*Photo courtesy of Pat Guthman*)

Mid-19th-century New England tin cookie mold in hand form, 4″ height × 3″ width. (*Photo courtesy of Kathy Schoemer*)

Molds, two turned wooden: (A) Trefoil leaf. D 3″ (B) Acorn and leaf. Both have age cracks, smaller case has edge damage. D 4⅝″

Garth 2/87 **$75**

Mold, rectangular case, machine-cut dovetails in case, two-part design, initialed "C.W." 4″ × 7″

Garth 3/87 **$25**

Mold, round cased mold, sheaf design, good design, old patina. D 3⅝″

Garth 3/87 **$55**

Molds, two round cased molds, pineapple and leaf design, old patina, age cracks. D 4¾″

Garth 3/87 **$90**

Molds, two, and print, three: two cased, primitive pineapple, strawberry print with floral, geometric detail, good age, color, some damage. 2″ × 5¾″

Garth 7/86 **$40**

Butter Prints/Stamps

Prints and hatchel: (A) Primitive hatchel on pine board with worn original painted decoration. L 22″ (B) Print, turned wood, concentric circles. D 4½″ (C) Small diamond-shaped print with thistle, some damage. L 3¼″

Garth 2/86 **$55**

Print, short-handled, good stylized foliage design, scrubbed finish, worm holes. 4¾″ × 5⅞″ × 4″

Garth 2/86 **$85**

Prints, three: (A) Rectangular with two flowers. 2¾″ × 5¾″ (B) Sheaf with self-turned handle. D 3⅞″ (C) Flower with turned inserted handle. D 4″ All have wear, age, and use.

Garth 3/87 **$75**

Prints, three: turned, one with pineapple design. D 3″, 3¼″, and 4″

Garth 7/86 **$75**

Prints, two cased wooden: both have leaf design, good small sizes, very good color. D 1⅞″ and D 3¼″

Garth 3/87 **$55**

Print and smoother: (A) Turned, circular smoother, minor age cracks. D 8½″ (B) Print, starflower design. D 3⅝″

Garth 5/86 **$25**

Prints, two: (A) Clear glass cased mold with wooden handle, cow design, marked "Bomer Pat applied for," edge chips. D 4¾″ (B) Small wooden print with camel-like animal, inserted turned handle, age cracks. L 3⅞″ × D 2⅜″

Garth 3/87 **$95**

Prints, two round prints: (A) Simple star design, no handle. D 4″ (B) Acorn and oak leaf, handle missing, both refinished. D 3⅝″

<div align="right">

Garth 3/87 **$50**

</div>

Prints, two turned wooden, stylized floral design, worm holes. L 4⅞″ × D 4¾″

<div align="right">

Garth 7/86 **$90**

</div>

Print, deeply carved floral design, faded inscription on back: "Lewis B. Pert, 1839," minor age cracks, edge wear. D 3¾″

<div align="right">

Garth 5/86 **$350**

</div>

Print, deeply carved star design, early, minor edge wear. D 4″

<div align="right">

Garth 5/86 **$125**

</div>

Print, dovetailed curly maple case, rectangular. L 5⅞″ × D 4¾″

<div align="right">

Garth 2/86 **$85**

</div>

Print, primitive leaf-shaped with carved veins, carved handle on back, good color. L 9″

<div align="right">

Garth 3/87 **$95**

</div>

Print, round, carved cow, age crack, handle missing. D 3⅞″

<div align="right">

Garth 3/87 **$75**

</div>

Print, round, turned handle, good carved star design, refinished. D 4″

<div align="right">

Garth 3/87 **$55**

</div>

Print, round, turned handle, stylized flower, scrubbed finish, some wear. D 3⅞″

<div align="right">

Garth 3/87 **$55**

</div>

Print, round, turned handle, stylized flower, scrubbed finish. D 4¼″

<div align="right">

Garth 3/87 **$65**

</div>

Candle Molds

Candle molds, made of pottery, pewter and, most commonly, tinned sheet metal, were set into frames varying in size to make from 1 to 96 candles simultaneously. Individual wicks were inserted into each tube followed by boiling tallow. To distinguish originals from reproductions, examine molds for signs of wear and look for heavy solder lines, characteristic of old tinned sheet metal examples.

Floor-standing candle mold, twenty-four redware tubes in pine frame, tubes have interior glaze, pine has old brown patina, one tube has chipped base, bottom shelf moved up and renailed a long time ago. 15″ × 8¹/₂″ × 23¹/₂″

Garth 2/87 **$800**

Cookie Boards/Molds

Alpine figures on both sides, carved wood, full-length. 6″ × 17¹/₂″

Garth 5/86 **$100**

Cat and dog, seated, carved wood, age crack, worm holes. 10¹/₄″ × 14″

Garth 5/86 **$395**

Couple arm in arm, carved wood. 7″ × 12³/₄″

Garth 5/86 **$95**

Five figures: pig, dog, windmill, two birds, carved wood. 3¹/₂″ × 26³/₄″

Garth 5/86 **$35**

Fourteen figures with pine trees, carved wood. 4¹/₂″ × 22″

Garth 5/86 **$25**

Horse and rider, dog, carved wood, minor age cracks. 6⁵/₈″ × 16″

Garth 5/86 **$155**

Man on horseback, carved wood, good geometric floral detail, age cracks, repairs. 11³/₈″ × 11⁵/₈″

Garth 5/86 **$50**

Man on horseback, lion on reverse side, carved wood, age crack, added braces. 12¹/₂″ × 14³/₄″

Garth 5/86 **$55**

Man and dog, woman with bird on shoulder on reverse side, full length, carved wood. 8³/₄″ × 21¹/₂″

Garth 5/86 **$275**

Man, woman with bird on shoulder on reverse side, full-length, carved wood. 6¹/₄″ × 16¹/₂″

Garth 5/86 **$145**

Primitive wood, two circular flower designs on one side, rectangle, recessed polka dots on other, good color, worm holes, minor age cracks. 5¹/₂″ × 9¹/₂″

Garth 3/87 **$135**

Six figures on each side, carved wood, age crack. 3¹/₂″ × 24″

Garth 5/86 **$55**

Cornucopia, lyre, and girl with pitcher, small, oval, cast iron, all have rough, grainy finish, age questionable.

Garth 3/87 **$30**

Cookie Cutters/Molds

Nineteen cutters, all open back with various animals, etc., tin, minor damage.

Garth 3/87 **$35**

Rabbit, tin. L 6⅝″

Garth 5/86 **$20**

Rabbit, cast iron, good design. H 11″

Garth 2/86 **$135**

Seven cutters, six animals and a heart, tin, minor damage.

Garth 3/87 **$55**

Seventeen cutters, various birds, animals, people, tin, several are battered, some damage. L 4″

Garth 3/87 **$45**

Six cutters, two birds, two fish, rabbit, chicken, tin. L 5½″

Garth 3/87 **$55**

Five cutters, including large horse, rooster, cat, pipe, and hatchet, tin, damage or resoldering.

Garth 3/87 **$80**

Five cutters, Dutch man and woman are pictured, also cat, bird, smaller Dutchman, tin. L 4½″

Garth 3/87 **$60**

Oval mold, cast iron, cornucopia. L 5¾″ × D 4¼″

Garth 3/87 **$25**

Oval mold, cast iron, girl with lyre. L 6½″ × D 4¼″

Garth 3/87 **$75**

Three cutters, horse, rabbit, duck, tin. L 4″

Garth 3/87 **$30**

Paintings

Portraits

Arising from English and Dutch traditions during the first half of the nineteenth century, itinerant, untutored American limners profited from a rising middle class seeking to display their status in portraits. Media used included oil, pastel, and watercolor. The paintings are now appreciated as social historical documents as well as art.

Known Artists

Ames, Ezra, "Lady," early 19th century, oil on canvas, relined. 30″ × 24″
<div align="right">

Skinner 3/85 **$250**
</div>

Balis, C., "D. Hallenbach," oil on canvas, Washington City, New York, dated 1850, documentation, signed. 33¼″ × 27″
<div align="right">

Sotheby's 6/87 **$2,100**
</div>

Bascom, Ruth Henshaw, "Miss Harriett Newhall Howard," Holden, Massachusetts, dated 1838, pastel on paper, provenance, signed. 19″ × 13½″
<div align="right">

Sotheby's 1/84 **$6,250**
</div>

Bascom, Andrew H., "Woman," 1839, oil on ticking, torn, inpainting. 26″ × 23″
<div align="right">

Skinner 11/85 **$1,300**
</div>

Bears, Orlando Hand, "Lady in Black Gown and Gold Jewelry," oil on canvas, Sag Harbor, New York, c. 1830, exhibited, original gilt frame. 32″ × 26″
<div align="right">

Sotheby's 6/87 **$10,000**
</div>

Belknap, Zedekiah, "Lady with Lace Bonnet," c. 1830, oil on canvas, good condition. 27″ × 23″
<div align="right">

Sotheby's 6/86 **$2,500**
</div>

Belknap, Zedekiah: attribution, "Gentleman in Black Coat," 1800–1850, oil on canvas, some inpainting. 28″ × 24″
<div align="right">

Skinner 5/86 **$600**
</div>

Belknap, Zedekiah, pair: "Young Lady" and "Young Gentleman," c. 1810, oil on canvas. 25″ × 21″
<div align="right">

Sotheby's 1/87 **$10,500**
</div>

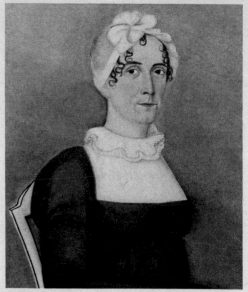

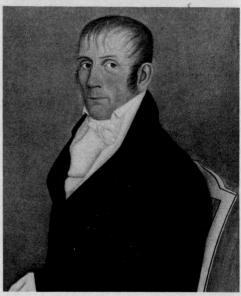

Pair of early 19th-century New England oil paintings on canvas, attributed to the Burpee Limner. (*Private collection; photo courtesy of Marna Anderson/American Folk Art*)

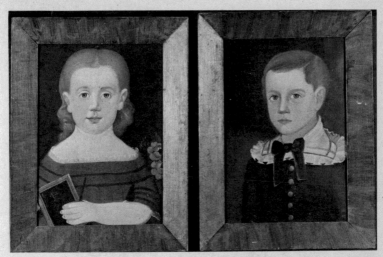

Pair of early 19th-century New England oil paintings on board, attributed to the Prior-Hamblen School. (*Photo courtesy of Sotheby's, New York*)

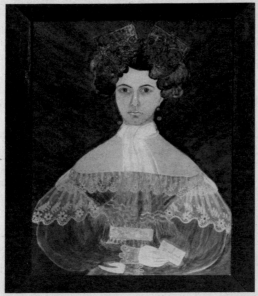

Early 19th-century American watercolor on paper, depicting Miss Adeline Bartlett, attributed to R.W. & S.A. Shute, Lowell, Massachusetts. (*Photo courtesy of Sotheby's, New York*)

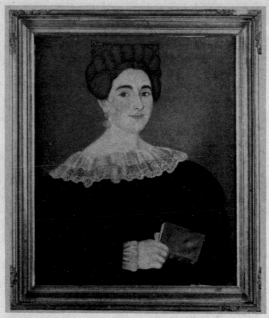

Early 19th-century New Jersey pastel on paper, depicting a woman holding a book, attributed to Micah Williams. (*Photo courtesy of Sotheby's, New York*)

Blunt, John, "Sarah Wood," oil on panel, inscribed, provenance. 15¼″ × 11¾″

Sotheby's 1/84 **$7,000**

Bradley, John, "Man Before Window," oil on canvas, inpainting. 36″ × 29″

Skinner 11/85 **$1,800**

Brewster, John, Jr., "Louella Juliette Bartlett," c. 1830, oil on canvas, original stretcher and frame, provenance. 26″ × 21″

Sotheby's 10/86 **$50,000**

Brewster, John, Jr., "Young Girl and Brother," New England, 1800–1850, oil on canvas, original frame, rare. 18″ × 15½″

Christie's 10/86 **$145,000**

Broadbent, Samuel: attribution, "Gentleman in Study," c. 1810, oil on canvas mounted on masonite. 22″ × 19″

Skinner 1/86 **$3,100**

Brown, John Lewis: attribution, "George Washington on Horseback," 19th century, oil on panel. 10″ × 13″

Skinner 11/85 **$375**

Brown, Mather, 1761–1831, "Lord William Russell and Family Before His Execution." 40″ × 49″

Skinner 1/87 **$4,250**

Bundy, Horace, "Pair of Portraits," c. 1840, oil on canvas, poor condition. 31″ × 23¼″

Sotheby's 6/86 **$2,750**

Chandler, Joseph, "Mr. Frederick A. Hand," dated 1842, oil on canvas, signed. 30″ × 24″

Skinner 1/85 **$850**

Cuceno, Arthur, 20th century, oil on panel, documentation, stamped signature on reverse. 10¾″ × 10⅞″

Sotheby's 10/86 **$1,600**

Davis, Joseph H., "Gideon G. Varney," New Hampshire, 1830s, watercolor on paper, calligraphy on bottom, verse, exhibited, provenance, published. 7⅝″ × 6¼″

Sotheby's 10/86 **$8,500**

Davis, Joseph H., "J. W. Sanborn," New England, 1830s, watercolor, ink, pencil on paper, documentation, exhibited, provenance. 10½″ × 7½″

Sotheby's 10/86 **$4,500**

Davis, Joseph H., "Betsy C. Sanborn," Brookfield, New Hampshire, 1835–1837, watercolor. 10″ × 7½″

Skinner 1/86 **$6,000**

Davis, Joseph H., "William B. Chamberlain with Violincello and Music," New Hampshire, 1835, watercolor and pencil on paper. 10½″ × 8½″

Skinner 1/86 **$26,000**

Davis, Joseph H., "Martha Nelson Furber," c. 1835, watercolor, pencil, ink on paper, provenance, inscribed. 8″ × 6″

Weschler 3/86 **$7,000**

Davis, J. A., "Sarah McPhaill . . . ," New England, c. 1835, watercolor, pencil on paper, documentation. 4½″ × 3½″

Sotheby's 10/86 **$1,300**

Davis, Joseph H., "Willey Family," New England, 1830s, watercolor, pen and pencil on paper, exhibited, provenance. 10½″ × 14¼″

Sotheby's 10/8 **$5,500**

Davis, Joseph H., "Young Lady," c. 1835, watercolor on paper, original frame. 10″ × 8″

Sotheby's 1/87 **$3,500**

DeRose, A. C., "Samuel Mott," c. 1840, oil on canvas. 34 1/4" × 27 1/4"

Skinner 6/86 **$700**

de Hals Janvier, Frances, "Young Girl at Piano," oil on canvas, documentation, signed. 29" × 22 3/4"

Sotheby's 1/84 **$550**

Dil, J. P., "Enos Wilder," New York, 1842, oil on canvas, documentation, signed. 34" × 27"

Sotheby's 10/86 **$800**

Doyle, Margaret Byron, "Young Girl Sewing," 1839, pastel on paper attached to canvas, gilded frame under glass. 24" × 18"

Skinner 11/85 **$2,000**

Evans, J., "Woman in a Garden," found in Portsmouth, New Hampshire, c. 1832, watercolor on paper, exhibited, provenance, published. 12" × 8"

Sotheby's 10/86 **$5,000**

Field, Erastus Salisbury, "Aeneas Landing at Carthage," New England, c. 1865, oil on canvas, signed, publicity. 33" × 38"

Christie's 1/84 **$65,000**

Field, Erastus Salisbury, "Hezekiah and Susan House," c. 1839, oil on canvas. 31" × 26"

Sotheby's 1/87 **$23,000**

Field, Erastus Salisbury, pair: "Maryette Field Marsh" and "Austin Lysander Marsh," New England, c. 1836, oil on canvas, framed. 35" × 29"

Christie's 5/85 **$24,000**

Field, Erastus Salisbury, pair: "Mother and Child" and "Gentleman," oil on canvas, 19th century. 35" × 29"

Christie's 10/85 **$3,800**

French, G. B., pair: "Gentleman" and "Lady," Massachusetts, c. 1840, oil on canvas, inscribed, identical frames, ripped, worn. 30" × 25"

Christie's 10/86 **$3,800**

Gilbert, I., "Gentleman in Napoleonic Pose and Lady with White Handkerchief," 1833–1840, oil on canvas, exhibited, provenance. 38 1/2" × 34 1/2"

Sotheby's 10/86 **$19,000**

Gustemer, G., "Young Girl in Blue Dress Holding an Orange," Newburyport, oil on canvas, documentation, provenance. 34 1/2" × 27 1/4"

Sotheby's 1/84 **$19,500**

Hamblen, Sturtevant, "Little Boy with Whip" and "Little Boy with Blue Bow," oil on canvasboard, c. 1840, illustrated in color, gilt frames. Each: 19″ × 13″
Sotheby's 6/87 **$7,000**

Hamblen, Sturtevant J., "Young Gentleman," c. 1840, oil on board, original frame. 13″ × 9½″
Christie's 1/87 **$4,250**

Hamblen, Sturtevant, "Young Gentleman," c. 1840, oil on academy board. 15″ × 11″
Sotheby's 1/87 **$4,250**

Hamblen Sturtevant, "Young Lady," c. 1840, oil on academy board. 13″ × 10″
Sotheby's 1/87 **$4,250**

Hamblen, Sturtevant J., "Young Lady with Blue Eyes," oil on board, c. 1840, original veneered frame. 14″ × 10″
Sotheby's 6/87 **$2,000**

Hegler, John Jacob, "Boy with Dog," published, oil on canvas, good condition, inpainting, relined. 26″ × 20″
Skinner 11/86 **$3,000**

Herring, James: attribution, 1794–1867, seated man holding book, oil on panel, illustrated, scratched. 28″ × 23″
Skinner 5/85 **$1,900**

Hesselius, John, "Thomas Clay," signed, 1759, oil on canvas. 28″ × 23″
Sotheby's 1/87 **$40,000**

Humphreys, James, Jr., "Robert Leckham," oil on canvas, dated 1809, documentation, illustrated.
Sotheby's 1/87 **$6,000**

Jennys, William, "Peggy Ashley," Westfield, Massachusetts, c. 1800, oil on canvas.
Sotheby's 1/87 **$8,000**

Jones, C. R., "Two Children with Cat," oil on canvas, dated, stamped signature on reverse. 32½″ × 35½″
Sotheby's 6/86 **$5,800**

Kennedy, William W., "John Somes and William Collins Dolliver," c. 1848, oil on canvas, documentation, provenance. 20″ × 24″
Sotheby's 1/84 **$18,000**

Kennedy, William W., "Young Girl in White Dress with Basket of Flowers," c. 1845, oil on canvas, documentation, provenance. 30½″ × 25½″
Sotheby's 1/84 **$38,500**

Kennedy, William, "Young Lady with Gold and Emerald Brooch," New England, 19th century, oil on academy board. 17″ × 13″

Skinner 1/86 **$5,000**

Lakeman, Nathaniel, "Young Lady," dated 1823, oil on canvas, signed. 25″ × 20″

Christie's 10/87 **$9,500**

Luther, Allen, "Young Gentleman," c. 1800, oil on canvas. 24″ × 17″

Sotheby's 1/87 **$12,500**

Lydston, William, Jr., "Three Family Portraits," active 1835–1860, oil on canvas, signed, minor restoration. 36″ × 29″ and a pair 27″ × 22″

Skinner 5/85 **$3,900**

Maentel, Jacob, "Aunt Hamm," Lititz, Pennsylvania, c. 1830, watercolor on paper. 13″ × 9″

Sotheby's 1/87 **$52,500**

Maentel, Jacob, "Lizette Margaret Hamm," Lititz, Pennsylvania, c. 1830, watercolor on paper. 11″ × 8″

Sotheby's 1/87 **$15,000**

Maentel, Jacob, "Luisa Duings Hamm and John Hamm," Lititz, Pennsylvania, c. 1830, watercolor on paper. 13″ × 9″

Sotheby's 1/87 **$121,000**

Maentel, Jacob, "Marian Kiffer," profile, possibly Pennsylvania, 1826, watercolor on paper, framed, ripped, stained. 10½″ × 8¾″

Christie's 1/84 **$1,800**

Maentel, Jacob, "Parents and Children," watercolor, 19th century, inscribed, illustrated. 11½″ × 9″

Sotheby's 1/87 **$33,000**

Maentel, Jacob, "Theodore Joseph Rochal," c. 1810, watercolor on paper, original frame, similar pieces known, publicity. 11¼″ × 8⅝″

Christie's 1/87 **$22,000**

Maentel, Jacob, "Young Lady," watercolor on paper, southeastern Pennsylvania, c. 1800, discolored, paper loss. 10″ × 8″

Sotheby's 1/87 **$6,250**

Maentel, Jacob, "Young Miss Faul Age 21 Years," Lancaster or York County, Pennsylvania, 1835–1840, watercolor on paper, documentation, exhibited, provenance, published. 16″ × 11″

Sotheby's 1/84 **$6,000**

Martins, S. K., two portraits, lady, bearded gentleman, 1846, oil on canvas, framed, small puncture, scratched, museum collection. $22\frac{1}{2}'' \times 17\frac{1}{2}''$

Skinner 6/86 **$750**

McNaughton, Robert, "Young Girl in White Eyelet Dress," c. 1830, oil on canvas mounted on board, original frame.

Sotheby's 1/86 **$12,500**

Moon, Samuel, "Two Boys with Hoop and Riding Crop," mid-19th century, oil on canvas. $46'' \times 34''$

Skinner 1/86 **$4,500**

North, Noah, "Marella Ryan," oil on canvas, provenance, similar piece in museum. $20\frac{1}{2}'' \times 17\frac{1}{4}''$

Sotheby's 6/86 **$22,000**

Paine, H. H., "L.M. H. Paine and Daughter Emily," oil on canvas, 1833. $29'' \times 34''$

Sotheby's 1/84 **$4,000**

Paradise, John Wesley: attribution, "Young Lady in White Bodice," c. 1815, oil on panel. $27'' \times 21''$

Sotheby's 1/87 **$4,750**

Parks, Joel, "Child in Red Dress," dated 1836, oil on canvas. $29'' \times 25''$

Sotheby's 1/87 **$9,000**

Peck, Sheldon, "Miss Palmer," Gloversville, New York, c. 1825, oil on panel. $27'' \times 22''$

Sotheby's 1/87 **$72,500**

Peckham, Robert, "James Humphreys, Jr.," possibly Massachusetts, 1809, oil on canvas, dated, period frame, inscribed, signed, similar pieces known, publicity. $25'' \times 19\frac{5}{8}''$

Christie's 1/87 **$6,000**

Peckham, Robert: attribution, "Young Boy in Gray and Blue," oil on canvas, c. 1825, similar pieces known, period gilt wood frame. $30'' \times 25''$

Sotheby's 6/87 **$4,000**

Phillips, Ammi, "Captain and Mrs. Isaac Cox," New York or Connecticut, mid-19th century, oil on canvas, provenance.

Sotheby's 1/84 **$30,000**

Phillips, Ammi; "Girl in Red Holding Strawberries," New England or New York, c. 1835, oil on canvas, similar pieces known. $32'' \times 27''$

Christie's 1/85 **$682,000**

Phillips, Ammi, pair: "Gentleman" and "Lady," oil on canvas, c. 1850. Each $34'' \times 26\frac{1}{2}''$

Sotheby's 6/87 **$60,000**

Phillips, Ammi, pair: "Wm Henry Ed Witt" and "Catherine M. Ten Broeck De Witt," c. 1835, oil on canvas, provenance. Each 32″ × 27″

Skinner 1/86 **$50,000**

Phillips, Ammi, "Sally Morgan Waldbridge," c. 1830, oil on canvas, exhibited.

Skinner 10/84 **$12,000**

Phillips, Ammi, "Fair Haired Young Woman," c. 1825, oil on canvas, original frame and stretcher. 29″ × 23″

Skinner 1/87 **$15,000**

Phillips, Ammi, "Gentleman in White Stock and Hat," c. 1825, oil on canvas. 30″ × 24″

Sotheby's 1/87 **$22,000**

Phillips, Ammi, "M.D.L.F. & Jane Marie Pells Phillips," oil on canvas, dated 1817, craftsmanship, provenance, illustrated. 32″ × 27″

Phillips 1/84 **$20,000**

Phillips, Ammi, pair: "Philo Reed" and "Abigail Reynolds Reed," New England or New York, 1829, oil on canvas, flaking. 31″ × 25″

Christie's 5/85 **$34,000**

Phillips, Ammi, "Young Woman with Books," c. 1830, oil on canvas, similar pieces known. 29¾″ × 24″

Christie's 5/87 **$19,000**

Pinx, C. Curtis, "Gentleman in High Collared Black Coat," c. 1820, oil on canvas, original frame. 26″ × 20″

Skinner 5/86 **$900**

Polk, Charles Peale, pair: "Mary Hancock" and "John Hancock," oil on canvas glued to panel, late 18th century.

Skinner 1/86 **$6,000**

Polk, Charles Peale, "George Washington," before 1792, oil on canvas, published. 36″ × 27″

Sotheby's 1/87 **$110,000**

Porter, Rufus: attribution, "Gentleman," miniature watercolor, c. 1800, profile. 5″ × 4½″

Skinner 6/86 **$800**

Powers, Amanda, "An Illinois Mother and Her Baby," possibly Illinois, c. 1835, oil on fine linen canvas, good condition, possibly related to Asahel Powers. 53¾″ × 27¾″

Sotheby's 10/86 **$60,000**

Powers, Amanda, "Little Boy with Whip," c. 1835, oil on canvas. 39″ × 19″

Sotheby's 1/87 **$20,000**

Powers, Asahel, "Albert and Julius," 19th century, oil on canvas, period gilded frame, exhibited, provenance, published. 19 1/2 " × 24 "

Sotheby's 1/84 **$14,500**

Powers, Asahel: attribution, "Woman with Concertina," illustrated, oil on canvas relined, restretched, inpainting. 30 " × 25 "

Skinner 11/86 **$750**

Prior, William Matthew, "Boy and Girl," probably Massachusetts, c. 1835, oil on board, publicity. 13 " × 19 1/2 "

Christie's 1/87 **$30,000**

Prior, William Matthew, "Boy with Drum," c. 1840, oil on panel, original frame, published. 13 " × 10 "

Sotheby's 1/87 **$5,750**

Prior, William Matthew, "Child with Dog," 19th century, oil on canvas, framed, relined, minor inpainting. 27 " × 22 "

Skinner 11/85 **$13,000**

Prior, William Matthew, pair: "Girl" and "Boy," c. 1835, oil on board. 13 " × 20 "

Sotheby's 1/87 **$30,000**

Prior, William Matthew, "Girl in Pink Dress with Brother," East Boston, Massachusetts, dated 1852, oil on board, signed, inscribed, publicity. 19 1/2 " × 24 "

Christie's 1/86 **$38,000**

Prior, William Matthew, "Infant in Pink Dress," Massachusetts, c. 1840, oil on board, original frame, old glass, documentation, provenance. 20 " × 14 "

Sotheby's 1/84 **$21,000**

Prior, William Matthew, "Mary Cary and Susan Elizabeth Johnson," Massachusetts, oil on board mounted on panel, documentation, exhibited, provenance. 16 1/2 " × 23 1/2 "

Sotheby's 1/84 **$31,000**

Prior, William Matthew, pair: "Mary Jane Baker" and "Althea Baker," Beverly, Massachusetts, 19th century, oil on board, original veneered mahogany frames. Each 13 1/4 " × 10 "

Christie's 5/85 **$16,000**

Prior, William Matthew, "Three Family Portraits: Boy, Infant, and Girl," Massachusetts, oil on board, documentation, exhibited, provenance.

Sotheby's 1/84 **$30,000**

Prior, William Matthew, "Portrait of Romanthayer," oil on canvas, 1859. 22 " × 18 "

Sotheby's 1/84 **$5,500**

Prior, William Matthew, "Portrait of Gentleman," oil on cardboard, 1842. 21″ × 15″

Sotheby's 1/84 **$3,500**

Prior, William Matthew, "Young Man," Massachusetts, 1847, oil on board, signed. 18″ × 14″

Christie's 10/86 **$2,000**

Prior-Hamblen School, "Girl in Blue Dress Holding Flowers," Massachusetts, mid-19th century, oil on wood panel. 14″ × 10″

Christie's 5/86 **$3,800**

Prior-Hamblen School, "Harriet Millakin," Massachusetts, c. 1840, oil on board. 16½″ × 12″

Christie's 10/85 **$14,000**

Prior-Hamblen School, pair: "Mr. and Mrs. George W. Brown," Scituate, Massachusetts, 19th century, oil on canvas. 27½″ × 21¾″

Christie's 1/86 **$3,000**

Prior-Hamblen School, "Sea Captain," oil on board, 19th century. 16″ × 12″

Sotheby's 1/84 **$1,200**

Prior-Hamblen School, "Woman in White Organdy Collar," oil on panel, 19th century. 16″ × 12″

Sotheby's 1/84 **$2,000**

Rasmussen, John, "Berks County Almshouse," Berks County, Pennsylvania, c. 1880, oil on zinc, published, publicity. 32″ × 38¾″

Christie's 1/87 **$48,500**

Reade, W.H.: attribution, "George Washington at Mt. Vernon," pastel on paper, provenance. 25″ × 33½″

Sotheby's 6/87 **$1,700**

Shute, Ruth and Samuel, "Child in Blue Dress," c. 1830, watercolor, pen and charcoal on paper, exhibited, published. 28″ × 19″

Sotheby's 1/87 **$10,500**

Shute, Ruth W. and Dr. Samuel A., "Electra Snow Pierce," New England, 1825–1836, documentation, provenance.

Sotheby's 1/84 **$27,000**

Shute, Ruth W. and Dr. Samuel A., "Gentleman in Black Frock Coat," New England, c. 1830, pastel on paper. 19½″ × 14″

Sotheby's 6/86 **$11,500**

Shute, Ruth W. and Dr. Samuel A., "Young Boy with School Book," New England, c. 1830, watercolor, gouache, pencil, ink on woven paper, gold foil, documentation, exhibited, provenance, published, signed. 26¾″ × 19¾″

Sotheby's 1/84 **$36,000**

Skynner, Thomas, "Mr. and Mrs. Moses Pike," 1846, New Hampshire, oil on canvas, documentation, dated. $29^7/_8" \times 23^1/_2"$

Sotheby's 10/86 **$107,250**

Skynner, Thomas, "Young Boy Holding an Open Book," New Hampshire, similar pieces in musuem. $4^1/_2" \times 3^3/_4"$

Sotheby's 10/86 **$1,100**

Sloan, A., "Albert Cheever with Cat," dated 1852, oil on canvas, unframed, crackling, nicks, scratches, history known of sitter, illustrated. $35" \times 28"$

Skinner 11/86 **$8,000**

Stock, Joseph Whiting, attribution: "Blond Haired Child on Red Cushion with Added Daguerreotype Miniature," oil on canvas, pressed leather, design unusual.

Sotheby's 10/86 **$1,900**

Stock, Joseph Whiting: attribution, "William M. Coleman" and "Margeret E. Coleman," c. 1850, oil on canvas, published, relined, inpainting. Each $29" \times 25"$

Skinner 1/86 **$3,000**

Stock, Joseph Whiting, "Addison C. Rand," oil on canvas over aluminum, 19th century. $46" \times 38"$

Sotheby's 1/84 **$20,000**

Stock, Joseph Whiting, "Boy and Dog," oil on canvas, 19th century, framed, fine condition, illustrated, minor old restoration. $47" \times 38"$

Sotheby's 11/85 **$35,000**

Stock, Joseph Whiting, "Two Children," New England, c. 1840, oil on canvas, exhibited, published, provenance, publicity. $47" \times 39"$

Christie's 1/84 **$6,500**

Stuart, Alexander, "Cornelius Zabriskie," possibly New Jersey, 19th century, oil on canvas, documentation, exhibited, provenance, oversized, signed, publicity. $40" \times 30"$

Christie's 10/84 **$11,000**

Taylor, G. J., "Raiding the Larder," dated 1869, oil on canvas. $12" \times 10"$

Sotheby's 1/87 **$1,300**

Thompson, Cephas: attribution, "Young Skelly," oil on canvas, Philadelphia, Pennsylvania, c. 1805, documentation, provenance. $9" \times 6^1/_4"$

Sotheby's 6/87 **$1,600**

Trumbull, John, "Circle of John Trumbull," early 19th century, oil on board. (Related to artist's first work: "Washington Before the Battle of Trenton," 1792.) 25″ × 19³/₄″

<div align="right">

Sotheby's 6/86 **$8,500**
</div>

Tucker, Mary, "Young Girl," 1841, 19th century, watercolor on paper, exhibited, provenance. 19¹/₄″ × 15¹/₂″

<div align="right">

Sotheby's 1/84 **$3,250**
</div>

Vanderlyn, Pieter, "Mrs. Myndert Myndertse and Daughter Sarah," Albany area, New York, early 18th century, oil on canvas, documentation, exhibited, provenance, published, publicity. 39¹/₂″ × 32¹/₄″

<div align="right">

Christie's 10/84 **$40,000**
</div>

Wallput, C. L., "Boy and Dog," dated 1831, oil on canvas. 29″ × 23″

<div align="right">

Sotheby's 1/87 **$7,500**
</div>

Walton, Henry, "Ruth Ann Gregory," c. 1840, oil on canvas. 28¹/₄″ × 21³/₄″

<div align="right">

Christie's 1/87 **$8,000**
</div>

Waters, Susan C.: attribution, "Young Naturalist," oil on canvas, relined, inpainting, new stretcher. 40″ × 30″

<div align="right">

Skinner 1/86 **$6,500**
</div>

Williams, Micah, "Gentleman in Green Vest and Blue Suit," 1815–1830, pastel. 24¹/₂″ × 20¹/₄″

<div align="right">

Sotheby's 6/86 **$22,000**
</div>

Williams, Micah, pair: "Mother" and "Son," 19th century, pastel on paper, ripped. 25¹/₂″ × 23¹/₂″ and 23³/₄″ × 19³/₄″

<div align="right">

Christie's 1/86 **$1,900**
</div>

Williams, Micah, "Portrait of a Lady," 19th century, pastel on paper. 25″ × 21″

<div align="right">

Christie's 10/85 **$3,000**
</div>

Williams, Micah, "Rosy Cheeked Young Lady," pastel on paper, c. 1835, original frame, documentation. 25″ × 21″

<div align="right">

Sotheby's 6/87 **$8,000**
</div>

Williams, Micah, "Young Boy," 19th century, pastel on paper. 22″ × 17¹/₈″

<div align="right">

Christie's 1/87 **$16,000**
</div>

Williams, Micah "Young Lady in Green Dress," c. 1825, pastel, original frame, poor condition. 24¹/₂″ × 20″

<div align="right">

Sotheby's 10/86 **$2,300**
</div>

Williams, Micah: attribution, "Woman," illustrated, oil on canvas, framed, good condition, relined, inpainting. 25″ × 30″

<div align="right">

Skinner 11/86 **$7,000**
</div>

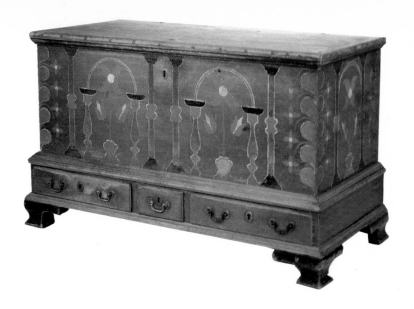

Above: Late 18th-century Lebanon or Berks County, Pennsylvania, paint-decorated dower or blanket chest. (*Photo courtesy of Olde Hope Antiques, Inc.*) Below: Early 19th-century Dauphin County, Pennsylvania, paint-decorated dower or blanket chest. (*Photo courtesy of Olde Hope Antiques, Inc.*)

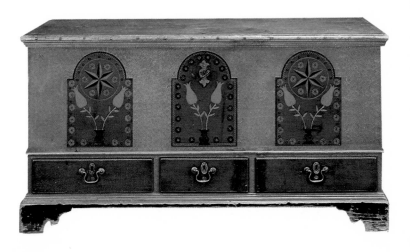

Above: American decorative setting featuring mid-19th-century New England dry sink with original painted decoration. (*Photo courtesy of Butterfield & Butterfield*) Below: Early 19th-century New England paint-decorated, domed lid, lift top box, 13″ × 27″ × 11″. (*Photo courtesy of Bari and Phil Axelband*)

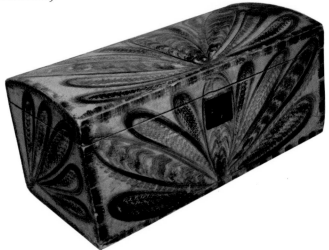

Above: Contemporary carved and painted wooden spice cabinet, entitled "Peace on Earth," by Stephen Huneck, Vermont artist. (*Photo courtesy of Jay Johnson America's Folk Heritage Gallery*) Below: Early 20th-century wood duck drake and blue bill drake decoys by Elmer Crowell. (*Photo courtesy of James Julia/Gary Guyette, Inc.*)

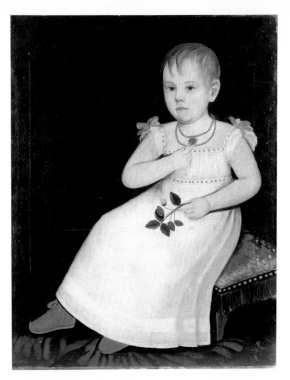

Above: "Portrait of Mary Margaret Deuel," oil painting by Ammi Phillips. (*Photo courtesy of Robert Skinner Auction House*) Below: Early 19th-century New England paint-decorated chest of four drawers. (*Private collection*)

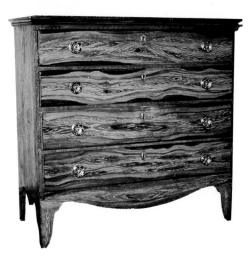

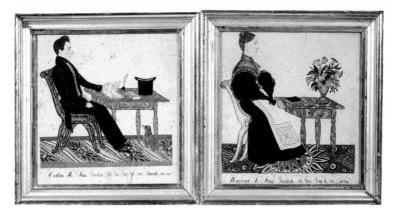

Above: Two early 19th-century New England (probably New Hampshire) watercolor portraits on paper, depicting Cotton & Harriet Foss by Joseph H. Davis (*Photo courtesy of Robert Skinner Auction House*) Below: Late 18th-century Philadelphia, Pennsylvania, silk thread on silk ground memorial needlework picture, having watercolor detailing. (*Photo courtesy of Marguerite Riordan*)

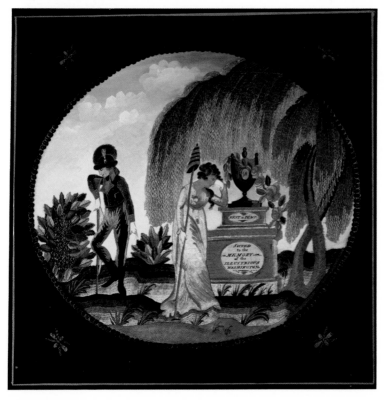

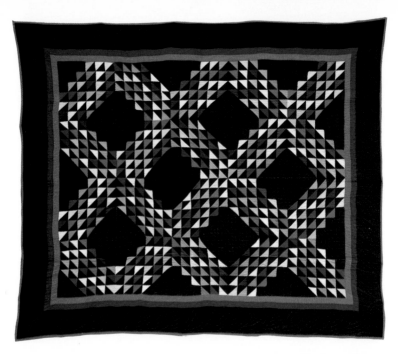

Above: Mid-20th-century Holmes County, Ohio, Amish quilt in Ocean Waves pattern. (*Photo courtesy of America Hurrah, New York*) Below Left: Group of mid-19th-century New England stoneware pottery including crocks and jugs with cobalt decoration, together with a batter jug. (*Photo by Diana and Gary Stradling; private collection*) Below Right: Group of early 19th-century New England redware pottery including crocks, some with manganese splotches, a pitcher, and a bowl. (*Photo by Diana and Gary Stradling; private collection*)

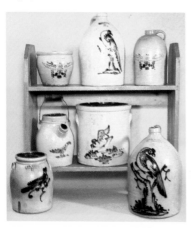
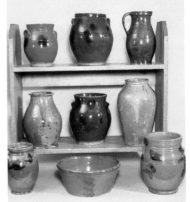

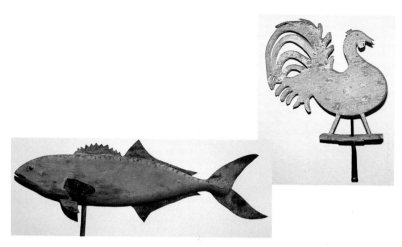

Above Left: Turn-of-the-20th-century Massachusetts wood and copper fish weather vane, 20½″ length. (*From the collection of William C. Ketchum, Jr.*) Above Right: Early 19th-century New England wooden rooster weather vane. (*Private collection*) Below: Applique album quilt from Baltimore, Maryland, c. 1860. (*Photo courtesy of Thomas K. Woodard American Antiques and Quilts*)

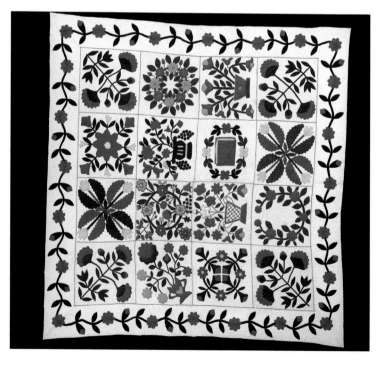

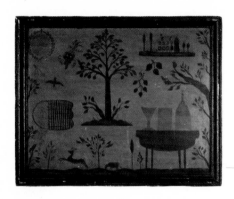

Above Left: Early 19th-century New England painting on wooden panel. (*Photo courtesy of Robert Skinner Auction House*) Above Right: "Diana Cow," contemporary American painting executed in house paint on board by Mose Tolliver, 40″ × 18″. (*Photo courtesy of Epstein Powell*) Below Left: Late 19th-century New England wool, hooked rug with floral design, 24″ × 41″. (*Photo courtesy of Anne Murray*) Below Right: Late 19th-century Maine wool, hooked rug in Log Cabin pattern, 30″ × 46″. (*Photo courtesy of Shoot the Chute*)

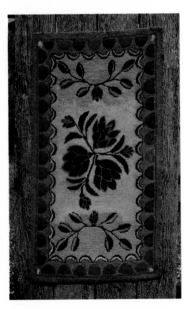

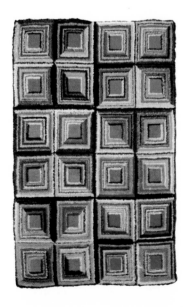

Williams, Micah: attribution, pair: "Woman with Book" and "Man in Black Jacket," pastel, 1815–1830, framed, good condition, relined, inpainting. 24″ × 19″ each

Skinner 1/86 **$3,000**

Williams, Micah: attribution, "Young Man," 19th century, pastel on paper. 13″ × 10¼″

Christie's 1/86 **$650**

Williams, Micah: attribution, pair of portraits, pastel, c. 1830, minor paper damage. 23″ × 19″

Sotheby's 1/87 **$3,000**

MINIATURES

Ellsworth, James, "Edmund Davison," watercolor on paper, Windsor, Connecticut, c. 1802, illustrated. 3¼″ × 2¾″

Sotheby's 1/87 **$1,600**

Ellsworth, James S.: attribution, "Edmund Davison," mid-19th century, miniature watercolor, Empire mahogany frame, illustrated. 3¼″ × 2¾″

Skinner 5/85 **$1,600**

Ellsworth, James S.: attribution, "Seated Young Man," mid-19th century, miniature watercolor, Empire mahogany frame, illustrated. 3¼″ × 2¾″

Skinner 5/85 **$1,400**

Stock, Joseph Whiting, "Child in Blue Dress," watercolor on ivory, Massachusetts, c. 1870. 3½″ × 2½″

Sotheby's 1/86 **$1,700**

ANIMALS

Bispham, Henry Collins, "Horse," dated 1874, oil on canvas, framed. 18″ × 24″

Skinner 3/85 **$800**

Lee, Violet, "Pooperdink," reclining white cat, 1884, oil on canvas, white painted frame. 10″ × 18″

Skinner 5/85 **$750**

Lee, Violet, "Pooperdink," reclining white cat, 1884, oil on canvas, white painted frame. 10″ × 18″

Skinner 11/86 **$2,500**

Neistly (?), David, "Yellow Bird with Flower," dated 1838, watercolor on paper, framed. 5½″ × 5″

Christie's 5/85 **$240**

Unknown Artists

"Black Gentleman and Wife," mid-19th century, watercolor on paper. 11 1/4″ × 8 1/4″

Christie's 1/86 **$3,800**

"Black Man," mid-19th century, oil on canvas, sketch on reverse, unframed, flaking, crackling, paint loss. 25″ × 25″

Skinner 1/85 **$450**

"Brother and Sister," c. 1845, oil on canvas, gilded period frame, provenance. 27″ × 34″

Sotheby's 1/84 **$9,000**

"Child," c. 1843, watercolor on paper, original frame and glass, exhibited, provenance. 6 1/2″ × 5″

Sotheby's 1/84 **$6,250**

"Child in Blue Dress" and **"Child in White Dress,"** 19th century, pastels. 27″ × 20 1/2″ each.

Sotheby's 1/84 **$4,500**

"Child with Cat," oil on canvas, 19th century, very good condition, similar pieces known. 23″ × 24″

Phillips 4/85 **$1,900**

"Child with Rabbit," c. 1840, watercolor on paper. 9″ × 7″

Sotheby's 1/84 **$550**

"Curly Haired Boy in Chair," 19th century, pastel on paper, provenance, published, similar pieces known. 26″ × 22″

Christie's 1/87 **$5,000**

"Elegant Lady," pastel, 19th century. 13″ × 10″

Phillips 4/85 **$90**

"Gentleman," c. 1840, oil on canvas, illustrated, flaking, crackling. 30″ × 25″

Skinner 1/85 **$275**

"Gentleman in Blue Coat Seated on Stencilled Chair," possibly Fayette City, Pennsylvania, c. 1827, inscription about sitter, similar piece known. 6″ × 5 1/2″

Sotheby's 10/86 **$3,750**

"Gentleman Seated at Desk," 19th century, oil on canvas, new frame, restoration. 32″ × 25 1/2″

Sotheby's 6/86 **$1,600**

"George Washington," late 19th century, oil on canvas, gilt frame, poor condition, provenance, repairs, copy of Gilbert Stuart likeness. 31 1/2″ × 37 1/2″

Garth 2/86 **$25**

"Grandmother in Rocker," 19th century, oil on canvas, provenance, original frame. 26″ × 20″

> *Christie's 1/87* **$8,550**

"Independent Gold Hunter on Way to California," c. 1849, watercolor, stencil, pencil on paper, design unusual.

> *Sotheby's 10/86* **$1,900**

"Jenkins Children," oil on canvas, fine, unusual design. 31½″ × 23¼″

> *Phillips 10/85* **$700**

"Joseph and Edwin with Pets," c. 1840, oil on canvas, inscribed, restored. 46¾″ × 43¾″

> *Christie's 10/86* **$20,000**

"Lady," 19th century, oil on canvas mounted on panel. 27″ × 23″

> *Weschler 6/86* **$550**

"Lady in Brown Dress," 19th century, oil on canvas. 33″ × 26″

> *Sotheby's 6/86* **$1,500**

"Lady with Seven Hair Combs," c. 1830, watercolor on paper, carved ornate frame. 3½″ × 2⅝″

> *Sotheby's 10/86* **$1,600**

"Lady with Tortoise Shell Combs," 19th century, watercolor, pencil on paper. 5″ × 4″

> *Christie's 1/87* **$950**

"Lady Wearing Jet Jewelry," c. 1815, oil on canvas, provenance, original frame, similar pieces known. 24″ × 19⅝″

> *Christie's 1/87* **$47,000**

"Little Girl," crayon on paper, 19th century. 24″ × 18½″

> *Phillips 4/85* **$90**

"Little Girl in Red Dress Holding a Spoon," oil on canvas, original gilt walnut frame, c. 1840–1845, exhibited, provenance. 42″ × 30″

> *Sotheby's 1/84* **$5,000**

"Mary Cooley," New Hampshire, 19th century, oil on panel, documentation, inscription on paper label has name, date (1825), and location.

> *Sotheby's 10/86* **$8,000**

"Matron," c. 1830, profile oil on tin, flaking, scratches. 9″ × 6″

> *Skinner 1/85* **$275**

"Miss Willet," probably South River, New Jersey, mid-19th century, oil on canvas, flaking, crackling. 27″ × 22″

> *Skinner 1/85* **$1,000**

"Mother with Baby Holding a Red Rose," Connecticut, c. 1860, oil on bed ticking. 36 1/8″ × 32 1/4″

Sotheby's 10/86 **$9,000**

"Mother Farber and Four Children," watercolor, pencil, charcoal, chalk on paper, found in Ohio, c. 1850, paper mark. 18 3/4″ × 25 1/4″

Sotheby's 6/87 **$7,450**

"Mr. Daniel Lambert," Connecticut, early 19th century, ink and wash on paper. 8 1/4″ × 6 1/4″

Christie's 5/85 **$200**

"Mrs. Boyd," Harrisburg, Pennsylvania, c. 1800, oil on wood panel.

Sotheby's 1/87 **$47,500**

"Mrs. Brown," oil on canvas, Rev. David Bulle, Midwest, dated 1845, exceptional craftsmanship. 32″ × 26″

Phillips 5/87 **$650**

Pair: "Gentleman" and "Lady," both oil on canvas, 19th century, very fine craftsmanship. 28″ × 23 3/4″

Phillips 5/87 **$1,000**

"Portrait of George Washington," after Gilbert Stuart, 19th century. 34″ × 27″

Weschler 5/86 **$950**

Primitive portrait of George Washington family, oil on canvas, repaired, crazing, flaking, walnut shadowbox frame, gilded liner. 33″ × 46 1/2″

Garth 7/86 **$200**

"The Reading Artist," Esther Bast in yellow painted rocker, 1844, watercolor, pen and ink on paper, provenance. 11″ × 8″

Sotheby's 1/87 **$3,500**

"Sarah and Peabody Webster Kimbell," Haverhill, New Hampshire, 19th century, oil on canvas, publicity. 36″ × 29″

Christie's 5/87 **$20,000**

"Sea Captain," early 19th century, oil on canvas, puncture, wear, paint loss patched, inpainting, unframed. 27″ × 22″

Skinner 1/85 **$950**

"Stedman and Betsey Williams," oil on canvas, Roxbury, Massachusetts, c. 1820, provenance, original frame, cracked, flaking. 28 3/4″ × 23 1/4″

Sotheby's 1/87 **$2,500**

"Three Children," possibly Albany, New York, 19th century, oil on canvas, some inpainting, relined. 36″ × 29″

Skinner 5/86 **$4,250**

"Three Girls," 1750–1800, oil on canvas. 25″ × 30″

Christie's 10/87 **$6,000**

"Two Boys," late 18th century, oil on canvas. 25″ × 30″

Christie's 10/87 **$6,000**

"Two Young Ladies with Child and Kitten," watercolor on paper, probably Midwest, c. 1820. 23″ × 30″

Sotheby's 6/87 **$4,000**

"Vinor Leay Craft," early 19th century, oil on canvas, documentation. 26¼″ × 23½″

Sotheby's 10/86 **$2,000**

"Woman," possibly Mahitable Nickerson, Chatham, Massachusetts, 1800–1850, oil on canvas. 32¼″ × 26¼″

Christie's 1/84 **$2,400**

"Woman," c. 1830, watercolor. 3¾″ × 2½″

Skinner 1/85 **$100**

"Woman Holding Flag in Landscape," c. 1800, polychrome, silk, foxing.

Christie's 1/84 **$2,400**

"Young Boy in Diamond-Patterned Vest," 19th century, oil on canvas, original frame and stretchers. 30½″ × 25½″

Sotheby's 10/86 **$20,900**

"Young Boy in Green Costume," 19th century, oil on canvas, similar piece in museum.

Sotheby's 6/86 **$2,200**

"Young Girl with Doll," 19th century, oil on board. 19½″ × 15½″

Sotheby's 1/84 **$1,500**

"Young Girl Reading," mid-19th century, oil on canvas. 34″ × 27″

Christie's 5/87 **$6,000**

"Young Girl with Strawberries," similar to A. Ellis, c. 1830, oil on wood panel, similar known. 27″ × 20″

Sotheby's 1/87 **$20,000**

"Young Lady with a Lace Collar," 19th century, oil on canvas. 29¾″ × 24½″

Sotheby's 1/84 **$1,300**

"Young Lady in Red Chair," oil on canvas, 19th century, original gilt wood frame, illustrated. 37″ × 29″

Sotheby's 6/87 **$1,400**

"Young Man," early 19th century, oil on tin, framed. 9¾″ × 7¾″

Christie's 5/85 **$400**

"Young Mother and Child," c. 1820, oil, gilding, gesso on wood panel, possibly "Clockface" artist, publicity. 7½″ × 9″

Sotheby's 10/86 **$4,500**

"Child in Tulip Dress," 19th century, oil on canvas on panel. 40″ × 23″

Sotheby's 1/84 **$6,000**

"Girl with Parakeet and Brother in Black Coat," c. 1830, oil on canvas. 30″ × 24″

Sotheby's 1/87 **$9,500**

"Two Brothers," 1830, oil on poplar panel, original frame, paint loss. 24″ × 19″

Skinner 3/85 **$26,000**

"Child," early 19th century, half-length portrait of young girl, oil on canvas, tear, patched, paint loss, unframed, unstretched. 15″ × 14″

Skinner 5/85 **$1,200**

"Boy with Grapes," early 19th century, oil on panel, unframed, illustrated. 27″ × 23″

Skinner 11/85 **$1,000**

"Flight into Egypt," New Hope, Rhode Island, 1870, watercolor. 8″ × 10″

Skinner 7/86 **$225**

Pair: "Captain" and "Mrs. Trull," Tewksbury, Massachusetts, early 19th century, oil on panel, period frames, illustrated. 34″ × 28″

Skinner 7/86 **$3,500**

Pair: "Lady in Profile" and "Gentleman in Profile," c. 1834, pencil and chalk, subjects known. 12″ × 7″ each

Skinner 7/86 **$400**

"Officer in Landscape," mid-19th century, watercolor on paper, torn. 6″ × 8″

Skinner 7/86 **$400**

Pair: "Lady" and "Man," oil on canvas, good condition, illustrated, framed, cleaned. 30″ × 25″ each

Skinner 11/86 **$850**

"Woman with Bonnet," 19th century, oil on canvas, relined, inpainting. 34″ × 26″

Skinner 11/86 **$950**

"Young Lady," silhouette, Pennsylvania, c. 1815. 23″ × 19″

Sotheby's 1/87 **$2,000**

"Curly Haired Boy," c. 1820, pastel on paper. 26″ × 22″

Sotheby's 1/87 **$5,500**

"Capt. Thompson," c. 1820, oil on canvas. 29″ × 23″

Sotheby's 1/87 **$6,250**

"Lady with Jet Jewelry," 19th century, oil on canvas, similar in museums. 24″ × 20″

Sotheby's 1/87 **$47,000**

"Black Man with Cane," initialed: "L.F.," oil on board, framed, good condition. 6″ × 9″

Skinner 6/87 **$700**

"Boston Harbor" Shadowbox, c. 1840, paper line frame, illustrated. 12″ × 14″

Sotheby's 6/87 **$1,000**

"Silhouette of Young Man," watercolor on paper, period frame, illustrated. 5″ × 5½″

Skinner 8/87 **$350**

"Captain in the Militia," oil on canvas, provenance, illustrated, unframed, relined, minor inpainting. 29″ × 23″

Skinner 8/87 **$5,500**

"Gentleman," possible Baltimore, Maryland, early 19th century, oil on canvas, original condition, minor paint loss, canvas maker's stamp on back. 30″ × 25″

Skinner 5/85 **$5,200**

"Jeremiah Wood," New York, 1815, oil on panel. 11″ × 9″

Skinner 1/87 **$3,000**

"Two Girls," c. 1850, oil on canvas, framed, minor paint loss. 36″ × 27″

Skinner 1/86 **$4,750**

"Bust of Young Man," c. 1840, oil on canvas, relined, inpainting. Oval: 20″ × 16″

Skinner 6/86 **$450**

"Sarah Ann Reeve Waterhouse," Brooklyn, New York, oil on canvas, c. 1830.

Skinner 1/86 **$7,800**

"Lucy Bentley Wheeler," Stonington, Connecticut, oil on canvas mounted on masonite, c. 1835, provenance. 54″ × 28″

Skinner 1/86 **$65,000**

Pair: "Gentleman" and "Lady," c. 1845, oil on canvas, original stretchers, frames. 28″ × 23″

Sotheby's 1/87 **$2,500**

"Boy in Blue Suit and Girl in Blue Dress," c. 1840, oil on canvas. 23″ × 28″

Sotheby's 1/87 **$45,000**

"Little Boy," c. 1830, oil on canvas, original yellow, black frame. 16″ × 12″

Sotheby's 1/87 **$15,000**

"**Lady and Gentleman Holding Books,**" half-length, 19th century, oil on canvas, unframed, restored. 27″ × 34″
Skinner 6/86 **$1,000**

MINIATURES

Three Revolutionary War Silhouettes, Millette, New England, 1775–1778, watercolor profiles. H 5″
Skinner 1/85 **$475**
"**Death of General Wolf,**" oil on tin, early 19th century, flaking, illegible signature, oval. 3½″ × 5¼″
Skinner 5/85 **$425**
"**George Washington,**" from a Gilbert Stuart portrait, watercolor (?) on ivory, early 19th century. 5″ × 5¾″ with frame
Skinner 11/85 **$300**
"**Gentleman,**" watercolor (?) on ivory, c. 1815. 3″ × 2⅜″
Skinner 7/86 **$225**
"**Lady in White Cap,**" watercolor on ivory, 19th century, excellent condition, leather case. 2¼″ × 2¾″
Skinner 8/87 **$100**
"**Woman,**" c. 1830, oval ivory locket, initials. 2¼″ × 1⅞″
Skinner 1/85 **$125**

ANIMALS

"**Cat's Head,**" late 19th century, white cat, oil on canvas. 9½″ × 8″
Skinner 1/85 **$5,000**
Portrait of Dog "Nester," c. 1880, oil on canvas. 30″ × 36″
Sotheby's 6/86 **$3,250**
"**Smutt the Cat,**" c. 1870, oil on cardboard, published. 20⅝″ × 16¼″
Skinner 6/86 **$50,000**
"**Spaniel with Collar,**" early 19th century, oil on canvas, wooden frame. 8½″ × 9½″
Skinner 6/86 **$300**
"**St. Bernard in Dog House,**" 19th century, oil on canvas, framed, relined, retouched. 18″ × 14″
Skinner 8/87 **$550**
"**Two Birds,**" 19th century, watercolor on paper. 13¼″ × 17½″
Sotheby's 1/84 **$425**

Genre

Genre and anecdotal painting roughly paralleled the emerging Hudson River landscape school of painting which flourished in America during the middle of the nineteenth century. Hundreds of untrained artists celebrated scenes from everyday life. Though some paintings are mildly didactic, genre painters do not intend serious social reform, but serve to record their surroundings.

"All We Ask is a Fair Trial," early 20th century, oil on canvas, good design, documentation, publicity—executed at the time of Sacco-Vanzetti trial. 36 1/4 " × 46 "
Sotheby's 10/86 **$12,500**

"Black Couple with Sunflower," oil on canvas, some wear, damage, canvas loose, faded signature. 19 " × 24 "
Garth 5/86 **$275**

"Girl in Blue Walking Dog," watercolor, pencil, paper, 20th century, good color. 7 1/2 " × 9 1/4 "
Garth 5/86 **$35**

Swans, cottage, two people, indistinguishable signature, good condition, old gilt frame. 28 1/2 " × 38 1/4 "
Garth 7/86 **$140**

Landscapes/House Portraits

Paintings of town views reached a height of popularity between 1840 and 1880. Folk artists satisfied their clientele by their attention to detail and alteration of perspective to include many vantage points from a single view. It was also common as one became more affluent to commission a painting of one's home, sometimes including even the outbuildings.

Known Artists

Bodin, V., "Victorian House," watercolor on paper, matted and framed under glass, late 19th century, dated 1888. 6 " × 6 3/4 "
Skinner 6/86 **$125**

Brader, F.A., house portrait: "Residence of Frank Schutz," Stark County, Ohio, 19th century, pencil on paper. 31 " × 45 "
Christie's 10/85 **$5,500**

Early 19th-century New England watercolor on paper, depicting the genre scene of a blacksmith's shop, 10″ height × 18″ width. (*Private collection*)

Early 19th-century American oil painting on canvas, depicting the landscape and genre scene of Garfield Park in Chicago, 28″ height × 34″ width. (*Photo courtesy of Barbara and Frank Pollack*)

Brader, F., "Ohio Farmstead," pencil on paper, Ohio, signed. 31″ × 50½″

Sotheby's 6/87 **$4,250**

Mid-19th-century American reverse painting on glass, with painted detailing executed under the glass and depicting a house in original molded gilt frame, found in New York State, 23″ height × 31″ width. *(Private collection)*

Brader, F. A., "Property of Andrew and Angeline Grim," pencil, crayon, and paper, Stark County, Ohio, 1893, signed, dated. 32″ × 42″

Sotheby's 6/87 **$7,250**

Bradford, William: attribution, "Arctic Scene," oil on canvas on panel, 19th century, gilded frame, museum deaccession, crackling. 18¼″ × 30″

Skinner 5/85 **$1,200**

Caswell, H., Winter scene: "A Brush on the Snow," pencil on paper, signed.

Sotheby's 6/87 **$800**

Chambers, Thomas, "View of Hudson River," oil on canvas, 19th century. 14″ × 14″

Sotheby's 1/87 **$9,000**

Chambers, Thomas, "View of Nahant," Massachusetts, c. 1845, oil on canvas, provenance, original frame. 25½″ × 34″

Christie's 1/87 **$80,000**

Chambers, Thomas, "View of West Point," oil on canvas, 19th century. 21 1/4″ × 29″

Sotheby's 1/87 **$40,000**

Chambers, Thomas: attribution, "View of Natural Bridge," Virginia, 19th century, oil on canvas, ripped. 18″ × 14″

Christie's 10/87 **$1,500**

Davis, A. J.: attribution, "House Portrait," watercolor, gilt frame, New York, c. 1840. 8″ × 11″

Skinner 11/86 **$550**

Davis, Mary DeForest: attribution, "Landscape," oil on canvas, Castleton, Vermont, 1870, gilded, gessoed frame, signed, dated before rebacking, relined, minor crackling, inpainting, oval. 24″ × 30″

Skinner 6/86 **$1,600**

Fletcher, C., "Niagra Falls," charcoal on sandpaper, Rockport, 1853, dated, signed, framed, documentation. 21″ × 29″

Sotheby's 1/87 **$750**

Furman, John, "Fulton County Poorhouse," watercolor, pen, ink on paper, 1862.

Sotheby's 1/87 **$5,500**

Hawkins, J., "Landscape," watercolor, good detail, 1914, matted, framed. 19 3/4″ × 23 1/2″

Garth 7/86 **$55**

Hofmann, Charles, "Berks County Almshouse," oil on zinc, Pennsylvania, c. 1875. 32″ × 39″

Sotheby's 6/87 **$101,000**

Keys, Mary: attribution, "Lockport on the Erie Canal, NY," New York, c. 1832, watercolor, pen, ink on paper, published. 14 1/4″ × 17 3/4″

Sotheby's 1/86 **$6,750**

Nutter: attribution, "Whittier Homestead," c. 1875, oil on canvas. 8 1/2″ × 11 1/2″

Skinner 1/85 **$325**

Plavean, Joseph M., "Sail boats," 20th century, signed. 18 1/2″ × 22 1/2″

Garth 7/86 **$60**

Prentice, Levi Wells, "River Valley Landscape," 1872, oil on canvas. 43″ × 73″

Sotheby's 1/87 **$9,250**

Pryor, William Matthew, "Landscape with Fisherman," oil on canvas, signed. 23″ × 27″

Weschler 9/86 **$1,300**

Ramussen, John, "Berks County Almshouse," oil on zinc, c. 1880. 32″ × 39″

<div align="right">

Sotheby's 1/87 **$47,500**
</div>

Rowell, ?, "Cohasset Common," oil on canvas, framed, Massachusetts, 19th century, signed, crackling. 10″ × 13″

<div align="right">

Skinner 6/87 **$1,400**
</div>

Scheurmann, Samuel, "Townscape of Robbins Place," watercolor, possibly Lexington, Massachusetts, 1858, illustrated. 10″ × 12½″

<div align="right">

Skinner 11/86 **$2,300**
</div>

Sturtevant, J. B., "Residence of William Rowland," possibly Ohio, 1882, oil on slate, inscribed. 12″ × 17″

<div align="right">

Christie's 5/87 **$1,400**
</div>

Vogt, Fritz, "New York Farmhouse with Two Barns," graphite on paper, dated, 1898, signed. 18″ × 23½″

<div align="right">

Sotheby's 1/84 **$650**
</div>

Waters, Susan, "Cow in the Pasture," Bordentown, New Jersey, dated 1888, signed. 24¼″ × 36¼″

<div align="right">

Christie's 10/87 **$4,000**
</div>

Unknown Artists

Alpine village scene, oil on canvas, mounted on plywood, good color. 6½″ × 22½″

<div align="right">

Garth 2/86 **$25**
</div>

Buildings and trees, oil on cardboard, strip frame, deteriorated frame, provenance, primitive. 18½″ × 48½″

<div align="right">

Garth 2/86 **$25**
</div>

"Butler's Nationwide Store," late 19th century, watercolor on paper, framed. 7″ × 9½″

<div align="right">

Christie's 5/85 **$200**
</div>

"Country Home," oil on canvas, c. 1860, gilt frame. 10″ × 12″

<div align="right">

Skinner 5/85 **$600**
</div>

"Country Landscape," early 19th century, watercolor on paper, tears, water stains, foxing, creases. 10¼″ × 13¼″

<div align="right">

Skinner 6/86 **$400**
</div>

"Fairbanks House," Dedham, Massachusetts, 1860, oil on canvas, provenance, original frame. 22″ × 14½″

<div align="right">

Christie's 1/87 **$3,000**
</div>

Farm Landscape, oil on canvas, rebacked, crazing, old gilt frame worn. 17⅜″ × 21¼″

<div align="right">

Garth 5/86 **$150**
</div>

"Farmhouse," mid-19th century, oil on canvas, flaking, patched, inpainting. 22″ × 27″

Skinner 5/86 **$350**

"Harper's Ferry," charcoal, chalk on sandpaper, period gilt frame, West Virginia, c. 1840. 21″ × 27″

Sotheby's 1/87 **$3,000**

"Hudson River Landscape," oil on canvas, 19th century, gilt frame, relined, inpainting. 30″ × 46″

Skinner 5/85 **$700**

"Lady in a Landscape," watercolor on paper. Sandwich, Massachusetts, early 19th century, faded. 6½″ × 5″

Skinner 11/85 **$450**

Lagoon, oil on canvas, minor edge wear, original stretcher, unframed.

Garth 5/86 **$135**

"Landscape," c. 1844, oil on canvas. 26″ × 38″

Skinner 5/86 **$4,500**

"Landscape," 1820, watercolor. 11½″ × 16½″

Skinner 6/86 **$150**

"Landscape with Cattle," 19th century, charcoal and pastel on sandpaper, provenance. 20¼″ × 29¾″

Christie's 10/84 **$500**

"Landscape with Waterfall," 19th century, oil on canvas, relined, crackling. 24″ × 13″

Sotheby's 6/87 **$200**

"Mount Tom in Holyoke," Plainfield, Massachusetts, c. 1820, stippled watercolor, frame with label, illustrated, repaired. 9″ × 13½″

Skinner 6/87 **$1,900**

Mt. Vernon and Washington's tomb, pastel, primitive white chalk drawing on black paper, framed. 24″ × 30¾″

Garth 3/87 **$500**

"The Natural Bridge," Virginia, 19th century, oil on board, framed. 25¼″ × 29½″

Christie's 5/85 **$800**

"Neptune Fire Company Hose #2," oil on canvas, 19th century. 18″ × 25″

Sotheby's 1/87 **$4,100**

"New Bedford," New Bedford, Massachusetts, late 19th century. 9″ × 12″

Skinner 1/85 **$300**

"The Old Homestead," 19th century, oil on canvas on board, framed, relined, retouched. $7^{1}/_{4}'' \times 12^{1}/_{4}''$

Skinner 8/87 **$450**

"Papa's Ship," oil on paper, 1880. $12'' \times 14''$

Sotheby's 1/86 **$2,500**

Primitive landscape, oil on canvas, modern grained frame. $16'' \times 20''$

Garth 7/86 **$75**

"Residence of Franklin Brickett, Esq.," watercolor on paper, Haverhill, Massachusetts. $21'' \times 38''$

Sotheby's 1/86 **$4,000**

"River Landscape," 19th century, oil on canvas, gilded frame liner, crackling, separation. $11'' \times 15^{1}/_{2}''$

Skinner 6/86 **$50**

"River View," 19th century, oil on board, gilded frame, primitive. $12'' \times 9^{1}/_{4}''$

Skinner 6/86 **$325**

"Scenes of My Childhood," watercolor, white gouache on paper, framed under glass, 19th century, exhibition label on reverse, minor paint loss. $21'' \times 27''$

Skinner 6/86 **$1,000**

Still life with lake, mountain, good color, minor edge wear, canvas loose, unframed. $24'' \times 34''$

Garth 7/86 **$20**

Stone building and bell tower, possibly school boy, possibly Utica, New York, watercolor, unframed, provenance, similar known, primitive. $9^{1}/_{2}'' \times 12^{1}/_{4}''$

Garth 2/86 **$95**

"Summer Landscape," oil on canvas, 19th century, gilded frame liner, minor inpainting, repairs. $30'' \times 40''$

Skinner 6/86 **$1,000**

Sunset, oil on canvas, gilt frame, no provenance. $30^{1}/_{4}'' \times 44''$

Garth 2/86 **$180**

"Three Street Scenes," watercolor on paper, probably Rhode Island, 1867, illustrated, torn. $8^{1}/_{2}'' \times 12''$

Skinner 7/86 **$650**

"View of the Falls," possibly New York, oil on canvas. $24'' \times 36''$

Christie's 10/87 **$1,900**

"View of Great Barrington, Massachusetts," c. 1850–1855, oil on canvas, period gilded frame, exhibited, provenance. 37″ × 53″

> Sotheby's 1/84 **$50,000**

"View of New Bedford," 19th century, oil on canvas, framed, minor inpainting. 12″ × 18″

> Skinner 5/86 **$350**

"View of Pembroke, New Hampshire," watercolor on paper, c. 1835, framed under glass, tears, foxing. 8″ × 12″

> Sotheby's 6/86 **$425**

Seascapes and Ship Portraits

From the earliest days, America has had a romance with the sea. Seascapes and ship portraits were painted by professional and amateur painters alike. A distinctive, native American style of ship portraiture and marine paintings developed among anonymous painters and others like the Bard brothers, J. F. Huge, and Thomas Chambers. Marine artists worked in oil, pastel, watercolor, and sandpaper drawings.

Seascapes

KNOWN ARTISTS

Chambers, Thomas, shipwreck: "The Red Rover in Stormtossed Seas," Massachusetts, c. 1850, oil on canvas. 18″ × 24″

> Sotheby's 1/87 **$75,000**

Chambers, Thomas, "View of Nahant," Massachusetts, c. 1850, oil on canvas. 21″ × 29″

> Sotheby's 1/87 **$17,000**

Jacobsen, Antonio, "Taking on a Pilot," New York City, dated 1877, oil on canvas, good condition, cleaned, frame, provenance, signed, repaired. 14 1/8″ × 22″

> Bourne 2/87 **$26,500**

Willis, T., collage, 19th century, racing yachts, oil, silk fabric, and thread on canvas ground. 17″ × 24″

> Sotheby's 1/87 **$2,600**

Willis, T., marine picture: "Submarine Attacking German U-Boat," American, 20th century, oil, silk on canvas, good condition, frame, signed. 16″ × 26″

> Bourne 2/87 **$400**

New York, 1873, oil painting on canvas of ship *Sylvan Dell*, attributed to James Bard, 30″ height × 50″ width. (*Photo courtesy of Smith Gallery*)

UNKNOWN ARTISTS

Clipper ship: "Sailing Out at Full Speed," oil on canvas, 19th century, good condition, unusual design. 20 1/2″ × 25 3/4″

Phillips 4/85 **$950**

"Steamship Anglers," dated 1876, oil on canvas, good condition, period frame. 33″ × 38″

Oliver 7/87 **$250**

Whaling scene, late 19th century, oil on relief-carved board, framed. 16 1/2″ × 27″

Skinner 3/85 **$400**

Whaling scene, New Bedford, Massachusetts, c. mid-19th century, watercolor on paper, made for William F. Nye Oil Co., Inc., inscription "NYE" on flag, good condition, frame, inscription. 15 1/2″ × 10 5/8″

Bourne 8/86 **$1,500**

Whaling scene, panorama of three whaling ships and polar bears, New Bedford, Massachusetts, c. mid-19th century, oil on canvas, good condition, rarity, restored, relined, modern frame. 23″ × 33¼″

Bourne 8/86 **$6,000**

Ship Portraits

KNOWN ARTISTS

Baas, F., sailing ship, signed "F. Baas, 1906," American, water-color, framed, dated, signed. 10″ × 12¼″

Garth 2/86 **$25**

Eaton, W. B., yacht: "Annie," Salem, Massachusetts, 1882, oil on canvas, good condition, signed, dated, restored. 22″ × 27″

Skinner 6/87 **$3,600**

Golding, William, "Ship America of Bath, Maine," Bath, Maine, dated 1935, pencil, crayon on paper, provenance. 9″ × 11½″

Sotheby's 1/84 **$900**

Jacobsen, Antonio, " 'Governor Robie' Passing a Headland," New York City, 1913, oil on canvas, good condition, signed, dated, provenance. 28″ × 44″

Bourne 2/87 **$8,500**

Jacobsen, Antonio: attribution, "Davy Crockett," New York City, oil on artist's board, condition, provenance. 17″ × 26″

Bourne 2/87 **$11,500**

Nelson, Jim, "Ship Paul Revere Boston," American, 1930, oil on canvas, good condition, signed, dated, titled, unframed.

Bourne 2/87 **$225**

Nemethy, Georgina, ship portrait: "Americus," 20th century, oil on wood panel, signed. 12″ × 24″

Weschler 9/86 **$800**

Williams, J. W., "The Ship Providence," mid-19th century, oil on canvas, original stretcher. 24¼″ × 29″

Sotheby's 1/86 **$4,000**

UNKNOWN ARTISTS

"Brig. L. Staples of Stockton, Captain Harriman," New England, oil on canvas, good condition, frame, titled. 24″ × 29″

Bourne 2/87 **$1,750**

"Isaac Clark Master," 19th century, watercolor, gouache on paper, documentation, provenance.

Sotheby's 10/86 **$3,850**

Portrait of the River Steamer "Albertina," c. after J. Bard, oil on canvas, period gilt frame, poor condition, holes.

Bourne 2/87 **$800**

Ship portrait, signed: Phillips (?), 19th century, charcoal on sandpaper, very good. 8½″ × 10½″

Skinner 8/87 **$150**

"Ship Stonington of New London on Coast of Japan," watercolor on paper, c. 1830, provenance, framed. 16″ × 18½″

Sotheby's 1/87 **$1,300**

Still Lifes

The still life rendering usually depicts flowers, fruits, vegetables, and foliage in bowls or within the home environment. They are usually done in freehand style. One particular mode of the still life is tinsel pictures, a 19th-century parlor art form. They were pictures painted on glass and backed by crinkled tinfoil. Tinsel pictures were sometimes called crystal painting or Oriental painting and frequently depicted still life paintings (see Theorems, following Still Lifes).

Known Artists

Chamberlain, Esther, "Strawberries in Bowl," watercolor on paper, early 19th century, foxing. 8″ × 6½″

Skinner 11/86 **$650**

Church, Henry, "Still Life," oil on paper on aluminum, Ohio, 19th century. 22½″ × 34¼″

Sotheby's 1/86 **$30,000**

Crook, A. L., "Basket of Peaches," oil on canvas, dated 1888, framed, minor paint loss, hole. 17½″ × 24″

Skinner 6/87 **$1,000**

Meyers, ?, "Tabletop Still Life," oil on panel, dated 1915, framed, good condition. 15¾″ × 20″

Skinner 1/87 **$475**

Ream, Carducius Plantagenet, "Still Life with Fruit," oil on artist board, late 19th century, framed, inpainting. 16″ × 13″

Skinner 1/86 **$325**

Unknown Artists

"Apples in Compote," watercolor, 19th century, Empire frame. 7½″ × 7¼″

Skinner 5/85 **$125**

"Basket of Flowers," watercolor on paper, New England, c. 1830. 10″ × 20″

Sotheby's 1/86 **$1,600**

"Flowers, Fruit in Footed Compote," oil on canvas, New Hampshire, c. 1840. 34″ × 47½″

Sotheby's 1/84 **$3,750**

Fruit, basket, jar, oil on academy board, some damage, indistinguishable signature, gilt frame. 16¾″ × 30½″

Garth 5/86 **$265**

"Fruit and Cheese," oil on canvas, 19th century, excellent condition, illustrated. 18″ × 24″

Skinner 11/86 **$2,800**

"Fruit Compote," oil on canvas, 19th century, framed, good condition, two small holes. 16½″ × 18½″

Skinner 11/86 **$750**

Fruit and flowers, oil on canvas, 1850–1900. 10″ × 14″

Skinner 1/85 **$500**

Pair: each "Compote of Fruit," pastel on paper, 19th century. 24″ × 20″

Sotheby's 1/87 **$6,000**

Pair: each "Fruit and Grape Leaves," pastel on board, one dated 1863. 12½″ × 16″

Sotheby's 1/87 **$2,100**

"Pears, Peaches, and Biscuits," oil on canvas, 1850–1900. 20″ × 27½″

Sotheby's 1/86 **$1,900**

"Still Life with Apples," oil on artist board, mid-19th century, areas of separation. 16″ × 20″

Skinner 3/85 **$700**

"Still Life with Fruit," oil on artist board, gilded frame, improperly varnished. 12″ × 18″

Skinner 1/86 **$450**

"Still Life with Watermelon," oil on canvas, late 19th century, unframed. 16″ × 44″

Skinner 3/85 **$800**

Stylized flowers, watercolor, fading, paper stains, framed. 7¼″ × 9¼″

Garth 5/86 **$65**

Early 19th-century New England theorem oil painting on velvet, depicting a basket of fruit, 24″ height × 26″ width. (*Private collection*)

Stylized flowers, pencil, watercolor drawing on lined paper, blue, brown, green, framed. 7″ × 9½″

Garth 5/86 **$120**

Tulips, Strawberries in Bowl," pastel on paper, 19th century, framed under glass, good condition. 9¼″ × 11½″

Skinner 11/86 **$850**

Theorems

A popular schoolgirl art form, as well as a creative outlet for adult women, was executed by using theorems, stencils arranged in pleasing designs and then painted. Frequent subjects for theorem paintings were still-life arrangements of fruit, flowers, and vegetables. Although tracing was a basis for the individual forms, the results were often not mechanical, as the artist demonstrated a fine sense of color, design, and handling of the medium on paper, silk, satin, and velvet (see Still Lifes, preceding).

Basket of Fruit, polychrome, paint on silk, inscribed "S.K.," early 19th century. 8½″ × 11½″

Christie's 1/84 **$475**

Basket of fruit, watercolor on velvet, c. 1840.

Sotheby's 1/84 **$700**

Basket of fruit, watercolor on paper, 1825, published, minor discoloration. 17³/₄″ × 22¹/₂″

Sotheby's 1/84 **$3,750**

Basket of fruit, stencilled on velvet, signed "Mathilde," Brunswick, Maine, 1970. 18″ × 24″

Skinner 5/85 **$150**

Basket of fruit, watercolor on velvet, signed "Mary Badger," c. 1830, geneological information on reverse, modern frame. 7″ × 8¹/₂″

Skinner 5/85 **$300**

Bird and butterfly with basket of fruit, polychrome, early 19th century, similar pieces known, framed, discolored. 15″ × 18″

Christie's 1/84 **$1,600**

Black compote with fruit, watercolor on paper, Mary C. Stomp, 1820, Dated, signed, inscribed. 8³/₄″ × 9″

Christie's 1/87 **$3,500**

Blue compote with fruit, c. 1835, watercolor on velvet. 16¹/₄″ × 18″

Sotheby's 1/86 **$2,100**

Compote and basket of fruit, oil on canvas, gilt frame, signed "B. Stauk," 1890, dated, damage, no provenance. 23³/₄″ × 28″

Garth 2/86 **$150**

Compote of fruit, watercolor on paper, c. 1840, stains, repairs, cleaned. 18″ × 23¹/₂″

Skinner 11/86 **$750**

Compote of fruit, watercolor, Mary C. Stomp, 1820, framed 1830.

Sotheby's 1/87 **$3,750**

Compote of fruit, oil on linen, early 19th century, stains, fabric loss, unframed. 7¹/₂″ × 9¹/₂″

Skinner 8/87 **$275**

Compote of fruit, oil on linen, early 19th century, stains, tiny holes. 8³/₄″ × 13¹/₂″

Skinner 8/87 **$300**

Compote of fruit with vase of flowers, watercolor on paper, 19th century, stained, fading, creased, torn.

Skinner 5/86 **$500**

Floral bouquet, watercolor on paper, c. 1830, rosewood frame, minor staining, crease in paper. 17¹/₂″ × 13″

Skinner 1/87 **$600**

Flowers, watercolor on paper, framed under glass, double-sided, 19th century. 8″ × 10″

Skinner 11/86 **$175**

Flowers with hummingbird, tinsel, polychromed, framed, poor craftsmanship, flaking, no provenance. 13½″ × 17¼″

Garth 2/86 **$45**

Flowers in a stylized blue compote, colorful, on velvet, old gilt frame, stained. 15¼″ × 18½″

Garth 3/87 **$350**

Flowers in woven basket, watercolor, elements cut and pasted on white paper, framed, c. 1850, poor condition, some soiling, minor discoloration. 18½″ × 23″

Sotheby's 1/84 **$425**

Fruit, stencilled on velvet, c. 1840, some foxing. 5½″ × 7½″

Skinner 5/86 **$100**

Fruit in basket, oil on velvet, mid-19th century. 26″ × 24¾″

Christie's 5/87 **$2,000**

Fruit, berries, and melon, watercolor on velvet, 19th century. 23″ × 24″

Sotheby's 10/86 **$2,600**

Fruit in woven basket, watercolor, 19th century, poor condition, some abrasions. 10″ × 12½″

Sotheby's 1/84 **$700**

Fruit, yellow orange in woven basket, watercolor on velvet, c. 1840. 12⅛″ × 11¾″

Sotheby's 10/86 **$3,600**

Geometric star with verse, watercolor on paper, early 19th century, discolored. 12″ × 7½″

Skinner 7/86 **$200**

Landscape, paint on velvet, stencilled frame, c. 1840, illustrated. 22″ × 24″

Skinner 1/85 **$400**

Memorial picture, New York, 1800–1825, illustrated, stains. 16″ × 22″

Skinner 6/86 **$650**

Mourning picture, watercolor on velvet, provenance. 16″ × 20″

Sotheby's 1/87 **$5,250**

Pair: (A) Footed compote and blossoms. (B) Footed compote of fruits and vines, both watercolor on velvet, framed, c. 1840, poor condition, some discoloration, foxing. 12½″ × 17″ each

Sotheby's 1/84 **$1,100**

Roses, deep greens, blue, faded pink, watercolor on paper, old gilt frame, minor stains. 14 1/2 ″ × 15 1/2 ″

Garth 2/87 **$100**

"Ruth and Naomi," watercolor on velvet, early 19th century, original gold leaf frame. 21 1/2 ″ × 27 ″

Skinner 1/87 **$100**

Still life, watercolor on velvet, framed, c. 1840, poor condition, some discoloration, foxing. 12 1/2 ″ × 16 ″

Sotheby's 1/84 **$700**

Still life, watercolor on velvet, c. 1840, good design, some discoloration. 16 ″ × 19 1/2 ″

Sotheby's 1/84 **$1,600**

Still life, watercolor, 1825, dated, published. 17 3/4 ″ × 22 1/2 ″

Sotheby's 1/84 **$3,750**

Still life, stencilled on velvet, probably Keene, New Hampshire, 1830, illustrated. 14 ″ × 17 ″

Skinner 1/85 **$450**

Still life with watermelon, peaches, blue plums, and knife, watercolor.

Sotheby's 6/86 **$2,500**

Strawberries, colorful, red, green, black, on cotton feed sack, framed, labeled, stained. 12 1/4 ″ × 16 1/2 ″

Garth 3/87 **$700**

Two watermelon wedges with fruit, watercolor on velvet, 19th century. 16 1/2 ″ × 24 ″

Sotheby's 1/86 **$3,750**

Urn of flowers, c. 1830, eastern United States, framed, gilt liner, illustrated. 18 ″ × 24 ″

Skinner 6/86 **$2,600**

Watermelon and grapes, watercolor on velvet, c. 1840, discoloration. 16 ″ × 19 1/2 ″

Sotheby's 1/84 **$1,600**

Pie Safes

These popular pieces of kitchen furniture were used throughout
the country primarily during the middle and late nineteenth cen-
tury. As storage cabinets, their doors had decorated pierced tin
panels to provide air while also preventing insect contamination.
Some pie safes were hung from ceilings on pulleys; others sat on
the floor. Sometimes legs were tarred before being set into cans
of water to deter rodents from entering the cabinets. Frequently
the legs of surviving examples have been cut because they rotted
from the tarring process.

One-piece poplar, scalloped base, paneled doors, one dovetailed
drawer, punched tin panels with stylized yellow-tan foliage de-
signs, one-board ends damaged, refinished, replacements. 77³/₄″
× 37³/₄″ × 16″

Garth 2/86 **$425**

Poplar, simple cut-out paneled doors, screen panels in ends, cast
iron thumb latches, worn original yellow graining. 57″ × 50″ ×
16″

Garth 7/86 **$285**

Pottery

Redware

Redware pottery is made from a red or brown clay thrown on a
potter's wheel and fired at a low temperature. It was manufactured
in all areas into the nineteenth century. The clay occurs naturally
and requires simple kilns to make. Utilitarian shapes were limited
to basic functional forms such as plates, bowls, and jars. Variety
was most often evident in the slip or clay-trailed designs (usually
yellow) or in the brushed splotches of other colorants such as man-
ganese. Plates with names or unusual colors, such as green, are
rare and highly prized by collectors.

Bowl, molded edge, flared rim, narrow green band, white slip
over green, marked "I. Bell," probably Pennsylvania, early 19th
century, glaze imperfections. H 2½″

Skinner 5/85 **$550**

Mid-19th-century Pennsylvania redware pottery loaf dish, with yellow slip decoration in the form of squiggly lines, 15″ length. (*Photo courtesy of Muleskinner Antiques*)

Early 19th-century New England redware crock with manganese splotches, together with a two-gallon, mid-19th century New England stoneware crock, with cobalt decoration in animal form. (*Photo courtesy of Kathy Schoemer*)

Bowl, rolled rim, unusual pine tree slip, crude swag band on side, early 19th century, break, rough repair. H 3″

Skinner 5/85 **$125**

Bowl, blue and white spongeware, chipped, crazing. H 3⅝″ ×
Dia 8½″

<div align="right">

Garth 2/86 **$95**
</div>

Bowl, glazed, 1800–1850, publicity, rarity. Dia 5½″

<div align="right">

Sotheby's 10/86 **$495**
</div>

Covered jar, ovoid, molded handles, mottled green, orange lead
glaze, Gonic Pottery, New Hampshire, 19th century, chips, large
flake. H 11½″

<div align="right">

Skinner 8/87 **$600**
</div>

Dish, baking, buff tan glaze, fluted sides, chipped. H 5¼″ × Dia
13″

<div align="right">

Garth 2/86 **$40**
</div>

Dishes, two, dark chocolate brown glaze, one with clear glaze
and yellow slip bearing the name "Adam," poor craftsmanship,
chipped. Dia 7″ to 7⅜″

<div align="right">

Garth 2/86 **$45**
</div>

Double handles, brown-orange glaze, manganese splashes, Penn-
sylvania, 19th century. Dia 12″

<div align="right">

Skinner 1/85 **$375**
</div>

Four plates, crimped rims, squiggle, looped and other decoration,
19th century, chipped, flakes. Dia 10″

<div align="right">

Skinner 3/85 **$300**
</div>

Grain measures, set of five, old dark paint, some wear, edge
damage. Dia 6″ to 13¾″

<div align="right">

Garth 7/86 **$175**
</div>

Grotesque jug, green ash glaze, "Lanier Meaders," signed. H 9″

<div align="right">

Garth 7/86 **$170**
</div>

Jar, glazed, New England, c. 1825, publicity, small flaking. H 8″

<div align="right">

Sotheby's 10/86 **$500**
</div>

Jar, glazed, c. 1860, publicity, small chip.

<div align="right">

Sotheby's 10/86 **$900**
</div>

Jar, ovoid, lead glaze, manganese splotches, 19th century. H 6″

<div align="right">

Skinner 3/85 **$100**
</div>

Jar, ovoid, dark brown glaze, chipped, wear. H 12½″

<div align="right">

Garth 2/86 **$30**
</div>

Jar, ovoid, decorated brown streak on green over yellow ground,
glazed, flared rim with cover, probably New Bedford, Massachu-
setts, early 19th century, slight glaze flaking. 8½″

<div align="right">

Sotheby's 10/86 **$2,600**
</div>

Jar, ovoid, brown interior glaze, firing crack on bottom, won't
hold water. H 13½″

<div align="right">

Garth 2/87 **$20**
</div>

Jug, ovoid, black glaze, strap handle, wear, chipped. H 9³/₄″
Garth 2/87 **$50**

Jug, ovoid, small, strap handle, greenish-brown glaze, black flecks, minor edge chips. H 9″
Garth 2/87 **$65**

Jug, ovoid, orange splotches over olive green, Bonic, New-Hampshire, early 19th century, unusual form. H 9″
Skinner 8/87 **$550**

Jug, ovoid, rolled rim, applied handle, tan glaze, green sponge cracks, Bonic, New Hampshire, early 19th century, firing blister. H 7″
Skinner 1/86 **$130**

Milk pan, deep glaring sides, molded rim, brown glaze, early 19th century, chipped. H 3³/₄″ × Dia 16¹/₂″
Skinner 3/85 **$75**

Mold: food #4, Turk's head, scalloped swirl rim, damaged, wear. H 4″ × Dia 10″
Garth 2/86 **$30**

Pie plates, three, white with dark glaze, chipped, cracks. 6¹/₂″ × 17¹/₄″ × 9″
Garth 2/86 **$50**

Pie plates, three, coggled edges, one has some dots of yellow slip, damaged, wear. Dia 8″ and 9″
Garth 2/86 **$80**

Pitcher, incised, molded features, pig, floral decoration, yellow, ochre, green, and red, 19th century. H 10¹/₂″
Skinner 3/87 **$2,000**

Plate, slip glaze, Lafayette, wear. Dia 11″
Skinner 3/87 **$1,100**

Platter, oval, molded body, notched rim, brown glaze, yellow slip scrolls, early 19th century, minor chips. 11³/₄″ × 14″
Skinner 3/85 **$350**

Platter, squiggle decoration, crimped rim, 19th century, chips. L 17¹/₂″
Skinner 3/85 **$1,100**

Punch cooler, red iron oxide glaze, figural "Civil War Soldier," c. 1860, incised, rarity, lacks lid.
Sotheby's 10/86 **$11,000**

Rectangular loaf dish, molded, notched rim, brown glaze, yellow slip swirl decoration, early 19th century, some chips.
Skinner 3/85 **$1,300**

Rectangular platter, notched rim, orange, brown glaze with yellow, brown, green slip marbleizing, 19th century, New England, chips, wear. L 13 1/2 "

> *Skinner 8/87* **$2,600**

Rooster, glazed, Pennsylvania, late 19th century. H 14 1/2 "

> *Sotheby's 1/87* **$1,600**

St. Eulogias slipware charger, molded body, notched rim, brown glaze, name in yellow slip over a scroll, possibly Connecticut, early 19th century, repairs, rim chips. Dia 12 "

> *Skinner 11/85* **$125**

Spice shaker, pear-shaped, footed, mottled blue glaze, blue, tan bands, cat's eyes, early 19th century, chipped. H 4 1/2 "

> *Skinner 6/87* **$350**

Sugar, domed lid, flattened ball finial, marbleized white and black slip decoration on red ground, Pennsylvania, 1800–1850, oversized, rarity, lid and base cracked. H 12 "

> *Sotheby's 10/86* **$3,410**

Sugar bowl, snail-shaped, some damage. H 3 "

> *Garth 2/87* **$300**

Turk's head baking mold, beautifully scalloped, green glaze, small chips. Dia 10 3/4 "

> *Garth 2/87* **$100**

Turk's head baking mold, clear glaze, brown sponging, wear on edges. Dia 7 3/4 "

> *Garth 2/87* **$30**

Turk's head baking mold, small, well-scalloped, clear glaze, running brown edge glaze, chips. Dia 6 1/2 "

> *Garth 2/87* **$25**

Two circular dishes, crimped rims, loop and squiggle decoration, 19th century, chipped, flaked. Dia 12 1/4 " and 13 1/4 "

> *Skinner 3/85* **$350**

Two pieces: (A) Bowl, strap handle, embossed leaf design, glazed, chipped, wear. D 6 1/2 " (B) Pie plate, coggled edge, yellow slip. Dia 10 1/4 " Both chipped, show wear.

> *Garth 2/86* **$25**

Two pieces: (A) Ovoid jug with strap handle, greenish glaze. H 11 1/4 " (B) Preserving jar, clear greenish glaze, brown splotches. H 7 3/4 " Chips on both.

> *Garth 2/87* **$100**

Two pieces: (A) Rockingham bowl. H 8 1/2 " (B) Cuspidore with embossed bust of classical soldier, hairline cracks. H 4 " × Dia 6 3/4 "

> *Garth 2/86* **$45**

Yellowware

Crock, small, oval splotches of brown, embossed "Butter," small chips. H 4 1/4″ × Dia 5 7/8″

Garth 3/87 **$135**

Food mold, oval, ear of corn design, small edge chips. L 6″

Garth 2/87 **$35**

Mug with brown sponged Rockingham glaze, broken bubbles in glaze, minor chips. H 3 3/4″

Garth 2/87 **$45**

Pitcher, embossed ribs, rectangular smooth area, black transfer label, light sponging of green and brown. H 4 1/2″

Garth 3/87 **$45**

Set of four bowls, exterior embossed foliage design with green and brown sponge spatter, largest has minor flakes, chips, glued repairs. Dia 5″ to 9″

Garth 9/87 **$118**

Jars

Face vessel, unglazed, found in Ohio, 1850–1900, publicity, chips.

Sotheby's 10/86 **$2,530**

Jar, ovoid, decorated brown streak on green over yellow ground, glazed, flared rim with cover, probably New Bedford, Massachusetts, early 19th century, slight glaze flaking. 8 1/2″

Sotheby's 10/86 **$2,600**

Jar, glazed, New England, c. 1825, publicity, small flaking. 8″

Sotheby's 10/86 **$550**

Jar, glazed, United States, c. 1860, publicity, small chip.

Sotheby's 10/86 **$900**

Pot, ovoid, glazed, attributed to Peter Clark, Braintree, Massachusetts, or Lyndeboro, New Hampshire, c. 1770, documentation, rarity, similar pieces in museums and published.

Sotheby's 10/86 **$2,800**

Pot, ovoid, glazed, covered and single handled, New England, c. 1825, good condition.

Sotheby's 10/86 **$1,000**

Spatterware/Spongeware

During the late nineteenth and early twentieth century, household items such as cups and saucers, bowls and pitchers, and plates were decorated with spatter or spongeware motifs. A brush or

sponge is used to apply blue-, green-, red-, or brown-colored glaze on the soft-bodied whiteware and harder-bodied stoneware. Often, very vibrant results in pattern or abstract form were achieved on otherwise heavy and monotonous pieces. The decorative examples were derived from English ware made specifically for the American trade during the 1820–1850 era.

Creamer, miniature, red, blue, yellow, dark brown stains, repairs. H 2 1/8″

Garth 2/87 **$90**

Cup and saucer, primitive, red, blue, green, black peafowl, hairline cracks.

Garth 2/87 **$85**

Mixing bowl, blue, white sponge spatter, rim chips, hairline cracks. H 6 1/4″ × D 12 3/4″

Garth 3/87 **$45**

Plate, red, blue, green, black peafowl, impressed "Adams," minor stains, wear. D 8 3/4″

Garth 2/87 **$225**

Sugar bowl, blue, red, green, yellow, black peafowl decoration, chipped, stained. H 8″

Garth 2/86 **$115**

Teapot, red, blue, yellow, black peafowl, chips, milky glaze. H 6 1/2″

Garth 2/87 **$175**

Stoneware

Stoneware is durable, hard pottery made from a blend of high-fired clays. Because the clay was found in relatively few locations, and the firing had to be done in kilns able to withstand high temperatures, the manufacture of stoneware was restricted to central areas. Ease of transport was also crucial, both for the import of materials and the export of finished wares. Stoneware potteries flourished during the nineteenth century.

The most common forms of stoneware were crocks, jugs, and churns. Their shapes were regionally quite uniform, but differed in surface design. Much early stoneware has incised decoration. In the nineteenth century, northern centers in Bennington, Vermont, New York, New Jersey, and Pennsylvania created elaborate slip trailed and brushed designs of birds, flowers, and animals in cobalt blue. Many potteries in Ohio, Pennsylvania, and West

Virginia used stencil decoration. Southern potteries often glazed their pots in dark earthen tones.

Crocks

#1. J & E. Norton, Bennington, Vermont, cracked. H 7 1/2 ″
<div align="right">*Skinner 1/85* **$250**</div>

#1. Cobalt blue man with hat, c. 1870, hairline cracks. H 7 1/2 ″
<div align="right">*Skinner 3/87* **$3,000**</div>

#2. Cobalt blue morning glory, "Frank B. Norton," Worcester, Massachusetts, rim chips. H 9 1/2 ″
<div align="right">*Skinner 5/85* **$100**</div>

#2. Cobalt blue double floral spray, "J & E Norton," Bennington, Vermont, 1850s, staining, chips. H 9 ″
<div align="right">*Skinner 5/85* **$150**</div>

#2. Cobalt blue cow, "J. C. Waelde," North Bay, c. 1870, faded design, rim chip. H 9 1/4 ″
<div align="right">*Skinner 5/85* **$650**</div>

#2. Cobalt blue decoration, "The Drinkers," salt-glazed, applied handles, William A. Macquoid, New York, New York, c. 1880, impressed inscription, rarity, chip, cracks. H 9 ″
<div align="right">*Sotheby's 10/86* **$4,000**</div>

#2. Cobalt blue bird, "Whites," Utica, New York, illustrated. H 9 1/2 ″
<div align="right">*Skinner 1/87* **$550**</div>

#2. Ovoid, cobalt blue inscription, "Boyer and Knott," Palatine, West Virginia, c. 1840, imperfections. H 10 ″
<div align="right">*Skinner 6/87* **$100**</div>

#2. New England, dated 1847, hairline crack, chipped. H 10 3/4 ″
<div align="right">*Skinner 8/87* **$300**</div>

#3. Cobalt blue double orchid, "Whites," Utica, New York, c. 1868, chips, flaking. H 10 1/2 ″
<div align="right">*Skinner 5/85* **$150**</div>

#3. Cobalt blue floral spray, "Hubbell Y. Chesebro," Geddes, New York, 1860–1880, glaze chip, staining. H 9 3/4 ″
<div align="right">*Skinner 5/85* **$150**</div>

#3. Cobalt blue bird, "West Troy Pottery," c. 1870, repaired, design blurred. H 16 1/2 ″
<div align="right">*Skinner 5/85* **$300**</div>

#3. "Ottoman Brothers," Fort Edward, New York, c. 1870, chips, staining. H 10 1/2 ″
<div align="right">*Skinner 5/85* **$200**</div>

#3. "Seymour & Bosworth," Hartford, Connecticut, late 19th century, blurred design, staining, chipped. H 10 1/2 ″

Skinner 5/85 **$200**

#3. Cobalt blue decoration, "The Farmer," salt-glazed, William A. Macquoid, New York, New York, c. 1860, impressed inscription, rarity. H 10 ″

Sotheby's 10/86 **$6,500**

#4. Cobalt blue double flower, "J. Mantell," Pennsylvania, c. 1850, cracks. H. 13 ″

Skinner 5/85 **$350**

#4. Cobalt blue turkey, "Whites," Utica, New York, c. 1865, illustrated, rim chips, cracked. H 11 ″

Skinner 5/85 **$200**

#4. Flourish of cobalt blue, chipped. H 12 ″

Garth 2/86 **$50**

#5. Cobalt blue flowers, "E. & L. P. Norton," Bennington, Vermont, 1860–1880, stained. H 13 ″

Skinner 3/85 **$100**

#5. Cobalt blue floral-filled compote, "A. O. Whittemore," Havana, New York, 1860–1880, repairs. H 12 1/2 ″

Skinner 5/85 **$150**

#20. Cobalt blue eagle, "J. Hamilton and Co.," Greensboro, Pennsylvania, 19th century, chips. H 25 3/4 ″

Skinner 11/86 **$650**

Bird on branch, cobalt blue slip, impressed label: "White & Sons, Utica, N.Y. 3," hairline cracks, small edge chips. H 10 1/4 ″

Garth 2/87 **$225**

Bird on branch, cobalt blue slip, impressed label: "Ottman Bros. & Co., Fort Edwards, N.Y.," small chips, flaking. H 11 3/4 ″

Garth 2/87 **$275**

Bird on branch, cobalt quill work, edge chips, hairline cracks. H 11 ″

Garth 2/87 **$250**

Brushed cobalt blue, wavy lines, good design. H 7 ″ × D 10 3/4 ″

Garth 2/86 **$235**

Cobalt blue, #4, floral medallion, salt-glazed. J. Heiser, Buffalo, New York, H 11 ″

Weschler 3/86 **$125**

Cobalt blue and brown, #3, salt-glazed, applied strap handles, E. J. Miller & Son, Alexandria, Virginia. H 14 ″

Weschler 6/86 **$300**

Cobalt blue floral slip decoration, side handles, cylindrical, late 19th century, provenance. H 13 1/4″

Weschler 5/87 **$250**

Cobalt blue quill work, "5" and flourish, hairline cracks. H 12 1/4″

Garth 3/87 **$65**

Cobalt blue quill work, stylized plan with "4," impressed label: "J. Burger," good color, cracks on interior. H 11″

Garth 3/87 **$200**

Cobalt blue stylized flower, #2, "White's," Utica, New York, chipped, cracked. H 12 1/2″

Skinner 5/86 **$125**

Open handles, good cobalt blue decoration. H 5″ × D 7″

Garth 2/87 **$140**

Ovoid, brown glaze, #2, Boston, Massachusetts. H 12 1/2″

Skinner 1/85 **$150**

Small, impressed, incised eagle, banner in blue, edge chips. H 7 1/2″

Garth 2/87 **$125**

Two: #4 and #5. (A) Flourish of cobalt blue. H 11 1/2″ (B) Cobalt blue floral design, "Fort Edward Stoneware Co, Fort Edward N.Y. 5." H 12″ Both damaged.

Garth 2/86 **$925**

Cobalt blue deer, glazed, Edward Pottery Co., Fort Edward, New York, 19th century, unusual design, rim chip. H 12″ × D 12 5/8″

Sotheby's 6/87 **$5,000**

Jars

#2. Cobalt blue triple flower, "D. Morgan," New York, restorations. H 10 1/4″

Skinner 5/85 **$300**

#2. Covered, "T. Harrington," Lyons, 1850–1875, blistered design, chipped, hairline cracks. H 13 1/2″

Skinner 5/85 **$300**

#3. Cobalt blue floral bouquet, ovoid, "Jordan," c. 1825, blurred design, cracked, chip. H 13″

Skinner 5/85 **$175**

Bird, cobalt blue slip, impressed label: "A.B. Wheeler & Co. 69 Broad Street, Boston, Mass. 3," chips, hairline cracks. H 12 3/4″

Garth 2/87 **$250**

Brushed cobalt blue floral design, impressed label: "Norton & Fenton, East Bennington, Vt.," firing imperfections, surface flaking. H 11¼"

Garth 3/87 **$150**

Brushed cobalt blue flower and "3," impressed label: "Lyons," hairline cracks. H 12½"

Garth 2/87 **$225**

Covered jar, #1, cobalt blue rowboat, 1880, illustrated, chips.

Skinner 1/87 **$350**

Cylindrical #3, cobalt blue decoration, "The Burglar," salt-glazed, flared rim, applied handles, attributed to William A. Macquoid, New York, New York, c. 1870, rarity, chips, cracks. H 13"

Sotheby's 10/86 **$12,500**

Dark cobalt blue ship design, impressed label: "Taunton, Mass., 4" small rim chips, cracks. H 15½"

Garth 2/87 **$145**

Ovoid, applied handles, impressed "4," chips, minor hairline cracks. H 15¼"

Garth 3/87 **$45**

Ovoid, brushed cobalt blue flower, impressed label: "C. Hart & Son, Serburne, 2," rim chips. H 10¾"

Garth 2/87 **$200**

Ovoid, cobalt blue grapes, c. 1820, cracks, firing imperfections, chipped. H 14"

Skinner 1/87 **$300**

Ovoid, cobalt blue swags, "Thomas Commeraw" attribution, possibly Coerlears Hook, New York City, illustrated, damaged. H 13"

Skinner 5/85 **$400**

Ovoid, splashes of cobalt blue, handles, impressed label: "I.M. Mead & Co 3," glaze worn, flaked, hairline cracks. H 13¾"

Garth 3/87 **$75**

Preserving jar, blue-stencilled labels, "A.P. Donaghho, Parkersburg, W. Va.," Parkersburg, West Virginia, label, lip chips. H 9½"

Garth 2/86 **$35**

Preserving jar, blue, small edge chips. H 11½"

Garth 3/87 **$35**

Preserving jar, blue-stencilled triangular rose and label: "Conrad, New Geneva, Fayette Co., Pa." H 8¼"

Garth 3/87 **$230**

Preserving jar, cobalt blue-stencilled label: "T.F. Reppert, Greensboro, PA., with plow," minor hairline cracks. H 9¾"

Garth 2/87 **$85**

Stencilled cobalt blue design, label: "Wm. Kinniev & Co., Lynchburg, Va. 4," cracks, small chips. H 15″

Garth 2/87 **$90**

Two, blue-stencilled labels, "A.P. Donaghho, Parkersburg, W. Va.," Parkersburg, West Virginia, damaged. H 8″ and H 10″

Garth 2/68 **$45**

Jugs

#1. Cobalt blue floral decoration, "J. & E. Norton," Bennington, Vermont, 1850s. H 11″

Skinner 3/85 **$80**

#1. Cobalt blue fish, late 18th century, hairline cracks, chips, one side unglazed. H 12″

Skinner 5/85 **$325**

#1. Ovoid, cobalt blue flowers, "Commeraws," Red Hook, New York, late 18th century, chips. H 12³⁄₄″

Skinner 5/85 **$1,500**

#1. Cobalt blue tied bow, "Warne & Letts," South Amboy, New Jersey, 1806. H 11¹⁄₄″

Skinner 5/85 **$1,700**

#1. Cobalt blue bird, "W.H. Farrar & Co.," Geddes, New York, chip. H 11″

Skinner 5/85 **$4,200**

#1. Cobalt blue bird,salt-glazed, "W.H. Farrar & Co.," 19th century, beautiful design. H 11″

Skinner 5/86 **$4,200**

#2. Cobalt blue flower, ovoid, "Thomas D. Chollar," Cortland, New York, 1830s H 13¹⁄₂″

Skinner 5/85 **$160**

#2. Cobalt blue spotted flower, "J. Burger," Rochester, New York, c. 1860, chip. H 14¹⁄₄″

Skinner 5/85 **$150**

#2. Cobalt blue tulip, ovoid, "Chollar & Darby" Homer, 1840s. H 13″

Skinner 5/85 **$140**

#2. Cobalt blue bird, possibly Ottman Bros & Co., Fort Edward, New York, c. 1880, chipped, cracked.

Skinner 1/87 **$300**

#2. Cobalt blue bird, "White's Utica," Utica, New York, c. 1880, illustrated, chipped, imperfections.

Skinner 1/87 **$300**

#2. Cylindrical, cobalt blue decoration, "Woman's jug," salt-glazed, applied handles, probably Dorchester Pottery Works, Dorchester, Massachusetts, c. 1880, attribution, impressed inscription, rarity, restored handle and neck lip. H 14″

Sotheby's 10/86 **$2,900**

#3. Cobalt blue flowers, "W. Hart," Ogdenburgh, c. 1855, hairline crack, blurred design. H 16″

Skinner 5/85 **$135**

#3. Cobalt blue floral decoration, "J. & E. Norton," Bennington, Vermont, 1850s, staining. H 13″

Skinner 3/85 **$300**

#3. Cobalt blue fish eating fish, late 18th, early 19th century, rim chips. H 16¼″

Skinner 5/85 **$900**

#3. Cobalt blue fantail peacock, "White's," Utica, New York, c. 1885, illustrated. H 15″

Skinner 5/85 **$1,600**

#3. Cobalt blue standing stag, "J. & E. Norton," Bennington, Vermont, 1850s, excellent color. H 14″

Skinner 3/87 **$7,000**

#3. Cobalt blue turtle doves, "S. Hart," Fulton, New York, mid-19th century, illustrated, spider lines on back. H 13½″

Skinner 7/86 **$425**

#4. Cobalt blue bird and flowers, "J. & E. Norton," Bennington, Vermont, c. 1855, imperfections. H 17″

Skinner 6/87 **$5,300**

#4. Cobalt blue double flower, "F.B. Norton," Worcester, Massachusetts, 1860s, design blistered. H 17¼″

Skinner 6/87 **$300**

Bird, cobalt blue slip, impressed label: "White's, Utica, 2," firing bubbles, small lip chip. H 13¾″

Garth 2/87 **$225**

Bird, cobalt blue floral design, small chips in design, impressed label: "White's, Utica, 2." H 13¾″

Garth 3/87 **$275**

Brown, white, black transfer label: "Thos. Martindale. Importing Grocers, Philadelphia," chipped H 11½″

Garth 2/87 **$20**

Brushed cobalt blue floral design, impressed label: "Sipe & Sons W'msport, Pa." drilled for a lamp, lip flakes. H 10¾″

Garth 2/87 **$175**

Cobalt blue decoration, ovoid, salt-glazed, probably L. Norton & Son, Bennington, Vermont, c. 1840, slight crack.

Sotheby's 1/84 **$400**

Cobalt blue decoration, "Mustached Gentleman," ovoid, salt-glazed, applied handles, Cowden, Harrisburg, Pennsylvania, late 19th century, impressed, inscribed, rarity. 16 1/4″

Sotheby's 10/86 **$4,750**

Cobalt blue floral decoration with inscription, Baltimore, Maryland, c. 1835.

Sotheby's 1/87 **$2,700**

Cobalt blue, "2," four brush marks, lip chipped, hairline crack. H 12″

Garth 3/87 **$65**

Cobalt blue seated dog, glazed, jar, Edward Pottery Co., Fort Edward, New York, 19th century, unusual design, chipped. H 9 1/2″

Sotheby's 6/87 **$2,300**

Cobalt blue fantail peacock, "White's," Utica, New York, c. 1885, beautiful design. H 15″

Skinner 5/86 **$1,600**

Cobalt blue quillwork label, "Gubert Muray 10 Terrace, Buffalo, N.Y." impressed label: "C.W.——, Buffalo, N.Y." lip flake. H 13 1/4″

Garth 3/87 **$65**

Cylindrical, cobalt blue decoration, "The Pointing Hand," salt-glazed, applied handles, c. 1880, rarity, crack. H 19″

Sotheby's 10/86 **$2,500**

Cylindrical, cobalt blue decoration, "The Acrobats," mustached gentleman in stove pipe hat and lady doing handstand, applied handles, Fulper Bros., Flemington, New Jersey, c. 1890, impressed inscription, rarity, stamped. H 16 1/2″

Sotheby's 10/86 **$26,000**

Flourish, blue quill work, "4." H 15 1/4″

Garth 3/87 **$75**

Grotesque decoration; face of man, possibly Satan, salt-glazed, Remmey, mid-19th century, minor flaking. H 8 1/2″

Sotheby's 10/86 **$12,500**

Impressed label: "Norton & Fenton, Bennington, Vermont. 3," hairline cracks, chipped. H 14 1/2″

Garth 3/87 **$175**

Ovoid, cobalt blue farmer and reindeer, "J. Norton," Bennington, Vermont, c. 1865. H 10 7/8″

Sotheby's 1/87 **$14,000**

Ovoid, cobalt blue quill mark "Jug," impressed label: "S. Hart." H 10 1/2 "

Garth 2/87 **$150**

Ovoid, good brushed floral design, cobalt blue, impressed label: "Sipe & Sons, Williamsport, Pennsylvania," stained, minor hairline cracks. H 14 1/2 "

Garth 2/87 **$325**

Ovoid, good floral design, brushed cobalt blue, impressed label: "Cowdon & Wilcox, Harrisburg 3." H 15 3/4 "

Garth 2/87 **$400**

Single flower, cobalt blue, impressed label: "C. Hart & Son, Sherburne, N.Y. 3," cracked. H 15 1/2 "

Garth 2/87 **$125**

Two pieces: (A) Jug, label: "F. Kette & Son." H 9 3/4 " (B) Candle mold, tin, twelve tube, damaged. H 10 1/2 "

Garth 2/86 **$60**

Two pieces: (A) Jug, pebbly tan glaze. H 7 3/4 " (B) Pitcher, dark brown Albany slip. H 11 1/2 "

Garth 2/86 **$40**

Two pieces: (A) Jug. "John Lyons, Cor Beach & South Sts, Registered, Boston," Boston, Massachusetts, impressed label. H 9 1/4 " (B) Poodle, seated, molded and hand-executed detail and white slip, "J.C." incised initials, chipped, cracks. H 9 1/2 "

Garth 2/86 **$45**

Miscellaneous

Boot-shaped vase, embossed design, cobalt blue, flaking, glued repair. H 10 1/2 "

Garth 2/87 **$25**

Churn, cobalt blue lily, "Ballard & Brothers," Burlington, Vermont, mid-19th century. H 15 3/4 "

Skinner 5/85 **$325**

Churn, #5, cobalt blue standing rooster, "John Burger," Rochester, New York, c. 1860, hairline cracks, blemishes, blistering. H 19 "

Skinner 11/86 **$29,000**

Churn, #6, cobalt blue cow, "Gardiner Manufactory," Gardiner, Maine, late 19th century, chips. H 19 1/2 "

Skinner 1/87 **$300**

Churn, ovoid, good floral decoration, cobalt blue, impressed label: "A.D. Whittemore, Havana, N.Y. 5," lid mismatched, hairline cracks. H 17″ with dasher

Garth 2/87 **$285**

Churn, faint blue quill work, "6" with flourish, mismatched lid chipped. H 17¼″

Garth 3/87 **$65**

Covered, blue and white, embossed birds and flowers, chipped, hairline cracks. H 9½″

Garth 2/86 **$150**

Donut bottle, embossed lines, cobalt blue collar. H 7¾″

Garth 3/87 **$200**

Pig flask, salt-glazed, inscription, Midwestern, c. 1860. H 7″

Sotheby's 1/87 **$1,200**

Pitcher, brushed floral design, cobalt blue, hairline crack, firing flakes. H 10¾″

Garth 2/87 **$395**

Pitcher, cream-colored bulbous body, strap handle, late 19th century, provenance. H 9¼″

Weschler 5/87 **$70**

Pitcher, grayish-blue slip floral design, minor small flakes. H 9½″

Garth 2/87 **$275**

Pitcher, cobalt blue leaves and scrolls, glazed, c. 1855, rim chip. H 8¼″

Sotheby's 6/87 **$2,000**

Pot, #1, cobalt blue swan, "Cowden & Wilcox," Harrisburg, Pennsylvania, rim chips, crack in back. H 8″

Skinner 5/85 **$500**

Pot #1, cobalt blue leaves, c. 1800, rim chips. H 6″

Skinner 5/85 **$575**

Pot, cobalt blue ferns, "Thomas Haig," Philadelphia, Pennsylvania, similar known and published, illustrated, chip, crack. H 7½″

Skinner 5/85 **$550**

Pot, ovoid, alkaline-decorated, two applied handles, probably Southern, second half 19th century, publicity.

Sotheby's 10/86 **$550**

Pot, ovoid, decoration: "Bust of Man with Hat," salt-glazed, two applied handles, flared rim, c. 1825, rarity. 12½″

Sotheby's 10/86 **$3,250**

Pot, ovoid, cobalt blue decoration: "The Politician," salt-glazed, applied handles, flared rim, c. 1845, craftsmanship, unusual design, rarity, inscribed.

Sotheby's 10/86 **$13,000**

Rockinghamware

Rockingham or yellowware glazed with brown manganese, creating a mottled and/or streaked effect, was produced by several American factories. Examples from Bennington, Vermont, are highly collectible.

Bedpan. L 16″

Garth 2/87 **$15**

Bowl, good glaze, rim flakes. H 3 1/8″ × D 11 1/4″

Garth 3/87 **$125**

Bowl, some wear. H 3 1/4″ × D 11″

Garth 2/87 **$65**

Bowl, minor flakes. H 2 5/8″ × D 8 3/8″

Garth 3/87 **$70**

Bowl, minor surface flakes. H 3 1/8″ × D 10 3/8″

Garth 3/87 **$45**

Bowl, minor surface flakes. H 2 3/8″ × D 5 3/8″

Garth 3/87 **$85**

Bowl, some wear, minor flaking, chips. H 4 1/4″ × D 11 3/8″

Garth 3/87 **$85**

Bowl, embossed diamond-quilted band near base. H 3 1/2″ × D 6 1/2″

Garth 3/87 **$60**

Bowl, embossed panels and flaring rim, small flake on foot, minor edge wear. H 4 1/4″ × D 10 1/8″

Garth 3/87 **$50**

Bowl, embossed reeding, minor flakes. H 3 1/8″ × D 9 1/2″

Garth 3/87 **$70**

Bowl, flared sides, minor wear, small flaking. H 2 7/8″ × D 10 1/4″

Garth 3/87 **$55**

Bowl, flared sides, minor edge wear. H 2 1/4″ × D 8″

Garth 3/87 **$40**

Bowl, heavier yellowware, running brown glaze, flaking, chips. H 3 5/8″ × D 8 1/4″

Garth 3/87 **$15**

Bowl, heavier yellowware, running brown glaze, blistering, minor chips. H 4¹/₂″ × D 10¹/₂″

Garth 3/87 **$40**

Crock, hairline, rim chips. H 5¹/₄″ × D 6²/₂″

Garth 3/87 **$45**

Dish, minor wear, small flakes. L 11¹/₂″

Garth 3/87 **$90**

Dish, decorative embossed rim, wear, chips, repairs. D 10¹/₄″

Garth 3/87 **$35**

Dish, embossed rim, scalloped edge, chips. D 8¹/₂″

Garth 3/87 **$55**

Dish, oval, minor wear. L 10³/₄″

Garth 3/87 **$30**

Dish, oval, hairline crack, minor flakes. L 11¹/₂″

Garth 3/87 **$35**

Dish, oval, minor wear. L 12″

Garth 3/87 **$90**

Dish, rectangular, with decorative embossed rim, surface worn. 8¹/₄″ × 9¹/₈″

Garth 3/87 **$105**

Dish, round. D 9″

Garth 3/87 **$40**

Dish, scalloped rim, minor surface flaking. D 7⁷/₈″

Garth 3/87 **$60**

Dish, square, decorative embossed rim. 9″ × 9″

Garth 3/87 **$175**

Dish, square, decorative embossed rim. 8⁷/₈″ × 8⁷/₈″

Garth 3/87 **$85**

Dishes, two, with embossed ray bottoms: (A) D 6″ (B) 7³/₄″

Garth 3/87 **$80**

Pair of octagonal plates, surface flaking. L 8³/₄″

Garth 3/87 **$30**

Pie plate, large, glaze flakes. D 10¹/₂″

Garth 3/87 **$65**

Pie plate, minor wear, flaking, chips. D 10¹/₈″

Garth 3/87 **$30**

Pie plate, minor wear, flaking. D 10″

Garth 3/87 **$35**

Pie plate, minor wear, chips. D 9¹/₄″

Garth 3/87 **$45**

Pie plate, minor wear, flaking. D 11¹/₄″

Garth 3/87 **$45**

Pie plate, some wear, flaking. D 10 1/4"

Garth 3/87 **$45**

Pie plate, edge flaking. D 9 1/2"

Garth 3/87 **$55**

Pie plate, blistering. D 10"

Garth 3/87 **$55**

Pie plate, minor wear, flaking, crazing. D 10 1/2"

Garth 3/87 **$65**

Pie plate, minor wear, flaking. D 9"

Garth 3/87 **$75**

Pie plate, minor wear, flaking. D 9 1/2"

Garth 3/87 **$75**

Pie plate, minor flaking. D 9 1/2"

Garth 3/87 **$100**

Pie plates, four, minor wear, flaking. All about D 9 1/4"

Garth 3/87 **$160**

Pie plates, three, minor wear, flaking, chips. All about D 10 1/2"

Garth 3/87 **$115**

Pitcher, cranes, acorns, oak leaves, serpent handle, animal-head spout, minor wear, flaking. H 8 3/8"

Garth 3/87 **$70**

Pitcher, embossed floral rim, small flaking. H 6"

Garth 3/87 **$40**

Pitcher, embossed peacock, chips. H 8 1/4"

Garth 2/87 **$50**

Pitcher, embossed peacock, chips. H 8 1/4"

Garth 3/87 **$85**

Pitcher, embossed scene of sleeping children, flaking. H 8 3/4"

Garth 2/87 **$65**

Pitcher, unidentified maker, Rockingham, embossed Swan. H 9 1/2"

Garth 2/86 **$85**

Pitcher, embossed tulips, minor wear, small chips. H 10"

Garth 3/87 **$35**

Pitcher, hanging fish design, large spout and lid, hairlines, chips. H 9 1/4"

Garth 3/87 **$25**

Pitcher, hound-handled, embossed animals, hairline cracks, minor chips. H 9 3/4"

Garth 3/87 **$50**

Pitcher, hunter, dog, game, small chips. H 9 1/4"

Garth 3/87 **$75**

Plate, hairline cracks. D 11"

Garth 3/87 **$85**

Platter, embossed scalloping on rim. L 15″

Garth 3/87 **$350**

Salt container with crest with hanging hole, embossed peacocks, no lid, chips. D 6″

Garth 3/87 **$45**

Soap dish. H 4³/₄″

Garth 2/87 **$40**

Teapot, figural, duck-shaped, simple embossed detail, minor flaking. L 9³/₄″

Garth 3/87 **$195**

Teapot: "Rebecca at the Well," small flaking, minor crazing, chips. H 8¹/₄″

Garth 3/87 **$65**

Tobacco jar, covered, embossed Gothic arches, small edge chips. H 9″

Garth 3/87 **$225**

Tobacco jar with lid, embossed design with peacocks, minor crazing. H 5¹/₄″ × D 6¹/₂″

Garth 3/87 **$125**

Tobacco jar, turned wooden lid, wear, hairline cracks. D 7″

Garth 3/87 **$25**

Toby barrel bottle. H 8¹/₂″

Garth 2/87 **$75**

Turk's head food mold. D 7³/₄″

Garth 3/87 **$45**

Quilts

A quilt is a bed covering consisting of three layers: a top, filling, and back. The layers are joined by either tying or quilting the pieces together. Types of quilts include whole cloth, pieced, and appliqued or a combination of these types. Quilt patterns are often abstract and geometrical forms, but patterns might also be naturalistic. There are many quilt names such as Album, Friendship, Patriotic, and Log Cabin. Outstanding regional examples are noted among Baltimore Album quilts and the vividly graphic examples made by the Amish and Mennonite sects.

Appliqued

Album, geometric patterns, Mary Ida Parnell Parson, New Jersey and Pennsylvania, 1853, missing squares, corroded brown print. 93″ × 103″

Skinner 5/85 **$3,000**

Central medallion, parrot, floral sprays, initialed "AY," New Jersey, 1937, excellent condition, elaborate design. 88″ × 94″

Skinner 11/86 **$8,500**

Child's, twenty appliqued squares of animals, embroidered detail, pink, white patchwork, faded, rebound. 44″ × 54″

Garth 7/86 **$25**

Conical pine trees, flowers, floral wreaths, green, salmon, goldenrod, unusual design, stained, fabric loose. 78″ × 90″

Garth 7/86 **$175**

Crazy, colorful folk art designs, cut-out, painted, embroidered animals, flowers, birds, butterflies, etc., red border, worn. 52″ × 64″

Garth 7/86 **$75**

Crib, Pennsylvania, c. 1870, applique, provenance, exhibited, published, minor stains, discoloration. 42″ × 37″

Sotheby's 1/84 **$2,000**

Crib, red and green calico snowflakes and stars appliqued, inscribed, probably Pennsylvania, dated 1860. 30″ × 35″

Sotheby's 6/86 **$1,300**

Feathered star design, cotton, red and green calicos, mid-19th century, stained. 72″ × 72″

Skinner 5/85 **$375**

Early 20th-century American cotton applique quilt, decorated with birds and vines, and stuffed grape motifs, 94″ height × 82″ width. (*Photo courtesy of Shelly Zegart's Quilts*)

Floral and bird motifs, stuffed cotton, inscription, Diana Morse, Tyrone, New York, 1861, dated, signed, publicity, rare. 74″ × 28″
Christie's 1/86 **$6,500**

Floral designs, bold, red, green, minor wear, some stains. 70″ × 89″
Garth 7/86 **$500**

Floral medallions, Indiana red, teal green, machine-sewn applique, stained, faded, hole, edge damage. 72″ × 88″
Garth 3/87 **$165**

Floral pinwheels, red and green, small embroidered initials "M. Mo.," beautifully quilted, fading, minor wear. 78″ × 83″
Garth 7/86 **$330**

Floral sprays, embroidered, needlework on velvet. 64″ × 64″
Weschler 5/86 **$375**

Flower basket, calico and cotton. 83″ × 68″
Weschler 5/86 **$125**

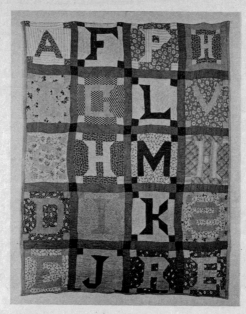

Early 20th-century American cotton pieced quilt in Alphabet pattern, made in Randolph County, North Carolina, possibly an an Afro-American, 80″ height × 64″ width. (*Photo courtesy of Robert Cargo Folk Art Gallery*)

Flowers, border swags, green, two shades of goldenrod sateen on white cotton, beautifully quilted, unwashed, pencil quilting pattern intact. 81″ × 103″

Garth 3/87 **$700**

Hearts, flowers, foliage, colorful, red, green on white, mint condition. 83″ × 84″

Garth 7/86 **$500**

Oak leaf variant, red, green calico on white, stained. 81″ × 83″

Garth 7/86 **$260**

Pineapple pattern, green, yellow, and red, c. 1840, illustrated, minor staining. 82″ × 98″

Skinner 11/85 **$2,000**

Red, gold, green flowers, birds, vines, 1850–1900, illustrated. 85″ × 74″

Skinner 11/85 **$1,200**

Reverse applique, red squares, 19th century, stained. 82″ × 84″

Skinner 6/87 **$200**

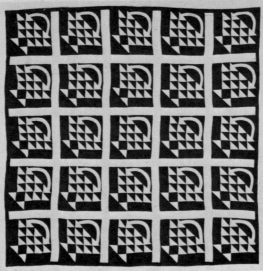

Late 19th-century Pennsylvania calico and muslin pieced quilt in Baskets pattern. (*Photo courtesy of Thomas K. Woodard, American Antiques and Quilts*)

Scalloped flower heads, green and red, Mrs. J. Walter Marshall, Lexington, Kentucky, c. 1860, original condition, attached label. 100″ × 117″

Skinner 11/85 **$2,000**

Squares, green and red plants, late 19th century, illustrated. 102″ × 81″

Skinner 5/85 **$2,200**

Stars and flags, seascape design, Slater's Mill, Pawtucket, Rhode Island, c. 1876, worn.

Skinner 5/86 **$625**

Stylized floral, meandering border, red, yellow, green calico on white, good design, wear, red fabric very worn. 100″ × 102″

Garth 2/87 **$75**

Stylized floral, pink calico, beige, blue, illustrated, minor stains, fading. 68″ × 85″

Garth 5/86 **$150**

Stylized floral, red, green calico, feather quilted border, beautifully quilted, minor age stains. 79″ × 81½″

Garth 5/86 **$350**

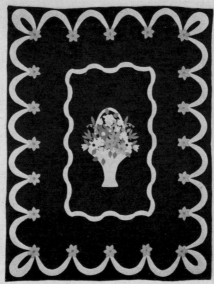

Early 20th-century Pennsylvania cotton and sateen applique quilt in Basket of Flowers design, with border of swags and flower heads. (*Photo courtesy of Thomas K. Woodard, American Antiques and Quilts*)

Stylized floral medallions, green, beige, blossoms, orange grid, worn, stained, fading. 71″ × 85″

Garth 5/86 **$100**

Stylized floral medallions, green leaves, red flowers, beautifully quilted, contemporary. 78″ × 102″

Garth 5/86 **$325**

Stylized meandering border, four oak-leaf medallions, red, green calico on white, beautifully quilted, some wear, stains, fading. 92″ × 94″

Garth 7/86 **$495**

Top, stylized floral design, green, red, goldenrod, stains, squares machine sewn. 70″ × 70″

Garth 7/86 **$135**

Miscellaneous

Block-printed cotton, floral center, whole cloth, 1800–1810, published, some discoloration. 92″ × 92″

Sotheby's 1/84 **$1,000**

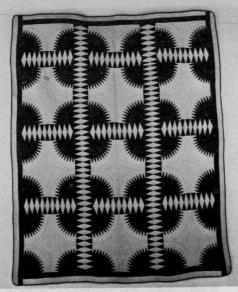

Mid-19th-century American pieced cotton quilt in New York Beauty pattern, 92″ height × 76″ width. (*Photo courtesy of Shelly Zegart's Quilts*)

Chintz, bouquets of roses, diamond-quilted, Vermont, c. 1854, provenance, stained. 96″ × 96″

Skinner 5/85 **$300**

Embroidered, crewelwork, linen, Mildred, New York or Connecticut, 1753, good color, condition, workmanship, dated, unusual design, rare, signed, age.

Sotheby's 6/87 **$4,000**

Floral stripes, chintz, maroon, green, white, gray, early fabrics, Indiana, good overall condition. 80″ × 91″

Garth 2/87 **$350**

Linsey-woolsey, indigo blue on one side, olive gold on reverse, beautifully quilted, worn, holes. 100″ × 106″

Garth 5/86 **$150**

Log Cabin, knotted comforter, mostly solid colors: red, blue, gray, brown, good colors, wear, holes. 65″ × 72″

Garth 2/87 **$75**

Pictorial: horses, 19th century. 78″ × 80″

Skinner 5/85 **$200**

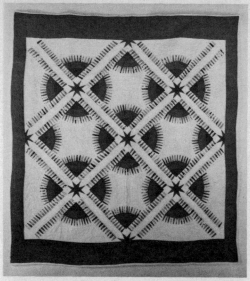

American pieced cotton quilt in New York Beauty pattern, c. 1930, 77″ height × 72″ width. (*Photo courtesy of Shelly Zegart's Quilts*)

Political, patchwork, blue and white stars commemorating Henry Clay presidential campaign, c. 1844, illustrated, stained, possibly trimmed. 88″ × 88″

<div align="right">

Skinner 6/87 **$1,200**

</div>

President's wreath with acorns, red, green, yellow flowers, excellent color, condition, craftsmanship. 88″ × 72″

<div align="right">

Phillips 5/87 **$750**

</div>

Stencilled, calico, inscribed names, early 20th century. 89″ × 89″

<div align="right">

Weschler 9/85 **$200**

</div>

United States with Liberty Bell, Capitol, and White House vignettes, pink on white, embroidered, 1937. 81″ × 67″

<div align="right">

Weschler 2/87 **$1,100**

</div>

Pieced

Amish, cotton, wool, and flannel, dark colors, Lagrange County, Indiana, c. 1925, provenance. 72″ × 80″

<div align="right">

Sotheby's 10/86 **$3,750**

</div>

Amish crib, basket pattern, blue, purple, green. 40″ × 40″

<div align="right">

Garth 7/86 **$55**

</div>

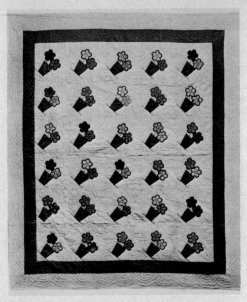

Early 20th-century American pieced and appliqued quilt in Pots of Flowers pattern. (*Photo courtesy of Thomas K. Woodard, American Antiques and Quilts*)

Amish crib, concentric circles, cotton, red, black, dark blue.

Oliver 7/87 **$330**

Amish crib, nine-patch pattern, provenance. 28¼″ × 23″

Sotheby's 1/84 **$600**

Amish, diamond in the square, blue, maroon, teal, and green, Pennsylvania, c. 1900, fabric loss. 72″ × 76″

Sotheby's 1/87 **$5,800**

Amish, diamond in the square, pieced cotton, possibly Pennsylvania, binding added later. 72″ × 72″

Christie's 10/87 **$1,200**

Amish, double peony design, cotton, tan on white, 1940–1950, craftsmanship, unusual design. 68″ × 80″

Phillips 5/87 **$300**

Amish, dusty pink, green border stripes, yellow back, feather, leaf, meandering vine patterns, well quilted, minor stains. 72″ × 72″

Garth 5/86 **$180**

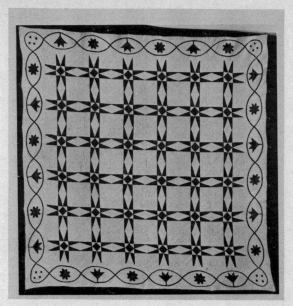

Late 19th-century American pieced and appliqued calico and muslin quilt in Darting Minnows pattern. (*Photo courtesy of Thomas K. Woodard, American Antiques and Quilts*)

Amish, Lone Star, multicolored prints, blue ground, Carion Co., Pennsylvania. 68″ × 86″

Garth 7/86 **$150**

Amish, ocean waves, blue, white, Indiana, some wear, fading, binding machine stitched. 66″ × 72″

Garth 7/86 **$325**

Amish, ocean waves, cotton, Ohio, c. 1920. 72″ × 72″

Sotheby's 10/86 **$4,200**

Amish, snowball pattern, cotton, possibly Kansas, early 20th century, provenance. 72″ × 57″

Christie's 1/84 **$350**

Amish, sunflower and diagonal line quilting, cotton, dark colors, Indiana, c. 1920. 56″ × 76″

Sotheby's 10/86 **$3,700**

Bear Paw, blue, white, quilted circles, never washed, pencil quilt patterns intact. 72″ × 82″

Garth 3/87 **$325**

Blazing Star, pieced cotton, possibly Ohio, c. 1920. 72″ × 67″

Christie's 1/84 **$480**

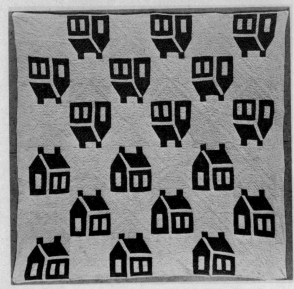

Early 20th-century Pennsylvania pieced quilt in School House pattern. *(Photo courtesy of Thomas K. Woodard, American Antiques and Quilts)*

Blue calico squares, white grid, some wear, small holes, binding machine stitched. 76″ × 82″

Garth 3/87 **$150**

Blue calico, white with cross designs, some wear, loose seams, bleach stains. 84″ × 84″

Garth 3/87 **$175**

Bow Tie, blue, white calico. 76″ × 80″

Garth 3/87 **$250**

Calamanco patchwork, diamond and square pattern, late 18th or early 19th century, excellent condition. 98″ × 102″

Skinner 5/85 **$1,600**

Calico, four red squares, multicolored stars, yellow ground, Berk's Co., Pennsylvania. 76″ × 76″

Garth 7/86 **$135**

Centennial, calico, inscription, c. 1876. 87″ × 87″

Weschler 3/86 **$275**

Central star, Phebeann H. Salem (?), Pennsylvania, 1848. 107″ × 108″

Skinner 11/85 **$1,900**

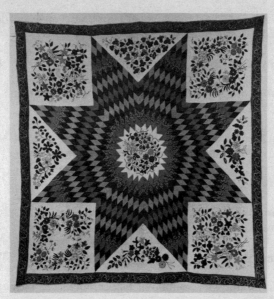

Pieced and appliqued quilt in Star of Bethlehem pattern, inscribed in ink "Rachel Trundle, Mt. Auburn, Frederick Co." (Maryland), c. 1860, 97″ height × 94″ width. (*Photo courtesy of American Hurrah Antiques, New York*)

Central star within a star, multicolored prints, red border stripes, machine sewn, overall and edge wear, minor stains, small size. 60″ × 78″

Garth 3/87 **$105**

Chimney Sweep, calico, mid-19th century, initials, staining. 82″ × 98″

Skinner 5/85 **$175**

Chintz calico, mid-19th century, stained. 102″ × 88″

Skinner 5/85 **$350**

Circular wreath framed by serpentine border, silk, discolored. 90″ × 83″

Christie's 1/84 **$120**

Compass stars, red, white, blue on white ground, red grid. 68″ × 77″

Garth 3/87 **$245**

Crazy, colorful silk and velvet, embroidered burgundy edges.

Phillips 2/87 **$800**

Crazy, illusion design, hand-painted rosebud velvet border, very fine condition, craftsmanship, good color, design.
Phillips 2/87 **$600**

Crazy, tiny, dark-colored velvet with embroidery. 8″ × 8″
Garth 2/87 **$25**

Crazy, wool and flannel, 1900–1910, published, unusual design, minor fading. 78″ × 73″
Sotheby's 1/84 **$700**

Crib, block pattern, calico and glazed chintz, diamond and petal quilting, c. 1856, minor stains. 40″ × 40″
Skinner 7/86 **$700**

Crib, cluster of star, cotton, c. 1880. 38″ × 40″
Sotheby's 1/84 **$375**

Crib, Friendship, calico and cotton, Lancaster, Pennsylvania, c. 1870, provenance, rare. 42″ × 42″
Sotheby's 1/84 **$750**

Crib, Lone Star, calico, provenance, exhibited. 34″ × 35″
Sotheby's 1/84 **$700**

Crib, Mennonite, wool, windmill blades, vivid colors, Pennsylvania, late 19th century. 50″ × 50″
Sotheby's 10/86 **$3,750**

Crib, multicolored prints, some wear, small repairs. 41″ × 42″
Garth 2/87 **$250**

Crib, optical pattern, calico and chintz, 19th century, unusual design. 40″ × 38″
Sotheby's 1/87 **$500**

Crib, star, 19th century. 40″ × 36″
Sotheby's 1/84 **$2,250**

Crib, twenty-five patches, Indiana orange grid. 36″ × 45″
Garth 7/86 **$25**

Crib, Star of Bethlehem, red, yellow, green calico, sawtooth band border, mid-19th century, illustrated, stained, worn. 28″ × 28″
Skinner 8/87 **$400**

Diamond Indiana square, wool, olive, green, lavender, dark taupe, Lancaster County, Pennsylvania, c. 1900–1925, fine condition, workmanship. 76″ × 76″
Sotheby's 6/87 **$4,000**

Double Irish Chain, possibly Iowa, c. 1920. 76″ × 70″
Christie's 1/84 **$200**

Dresden Plate, colorful prints on white ground, green sateen grid, binding machine stitched. 74″ × 92″
Garth 2/87 **$70**

Ecru with blue, green border stripes, meandering feather pattern, beautifully quilted. 72″ × 78″

> *Garth 7/86* **$350**

Feathered star pattern, green, beige, white cotton, 1890, minor fabric loss. 80″ × 84″

> *Sotheby's 1/84* **$375**

Four-petal reversible ground pattern, flowered chintz, calico, faded, worn, holes. 96″ × 98″

> *Garth 7/86* **$75**

Friendship quilt, star pattern patchwork, c. 1855, minor staining, worn. 82″ × 88″

> *Skinner 5/85* **$650**

Geometric design, red and blue patchwork, 1800–1850, unusual design, illustrated, damaged. 108″ × 100″

> *Skinner 11/85* **$1,200**

Hand or paw, colorful prints, green and white stripe ground, center hand has stitched heart, back with ink label "Mary Johnston 1851." 60″ × 74″

> *Garth 2/87* **$165**

Hexagonal designs, stars on blue, red, salmon, on white ground, some wear, small holes. 68″ × 74″

> *Garth 2/87* **$65**

Irish Chain, red, goldenrod, beige, white. 86″ × 86″

> *Garth 7/86* **$250**

Log Cabin, brightly colored, some minor stains, some wear. 66″ × 82″

> *Garth 3/87* **$170**

Log Cabin, cotton, brown, blue, orange, beige, checkerboard design, minor wear. 86″ × 96″

> *Garth 3/87* **$100**

Log Cabin, navy, red, purple, brown, reverse green, yellow, lavender plaid, good condition. 60″ × 50″

> *Phillips 5/87* **$140**

Lone Star, pink, orange, green, cream on beige ground, beautifully quilted. 82″ × 84″

> *Garth 7/86* **$250**

Lone Star, pink, yellow, green, beige, lavender on pale blue ground, some fading. 81″ × 85″

> *Garth 2/87* **$300**

Lone Star, red, orange, yellow, blue, lavender, yellow ground, minor overall wear, binding machine sewn. 74″ × 86″

> *Garth 2/87* **$175**

Maltese cross pattern, cotton, possibly Iowa, c. 1920. 86″ × 76″

Christie's 1/84 **$260**

Mennonite, mariner's compass variation, Pennsylvania, c. 1920, color illustration. 76″ × 80″

Sotheby's 10/86 **$3,750**

Multicolored print stars, red calico ground, worn, fragile, binding machine stitched. 36″ × 47″

Garth 2/87 **$95**

Multicolored prints on blue bars, alternating stripes of yellow, goldenrod backing, never washed. 68″ × 82″

Garth 2/87 **$175**

Nine-patch, hand-tied, Vermont, early 19th century, stained. 80″ × 82″

Skinner 5/85 **$200**

Ninety-nine stars, multicolored prints, pink, white, brown, checkerboard design, New York State, some stains, wear. 68″ × 78″

Garth 7/86 **$125**

Ocean waves, red, white, blue, hand-sewn, machine quilting, wear, stained. 72″ × 72″

Garth 3/87 **$95**

Patchwork calico, squares and triangles, c. 1875. 72″ × 72″

Skinner 5/85 **$7,100**

Patchwork throw, all wool, black, beige, and dark color squares, colorful connecting embroidery, stylized flowers, Indiana dime-size circles of appliqued felt, gold fringe. 48″ × 91″

Garth 3/87 **$225**

Pinwheel, multicolored prints, blue, white, wear, fading, worn edges. 56″ × 74″

Garth 3/87 **$75**

Postage stamp-size squares, Indiana prints, solids, brightly colored. 68″ × 89″

Garth 3/87 **$300**

Rose blossom and bud, cotton, calico, and chintz, C.A. Harris, 1855, diamond quilting, good workmanship, some stains, deterioration of fabric. 88″ × 100″

Sotheby's 1/84 **$1,300**

Sawtooth medallion, green print, white ground, beautifully quilted, minor stains, large size. 102″ × 104″

Garth 7/86 **$925**

Seven sisters, multicolored calico patches, c. 1930. 100″ × 80″

Sotheby's 1/84 **$800**

Single star, calico, red, pink, goldenrod, beige, sawtooth border, good quilting, minor age stains, little overall wear. 72″ × 76″

Garth 2/87 **$255**

Single star, prints, bold background design of yellow, purple calico. 82″ × 84″

Garth 3/87 **$325**

Sixteen blazing stars, dog tooth pattern border, cotton, early 20th century. 97″ × 95″

Christie's 1/84 **$450**

Spade blade pattern, calico, 19th century. 100″ × 92″

Christie's 1/87 **$1,500**

Squares and diamonds, roses, brown, chintz, polished cotton, late 19th century, very fine craftsmanship. 99″ × 72″

Phillips 5/87 **$250**

Stairsteps, calico, 1850–1900. 90″ × 73″

Weschler 9/86 **$375**

Star, goldenrod, navy blue, salmon, good color, beautifully quilted, illustrated. 76″ × 79″

Garth 7/86 **$1,000**

Star, multicolored prints on pink calico ground. 74″ × 85″

Garth 2/87 **$285**

Stars, red, blue on white ground, hand-sewn, top machine quilted, stained, some wear. 76″ × 88″

Garth 2/87 **$100**

Star, red, blue, yellow on white ground, edges rebound. 67″ × 80″

Garth 3/87 **$300**

Star, red, white. 76″ × 94″

Garth 3/87 **$325**

Star of Bethlehem, calico and chintz, 19th century, minor stains. 101″ × 108″

Sotheby's 1/86 **$1,100**

Stars, red, yellow, blue, white ground, pinwheels, olive, white, and salmon border strips have quilted swags, age stains, wear, small edge tears, faded, colors bleeding. 72″ × 86″

Garth 3/87 **$190**

Stars, sixteen pink and blue, Dauphin Co., Pennsylvania, good color, minor repairs, rebound. 72″ × 72″

Garth 7/86 **$225**

Stylized blossoms, green, blue calico, solid goldenrod, backing of check homespun, beautifully quilted, minor wear. 85″ × 87″

Garth 3/87 **$500**

Stylized starflowers, red, green goldenrod on black, white print ground, diamond border, corner compass stars, excellent workmanship, minor fading. 86″ × 94″

Garth 7/86 **$350**

Sunburst pattern, calico and cotton, S.T., probably Pennsylvania, 1860, signed, dated.

Sotheby's 6/86 **$1,200**

Thirty yellow stars on red squares alternating with green zigzag border, binding machine sewn, good color, Lycoming Co., Pennsylvania. 72″ × 80″

Garth 7/86 **$300**

Tree-like design, green and white on goldenrod, minor fading, repairs. 54″ × 71″

Garth 3/87 **$150**

Trip around the world, brightly colored prints, red, border, quilting later than piece work. 80″ × 82″

Garth 5/86 **$55**

Trip around the world, brightly colored calico and prints, pink border, green strip. 84″ × 84″

Garth 5/86 **$125**

Trip around the world, brightly colored calico, yellow, green pink, white, embroidered date 1888, Snyder Co., Pennsylvania, rebound. 70″ × 72″

Garth 7/86 **$135**

Wild goose chase, linsey-woolsey, 19th century, some fading. 90″ × 90″

Sotheby's 1/84 **$850**

Windmill, cotton calicos, mid-19th century, patched, stained. 82″ × 95″

Skinner 5/85 **$200**

Windmill, multicolored prints, blue, white, Berk's Co., Pennsylvania, minor wear, stains. 76″ × 76″

Garth 7/86 **$300**

Pieced and Appliqued

Album, stars, geometric motifs, cotton, embroidered calico, Brooklyn, New York, dated, signed, unusual design, inscription. 72″ × 80″

Sotheby's 6/87 **$5,250**

Baltimore Album, pieces signed in ink, c. 1840s, fabric loss. 96″ × 96″

Sotheby's 1/87 **$7,000**

Baltimore Album, Mary and Sarah Pool, Baltimore, Maryland, c. 1845, good workmanship, provenance, publicity, similar pieces known, signed. 106″ × 107³/₈″

Christie's 1/87 **$176,000**

Baskets, Indiana, red and blue triangles. 66″ × 72″

Skinner 5/86 **$125**

Christmas motifs, red and green, c. 1850, minor stains. 100″ × 100″

Sotheby's 6/87 **$1,900**

Cotton, trapunto, signed, Gorsuch Family, Baltimore, Maryland, rare, documentation, exhibited, published, minor fabric loss. 108″ × 108″

Sotheby's 6/87 **$25,000**

Diamonds and roses, chintz, Charlotte Penfield, 19th century, good workmanship, stained, discolored. 108″ × 122″

Sotheby's 1/84 **$2,250**

Floral squares, cotton, 19th century, some stains, fading. 88″ × 76″

Sotheby's 1/84 **$700**

Kaleidoscopic pattern of flags, flowers, Masonic symbols, Martha Hewitt, Michigan, dated 1855.

Sotheby's 1/86 **$27,000**

Pot of flowers, Pennsylvania, c. 1850, exhibited, published.

Sotheby's 1/84 **$2,500**

Trapunto

Bride's quilt, white cotton, initialed "WMC," probably New England, c. 1830, repaired, stained. 100″ × 100″

Sotheby's 1/86 **$2,500**

Floral medallions, white field, grapevine border, 19th century, stained, fading, worn. 88″ × 88″

Skinner 3/85 **$600**

Nine squares, Indiana Whig Rose variation, late 19th century, worn. 78″ × 78″

Skinner 7/86 **$200**

Rugs

Hooked rugs became popular at the end of the nineteenth century and are thought of as an indigenous American folk art form. Primitive designs were executed as fabric-dyed strips of wool were worked into a backing material with a special hook. Geometric patterns as well as flowers, animals, and houses were favored designs. Two distinct, identifiable hooked rug styles may be noted. From the Grenfell Handicrafts cooperative in Newfoundland and Labrador come some fine hooked mats, which are much smaller in size. During the middle of the nineteenth century, Edward Frost, from Maine, introduced pre-stamped rug designs on burlap. The Frost pre-printed patterns popularized and spread the craft.

Braided rugs first appeared in the early nineteenth century and are technically one of the simplest types of rugs to execute. After braiding strips of cut fabric, the fabric pieces are usually sewn into circular or oval shapes. Color patterning was usually random but the Shakers created some exceptionally color-controlled examples.

No bed rugs have sold at public auction recently. They have sold privately. Interested readers may find them by consulting the dealers' list in the back of the book.

Hooked

American Indian design, eagle, fish, serpent, 20th century, unusual design. 36″ × 43″

Skinner 1/86 **$1,500**

Black dog, red collar, surrounded with blue, black, striped ground, floral sprays in red, browns, black, 19th century. 16″ × 30″

Skinner 1/87 **$475**

Blocks of six pointed stars, black, 19th century, beautiful. 89″ × 95″

Skinner 8/87 **$800**

Blue star, multicolor background, late 19th century. 32″ × 50″

Skinner 1/85 **$120**

Bold geometric, grays, black, blue, purple, rag, some wear. 27″ × 50″

Garth 3/87 **$75**

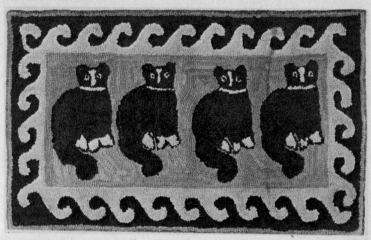

Late 19th-century Pennsylvania hooked rug, depicting four cats. (*Photo courtesy of Thomas K. Woodard, American Antiques and Quilts*)

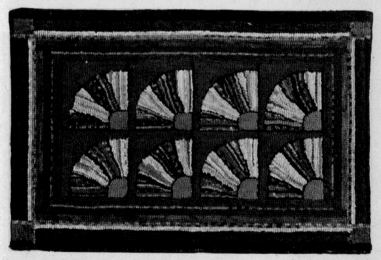

Late 19th-century Pennsylvania hooked rug, depicting fans, 19″ height × 30″ width. (*Photo courtesy of M. Finkel & Daughter; private collection*)

Cartouche floral design, red, orange, magenta blossoms, striated gray, black, gold ground, late 19th century, minor holes. 49″ × 38″

Skinner 6/86 **$225**

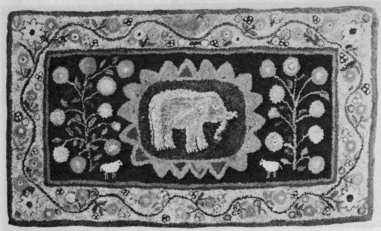

Early 19th-century New England homespun and vegetable dyed wool shirred rug, 35″ height × 61½″ width. (*Photo courtesy of America Hurrah Antiques, New York*)

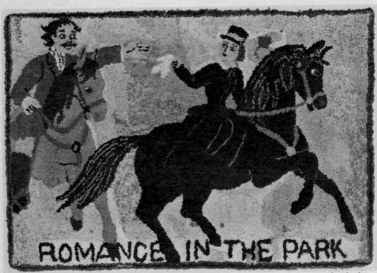

Early 20th-century New England cotton and wool hooked rug, depicting "Romance in the Park," attributed to James and Mercedes Hutchinson, 30″ height × 50″ width. (*Photo courtesy of America Hurrah Antiques, New York*)

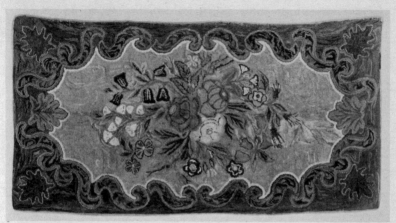

Turn-of-the-20th-century New England hooked rug, depicting floral bouquet in cartouche. (*Photo courtesy of Sotheby's, New York*)

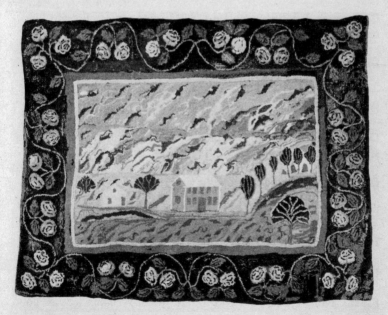

Early 19th-century New England homespun wool yarn, sewn and shirred, rug, 46″ height × 60″ width. (*Photo courtesy of America Hurrah Antiques, New York*)

Center medallion, white, green, red, good condition. 24″ × 36″

Skinner 1/85 **$75**

Central heart, stars, leaf scrolls, red, pink, white, olive gold, gray ground, good stylized design, wear, repairs. 31½ ″ × 43″

Garth 5/86 **$95**

Central spray of roses and flowers, oak leaves, scroll border. 41″ × 83″

Sotheby's 1/87 **$1,600**

Colorful flowers, vase, black ground, circular border, some edge wear. D 35″

Garth 5/86 **$50**

Colorful squares in geometric design, rag, minor wear. 36″ × 36″

Garth 2/87 **$225**

Concentric rectangles, bands of solid color, hooked and sheared rag, minor wear. 28″ × 40″

Garth 2/87 **$65**

Cottage and country setting, red, greens, gold, brown, black-blue, rag, 19th century. 32″ × 40″

Skinner 1/86 **$275**

Dalmation, Waldoboro, Maine, 1865–1875, minor fraying, small hole, published. 31″ × 54½″

Skinner 1/86 **$4,000**

Diagonal tile pattern with dots, 1850–1875. 64″ × 110″

Sotheby's 1/87 **$5,000**

Dog named Dick, browns, blue sky pattern, flowering red bush, stylized floral corners, late 19th century. 29″ × 53″

Skinner 6/87 **$1,500**

Dog sled and driver, probably Grenfell. 10½ ″ × 15″

Skinner 1/85 **$150**

Eagle, 19th century, some holes. 64½ ″ × 35″

Skinner 3/85 **$225**

Farm landscape, c. 1930.

Sotheby's 1/84 **$1,300**

Floral center, scroll border, 19th century. 36″ × 54″

Skinner 1/85 **$80**

Floral, ivory center, brown ground, green scrolling leaves, good condition. 54″ × 86″

Skinner 1/86 **$275**

Floral, 19th century. 31″ × 55″

Sotheby's 1/87 **$500**

Floral design, 19th century. 41″ × 83″

Christie's 1/87 **$1,300**

Floral, red, pink, blue, green, brown, gold, turquoise, c. 1885, exceptional color, oversized. 99″ × 122″

Sotheby's 1/87 **$3,200**

Floral, roses, good color, wear, repairs, new binding. 26″ × 44″

Garth 5/86 **$45**

Floral sprays, late 19th century. 28½″ × 41″

Skinner 1/85 **$100**

Floral, squares and triangles, mid-19th century. 39″ × 40″

Skinner 1/87 **$1,300**

Floral zigzag border, small hole. 24″ × 45″

Skinner 8/87 **$275**

Flowers, flower border, orange, red, purple, tan, brown, 19th century. 34″ × 68″

Skinner 8/87 **$225**

Four owls, flowers, shades of brown, beige, gray, red flowers on black and olive ground, good folk art design, repaired, rebound edges. 25″ × 60″

Garth 3/87 **$400**

Geometric, late 19th century. 64″ × 110″

Christie's 1/87 **$5,000**

Geometric, stripes on one end, rag, good design, wear, stains. 35″ × 53″

Garth 2/86 **$85**

Geometric checkerboard, roses alternating with squares, reds, greens on gray ground, minor wear. 29″ × 40″

Garth 7/86 **$45**

Grape cluster and vine border, cartouche of a still life, H.O. 1950, good condition, initialed. 65″ × 93″

Sotheby's 6/87 **$1,200**

Interlaced cartouche border of tassel and leaf design, blue and pink, striated gold, brown, tan field, floral wreath center, late 19th century. 57″ × 58″

Skinner 6/86 **$200**

House, initialed, dated 1902, repaired. 40″ × 50″

Sotheby's 1/84 **$750**

Leaping deer, blue, beige, green, with black, yarn and rag. 22″ × 35″

Garth 5/86 **$125**

Leopard in beige, vine border in shades of pink, green, 19th century, repairs. 32″ × 59″

Skinner 11/86 **$1,000**

Lion with blue eye, black outline, early 20th century. 24″ × 40″

Skinner 11/86 **$225**

Lions, flowering tree, striped border, gold, browns, red, green, beige, rectangular, 19th century, illustrated. 31″ × 62″

Skinner 8/87 **$1,000**

Map of Newfoundland, Grenfell, early 20th century, provenance, some damage. 18″ × 22″

Skinner 5/86 **$325**

Oriental geometric pattern, amber, blue, gray, reds, late 19th century, damaged. 36″ × 60″

Skinner 7/86 **$400**

Pair: two swans, late 19th century, worn. 29″ × 48″ and 25″ × 54″

Sotheby's 5/86 **$225**

Parrot in flowering vine, on frame. 23″ × 32½″

Sotheby's 1/87 **$950**

Peacock feather, multicolored, late 19th century, some wear. 66″ × 84″

Skinner 5/85 **$350**

Pictorial: coach, driver, passengers, town, many colors, linen backing, 19th century. 27″ × 60″

Skinner 1/87 **$600**

Pictorial: house, landscape, repairs. 40″ × 50″

Skinner 1/84 **$750**

Pictorial, Mrs. Yoder, Big Valley, Pennsylvania, c. 1930, good condition, workmanship, design unusual. 26½ ″ × 58″

Sotheby's 6/87 **$3,900**

Pictorial scene: four deer with geometric designs, rag, good design, wear, repairs. 35″ × 54″

Garth 5/86 **$175**

Pictorial mat: winter scene, small, wooden stretcher. 13½″ × 14″

Garth 5/86 **$25**

Rabbits, multicolored leaf border, light ecru on brown ground, late 19th century. 23″ × 43″

Skinner 7/86 **$495**

Reclining lion and serpent, late 19th century. 29″ × 68″

Sotheby's 1/84 **$600**

Red, green rose design, beige ground, foliage, border, rag, good design. 26¾ ″ × 45½ ″

Garth 2/86 **$70**

Reindeer under moon. 23″ × 23½″

Skinner 1/84 **$500**

Runner, colorful stripes, navy blue, rag. 32½″ × 140″

Garth 2/87 **$175**

Scottie dog with floral border, rag, good color. 21½″ × 28½ ″

Garth 2/86 **$100**

Spanish galleon sailing on colorful sea, intricate sky design, brown, gold, blue, amber, etc., rag, wear, faded colors. 35″ × 48″

Garth 3/87 **$85**

Stylized floral design, rag, good design, size, wear. 46″ × 88″

Garth 2/86 **$100**

Three bears, 1875–1925. 18½″ × 36″

Sotheby's 1/84 **$900**

Three kittens, basket, bright green, red, browns, grays, blue, rag, good colors, some wear. 25″ × 40″

Garth 5/86 **$350**

Three-masted brown ship, light blue sky, green-blue water, c. 1926. 27″ × 47″

Skinner 5/85 **$125**

Three-masted ship with American flag on blue ground, yarn, good design, minor repair. 26¾″ × 45½″

Garth 2/86 **$70**

Three-masted ship passing lighthouse, late 19th or early 20th century, good condition, mounted. 33½″ × 52″

Bourne 2/87 **$700**

Two: (A) Lioness, cub, stylized field of flowers, red, green, browns, late 19th century, worn. 30″ × 60″ (B) Lion, floral border, minor damage. 26″ × 30″

Skinner 6/86 **$425**

White horse on green, star border, New England, late 19th century, worn.

Christie's 1/84 **$600**

Woman, horse, carriage, yellow house, rose sprays, blue birds, black field, late 19th century, edge wear. 40″ × 31″

Skinner 6/86 **$325**

Yarn rug, colorful ovals, brown ground, minor wear. 30½″ ×47″

Garth 5/86 **$100**

Miscellaneous

Penny type, wool and flannel, late 19th century. 35¼″ × 53″

Sotheby's 10/86 **$750**

Woven carpet, brown, green stripes, Pennsylvania, minor wear, hole, red stains. 36″ × 144″

Garth 5/86 **$65**

Shirred

Dog in black, ivory, taupe center, floral design, wool strips stitched to blue, brown, ivory linen ticking, New England, 1800–1825, rare, good condition, illustrated. 27″ × 59″

Skinner 1/87 **$2,500**

Hearth rug, floral border surrounds bouquet, mid-19th century, worn. 35″ × 50″

Skinner 5/86 **$650**

Yarn-Sewn

Floral design, wool, 19th century, good workmanship. 26″ × 62½″

Christie's 1/87 **$3,000**

Hearth, flowers, green, red, tan, white, cut corners, braided edges, early 19th century, fabric loss. 30½″ × 64″

Skinner 1/86 **$400**

Initialed: "P.S.," Vermont, dated 1824. 21″ × 74″

Sotheby's 10/86 **$23,000**

Shaker, wool shag, red, blue, brown, pink, and green, 19th century.

Sotheby's 10/86 **$500**

Sprays of roses and vines, 19th century. 26″ × 62½″

Sotheby's 1/87 **$3,000**

Samplers and Needlework Pictures

Samplers are ornamental needlework examples which often include a variety of embroidered stitches and may indicate the maker's name, date, alphabets, numerals, design, and pictorial elements. Types of samplers include band, alphabet, verse, pictorial, family record, map, and combination types. Originating from a long European and continental tradition, early American samplers were reference pieces used to learn to mark precious household linens. During the last quarter of the eighteenth century and the first quarter of the nineteenth century, sampler making functioned as an essential "accomplishment" in the female academy and seminary curriculum. Regional styles developed, the best known from the Mary Balch School in Providence, Rhode Island, and the Westtown School in Westtown, Pennsylvania. Fully realized pictorial samplers, otherwise known as needlework pictures, were embroidered genre or fantasy scenes loosely based upon prints.

Samplers

Alphabet, Anna Fowler, Newburyport, Massachusetts, 1754, provenance, published, illustrated. 13″ × 19½″
Skinner 11/85 **$2,300**

Alphabet, birds, flowers, trees, animals, verse, homespun, brown, green, blue, black, gold, white, Clarissa O. Prentice, dated 1836, stains, faded, unfinished, matted, framed. 35″ × 36″
Garth 5/86 **$450**

Alphabet, flowers, silk, Eliza Johnson, Leominster, Massachusetts, 1809, similar known. 16½″ × 17½″
Skinner 1/85 **$500**

Alphabet, flowers in cartouche, silk, Susan Cutler, 1811. 15½″ × 16½″
Skinner 3/85 **$495**

Alphabet, flowers, linen backing, Agusta [sic] Brown, Fitchburg, Massachusetts, 1824, excellent condition. 13″ × 13½″
Skinner 6/87 **$1,400**

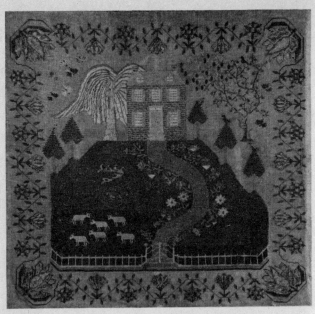

Early 19th-century Delaware Valley silk and watercolor sampler on linen, 20″ height × 21½″ width. (*Private collection*)

Alphabet, foliage, verse, homespun, green, blue, yellow, brown, black, Elizabeth L. Mason, 1846, stains, holes, framed. 21½″ × 21½″

Garth 5/86 **$400**

Alphabet, genre scene, silk on natural linen, Sarah Johnson, Newport, Rhode Island, 1769, illustrated, provenance, darkened linen. 9″ × 16″

Skinner 5/85 **$21,000**

Alphabet, landscape, silk on linen, Narcessa M. Pierce, probably 19th century. 16″ × 21″

Skinner 5/86 **$400**

Alphabet, landscape, embroidered silk, Lois Burnham, Massachusetts, 1775. 15¾″ × 22″

Christie's 5/87 **$2,000**

Alphabet, numbers above flowers, Susan B. Caswell, 1825, rosewood frame. 11½″ × 12½″

Skinner 3/85 **$300**

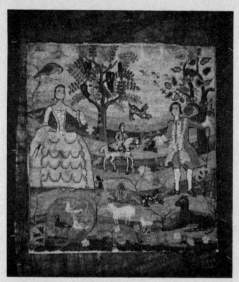

Mid-18th-century Boston, Massachusetts, needlework picture attributed to Fishing Lady School. (*Photo courtesy of Carol and Steve Huber*)

Alphabet, numbers, genre, needlework on linen, Mary E. Amos, early 19th century. 17″ × 16″

Weschler 9/86 **$225**

Alphabet, pictorial, Elvira Bell, probably Massachusetts, c. 1820, documentation. 15″ × 15¾″

Sotheby's 1/84 **$3,000**

Alphabet, pictorial, blue, gold, pink, black, Harriot [sic] N. Munroe, 1800–1825, provenance, original frame, stains, fading, corrosion, damage. 16″ × 12″

Skinner 6/87 **$375**

Alphabet, pictorial, house, figures inside floral border, Melinda Borden, Massachusetts, 1814, good condition, workmanship, documentation, darkened line. 17″ × 16¼″

Sotheby's 6/87 **$3,250**

Alphabet, schoolhouse, Margaret Kibbes, New England, 1806, silk on dark green ground, loose threads. 16½″ × 22″

Sotheby's 1/87 **$34,000**

Alphabet, verse, floral border, Elenora Bakers, 1835, holes. 21″ × 16″

Skinner 1/87 **$225**

Alphabet, verse, embroidered needlework, Catherine Shute, Hopkinton, New Hampshire, 1823, dated, provenance, signed. 16½″ × 20″

Christie's 5/87 **$2,000**

Alphabet, verse, numbers, buildings, landscape, blue, pink, green, black, and gold, East Sudbury, Massachusetts, 1816, stains. 16″ × 16″

Skinner 1/87 **$750**

Alphabet, verse, flowers, Betsey Battles, 1819, original frame. 15½″ × 16″

Skinner 3/87 **$3,400**

Alphabet, verse, Esther Shwers, Virginia, 1808, embroidered silk on linen, beautiful, documentation, provenance, original frame, small hole, minor imperfections. 25²/₂″ × 16¼″

Sotheby's 6/87 **$16,000**

Alphabet, village, silk on linen, Hannah Thayer, Randolph, Massachusetts, 1818, published, some discoloration. 18″ × 16½″

Sotheby's 1/87 **$9,000**

Alphabets, flowering tree, homespun, Harriet W. Silberts, 1840, stains, small hole, fading, old gilt frame. 14″ × 20½″

Garth 7/86 **$250**

Alphabets, homespun linen, "E.L.," 1825, stains, fading, tear, framed. 14¾″ × 16¾″

Garth 7/86 **$150**

Alphabets, initials, signed, 1885, minor stains, frame worn. 24¾″ × 29¾″

Garth 7/86 **$230**

Alphabets, inscription, homespun, faded, some floss missing, modern frame, small. 6½″ × 13½″

Garth 2/87 **$150**

Alphabets, primitive birds, hearts, flowers, homespun, good color, some floss missing, names indistinct, pine frame. 10¾″ × 10¾″

Garth 2/87 **$100**

Alphabets, small figure, bird, homespun linen, dated 1786, faded, name indistinct, mahogany veneer frame. 12″ × 13¼″

Garth 2/87 **$400**

Alphabets, trees, flowers, homespun, Mary Bowmar Wragby, 1809, good color, worn, damage. 8″ × 10¾″

Garth 5/86 **$325**

Alphabets, verse, birds, crowned lions, potted flowers, homespun, Mary Ann Brewster, 1822, some stains, bleeding colors, damage, small, framed. 9″ × 13⅞″

Garth 7/86 **$175**

Alphabets, verse, homespun, inscribed, dated 1815, faded small holes, framed. 14″ × 17¾″

Garth 2/87 **$225**

Animals, poem, silk on linen, Oprah P. Lewis, Chester County, Pennsylvania, 1825.

Sotheby's 1/87 **$7,000**

Black on white woven support, pale blue pinstripe, inscription, dated 1867, gilt frame. 9″ × 15½″

Garth 5/86 **$200**

Boston School needlework picture, wool and silk, Caleb Rice, Sarah Henderson, Sturbridge, Massachusetts, excellent condition, provenance, illustrated. 16″ × 21″

Skinner 1/85 **$19,000**

Boston School needlework picture, silk on linen, blue, green, pink, ivory, Sarah Henderson, 1765, provenance, similar published, illustrated. 21″ × 18½″

Skinner 1/85 **$20,000**

Building in landscape, Catherine Anderson, early 19th century. 12½″ × 16½″

Skinner 6/86 **$450**

Churches among children, flowers, wool on linen, Mary Butz, Kutztown, Pennsylvania, 1842, exhibited. 17½″ × 24″

Sotheby's 1/87 **$13,000**

Family record, "Crane," embroidered, 1824, discolored, some fading. 18″ × 17″

Skinner 5/86 **$320**

Family record, alphabet, hearts, Lucy Ann William, Charlestown, Massachusetts, dated 1830, similar piece published.

Sotheby's 1/84 **$1,300**

Family record, a register: the Stone Family, embroidered silk thread on linen canvas, early 19th century. 16¾″ × 16¾″

Christie's 6/84 **$140**

Family record, embroidered, Elizabeth Rowe, probably Massachusetts, 1830, provenance, dated documentation, good condition. 17″ × 15″

Sotheby's 6/87 **$1,200**

Family record, fine linen backing, Hannah Ann Sperry, Bristol, Connecticut, 1825, unframed, torn, stains. 16½″ × 16½″

Skinner 5/85 **$100**

Family record, Loomis Family, Connecticut, late 18th century, illustrated, minor stains. 10¹/₂″ × 16″

Skinner 11/85 **$3,100**

Family record, silk on natural linen, Eleanor Robertson, Massachusetts, 1831, corrosion of threads. 18″ × 22″

Skinner 3/85 **$400**

Family record, silk, Louisa Davis, Portland, Maine, c. 1825, provenance, illustrated, excellent condition. 22″ × 22″

Skinner 5/85 **$11,500**

Family record, silk on linen, Daniels Family, Providence, Rhode Island, 1832, illustrated. 16″ × 18″

Skinner 11/85 **$1,000**

Floral genre scene, Margaret MacLean, 1794. 12¹/₂″ × 9″

Skinner 11/85 **$3,000**

Flowers, fauna, Ann Davison, 1843. 17″ × 18″

Skinner 11/85 **$425**

Flowers, fauna, Anne Green, New Hampshire, 1741, rebacked. 20¹/₂″ × 8¹/₄″

Skinner 11/85 **$1,400**

Flowers, fauna, Nancy Rawnsley, probably New York, early 19th century, original mahogany Empire frame, stained. 12¹/₂″ × 12¹/₂″

Skinner 6/86 **$450**

Flowers, mermaids, silk and lace, probably Mary Tratt, Boston, Massachusetts, 17th century, good condition, provenance, illustrated. 7¹/₂″ × 22³/₄″

Skinner 5/86 **$2,500**

Fruits, flowers, silk on natural linen, Sarah Tomlinson, New England, 1796. 12″ × 16″

Skinner 6/86 **$500**

Fruits, flowers, silk on natural linen, Elizabeth Coward, probably Pennsylvania, 1813. 15¹/₂″ × 16″

Skinner 6/86 **$700**

Genre scene, Maria S. Furrer, 1829, documentation. 16″ × 17¹/₂″

Christie's 5/87 **$5,000**

Genre scene, silk on natural linen, possibly Hannah Nimble, Marblehead, Massachusetts, late 18th century, provenance, corrosion of material. 7″ × 10¹/₂″

Skinner 11/86 **$3,000**

Genre scene, silk on natural linen, Sally Butman, Marblehead, Massachusetts, 1801, good condition, provenance, illustrated. 10³/₈″ × 12¹/₂″

<div align="right">

Skinner 11/86 **$15,000**
</div>

Genre scene, woman in landscape, Ruthy Rogers, Marblehead, Massachusetts, c. 1788, provenance. 9″ × 10¹/₂″

<div align="right">

Skinner 6/86 **$198,000**
</div>

House, animals, vine border around poem, Martha C. Hooton, 1827, published, exhibited.

<div align="right">

Sotheby's 1/87 **$40,000**
</div>

House, trees, flowering border, verse, homespun, Eliza Reed, minor stains, fading, framed. 19¹/₂″ × 22″

<div align="right">

Garth 5/86 **$900**
</div>

Landscape, embroidered on linen, Mary Garr, 1827. 18″ × 16″

<div align="right">

Weschler 9/86 **$500**
</div>

Landscape, embroidered silk, 1750–1800, provenance, similar pieces known. 16¹/₂″ × 17″

<div align="right">

Christie's 5/86 **$19,000**
</div>

Landscape, silk on linen, Emma Dubel, 1835, provenance, stained from colors running. 16″ × 17″

<div align="right">

Skinner 5/86 **$650**
</div>

Landscape, silk on linen, Kitty Dubel, 1822, illustrated, yarn loss, holes. 17″ × 19¹/₂″

<div align="right">

Skinner 5/86 **$3,250**
</div>

Landscape, silk on linen, Hariot [sic] Stanwood, illustrated, provenance, some yarn corrosion. 16″ × 17″

<div align="right">

Skinner 5/86 **$4,300**
</div>

Landscape, verse, silk on linen, Eliza Carter, Peterboro, New Hampshire, 1811, good condition, provenance. 16³/₄″ × 17″

<div align="right">

Skinner 5/86 **$4,000**
</div>

Memorial, building in landscape, brown, green, black, Ann Hopkins, 1816, illustrated, stains. 16″ × 16″

<div align="right">

Skinner 1/87 **$3,000**
</div>

Memorial, silk on silk, c. 1820, damage, repairs. 22″ × 23¹/₂″

<div align="right">

Skinner 1/85 **$400**
</div>

Miniature, letters, stitches missing, framed. 6³/₄″ × 8¹/₄″

<div align="right">

Garth 5/86 **$150**
</div>

Pastoral scene, silk on silk, embroidered, Mary Flower, Philadelphia, Pennsylvania, 1764, rare, documentation, original frame, signed, similar pieces known, publicity. 25″ × 21³/₄″

<div align="right">

Christie's 5/87 **$60,000**
</div>

Pastoral scene, verse, embroidered, Mary Fentun, 1787, inscribed, discolored. 21 1/4" × 16 1/2"

Christie's 10/86 **$2,600**

Pictorial, Mary Ann Morton, Portland, Maine, 1820, documentation, provenance, exhibited, published. 20 1/2" × 16 1/2"

Sotheby's 1/84 **$12,000**

Pictorial, Mary S. Little, probably Rhode Island, 1833. 17" × 16 3/4"

Sotheby's 1/84 **$1,000**

Pictorial, Mary Snowden, Philadelphia, Pennsylvania, 1800, some holes, discoloration, glass replaced. 24" × 23"

Sotheby's 1/84 **$1,300**

Pictorial, Sally Bullock, Providence, Rhode Island, 1789, beautiful color, condition, workmanship, date, unusual design, published, documentation. 17" × 13 1/2"

Sotheby's 6/87 **$110,000**

Pictorial, Sarah Otilla and Ann Carver, Pennsylvania, 1833. 18" × 18 3/4"

Sotheby's 10/86 **$3,100**

Rows of alphabets, numerals, 23rd Psalm, homespun, lone [sic] Elliott, 1722, found in Massachusetts, good color, minor wear, fraying, some damage, modern frame. 10 1/4" × 23 1/4"

Garth 7/86 **$950**

Stag, flowers, Sophia Hunt, 1846, provenance, holes, stains. 16" × 17"

Skinner 11/86 **$300**

State House, silk on linen, Eliza Waterman, Providence, Rhode Island, 1788, published, exhibited, provenance.

Sotheby's 1/87 **$192,500**

Tappan Inn, embroidered needlework, Jane Mable, Orangetown, New Jersey, documentation. 16" × 18"

Christie's 5/87 **$2,400**

Verse, Mary Ann Brown, 1823, provenance, stained. 21" × 17"

Skinner 7/86 **$400**

Verse, buildings, silk on natural linen, Caroline N. Arnfield, probably middle Atlantic states, 1838, illustrated, stained. 15 1/2" × 16"

Skinner 6/86 **$475**

Verse, floral design, Emma Abell, possibly Higham, Massachusetts, c. 1860. 15" × 13"

Weschler 5/87 **$325**

Verse, flowers, Susan Chase Marble, 1827, gilt-stencilled frame, minor stains, fading. 16″ × 17″

Skinner 1/85 **$225**

Verse, flowers, Emily Furber, Portsmouth, New Hampshire, 1827, unusual frame, illustrated. 23″ × 26″

Skinner 11/85 **$2,400**

Verse, flowers, fauna in cartouche, silk on natural linen, Nancy Walker, probably New York, 1816. 16″ × 12″

Skinner 6/86 **$500**

Verse, flowers, linen backing, Eliza Machett, New York, 1828, illustrated, provenance, holes. 16½″ × 16″

Skinner 7/86 **$500**

Verse, flowers, fauna, Mary Hawick, 1835, provenance, holes. 13″ × 12″

Skinner 11/86 **$300**

Verse, flowers, Susanna Stuttle Lawrence, 1840, holes. 12½″ × 16″

Skinner 6/87 **$375**

Verse, landscape, silk on linen, Eliza Kemmish, 1836, excellent condition, provenance. 13¼″ × 13½″

Skinner 5/86 **$900**

Verse, landscape, Salem, Massachusetts, 1750–1775.

Skinner 5/86 **$7,400**

Verse, pictorial, Ann Osborn, Lancaster county, Pennsylvania, 1823, discoloration, holes.

Sotheby's 1/84 **$1,000**

Verse, oval cartouche in gold, blue, pink, green, and brown, floral border, Mary Hyslop, 1812, holes. 16″ × 12½″

Skinner 1/87 **$400**

Verse over flowers, silk on linen, Louise S. Campbell, 1824, excellent condition, provenance. 17″ × 16¾″

Skinner 5/86 **$2,500**

Verse, six-stanza poem, finely stitched, dated 1780, old gilt frame. 10″ × 19½″

Garth 3/87 **$75**

Village scene, silk on linen, probably Newburyport, Massachusetts, 1775–1825. 16″ × 17″

Sotheby's 1/86 **$92,500**

Needlework

General Pictures

Adam and Eve, "GE," 1825–1850, illustrated, similar known, fraying. 7″ × 12″

Skinner 1/85 **$7,000**

Adam and Eve, embroidered silk, wool threads on linen, Catherine Miller, New England, 1791, provenance, publicity, minor discoloration. 17″ × 21″

Christie's 10/84 **$7,500**

Basket of flowers, embroidery on paper, 19th century. 7½″ × 9¼″

Skinner 3/85 **$300**

"Cornelia's Jewels," silk on silk, painted faces, Mary Beach, Massachusetts, early 19th century, documentation, published, provenance.

Sotheby's 1/84 **$8,250**

Embroidered, painted, silk on silk, Ann Faulkner, New England, dated 1814, provenance, original gilded frame. 17″ × 13″

Sotheby's 6/87 **$4,750**

Figural scene, wool, silk, and metallic yarns on natural linen, North Shore, Massachusetts, 1750–1775, illustrated. 8¼″ × 9¼″

Skinner 1/86 **$22,500**

Figural scene, faces and sky in oil paint, mid-19th century, mahogany-veneered Empire frame. 24″ × 16″

Skinner 6/87 **$100**

"Fishing Lady," wool on canvas, Quincy Family, Massachusetts, c. 1750, similar well known. 31″ × 36″

Sotheby's 1/84 **$3,500**

Genre scene, black people, wool embroidered, initialed "MED," Reading, Pennsylvania, 1876.

Skinner 6/86 **$1,900**

Genre scene, sprig bud and blossom border, Mary Hofecers [sic] Pennsylvania, 1798, stains, minor running. 21″ × 20″

Skinner 6/86 **$2,300**

Hunting scene, embroidered silk, Mary Flower, Philadelphia, Pennsylvania, dated 1768, good workmanship, inscribed, provenance, signed, rare. 18½″ × 23″

Christie's 1/87 **$187,000**

"The Lady of the Lake," embroidered, paint, yarn sewn on silk, Mrs. Phoebe Petit, Sandy Hill, New York, 1825, original gilt and gessoed wooden frame, restoration, holes.

Sotheby's 6/87 **$4,250**

Landscape, Elizabeth Arnold, Warwick, Rhode Island, 1807, fading, stains. 27″ × 21″

<div align="right">

Skinner 6/87 **$275**
</div>

Map of Boston Harbor, silk, Sally Dodge, Boston, Massachusetts, 1800, published, illustrated, similar known, splits in silk backing. 19″ × 23″

<div align="right">

Skinner 3/85 **$3,900**
</div>

Moses in the bulrushes, silk panel, watercolor details, torn, fragile, oval mat, gilded frame. 18³/₄″ × 23″

<div align="right">

Garth 5/86 **$185**
</div>

Pair of panels, stylized floral designs, birds, gold, green, brown, bluish-gray, inscribed, minor damage, stains, old frames. 10″ × 12″

<div align="right">

Garth 3/87 **$850**
</div>

Panel, colorful scene, sheep, church, people, flowers, ivory ground, minor wear, stains, unframed. 16³/₄″ × 25¹/₂″

<div align="right">

Garth 2/87 **$150**
</div>

Picture, Sally Phelps, Litchfield, Connecticut, c. 1800, gilt lettering, oval mat.

<div align="right">

Sotheby's 6/86 **$9,000**
</div>

Picture, twelve stars, embroidered silk on great seal panel, c. 1900, oak frame. 29″ × 24″

<div align="right">

Weschler 6/86 **$800**
</div>

Steam and sailing vessels, woolwork, 1850–1900. 22″ × 29″

<div align="right">

Sotheby's 10/86 **$2,100**
</div>

Verse, genre scene, Esther Hibbards, Chester County, Pennsylvania, 1824, published. 24″ × 15¹/₂″

<div align="right">

Skinner 3/87 **$7,000**
</div>

The Washington family, probably Massachusetts, c. 1810, provenance.

<div align="right">

Sotheby's 1/87 **$5,250**
</div>

Woman with basket of flowers holding a lamb, Pennsylvania, early 19th century, original frame, unusual design. 8″ × 10″

<div align="right">

Phillips 1/84 **$1,000**
</div>

Woman in garden, small silk panel, partial inscription, faded oval gilt frame, some repair. 8¹/₂″ × 9⁷/₈″

<div align="right">

Garth 2/87 **$200**
</div>

Miscellaneous

Lady's picket, marked: "M.F.," Pennsylvania, late 18th century. 10″ × 8¹/₄″

<div align="right">

Sotheby's 10/86 **$1,700**
</div>

Mourning Pictures

Angels, tomb, trees, woman, green, brown, black, gold, lavender, inscription, signed "Emma Marsden," dated 1862, stitches missing, framed. 27 1/2″ × 27 1/2″

Garth 5/86 **$65**

Animals, angels, floral border, embroidered inscription, Fanny Ashworth, 1867. 16″ × 18″

Weschler 9/86 **$250**

Mourning sampler, embroidery on silk, Sara Ann Pitt, possibly Baltimore, Maryland, c. 1809, inscribed. 14 1/2″ × 11″

Weschler 9/86 **$250**

Tomb, weeping woman, child, embroidered on worn red silk, lively though faded, matted, framed. 19 1/2″ × 21 1/2″

Garth 5/86 **$100**

Tomb, willow, blooming roses, white, green, red, black needlework, punched blue paper memorial, inscription: "E. Campbell, dated 1855," wear, torn, unframed. 17 1/2″ × 21 3/4″

Garth 5/86 **$25**

Tomb, willow, flowering roses, punched blue paper memorial, inscription: "A.D. Ten Eyck, Argusville, Feb 23, 1853," wear, colors faded, framed. 14″ × 18 1/2″

Garth 5/86 **$100**

Tomb, woman, willow, landscape, soft colors, silk, watercolor added, printed inscription listing Larkin family members, tear in silk, oval mat, gilt frame. 14″ × 15 3/8″

Garth 5/86 **$375**

Urn, tombstone, willow trees, embroidered, painted on silk, McLellan family members, Gorham, Maine, c. 1800, provenance, original frame. 16″ × 18″

Sotheby's 6/86 **$3,000**

Woman, tomb marked Werter, silk floss on wool flannel, felt, paper hands, face, watercolor details, lovely old colors, frayed, worn, old gilt frame. 16 3/8″ × 18″

Garth 5/86 **$350**

Scherenschnitte

Scherenschnitte are paper cuttings derived from Pennsylvania German-Swiss traditions. The earliest American forms are from the late eighteenth century and were love letters (liebesbrief) and birth certificates (taufschein). Various Protestant sects such as the Moravians, Seventh Day Baptists of Ephrata, Scwenkfelders, Mennonites, and many adherents of the Lutheran and Reformed Church produced this type of work. Scherenschnitte uses a technique of cutting paper in a continuous design after folding the paper from one to three times for uniform pattern repeats, and it should not be confused with paper cuttings made from using a knife.

Rylands, William, "Jacob's Ladder," cut and pierced paper, possibly Pennsylvania, early 19th century, discolored. 11 1/2" × 8"
Christie's 6/84 **$1,000**

Scrimshaw

Scrimshaw signifies engraved carvings on whalebone and whale teeth executed primarily by sailors associated with the American whaling industry during the nineteenth century. Simple jackknives, sail needles, files, and saws made from barrel hoops functioned as tools. After being carved and etched, the design was highlighted by rubbing it with a mixture of a varnish fixative and ink. This darkened the carved design on the ivory. In addition to such utilitarian items as bodkins, boxes, busks, canes, clothespins, dippers, ditty boxes, jagging wheels, pie crimpers, plaques, rolling pins, and swifts, scrimshaw or scrimshaw decoration appears on whimseys and whale's teeth themselves.

Box, oval, baleen, pine top and bottom, buildings, lighthouse, ships scrimshandered, c. 1850, cracks, damage. 4" × 6 1/2" x 5"
Skinner 6/86 **$550**

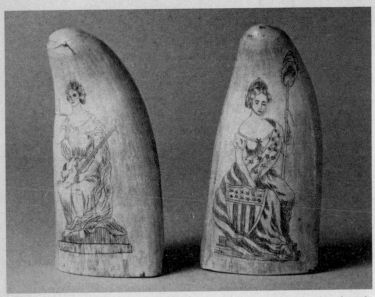

Two late 19th-century New England scrimshaw teeth, depicting female figures, one in classical motif and the second with patriotic symbols. (*Photo courtesy of Sotheby's, New York*)

Busk, carved hearts, wheels, crosshatching, initialed "M.S.," late 18th century, cracked.

Skinner 3/85 **$200**

Busk, sketch of Washington, schooner, late 18th century. L 13½"

Skinner 6/86 **$900**

Busk, engraved and polychromed pan bone, initials: "M.A.D.," c. 1845, fine workmanship.

Sotheby's 1/87 **$1,300**

Cane, ivory, clenched hand, 1825–1850.

Skinner 3/87 **$550**

Dipper, whale ivory, carved ebony, c. 1900. L 16"

Sotheby's 1/84 **$375**

Dolphin jaw, engraved bone, Napoleon III on horseback, rigged ship, c. 1860. L 20¼"

Sotheby's 1/84 **$700**

Ivory tusk, 19th century, fine patina, workmanship. L 66"

Sotheby's 6/86 **$2,000**

Mid-19th-century carved ivory eating utensils from the Maritime Provinces. (*Photo courtesy of Muleskinner Antiques*)

Jagging wheel, seahorse, carved ivory, ebony, c. 1870, repair.

Sotheby's 1/87 **$5,000**

Jagging wheel, arm holding serpent, whalebone, ebony, c. 1870, repairs. L 8 1/2 ″

Sotheby's 1/87 **$1,600**

Jagging wheel, trident tail, carved ivory, c. 1870, excellent workmanship. L 5 3/4 ″

Sotheby's 1/87 **$5,500**

Pan bone, engraved bone, whaling bark, c. 1850, some warping. 8 3/4 ″ × 14 1/2 ″

Sotheby's 1/84 **$2,750**

Porpoise jaws: a pair, engraved bone, two whaling vessels, cracks. 12 1/2 ″ and 14 ″

Sotheby's 1/84 **$125**

Powder horn, carved and engraved, dated 1776, inscription. L 11 ″

Skinner 3/85 **$750**

Powder horn, engraved French and Indian war map, mid-18th century, provenance. L 13″

<div align="right">

Sotheby's 1/86 **$2,200**
</div>

Snuff box, bone, fitted cover, early 19th century, inscription. 2½″ × 1¼″

<div align="right">

Skinner 11/85 **$425**
</div>

Swift, ivory, bone, red paint, 19th century, cracked. H 26½″

<div align="right">

Skinner 1/86 **$550**
</div>

Table yarn swift, whale bone, 19th century, damaged. H 16½″, case: 4½″ × 17½″ × 4″

<div align="right">

Skinner 11/86 **$850**
</div>

Walrus tusk, engraved, polychromed, design of "Liberty," flag, eagle, shield over whale, c. 1870. H 14″

<div align="right">

Skinner 1/86 **$750**
</div>

Walrus tusks: pair, carved ivory depicting "Liberty" and "Justice." New England, good condition, craftsmanship, one damaged. L 22½″

<div align="right">

Phillips 5/87 **$700**
</div>

Watch holder, mahogany and inlaid whale ivory, whale bone, dated 1839. 11″ × 7″

<div align="right">

Sotheby's 1/87 **$1,300**
</div>

Whale's tooth, finely detailed engraving of eagle, olive branch, and arrows, inscription, dated 1878, excellent condition, craftsmanship. L 72″

<div align="right">

Phillips 5/87 **$1,400**
</div>

Whale's tooth, sperm whale: "The Confederate Cruiser," 1863, documentation.

<div align="right">

Sotheby's 6/86 **$1,500**
</div>

Whale's tooth, "Susan's Tooth," provenance, documentation, similar pieces known, published, exhibited.

<div align="right">

Sotheby's 6/86 **$25,000**
</div>

Ship Models

Ship models are decorative objects often created by seamen using simple tools: a jackknife, awl, needle and file. The most collectible pieces are the fully rigged models of actual ships. Eclectic folk art

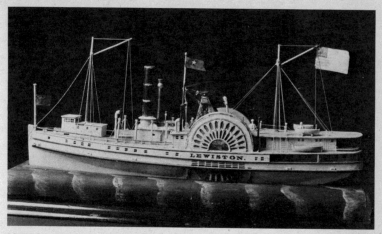

Mid-19th-century American ship model, *The Lewiston*, 14″ height × 29″ length. (*Photo courtesy of The Red Piano Gallery*)

forms include composite features of no specific ship but several vessels, and are frequently named after a daughter, wife, or sweetheart. Ambitious artisans created dioramas (three-dimensional scenes) in which a fully rigged ship or half model is placed against a background simulating an ocean setting.

Ship, encased half ship, three-masted schooner, smokestack, lifeboats, crew members, mid-19th century. Case 21½″ × 40″ × 6″
Skinner 1/85 **$300**

Ship, half ship in shadowbox, mounted, 19th century. D 15″
Skinner 3/85 **$325**

Ship, "Sarah Ann," carved and painted wood, New England, 19th century. H 11″ × 14″
Skinner 11/85 **$385**

Ship, three-masted bark, early 20th century, encased, excellent example. H 11½″ × L 18″
Skinner 11/85 **$800**

Ship, two half ships on rough sea, late 19th century, framed. 24″ × 44″
Skinner 1/86 **$350**

Whale boat, carved and painted wood, with crew, L.A. Keegan, Kingston, Rhode Island, 1941, minor damage to boat and stand. L 15″
Skinner 11/86 **$400**

Old Town Canoe, labeled "Old Town Canoe Co., Old Town, Maine," 1900–1925, good condition, illustrated. L 48″
<div align="right">Skinner 6/87 $2,400</div>

Ocean liner, "Fleischmann," twin stacks, two masts, four lifeboats, four flags, tin plate, white with blue and white hull. L 20″
<div align="right">Phillips 6/87 $2,700</div>

Ferry, "Keywind," twin pilot houses, two side wheels, tin plate, excellent condition, craftsmanship. L 16″
<div align="right">Phillips 6/87 $2,800</div>

Gun boat, tin plate, "Bing," original two-tone gray paint, excellent craftsmanship, flaking. L 25½″
<div align="right">Phillips 6/87 $2,800</div>

Shop and Cigar Store Figures/Trade Signs

Shop and Cigar Store Figures

The cigar store figure was most popular during the last half of the nineteenth century. Makers of cigar store figures tended to include artisans who had been forced to find new ways of income when the market for figureheads and other ship carvings declined. Not all cigar figures were Indians. Many were popular figures such as foreigners (Turks), average folk (preachers, ladies of fashion, policemen, sailors), characters of folklore and history (Punch, Sir Walter Raleigh), American symbols (Uncle Sam), and topical notables (Dolly Yarden, Admiral Dewey). By the early 1900s, sidewalk obstruction laws prohibited these figures from being set in front of shops, and what has been called the most popular trade sign ever known became all but extinct by 1925.

Boy, carved, painted, probably American, late 18th century, full-length, tricorn hat, long frock coat, repainted several times, loss of detail, missing arm, foot, provenance,
<div align="right">Skinner 1/86 $3,400</div>

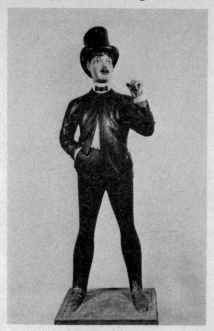

Late 19th-century New England full figure, carved and painted, wooden trade sign in the form of a race track tout. (*Photo courtesy of Sotheby's, New York*)

Charles Oliver, Tom Long, M.D., driver and medical preparer, carved and painted, gilded hickory wood, figure with mortar and pestle, exhibited, published. H 57"

Skinner 1/87 **$30,000**

Indian, papier-mâché, painted, c. 1880, feathered headdress, holds cigars, base painted with "A. R. Ring's Cigars 5 cents," some paint loss. H 51"

Skinner 3/85 **$500**

Indian, painted wood, 19th century, carved on both sides, raised tomahawk, provenance, illustrated. H 78"

Skinner 1/86 **$5,000**

Indian brave, c. 1870, feathered headdress and blanket, holds cigars, original paint under worn repaint. H 32½"

Skinner 3/85 **$500**

Indian, carved and painted pine, 1850–1870, fine craftsmanship. H 67"

Skinner 1/84 **$2,250**

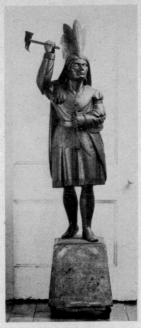

Late 19th-century American carved and painted wooden cigar store Indian. (*From the collection of Patricia and Sanford Smith*)

Indian maiden, late 19th century, feathered headdress, green robe over red dress, carved and painted, some restoration. H 41½"

Skinner 3/85 **$2,800**

Indian maiden, late 19th century, restored. H 41½"

Sotheby's 5/86 **$2,800**

Indian maiden, attributed to William Demuth, New York, c. 1890, molded zinc, polychrome, holding cigars, tomahawk, wooden standard on wheels, weathered, cracked at ankles. H 68¼"

Skinner 6/87 **$11,500**

Indian princess, painted wood, probably New York State, 1850–1875, feathered headdress, holding books, cigars, some age cracks, on blocks and wheels.

Skinner 1/86 **$40,000**

Indian princess, molded zinc, polychrome, William Demuth, New York, 1890, minor color loss. H 67½"

Skinner 3/87 **$11,000**

Indian warrior, W. Demuth & Co., polychromed, cast zinc, provenance, published. H 68 1/2 "

Sotheby's 1/84 **$10,000**

Indian warrior, cast zinc, polychromed, William Demuth & Co., New York, 1870, published, illustrated. H 68 1/2 "

Skinner 1/84 **$11,000**

Punch, counter top, carved and painted wood, Charles Henkel, Brattleboro, Vermont, 1870, dated, inscribed, signed, publicity, cracked. 26 " × 9 " × 9 "

Christie's 10/86 **$18,000**

Punch, carved and painted, 1850–1900, some repair. H 82 "

Skinner 1/87 **$23,000**

Uncle Sam, 19th century, counter-top figure, provenance. H 39 3/4 "

Skinner 1/86 **$2,400**

Trade Signs

Prior to the standardization of English in 1825, literacy was rare. Signs identified shops and services, the local tavern/inn's location, and charges for roads, bridges, ferry crossings, and travel directions. Two-dimensional painted signs display animals, birds, and fanciful abstractions. Three-dimensional carved figures include Gabriel calling the townsfolk to drink, barber poles, boots for boot makers, teeth for dentists, fish for fish markets, and eyeglasses for opticians. It was common for portrait, coach, and house painters to also paint trade signs.

Apothecary sign, gilt mortar, pestle, glass panels, late 19th century, replacements, incomplete. H 36 "

Skinner 1/86 **$1,200**

Barber's pole, turned wood, red, white, old repaint. H 50 "

Garth 5/86 **$175**

Barber's pole, turned wood, red, white, blue, gold finial, worn old repaint, age cracks. H 77 "

Garth 7/86 **$475**

Barber poles, pair: (A) Acorn finial, weathered paint. H 92 " (B) Ball finial, wall bracket, 19th century, paint cracked. H 35 "

Skinner 1/86 **$300**

Butcher's sign, cast iron, 19th century. H 20 "

Sotheby's 1/84 **$700**

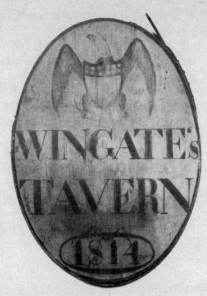

Early 19th-century New England oval, painted wooden tavern sign. (*Photo courtesy of Sotheby's, New York*)

Dapper Dan, carved and painted wood, found in Washington, D.C., c. 1880, provenance, published, beautiful workmanship, excellent condition.

Sotheby's 10/86 **$258,500**

Doctor's sign: Dr. Lovejoy, painted wood, black lettering, late 19th century. H 120″ × L 36″

Skinner 3/85 **$240**

Dress-making sign, wood, yellow letters, red edging, white ground. 13³/₄″ × 74″

Garth 7/86 **$100**

Firehouse sign, carved relief on wood banner, gold leaf decoration, late 19th century. H 10¹/₂″ × L 26″

Skinner 3/85 **$475**

Fish, carved and painted wood, probably New England, restored. H 20¹/₂″

Sotheby's 1/84 **$2,000**

Fish, carved and gilded wood, early 20th century. 57¹/₄″ × 17″

Christie's 10/86 **$4,000**

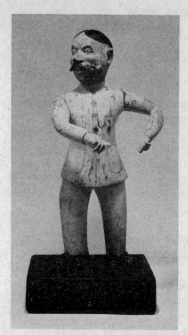

Late 19th-century New England carved and painted wooden sculpture, depicting a barber. (*Photo courtesy of Sotheby's, New York*)

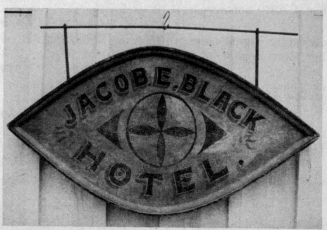

Late 19th-century New England wooden and iron trade sign for a hotel, 21″ height × 41″ width × 3″ depth. (*Photo courtesy of Sterling & Hunt*)

Fishmonger's sign (fish), carved pine, wrought iron, gold leaf surface, c. 1860, illustrated, weathered. H 140″ × L 40″

Skinner 6/86 **$4,100**

Hand and umbrella, polychromed cast iron, 19th century. 40″ × 15″

Christie's 5/87 **$2,400**

Honey trade sign, general store, painted wood, beehive gilt top, shaped base, turned feet, red ground, mid-19th century. H 8″

Skinner 3/85 **$500**

Indian scout, painted wood, wrought iron molding, William Follett, Massachusetts, c. 1830, both sides painted. 50″ × 60″

Sotheby's 10/86 **$23,000**

Leather shoe sign, three dimensional, painted, leather, 20th century. H 41″ × L 26″

Sotheby's 1/84 **$2,750**

Male figure, wood, signed "M.L. Paine," found in Dallas, Texas, c. 1900, similar pieces well known. H 50½″

Sotheby's 10/86 **$45,000**

Office sign: Isaac Randall's Office, gilt-carved letters, wood, 19th century, weathered.

Skinner 11/85 **$350**

Pig, copper, molded on copper base. H 19½″ × L 29″

Sotheby's 1/87 **$4,750**

Post office sign, rectangular, black, gold, green lettering and decoration, c. 1870, some wear. H 10″ × L 72″

Skinner 11/85 **$300**

Semicircular signs: pair, brown paint, Philadelphia Drug Exchange, worn, weathered, age cracks, holes for flags. 9″ × 24″

Garth 5/86 **$130**

Shoe, painted wood, leather, 20th century, unusual design. 26″ × 41″

Sotheby's 1/84 **$2,500**

Shop sign: Isaac Randall's Office, carved and painted, gilt, 19th century, weathered. 17″ × 60″

Skinner 5/86 **$350**

Spectacle sign, cast iron, gilt-painted cast frames, one blue, one red, late 19th century. H 17″ × L 32″

Skinner 6/87 **$900**

Spectacle sign, brass, cast brass frame, one glass blue, one red, late 19th century, damaged, cracked. H 18″ × L 25″

Skinner 8/87 **$225**

Tavern sign, wood, golden eagle above shield, c. 1820. 27 1/2 ″ × 35 ″

Skinner 1/85 **$900**

Tavern sign: Ozias Coleman Jr. Inn, carved and painted, signed "Morgan Lewis," probably New York, late 18th century, inscribed.

Sotheby's 1/86 **$2,500**

Undertaker's sign, wood, with picture-frame molding, black, white paint, stencilled letters, A.H. Seals. 12 1/2 ″ × 25 ″

Garth 7/86 **$75**

Silhouettes

Profile paper cuttings, or shades, are usually cut black negatives depicting a head and shoulder portrait against a white ground, although reverse procedures are known as well. The term derived from the eighteenth-century profile portraitist and finance minister Etienne de Silhouette, and they were popular in America from 1790 to 1850 when they yielded to the daguerreotype.

Known Artists

Edouart, Auguste T., man and woman, cut paper, 1829, dated, signed, documentation, water damage. 10 1/4 ″ × 9 ″

Christie's 1/84 **$390**

Folwell, S., miniature of George Washington, watercolor and needlework, 1791, good design and form, unusual, provenance. 3 1/2 ″ × 2 1/2 ″

Sotheby's 1/84 **$700**

Unknown Artists

Double portrait: gentleman and lady, c. 1840, original gold leaf frame, repainted. 12 ″ × 9 1/2 ″

Skinner 5/85 **$150**

Full-length figure group: couple, three children, black glazed paper, embossed detail, cream, green gound, tear in background, old gilt frame. 11 1/4″ × 15″

Garth 5/86 **$130**

Gentleman, signed "Aug," Boston, Massachusetts, 1828, newspaper on backing.

Skinner 3/85 **$200**

Gentleman, hollow cut, inscription: "Thos. Edwards," 1838, provenance. 6 1/4″ × 7 1/2″

Garth 3/87 **$300**

Man and woman with child, black paper cut-out on a watercolor background, beveled poplar frame. 13 3/4″ × 17 3/4″

Garth 3/87 **$350**

Pair: boy and girl, hollow cut, Eglomise glass, gilt frame, stained. 5 1/4″ × 6 1/2″

Garth 2/87 **$60**

Pair: man and woman, hollow cut, Eglomise glass, gilt frame, inscription, stained. 5″ × 7 5/8″

Garth 2/87 **$65**

Pair, primitive cut, signed "M.A. Honeywell," some wear, soiling, old gilt frame chipped. 8 1/2″ × 10″, 5 1/4″ × 6 1/2″

Garth 2/87 **$250**

Pair of portraits, watercolor, hollow cuts, c. 1825, peeling.

Sotheby's 1/87 **$1,000**

Six profiles, one reverse painting on glass, early 19th century, assorted frames.

Sotheby's 1/87 **$350**

Triple portrait: three boys, pen, ink, reverse-painted sky and grass, early 19th century, sitters known, illustrated, glass broken. 6 1/4″ × 8 1/2″

Skinner 11/86 **$1,800**

Two full-length portraits: (A) Gentleman (B) Lady, probably Connecticut, c. 1840, sitters known, unmatched frames. 10″ × 7 3/4″

Skinner 11/85 **$225**

Two girls, cut paper, c. 1840, inscribed. 3″ × 2 1/2″

Weschler 9/86 **$125**

Young boy with rose, watercolor, c. 1830, original frame. 2 3/4″ × 3 1/2″

Skinner 7/86 **$450**

Tables and Candlestands

Tables

Country tables followed formal furniture styles with simpler lines. Workmanship varied with the maker's capabilities, from primitive execution to fine cabinetmaking. Indigenous domestic woods such as pine, walnut, poplar, and maple were favored.

Country drop leaf, wood, turned legs, pine top, old refinishing, replaced top, swivel leaf support arms replaced, loose hinge, leaves warped. 29¾″ × 19¾″ × 46¾″ with 13¼″ leaves

Garth 3/87 **$55**

Country, Federal style single drawer, cherry, birch, bird's-eye maple, New England, c. 1810, refinished. 28″ × 18″ × 16″

Skinner 5/86 **$325**

Country folding type, oak base, round hardwood top, bentwood edge strip, V-shaped swivel arm, refinished, some repairs, replaced base, some edge damage, age cracks, worm holes. H 28″ × D 36″

Garth 3/87 **$175**

Country Hepplewhite demilune, pine, square tapered legs, nailed curved apron, two-board top, old red paint worn, repairs, replacements. H 28¾″ × 18″ × 35¾″

Garth 2/87 **$275**

Country Hepplewhite, pine, square tapered legs, one-board top, pale blue paint over gray and red, stained, age crack. H 29″ × 19½″ × 36″

Garth 3/87 **$200**

Country Hepplewhite work table, poplar, square tapered legs, one-board top, base worn green enamel, age cracks, legs braced. H 28¼″ × 28½″ × 72″

Garth 3/87 **$195**

Country hutch type, poplar, one-board ends have well-shaped cut-out feet, refinished, some yellow overpaint, old replaced top, seat lid rehinged. 30″ × 28¼″ × 48″

Garth 3/87 **$500**

Country, pine, square tapered legs, H stretcher, one-board top, some edge damage, age crack, late 29th century. H 26¼″ × 18″ × 30″

Garth 3/87 **$175**

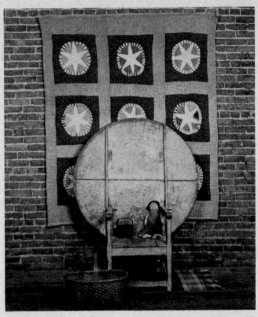

American country grouping featuring an early 19th-century New England hutch table in original paint. (*Photo courtesy of Butterfield's*)

Country Queen Anne drop leaf swing leg, maple, cabriole legs, duck feet, cut-out apron, small size, minor filled age cracks, old metal brace added, leg scratched, two returns missing. H 26″ × 13 1/2″ × 42″ with 13 3/4″ leaves

Garth 2/87 **$3,100**

Country Queen Anne style tavern table, red paint, turned legs, three-board curly maple top, handmade reproduction by Jim Johnston, Delaware, Ohio. H 27 3/8″ × 23″ × 20 3/4″

Garth 2/87 **$175**

Country Queen Anne work table, butternut base, tapered, turned legs, blue paint, natural patina, worn feet, one overlapping dovetailed drawer, removable pine top old replacement, repairs. 36 3/4″ × 73 1/2″

Garth 2/87 **$900**

Country sawbuck, reconstructed from old pine, wrought iron nails, one-board top, good red finish, added braces. 28 3/4″ × 24 1/2″ × 60″

Garth 3/87 **$375**

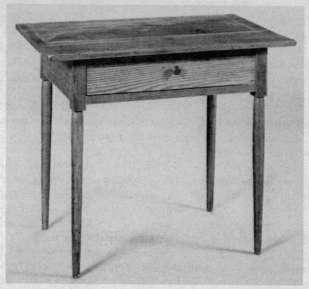

Late 19th-century American Shaker maple tavern table, probably New Hampshire in origin, 28¼″ height × 35″ width × 21″ depth. (*Photo courtesy of Christie's, New York*)

Country Sheraton table, walnut turned legs, reeded detail, one dovetailed, cock-headed drawer, two-board top, pine wood, old worn finish, minor age crack in top. H 30″ × 23″ × 29¾″

Garth 2/87 **$475**

Country tavern table, splayed base, turned tapered legs, oval top, repairs, replaced top, old red repaint, legs cut down. H 25″ × 23½″ × 37½″

Garth 3/87 **$75**

Country tilt top tea table, oak, well-shaped legs, turned column, three-board top, refinished. H 28½″ × D 31¾″

Garth 2/87 **$325**

Country walnut drop leaf, turned legs, beveled edge on leaves, good color, minor age cracks, refinished, stained, minor warp in top. H 28¼″ × 18½″ × 41½″ with 2¼″ leaves.

Garth 2/87 **$125**

Country work table, poplar, turned legs, mortised and pinned apron, three-board top, cherry-colored finish. H 30″ × 28″ × 36″

Garth 3/87 **$350**

Federal style, painted and decorated pine, Baltimore, Maryland, c. 1815, restoration. 34 1/2 ″ × 45 ″ × 23 ″

Sotheby's 1/84 **$2,500**

Hepplewhite card table, mahogany, inlay, bird's-eye diamonds on apron, some repairs, warped, bad veneer application. 28 1/4 ″ × 17 1/2 ″ × 36 ″

Garth 2/87 **$475**

Hepplewhite drop leaf, swing leg, mahogany, six square tapered legs, one-board top, leaves replaced, repairs. H 28 1/2 ″ × 20 ″ × 49 1/4 ″ with 19 ″ leaves

Garth 2/87 **$300**

Hepplewhite Pembroke, cherry, square tapered legs, banded inlay around base of apron, one dovetailed drawer, replacements. H 26 1/2 ″ × 21 ″ × 34 1/2 ″ with 9 3/4 ″ leaves

Garth 2/87 **$175**

Hutch table, carved and painted pine, mid-18th century. 27 ″ × 46 ″

Sotheby's 1/84 **$3,500**

Sawbuck, pine, New England, 19th century. 28 ″ × 59 ″ × 24 ″

Skinner 5/86 **$600**

Sheraton card table, mahogany, turned, reeded legs, curly maple veneer, edge damage, reattachments, top replaced, worn old finish, top warped. H 28 1/2 ″ × 13 3/4 ″ × 35 3/4 ″

Garth 2/87 **$1,250**

Side, square feet, plain frieze, painted and turned maple, probably Pennsylvania, early 19th century. 28 ″ × 18 ″ × 19 ″

Skinner 1/87 **$950**

Side, William and Mary style, turned and carved walnut, probably Virginia, c. 1740, provenance.

Sotheby's 1/87 **$8,250**

Tea, Queen Anne style, cherry wood, Connecticut, c. 1750, extremely fine, repairs. 24 ″ × 30 ″ × 20 1/2 ″

Sotheby's 1/87 **$145,000**

Work table, Federal style tiger maple, painted and decorated, Massachusetts or New Hampshire, c. 1820, minor varnish loss, replacements. 29 ″ × 18 ″ × 16 1/4 ″

Skinner 5/86 **$1,000**

Work table, single drawer, overhanging rectangular top, square tapering legs, New England, c. 1800. 27 ″ × 23 1/2 ″ × 20 ″

Skinner 5/86 **$800**

Candlestands/Stands

Candlestands, found in a variety of styles, are small wooden tables used to support candles. Persisting for hundreds of years, candlestands ceased to be made with the advent of electric light. Typically the table and post are supported by crossbar feet, though contoured feet and flat feet were made during the eighteenth and nineteenth centuries respectively. Other examples include the screw type and tripod feet. These have been reproduced a great deal.

Chippendale, cherry, arris cabriole legs, pad feet, New England, c. 1770, restored. 28″ × 15″ × 16″

Skinner 6/86 **$800**

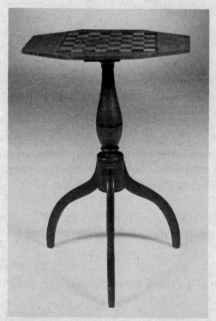

Early 19th-century New England paint-decorated candlestand with gameboard top. (*Photo courtesy of Sotheby's, New York*)

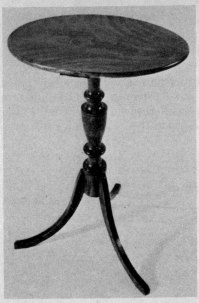

Early 19th-century American grain-painted wooden candlestand from the Portsmouth, New Hampshire, area, 20″ height. (*Photo courtesy of Litchfield Auction Gallery*)

Country type, curly maple with cherry legs on small ball feet, turned column and one-board top with rounded corners, repairs to legs where they join base, more are necessary, age cracks in top of post, refinished. 27½″ × 16¼″ × 17⅝″

<div align="right">

Garth 3/87 **$325**
</div>

Country type, ash, spider legs, turned column and rectangular top, refinished, top is stained and gallery has minor edge damage. 30″ × 12¾″ × 20¼″

<div align="right">

Garth 2/87 **$175**
</div>

Federal, maple, painted, three spider legs, probably New England, c. 1800. 28½″ × 15″ × 17½″

<div align="right">

Skinner 1/85 **$400**
</div>

Hepplewhite tilt-top, cherry with old dark varnish stain finish, spider legs, turned column, rectangular two-board top with cut corners, minor repairs, top is old replacement. 28″ × 14″ × 20½″

<div align="right">

Garth 2/87 **$350**
</div>

Country tilt-top, walnut with old dark finish, late 19th century, repairs, top replaced. 29″ × 18⅞″ × 23¼″

Garth 2/87 **$140**

Candlestand, country Federal style, tripod cabriole legs, possibly Connecticut, c. 1810. H 27⅝″

Skinner 5/86 **$900**

Candlestand, country make-do, octagonal top, tripod cabriole leg case, New England, 18th century, refinished. 26″ × 15″

Skinner 8/87 **$150**

Candlestand, country Queen Anne style, New Hampshire, c. 1780, original red paint, minor repairs. H 26″

Skinner 5/86 **$900**

Candlestand, hexagonal top, painted, decorated checkerboard top, New England or Midwest, c. 1820, common form. 25″ × 21½″ × 16½″

Sotheby's 10/86 **$1,200**

Candlestand, stained maple, 1825–1850. 24″ × 13¾″

Sotheby's 1/87 **$700**

Candlestand, tilt top, birch, snake feet, turned column, reproduction, repairs. 29½″ × 18½″ × 19″

Garth 2/86 **$150**

Cherry, turned edges, three dovetailed curved drawers, worn, refinished, replacements, edge damage. 29″ × 19½″ × 23½″

Garth 3/87 **$200**

Country, cherry, well-turned edges, one drawer, one-board top, refinished, good color, top refastened. 31″ × 18½″ × 23″

Garth 2/87 **$200**

Country, cherry base, tapered post legs, maple, refinished, some repair, edge damage, top replacement, leg chewed. 29¾″ × 22¼″ × 22¾″

Garth 3/87 **$195**

Country, turned legs, one drawer, worn blue paint over red, replacements. 26¾″ × 15⅝″ × 18¾″

Garth 5/86 **$225**

Country Empire, cherry, well-turned edges, one dovetailed drawer, scrolled apron, maple, opalescent pull, top reattached, braces aded, old finish has been cleaned down, but good color. 29″ × 22¼″ × 22½″

Garth 3/87 **$475**

Country Hepplewhite, cherry, square tapered edges, one nailed drawer, two-board top, old reconstruction, age cracks. 28½″ × 19¾″ × 23¼″

Garth 2/87 **$175**

Country work stand, walnut, turned feet, two dovetailed overlapping drawers, one-board top, turned wooden pulls, pine, old alligatored varnish finish. 29³/₄″ × 20″ × 36″

Garth 2/87 **$1,600**

Curly maple, turned edges, one dovetailed drawer, old worn refinishing, good color. H 30¹/₂″ × 23³/₄″ × 24¹/₄″

Garth 3/87 **$500**

Primitive, tripod base, cut-out legs, cylindrical column, two-board rectangular top, old gray paint. 28¹/₂″ × 17¹/₂″ × 22¹/₂″

Garth 7/86 **$60**

Primitive, pine, legs removable, worn dark paint, red, yellow striping. H 28¹/₄″ × D 19³/₄″

Garth 7/86 **$65**

Primitive wooden stand for wash tub, Shaker, attributed to Enfield, Connecticut. 10″ × 12″ × 27″

Garth 5/86 **$60**

Stand, cherry, turned legs, one dovetailed drawer, one-board top, red-grained finish, repairs, insect hole. 29″ × 17¹/₄″ × 20″

Garth 2/86 **$145**

Stand, decorated, vinegar-grained maple, pine, New England or Midwest, c. 1830. H 30³/₄″ × L 22″

Sotheby's 10/86 **$8,000**

Walnut, well-turned legs, one dovetailed drawer, one-board top, old refinishing, good color. 29³/₄″ × 22³/₄″ × 28¹/₂″

Garth 2/87 **$350**

Tinware

Tin was a popular material for teapots, candle sconces, chandeliers, and document boxes. Kitchen utensils were also fashioned from this durable metal. It was common to decorate tinware by painting it. Tinware is sometimes mistakenly called toleware. Toleware is actually French-painted tinware. Another means of decorating tin is to dent the surface with a hammer and nail. When holes are created, the result is called pierced tin.

Mid-19th-century Pennsylvania miniature tin shoe, made as a 10th wedding anniversary gift with a painted heel and a cut floral decoration, 4 1/2″ height × 2″ width. (*Photo courtesy of Bari and Phil Axelband*)

Box with original bale handle, blue paint, yellow striping, lid in silver, bands of gold, green, red and black striping, paint original but worn. L 11 1/2″

Garth 3/87 **$60**

Boxes, two: (A) Flat top with hasp, gold-stencilled lid, flowers and Friendship, worn original black paint. L 6 1/4″ (B) Beveled-edge lid, brass bale handle, lock and key, worn old dark paint. L 8 5/8″

Garth 3/87 **$70**

Bread tray, painted and decorated tin, 19th century. L 12 1/2″

Christie's 1/87 **$1,600**

Candleholders: a pair, painted and decorated tin, rare. H 5 1/2″

Christie's 1/87 **$2,800**

Coffee pot,, wriggle work decoration, Pennsylvania, early 19th century, similar pieces in museums with provenance known, finial missing, corrosion. H 12 1/2″

Sotheby's 10/86 **$2,800**

Coffee pot, conical and hinged dome lid, fitted brass finial, early 19th century. H 10 1/2″

Sotheby's 1/87 **$3,700**

Coffee pot, painted and decorated floral motif on black, hinged lid, brass finial, early 19th century. H 10¾"

 Sotheby's 1/87 **$1,200**

Coffee pot, painted and decorated tin, early 19th century. H 10½"

 Christie's 1/87 **$3,700**

Coffee pot, tin punch work, rare.

 Sotheby's 1/87 **$2,500**

Coffee pot, wriggle work decoration, Pennsylvania, early 19th century, similar pieces known. H 8¼"

 Sotheby's 1/87 **$1,800**

Hatbox, red paint, black striping, polychrome crest, B. Oscar Doyle P.C., paint original but worn, damaged. H 14"

 Garth 2/87 **$110**

Hat, tenth anniversary piece, Chapeau de Bras with ostrich plum. 6½" × 16"

 Skinner 6/87 **$250**

Lamp, green paint, c. 1840, damaged. H 10"

 Sotheby's 1/86 **$700**

Oil lamp, polychromed, early 19th century. H 7¼"

 Sotheby's 1/87 **$700**

Sugar bowl and creamer, red, green, yellow, 19th century.

 Sotheby's 1/87 **$900**

Tray, Victoria, New York, 1844, painted, rare, provenance.

 Skinner 1/87 **$4,500**

Tray, early 19th century, painted flowers, yellow brush-stroke decoration, paint loss. 9" × 12½"

 Skinner 3/87 **$175**

Toys

Rocking horses were a favorite toy among young American children during the nineteenth century. Many examples have survived and show wide gradations of skill among the craftsmen. They range from the very primitive wood carvings to the elaborate full-figured horse with leather ears and real horsehair tails.

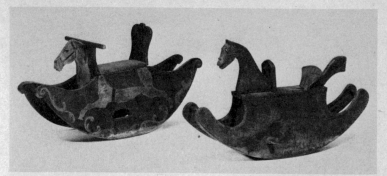

Two late 19th-century New England carved and painted wooden rocking horses, 42″ and 41″ length. (*Photo courtesy of William Doyle Galleries, Inc.*)

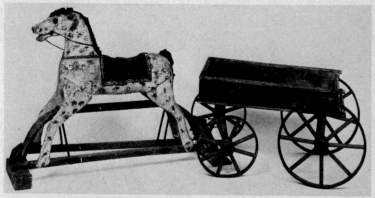

Late 19th-century Pennsylvania carved and painted wooden rocking horse with fabric saddleblanket and pulling wagon, 28″ height × 40″ length. (*Photo courtesy of All Of Us Americans Folk Art*)

Noah's ark was another popular toy. The many hand-carved miniature wooden animals provided hours of entertainment and enjoyment for American children. The variety of animal breeds enabled one to learn these different species. These are some of the many various toys that were available to children of the eighteenth and nineteenth centuries.

Figure: female and washboard, wood, cloth, primitive. L 11½″

Garth 2/86 **$16**

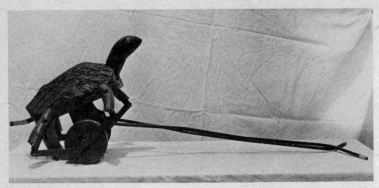

Early 20th-century New England carved and painted wooden turtle pull toy. (*Private collection*)

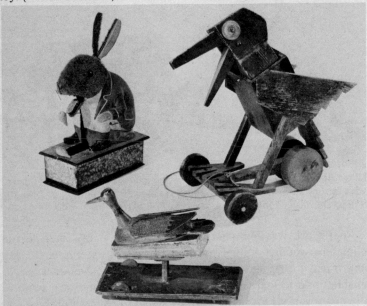

Group of three late 19th- and early 20th-century New England wooden and painted toys. (*Private collection*)

Horse-drawn police wagon: Happy Hooligan, cast iron, yellow and red paint, excellent craftsmanship, repairs. L 17½"

Phillips 6/87 **$2,800**

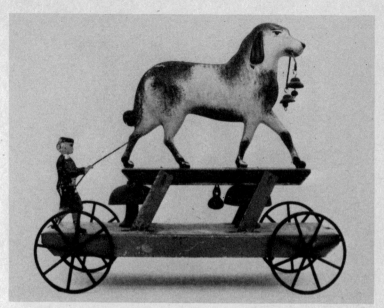

Late 19th-century American tin toy. (*Private collection*)

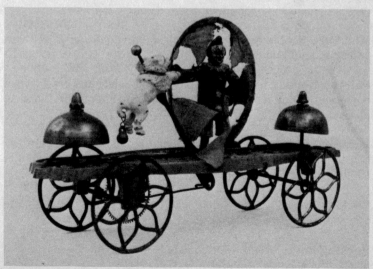

Late 19th-century American tin toy. (*Private collection*)

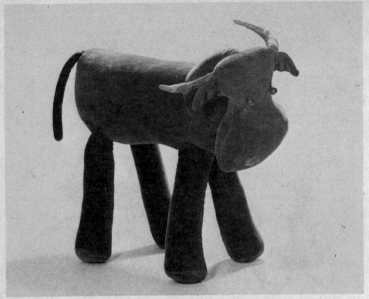

Early 20th-century American velvet stuffed moose toy. (*Photo courtesy of Muleskinner Antiques*)

Miniature Noah's ark, eight animals, woman (missing arms), original paint, good condition, some damage. L 6³/₈″

Garth 7/86 **$200**

Miniature Noah's ark, seven animals, one figure, original paint, good condition, lid cracked. L 7³/₄″

Garth 7/86 **$300**

Pull toy: horse, carved and painted wood, white and gray, brown mane and tail, green base, red wheels, late 19th century, missing pieces.

Skinner 6/87 **$375**

Puzzles, set of two, carved and painted wood, (A) Lantern toy puzzle sculpture (B) Stepped carved box with hinged lid, found in Virginia. 11¹/₂″

Sotheby's 10/86 **$400**

Rocking horse, wood, leather seat, painted, c. 1840, minor damage, worn. H 31¹/₂″ × L 60″

Skinner 1/85 **$400**

Rocking horse, wood, painted dapple gray, leather seat, red and black, probably Massachusetts. H 31″ × 68″

Skinner 1/85 **$1,000**

Rocking horse, carved and painted wood, dapple gray, horsehair mane, tail, glass eyes, leather accessories, trestle foot base, c. 1880. 54″ × 72″

Skinner 3/85 **$1,800**

Rocking horse, carved and painted wood, dapple gray, metal eyes, bentwood supports, New England, c. 1880. 38″ × 45″

Skinner 1/86 **$625**

Rocking horse, carved and painted wood, dapple gray on white and red turned base, c. 1880, minor restoration. H 49″ × 52″

Skinner 1/86 **$1,200**

Rocking horse, carved and painted dapple gray, metal eye, horsehair, New England, c. 1880. 38″ × 45″

Skinner 5/86 **$575**

Sled, red with gold scrolls, name and picture of dog, dated 1905, repairs. L 61″ × W 12″

Skinner 5/85 **$325**

Soldier, carved and painted pine, movable arms, blue hat, red and yellow vest, decorated pine, Pennsylvania, 1780–1815, published, similar pieces known, publicity. 14⅛″

Christie's 10/85 **$4,500**

Soldier, carved and painted pine, straight movable arms, blue jacket, red vest, possibly Pennsylvania, 1780–1815, published, publicity. H 14″

Christie's 10/85 **$5,800**

Squeak, cardinal bird, mid-19th century. H 7″

Skinner 1/85 **$225**

Team of horses, painted tin sheet on oak block, articulated, probably Pennsylvania, 19th century. H 19½″

Sotheby's 1/87 **$4,800**

Wagon, rectangular splat, side rail on plank seat, tin wheels, green paint, c. 1820. 24½″ × 31″ × 22″

Skinner 11/86 **$550**

Wagon, small, red painted pine, 19th century. 13¾″ × 40″

Sotheby's 1/87 **$700**

Whistle, nude male, carved pine, 19th century. H 7½″

Skinner 3/85 **$650**

Valentines

The American custom of giving valentines began before the middle of the eighteenth century. Early American valentines were handmade, the makers using watercolor, pen work, scissor-cut and pinprick decoration. Pennsylvania German examples are among the most distinctive scissor-cut and colored pinprick decoration. Some Pennsylvania German valentines were embellished with "fraktur schriften," a highly ornamental writing style. In girls' seminaries and academies, theorems or stencils combined with watercolor were a favored style. Commercial lithographs colored by hand appeared around 1840. Wide distribution of engraved woodcuts and aquatints was followed by lacy and embossed styles, and this culminated in flamboyant combinations incorporating photographs, textile netting, and/or stand-up figures.

"To Miss Martha Henshall," John Peacock Grenadier, New England, c. 1800, inscription of famous verse. $12'' \times 6\frac{3}{4}''$
Sotheby's 10/86 **$2,100**
Eight hearts, verse, watercolor on paper, c. 1840
Sotheby's 1/87 **$400**

Wall Racks and Shelves

Wall racks, storage boxes, and shelves for hanging on walls or sitting on cupboards were used by early settlers. They served the same functions as those pieces do today. They held pipes, candles, spoons, combs, and various foodstuffs. Commonly made of wood, some of the more fanciful of these utilitarian containers were decorated by handcarving, machine fretwork, incising, and painting.

Hanging, green-painted pine. 31 1/2" × 49 1/2"

Sotheby's 1/87 **$1,300**

Hanging, modified whale end, walnut frame, three shelves, mid-19th century, old repair. 21" × 24"

Skinner 8/87 **$425**

Hanging, walnut, brown sponge decoration, four shelves, natural finish, c. 1840, top shelf split. H 28"

Skinner 1/85 **$750**

Hanging salt box, inscribed "S.S. Plank," near Allensville, Pennsylvania, dated 1888, provenance.

Sotheby's 1/87 **$4,500**

Hanging spoon rack, glazed, painted and decorated pine, gilded, Milford Township, Bucks County, Pennsylvania, c. 1800, dated, rare, workmanship, documentation, inscribed, provenance, published, similar pieces known. 18 1/2" × 9"

Christie's 1/87 **$41,000**

Hanging spoon rack, John Crissel, Bucks County, Pennsylvania, 1800, painted and decorated. 18 1/2" × 9 1/4"

Sotheby's 1/87 **$41,000**

Plate rack, dovetail cut-out sides, five rails, old brown paint, New England, c. 1780. 32" × 39" × 8"

Skinner 5/85 **$650**

Set of triangular-shaped hanging shelves, insect damage, age cracks, repainted, top crest incomplete. H 26"

Garth 3/87 **$70**

Spoon wall rack, red painted wood, two tier, "A.H.," 19th century, illustrated. 17 1/2" × 12 1/2" × 7"

Skinner 5/86 **$600**

Weather Vanes

Weather vanes were used to forecast weather conditions. The first symbols were sheet iron or wooden banners and religious figures depicting the cockerel and angel Gabriel. Until the mid-19th century, virtually all weather vanes were handcrafted. With the Industrial Age, however, notable commercial vane makers like J. W. Fiske of New York City and J. Harris & Son of Boston, Massachusetts, became established. Companies like these began to use molds to form full-figure animals, people, and other familiar images. The eagle became a favorite design motif as well as other patriotic figures (George Washington, Columbia). Animals such as pigs, horses, and cows appeared as well.

Angel Gabriel blowing horn, 19th century, sheet metal silhouette, silver, modern black wooden base. H 16″ × L 23″

Skinner 1/87 **$500**

Angel Gabriel with trumpet, 19th century, exhibited. H 18″ × L 24″

Sotheby's 1/87 **$34,000**

Apple tree, sheet iron silhouette, cut-out directionals, probably early 20th century, illustrated. H 30″

Skinner 5/86 **$5,600**

Armed bi-plane, blue paint, two-blade propeller, cannons, wings, 20th century. 28″ × L 27″

Skinner 11/86 **$485**

Arms of Massachusetts with Massasoit Indian, J. Harris & Co., Boston, Massachusetts, 1850–1875, unusual size, distinguished design. 50″ × 61″

Sotheby's 1/87 **$14,500**

Arrow, wood and tin, late 19th century or early 20th century, paint loss. L 19″

Skinner 6/87 **$225**

Banner, copper, cut-out silhouette on arrow, directionals, late 19th century, incomplete. H 26″

Skinner 6/87 **$225**

Banner, copper and zinc, lyre-shaped tail, peacock feather finial, possible J. Howard, West Bridgewater, Massachusetts, mid-19th century, unlabeled. H 19″ × L 70″

Skinner 6/87 **$2,700**

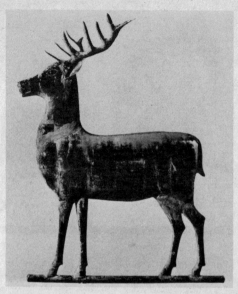

Late 19th-century New England cast-metal deer weather vane. (*Private collection*)

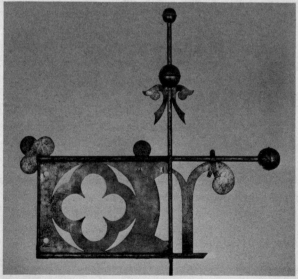

Late 19th-century New England banner weather vane, 30″ length. (*Photo courtesy of Muleskinner Antiques*)

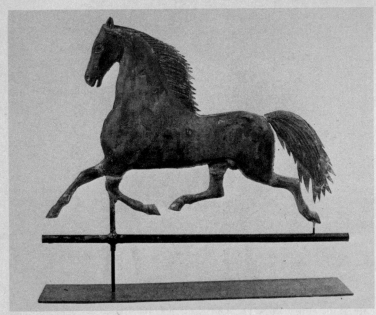

Late 19th-century New England molded copper weather vane, depicting the horse "Black Hawk," 22″ length. (*Photo courtesy of Olde Hope Antiques, Inc.*)

Banner, silhouette of arrow banner made from factory accessories: gear wheel, textile bobbins, steam regulator, yellow, Lafayette, Rhode Island, mid-19th century, directionals, illustrated, provenance, very weathered paint. L 50″
Skinner 8/87 **$2,500**

Bannerette, cast iron, cut sheet copper, J. Howard & Co., West Bridgewater, Massachusetts, 1850–1875. H 7¾″ × L 24″
Sotheby's 1/87 **$1,600**

Boathouse, carved and painted wooden silhouette, eastern shore of Maryland, c. 1920, published. H 22½″
Sotheby's 10/86 **$3,500**

Bull, copper, gilded, New England, 19th century. H 18″ × L 25″
Sotheby's 1/87 **$3,200**

Car with driver, copper silhouette, Prides Crossing, Massachusetts, C. 1914, illustrated, provenance, minor damage. L. 44″
Skinner 6/87 **$6,250**

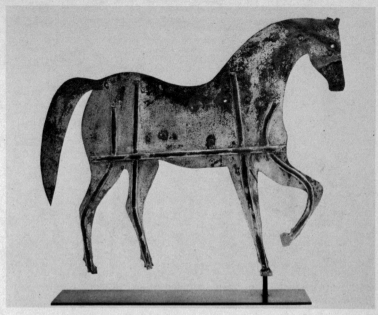

Late 19th-century New England sheet-iron horse weather vane. (*Photo courtesy of Harvey Antiques*)

Centaur, probably A. L. Jewell & Co., Waltham, Massachusetts, c. 1860, provenance, fine condition, original gilt. H. 30 1/4″ × L 40″

Skinner 6/87 **$143,000**

Cherub: North Wind, molded copper, arrow and directionals included. 23″ × 56 1/2″

Christie's 5/87 **$17,000**

Cock, cast iron, sheet iron, traces of gold leaf, directionals, c. 1860, weathered, rust. H 22″

Skinner 11/87 **$2,100**

Cod, molded and gilded copper, metal base, late 19th century or early 20th century. 18″ × 35 1/2″

Sotheby's 1/84 **$1,100**

Cod, molded copper, New England, c. 1880. 8 3/4″ × 26″

Skinner 5/86 **$4,700**

Cow, copper and zinc, rod, black base, 19th century. 33 1/4″ × 46 1/4″

Sotheby's 1/84 **$2,400**

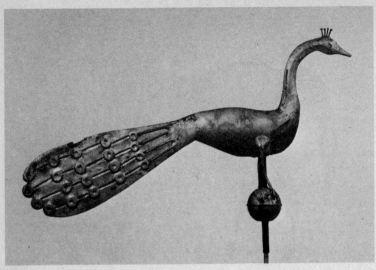

Early 19th-century Pennsylvania molded copper peacock weather vane. *(Photo courtesy of Sotheby's, New York)*

Cow, copper, traces of gold leaf, mounted on pipe, possibly J. Howard, mid-19th century, illustrated, seam separation, minor damage. H 15½″ × L 27″

Skinner 11/85 **$800**

Cow, copper, 19th century, repairs. H 15″ × L 28″

Skinner 7/86 **$1,900**

Cow, copper, zinc, late 19th century, horn missing, dents, repaired bullet holes. H 15″ × L 26″

Skinner 1/87 **$1,800**

Cow, copper, zinc, metal base, J. Harris & Co., 1850–1875, restored gilding. H 24″ × L 28″

Sotheby's 1/87 **$6,750**

Cow, molded and gilded copper, zinc, J. W. Fiske, New York, 1850–1875. 33″ × 46¼″

Sotheby's 1/84 **$2,400**

Cow, molded copper, L. W. Cushing & Sons, Waltham, Massachusetts, 1850–1875, provenance, published.

Sotheby's 1/84 **$5,000**

Cow, molded copper, zinc, L. W. Cushing & Sons, Waltham, Massachusetts, 1850–1875, similar pieces known. H 17½″

Sotheby's 10/86 **$3,800**

Cow, molded copper, zinc, 19th century. H 29¹/₂″
 Sotheby's 6/87 **$2,500**
Deer or stag, copper, wrought iron on rod, 19th century, unusual design. H 26¹/₄″ × L 25¹/₂″
 Sotheby's 1/87 **$7,000**
Eagle, copper, gilt, c. 1880, weathered. 33″ × 30″ × 27″
 Skinner 5/85 **$2,250**
Eagle, molded and gilded copper. 26¹/₄″ × 23″
 Sotheby's 1/84 **$1,100**
Eagle on globe, copper, gilt, c. 1880, repaired. H 24″ × W 36″
 Skinner 6/86 **$1,300**
Eagle on sphere, molded copper and iron, gilded, arrow with directionals, probably 19th century. 65″ × 24¹/₂″
 Christie's 6/84 **$1,600**
Ewe, copper, late 19th century, dents, no rod. H 18″ × W 29″
 Skinner 7/86 **$1,150**
Fish, wood, iron rod, Dexter: attribution, Maine, 19th century, primitive, repairs. L 34″
 Skinner 11/85 **$450**
Fish, wood, inserted carved fins, relief details, weathered, age cracks, traces of red, yellow paint.
 Garth 5/86 **$180**
Fish, carved, painted and gilded wood, 19th century, also used as trade sign.
 Sotheby's 10/86 **$6,500**
Fish, wood with tin tail, fins, tack eye, 19th century, weathered, worn paint. H 14″ × L 28″
 Skinner 11/86 **$800**
Fisherman and fish, carved and painted wood, good condition. L 29″
 Oliver 7/87 **$450**
Flying horse, A. L. Jewell & Co., Waltham, Massachusetts, c. 1870, published, fine condition. L 35¹/₂″
 Skinner 11/86 **$7,000**
Four-wheel sulky and driver, molded copper and zinc, J. W. Fiske: attribution, New York, c. 1887. 17″ × 51¹/₂″
 Christie's 1/87 **$15,000**
Foxhound, L. W. Cushing & Sons, Waltham, Massachusetts, c. 1833, weathered verdigris, traces of gold leaf, very fine condition, published. 27″
 Skinner 11/86 **$12,500**

Game cock, sheet copper tail, traces of gold leaf, late 19th century, dents, damaged. H 18″

Skinner 11/86 **$1,100**

Goddess of Liberty, molded copper, Thomas W. Jones, New York, c. 1884, provenance, published.

Sotheby's 1/84 **$26,000**

Goddess of Liberty holding 13-star flag, red, white paint traces on copper, Cushing and White, Waltham, Massachusetts, 1865, replacements. H 23″

Skinner 1/86 **$11,000**

Grasshopper, copper, verdigris, 20th century, illustrated H 19″ × 34½″

Skinner 1/86 **$950**

Horse, copper and zinc, 19th century, unusual small size. H 13″ × L 24″

Sotheby's 1/84 **$1,400**

Horse, cast iron, sheet iron tail, Rochester Iron Works Co., Rochester, New Hampshire, 1850–1875, provenance. 19½″ × 24″

Sotheby's 1/84 **$2,500**

Horse, molded copper, cast zinc, J. Howard & Co., West Bridgewater, Massachusetts, 1850–1875, provenance, published. 19″ × 24½″

Sotheby's 1/84 **$9,250**

Horse, sheet copper, Cushing: attribution, mid-19th century, bullet holes, seam separation on tail. H 16″ × L 28″

Skinner 1/86 **$400**

Horse, molded copper, cast zinc, c. 1875. H 26½″ × L 34¼″

Sotheby's 1/86 **$4,000**

Horse, copper, gilding, poor condition, damage, repairs. L 31″

Garth 2/86 **$325**

Horse, primitive, sheet metal, pitted, minor damage, traces of aluminum paint. H 20¾″

Garth 7/86 **$100**

Horse, molded sheet metal on rod, 1850–1875, unusual design. H 24″ × L 31″

Sotheby's 1/87 **$2,900**

Horse and buggy, brass, copper with directionals, probably late 19th century. H 60″

Weschler 9/86 **$600**

Horse: American Girl, molded, painted, later gold mount, c. 1880, repaired bullet holes. H 18″ × L 32″

Skinner 1/86 **$500**

Horse: George Patcham, copper, 20th century, patina. H 15″ × L 39″

Skinner 1/86 **$550**

Horse: Index, molded copper, cast zinc, J. Howard & Co., West Bridgewater, Massachusetts, 1850–1875, provenance, rare, traces of original gilding. H 14″

Sotheby's 1/84 **$11,000**

Horse: Index, molded copper, cast zinc, J. Howard & Co., West Bridgewater, Massachusetts, 1850–1875, similar piece published. H 25″

Sotheby's 10/86 **$5,250**

Horse: Index, copper, zinc on rod with finials, J. Howard & Co., West Bridgewater, Massachusetts, 1850–1875. H 16″ × L 17½″

Sotheby's 1/87 **$18,000**

Horse: Lady Suffolk, copper, J. Howard & Co.: attribution, c. 1880, bullet holes. H 21″ × L 29″

Skinner 11/85 **$3,300**

Horse and groom, sheet copper and sheet iron, old gold leaf, mid-19th century, dents, seam breaks. H 20½″ × L 30″

Skinner 11/85 **$650**

Horse and rider, molded copper, found in Sunapee, New Hampshire, rare, provenance. 20½″ × 18¾″

Sotheby's 1/84 **$5,000**

Horse and rider, molded and gilded copper, zinc, 19th century. 20″ × 30½″

Sotheby's 6/87 **$2,500**

Horse and rider on arrow, painted sheet tin, 19th century, exhibited. H 8½″

Sotheby's 1/86 **$3,500**

Horse silhouette, primitive iron figure, traces of old paint, tail replaced, modern wooden base. H 14″

Garth 2/87 **$175**

Horse and sulky, molded copper, 1850–1875, exhibited, bullet holes. 19″ × 34½″

Sotheby's 6/87 **$3,600**

Jockey on horse, sheet iron silhouette, mustard yellow, brown, c. 1900, minor rust. H 21″ × L 30″

Skinner 1/86 **$400**

Jockey and horse, cut-out wooden silhouette, 20th century, weathered white, black paint, repairs. L 19″

Garth 5/86 **$175**

Jumping horse, sheet copper, zinc, A. L. Jewell & Co., Waltham, Massachusetts, 1850–1875, provenance.

Sotheby's 1/84 **$34,000**

Jumping horse, sheet iron, mustard yellow, black mane and tail, wood base, metal arrow, c. 1900, bullet holes, rust. H 21½″ × L 42″

Skinner 1/86 **$150**

Leaping stag, late 19th century, illustrated, regilded. H 26″ × L 27″

Skinner 6/86 **$2,750**

Leaping stag, molded copper, J. W. Fiske, New York, 1850–1875. H 13″

Sotheby's 10/86 **$8,000**

Mashamoquet Indian, copper, New England, 1875–1900, provenance, rare. H 36″ × W 30″

Skinner 6/86 **$93,500**

Massasoit Indian holding bow and arrow on directional, silhouette, gilded, 1850–1875, published, exhibited, restoration. H 37½″ × L 29″

Sotheby's 1/87 **$45,000**

Mermaid silhouette, sheet iron, blue, green, lavender paint, worn paint finish, some rust. H 18¾″

Garth 5/86 **$400**

Military rider on prancing horse, sheet iron silhouette, 19th century, old paint. H 20″ × L 27″

Skinner 1/86 **$2,200**

Pig, molded copper, cast zinc, L. W. Cushing & Sons, Waltham, Massachusetts, 19th century.

Sotheby's 1/84 **$6,250**

Pig, copper silhouette, E. G. Washburne & Co., New York, late 19th century, exhibited, provenance. 26″ × 46″

Sotheby's 1/84 **$10,000**

Pig, copper, late 19th century, published, similar known. 20″ × 35″

Christie's 10/85 **$10,000**

Plow, sheet copper, zinc, 19th century.

Sotheby's 10/86 **$6,750**

Prancing horse: Black Hawk, copper, probably New York, 1850–1875, restoration. H 25″ × L 36″

Sotheby's 1/86 **$2,200**

Prancing horse, sheet iron, good silhouette, repaired, replacements. L 19¼″

Garth 5/86 **$75**

Prancing horse, sheet iron, black paint, iron braces removed, replacements, cracked. L 13½″

Garth 5/86 **$180**

Prancing horse, copper, zinc, J. Howard & Co., West Bridgewater, Massachusetts, 1850–1875. H 19″ × L 24″

Sotheby's 1/87 **$4,500**

Prancing horse and rider, copper and zinc, A. L. Jewell & Co., Waltham, Massachusetts, 1850–1875, provenance, published. 27″ × 28″

Sotheby's 1/84 **$7,000**

Race horse and jockey, painted, late 19th century, weathered, very good condition, illustrated, old repaint. H 17″ × L 32″

Skinner 11/86 **$3,100**

Ram, copper, gold leaf, late 19th century, excellent condition, illustrated. H 18½″ × L 24″

Skinner 1/87 **$6,500**

Ram, copper, Harris & Son, Boston, Massachusetts, late 19th century, fine repousse detail. H 20½″ × L 28″

Sotheby's 1/87 **$7,000**

Ram, molded copper, 1850–1875, rare. 14″ × 18″

Sotheby's 1/84 **$5,500**

Ram, found in New York State, mid-19th century, provenance, exhibited, published. 22″ × 28½″

Sotheby's 1/84 **$7,000**

Ram, molded copper, directionals, 20th century. 73″ × 67½″

Skinner 5/86 **$2,000**

Rearing horse, A. L. Jewell & Co., Waltham, Massachusetts, 1850–1875, provenance. 17¼″ × 18″

Sotheby's 1/84 **$4,500**

Rooster, cast iron, sheet iron tail, late 19th century. 21″ × 24″

Christie's 1/84 **$950**

Rooster, cast zinc, sheet copper, J. Howard & Co., West Bridgewater, Massachusetts, 1850–1875, undersized.

Sotheby's 1/84 **$5,000**

Rooster, molded zinc, sheet copper, J. Howard & Co., West Bridgewater, Massachusetts, 1850–1875, provenance. 28″ × 25½″

Sotheby's 1/84 **$6,000**

Rooster, copper, feather details, probably early 20th century, good patina. H 47″

Skinner 5/85 **$1,600**

Rooster, copper, embossed tail, c. 1890, weathered. H 27″ × L 27″

Skinner 11/85 **$1,900**

Rooster, molded, gilt, sheet metal tail, arrow, 19th century, broken. H 43″

Skinner 1/86 **$900**

Rooster, copper, cast zinc, metal stand, J. Howard & Co., West Bridgewater, Massachusetts, c. 1875. H 26½″ × L 25″

Sotheby's 1/86 **$2,800**

Rooster, molded and sheet copper, probably 20th century, good patina, detail. H 47″

Skinner 5/86 **$1,600**

Rooster, copper, verdigris patina, late 19th century, provenance, illustrated. H 19″

Skinner 6/86 **$1,600**

Rooster, zinc, sheet metal tail, old yellow paint, late 19th century, weathered, bullet hole. H 25″ × 26″

Skinner 7/86 **$2,100**

Rooster, cast iron, sheet iron tail, 19th century, corrosion. 30½″ × 34″

Sotheby's 10/86 **$2,750**

Rooster, copper, black base, 19th century, no directionals. H 24″ × L 21¾″

Skinner 1/87 **$3,000**

Rooster, painted copper, 19th century. H 25″ × L 28″

Sotheby's 1/87 **$3,250**

Rooster, copper, zinc, wood base, J. Howard & Co., West Bridgewater, Massachusetts, 1850–1875. H 17″ × L 12½″

Sotheby's 1/87 **$3,300**

Rooster, copper, arrow directional, 19th century. H 49″ × L 30½″

Sotheby's 1/87 **$3,500**

Rooster, copper, sheet metal tail, legs, A. L. Jewel & Co., Waltham, Massachusetts, late 19th century, directionals, dents, repainted. H 23″

Skinner 8/87 **$1,500**

Running horse, copper, zinc head, sheet copper tail, late 19th century, incomplete, no directionals. H 15½″ × L 26″

Skinner 1/85 **$300**

Running horse, molded copper and zinc, 19th century. 15″ × 9″

Weschler 9/85 **$200**

Running horse, sheet iron silhouette, old black paint, bullet holes, rust, pitted. L 49″

> *Garth 5/86* **$475**

Running horse, sheet iron silhouette, Oronaco, Michigan, 19th century, bullet holes. 27″ × 60″

> *Skinner 5/86* **$500**

Running horse, copper, traces of original gold leaf, late 19th century, damaged. L 30″

> *Skinner 11/86* **$900**

Running horse, copper, zinc, 19th century. H 31″ × L 46″

> *Sotheby's 1/87* **$4,200**

Running horse, copper, zinc, gold leaf, directionals, late 19th century, repaired, dents, repainted, regilded. H 48″ × 31 1/2″

> *Skinner 6/87* **$1,500**

Running horse: Colonel Patchen, molded copper, 19th century. 20 1/2″ × 38 1/2″

> *Sotheby's 6/87* **$2,400**

Running horse: Ethan Allen, copper, gold, c. 1880, old gold paint, good verdigris, illustrated. H 14″ × L 26 1/2″

> *Skinner 1/86* **$500**

Running horse: Goldsmith Maid, molded, some gold, c. 1880, fine color, illustrated, minor repairs. H 14″ × L 29″

> *Skinner 1/86* **$700**

Running horse through hoop, copper, zinc, 19th century, weathered. L 30″

> *Skinner 1/86* **$3,900**

Running horse with jockey, copper, gilt and polychrome detail, possibly J. L. Mott, New York, c. 1880, illustrated imperfections. H 16″ × L 34″

> *Skinner 1/86* **$2,000**

Running horse, possibly Ethan Allen, copper, Harris Co., Boston, Massachusetts, late 19th century, old patina, tail broken. L 28″

> *Skinner 8/87* **$500**

Sachem chief: Mashamoquet, molded copper, New England, 1875–1900, provenance, rare.

> *Skinner 5/86* **$8,500**

Sheep, molded copper, gilt over weathered surface, c. 1880. 20″ × 24″

> *Skinner 5/86* **$2,000**

Ship: Mayflower, sheet copper, sails, rudder and flags, E. G. Washburne & Co.: attribution, New York, c. 1920, illustrated. H 39″ × W 36″

> *Skinner 11/86* **$1,900**

Ship, three-masted bark, painted wood, early 20th century. 30″ × 42″

Skinner 5/86 **$250**

Ship, three-masted, carved wood, painted red and black, gilded, wire rigging, 19th century. 54½″ × 42″

Christie's 5/87 **$650**

Stag, gilded and molded copper and iron, 19th century. 19½″ × 31½″

Christie's 1/84 **$1,800**

Stag jumping log, copper, original gilding, J. Harris: attribution, Boston, Massachusetts, c. 1879, fine condition, rare, illustrated. 30″ × 32″ × 8½″

Skinner 11/85 **$28,000**

Stag, molded and gilded copper, applied sheet copper rack of antlers and ears on a rod. 19th century. H 31″ × L 23″

Sotheby's 1/86 **$6,250**

Standing bull, hollow copper and cast iron, gilded, late 19th century. 39″ × 23″

Christie's 10/86 **$3,000**

Standing deer, molded copper, L. W. Cushing & Sons, Waltham, Massachusetts, 1850–1875, much original gilding, provenance, good workmanship.

Sotheby's 1/84 **$12,000**

Sulky and driver, carved and painted wood, tin cart, leather harness, 1880–1900. H 10½″ × L 19¼″

Sotheby's 1/87 **$4,500**

Sulky and driver, molded copper, zinc, probably J. W. Fiske, New York, c. 1887. 17″ × 51½″

Sotheby's 1/87 **$15,000**

Sulky, rider, and horse, cast, T. W. Fiske: attribution, c. 1880, later paint repairs. H 17″ × L 36″

Skinner 1/86 **$2,750**

Swordfish, wood, wrought iron, applied fins, eye, sword beak, Dennis, Massachusetts, 19th century, illustrated, provenance, weathered. L 59″

Skinner 11/86 **$1,200**

Three prospectors over arrow, iron, Pennsylvania, c. 1900, damaged. H 27½″ × L 49″

Skinner 11/85 **$750**

Trotting horse, molded copper, zinc, L. W. Cushing & Sons, Waltham, Massachusetts, 1850–1875, provenance, published, retains some original gilding. 15¼″ × 32″

Sotheby's 1/84 **$3,500**

Trotting horse, copper, gold leaf, late 19th century, directionals, verdigris, open seals, loose tail. L 27″

Skinner 1/86 **$800**

Trotting horse, copper and zinc, contemporary black paint, impressed: "J. Howard & Co.," Bridgewater, Massachusetts, 19th century, incomplete, repairs. L 40″

Skinner 3/87 **$9,250**

Two setters: (A) H 18″ × L 36″ (B) Carved and painted, probably Henry Leach for Cushing and White, Waltham, Massachusetts, c. 1871, exhibited. H 16 1/2″ × 34 1/4″

Sotheby's 1/87 **$62,500**

Whaler with horn, carved and old white painted wood, head cracked. H 9 1/4″ × 40 1/2″

Sotheby's 1/87 **$3,750**

Whirligigs

Also called wind toys, whirligigs were fashioned from wood and/or metal by untrained artists. These carvings, in either silhouette or three-dimensional form, were constructed with either paddle-like arms (baffles) or multifigured objects with propellers that catch the wind and turn the crank. Whirligigs often satirized animals or people, making social statements through their motion's rate of speed. Their forerunner may well have been the scarecrow.

Bird house, wood, polychromed, 20th century. H 11 1/2″

Garth 2/86 **$50**

Carousel, mounted on platform propelled by weather vane, Mr. Otter, Worcester, Massachusetts, c. 1900. H 32 1/2″

Skinner 8/87 **$100**

Goose, wood, painted black and white, good paint, reinforced. H 24 1/2″ with base.

Garth 2/86 **$115**

Indian, carved, painted wood, yellow canoe, paddle-form arms, 20th century, replacements. H 17″ × L 17 1/2″

Skinner 3/85 **$350**

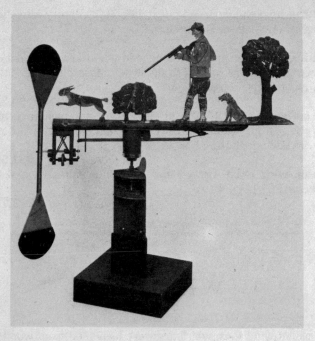

Early 20th-century American painted wood and tin whirligig, probably from southern Virginia. Propeller raises and lowers hunter's gun, 16″ length. (*Photo courtesy of All Of Us Americans Folk Art*)

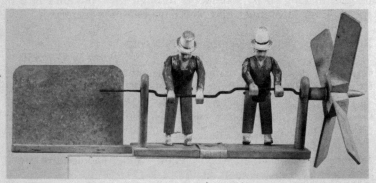

Early 20th-century American painted metal and wooden whirligig, probably from Pennsylvania. Men raise and lower arms, 18″ height × 44″ length. (*Photo courtesy of All Of Us Americans Folk Art*)

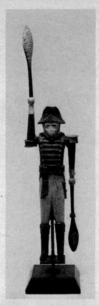

Early 19th-century New England carved and painted wooden whirligig in the form of a Revolutionary War soldier. (*Photo courtesy of Sotheby's, New York*)

Indian, paddles for vanes, bright green with yellow, white, red, black, original base, some wear, paddles replaced, missing head-dress. H 15½″

<div align="right">

Garth 5/86 **$800**
</div>

Man sawing wood, painted wood, propeller, red, blue, green, early 20th century, some flaking. L 31″

<div align="right">

Skinner 3/85 **$375**
</div>

Man sawing wood, early 20th century, painted wood, propeller front in red, blue, green, flaking. L 31″

<div align="right">

Skinner 5/86 **$375**
</div>

Man in tall hat, carved wood, painted red, missing a paddle hand. H 10″

<div align="right">

Skinner 3/87 **$875**
</div>

Sailor painted blue and white, pivot arms with red paddles, small stand, late 19th or early 20th century. H 8¼″

<div align="right">

Sotheby's 6/87 **$375**
</div>

Soldier, carved wood, polychrome paint, branded "S," contemporary, worn, weathered. H 16½″

<div align="right">

Garth 5/86 **$125**
</div>

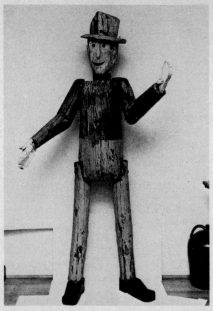

Early 20th-century New England carved and painted wooden scarecrow, 6' height. (*Private collection*)

Swordsman, probably Newport, New Hampshire, c. 1835. H 22 1/2"

Sotheby's 10/86 **$39,000**

Washerwoman, painted pine and metal, c. 1930.

Sotheby's 1/84 **$5,750**

Washerwoman, painted pine, metal, 1900–1950. 20 1/2" × 29"

Christie's 1/87 **$5,800**

Whimsey, wood and metal, straight razor form, 19th century. L 17"

Skinner 3/85 **$100**

Wood Carvings

Carvers, sometimes called whittlers, like Wilhelm Schimmel of Pennsylvania, created small figures, toys, and other decorative

objects for their own or other's enjoyment. Eagles, cats, owls, and roosters were popular, as well as human forms frequently depicting blacks, notable personages, and spiritual entities. The humor often embued into the pieces makes them endearing collectibles for folk art aficionados.

Bird on a branch, original brown, white, yellow paint, glitter over green paint on base, glass eyes, minor wear. H 9¼"
Garth 2/87 **$45**

Bird, wood, good craftsmanship, split tail, weathered surface, beak incomplete, rod missing, tail repaired. L 10½"
Garth 5/86 **$45**

Birdcage, tramp art, carved wooden frame, gilt and silver paint, c. 1880. H 26"
Skinner 5/85 **$475**

Black man, 20th century, carved and painted wood, articulated head, holds music box and removable copper ashtray, illustrated, minor damage. H 35"
Skinner 1/85 **$2,000**

Boxer, late 19th century, carved and painted wood, provenance, illustrated, damage. H 18"
Skinner 7/86 **$2,200**

Cat, 19th century, seated, marble, illustrated. H 8¾"
Skinner 11/86 **$700**

Charlie Chaplin figure, primitive detail, wood, black paint, hat damaged. H 12½"
Garth 5/86 **$90**

Comic carving: Buxom lady showing her wares to monk, wood, faded, worn polychrome paint, base block replaced. H 16¼"
Garth 3/87 **$45**

Comic carving: Old man with concertina, wood, worn polychrome paint, shallow flake on foot. H 11½"
Garth 3/87 **$30**

Dog, late 19th century, mastiff, molded zinc, illustrated, repainted, repairs. 48" × 48" × 19"
Skinner 1/86 **$1,400**

Dog, late 19th century, Newfoundland, cast iron, provenance, illustrated. 36" × 65" × 12"
Skinner 1/86 **$10,500**

Dog, c. 1920, carved and painted wood, primitive, red, black markings. 12½" × 17"
Skinner 5/86 **$700**

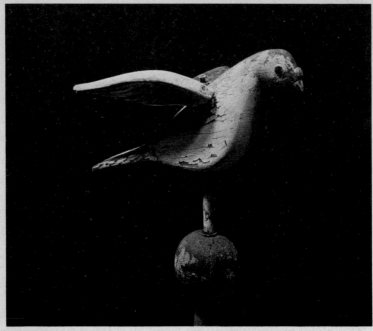

Early 20th-century New England carved and painted wooden finial in the form of a bird on a ball, 6½″ height × 8½″ wingspan. (*Photo courtesy of American Primitive*)

Dog, possibly J. W. Fiske, New York, 19th century, lawn ornament, painted cast iron dalmation. 30″ × 50″

Sotheby's 1/87 **$6,250**

Dove, early 19th century, gold leaf, minor imperfections. 13″ × 23″

Skinner 7/86 **$1,300**

Duck, Birchler, c. 1925, carved and painted black, craftsmanship, very fine condition, illustrated. 19″ × 18″

Skinner 1/86 **$2,700**

Eagle, 1800–1830, carved spread wings, gilded, damage. H 10″

Skinner 5/86 **$250**

Eagle, M. L. Becker attribution, Dark Harbor, Maine, c. 1910, carved and polychromed wood, primitive. H 9½″

Skinner 6/86 **$300**

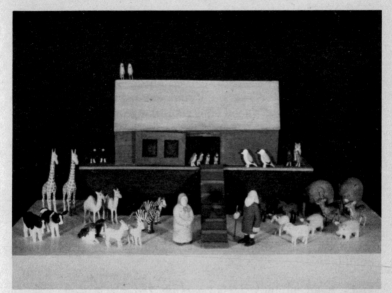

Contemporary New York painted wooden carving, depicting Noah's Ark by John Cross, 15″ height. (*Photo courtesy of Jay Johnson, America's Folk Heritage Gallery*)

Eagle, 19th century, carved and painted wood, damage, illustrated. 29″ × 33″

Skinner 6/86 **$500**

Eagle, 19th century, carved wood, gilt, illustrated, gesso lifting. H 32″

Skinner 6/86 **$750**

Eagle, early 20th century, carved and decorated wood in the style of John Bellamy, banner reads "DON'T GIVE UP THE SHIP," good condition, minor chips, banner needs refastening. Wingspread 27½″

Bourne 8/86 **$1,000**

Eagle, 19th century, papier-mâché, red, white, and blue, damage, flaking. H 33″

Skinner 11/86 **$200**

Eagle, carved and painted pine, Wilhelm Schimmel, Cumberland County, Pennsylvania, late 19th century, similar pieces known. 7 1/2″ × 11 1/2″

> *Christie's 1/87* **$4,500**

Eagle, carved and stained maple, glass eyes, 19th century. 34 1/2″ × 31″ × 23″

> *Christie's 1/87* **$7,500**

Eagle, probably 1800–1825, carved and decorated wood in the style of John Bellamy, design of ship with banner reading "DON'T GIVE UP THE SHIP," good condition. Wingspread 27″

> *Bourne 2/87* **$600**

Eagle, early 19th century, carved and decorated wood, possibly ship's gangway board, traces of green paint, good condition, shrinkage. H 35 1/2″ × W 29″

> *Bourne 2/87* **$650**

Eagle, 19th century, carved and gilded wood, regilded. 28″ × 35″

> *Oliver 7/87* **$1,100**

Eagle, early 20th century, carved pine, primitive, damage, weathered. L 21″

> *Skinner 8/87* **$350**

Eagle head, primitive, relief carving, red, black paint, good silhouette, eye missing. L 12 1/2″

> *Garth 5/86* **$50**

Elk, late 19th century, cast iron, minor damage. 61″ × 49″ × 29″

> *Skinner 1/86* **$2,900**

Frog, twentieth century, carved wood, primitive, painted old grayish-green, good paint. H 3 3/4″

> *Garth 2/86* **$10**

Gabriel, 20th century, carved in bas relief and painted wood, provenance, some damage. H 38″

> *Skinner 1/85* **$2,900**

Game birds: quail and grouse, John Nowicki, 1942, carved wood, paint original, dated, signed, paint. H 7″ and H 8″

> *Garth 2/86* **$70**

Horse, small, wood, chestnut color, white stocking, black string mane, tail chipped, harness missing. H 4 1/4″

> *Garth 5/86* **$25**

Horse, small, wood, black paint, worn leather harness, twine tail. H 4 3/4″

> *Garth 5/86* **$35**

Horse and buggy, wood, good primitive detail, bright original paint. L 16″

> *Garth 3/87* **$350**

Human and animal figures, c. 1900, carved wood, primitive, illustrated, some damage. H 5½″, platform 5″ × 9″

> *Skinner 8/87* **$350**

Lion, wood, 20th century, good detail, glued tail. H 6⅝″

> *Garth 5/86* **$45**

Little lady with handbags, William Edmundson, Nashville, Tennessee, c. 1935, carved limestone. 13″ × 10″ × 4″

> *Christie's 1/87* **$4,000**

Man, Amish, 20th century, carved wood. H 11¼″

> *Skinner 3/85* **$150**

Man, dated 1910, carved wood, documentation. H 12½″

> *Skinner 6/87* **$1,300**

Man, head, early 19th century, carved wood. H 9⅜″

> *Skinner 1/85* **$100**

Man in black evening clothes, marionette, wood, painted features, H 18″

> *Garth 3/87* **$45**

Man with a pipe and shillelagh, wood, primitive, colored with crayons. H 7¼″

> *Garth 3/87* **$65**

Mirror: hand, twentieth century, carved wooden frame, with owl and mouse in its talons, good craftsmanship, design, discoloration, cracks. 6″ × 14″

> *Garth 2/86* **$90**

Church, wooden model, good detail, old bluish-gray paint, white trim, found in Pennsylvania, damaged. H 23½″

> *Garth 3/87* **$160**

Newsboy, South Carolina, late 19th century, carved and painted gessoed wood. H 24½″

> *Sotheby's 1/84* **$2,250**

Noah's Ark: 42 animals, 2 people, wooden ark, black, gray, white, tan paint, red, black printed paper roof, carved, painted animals, some wear, few are damaged. L of Ark 15″

> *Garth 2/87* **$400**

Owl, 20th century, carved, painted wood, glass eyes, cracked. H 25″

> *Skinner 1/85* **$575**

Oxen: pair, brown paint, damage, repairs. L 11½″

> *Garth 5/86* **$50**

Parrot and cockatoo on perches, carved and polychrome wood, small chips, contemporary. H 4¼″

Garth 5/86 **$20**

Parrot, unidentified maker, American, twentieth century, carved wood, primitive, brightly painted, good paint. H 8¼″

Garth 2/86 **$5**

Peasant couple dancing, wood, original polychrome paint in subdued colors, minor wear and some repair. H 20¼″

Garth 2/87 **$55**

Red salmon, Frank Finney, c. 1987, Pungo, Virginia, wood, glass eye. L 42″

Oliver 7/87 **$150**

Rooster, 19th century, carved wood, repairs. H 12½″

Skinner 11/85 **$1,500**

Rooster, c. 1920, carved and painted wood, primitive, published. H 11½″

Skinner 6/87 **$850**

Rooster, late 19th century, carved and painted wood, damaged, missing feet. H 32″

Skinner 6/87 **$1,300**

Sea gull, late 19th century, painted wood, original worn paint. 21½″ × 22½″

Skinner 6/87 **$600**

Man, wooden silhouette, worn polychrome print, some damage. H 43″

Garth 7/86 **$45**

Standing lion, carved and painted pine, Wilhelm Schimmel, Cumberland Valley, Pennsylvania, late 19th century. 5¾″ × 8¾″

Christie's 5/85 **$9,000**

Wall plaque, eagle with shield and banner, carved, gilded wood, inscribed, "Live and Let Live," mid-19th century. 23″ × 72″

Christie's 5/87 **$3,500**

Woman and goat, wood, polychrome paint, damaged. H 5″ and 8″

Garth 7/86 **$135**

Woman and two birds, wood, brown varnish, some minor wear, worn pencil inscription. H 7½″

Garth 5/86 **$95**

Resources

Auction Houses

Dealers

Museums

Trade Publications

Bibliography and Suggested Readings

Auction Houses

F.O. Bailey Antiquarians
141 Middle Street
Portland, ME

Ron Bourgeault
P.O. Box 363
Hampton, NH 03842

Richard A. Bourne Co., Inc.
P.O. Box 141 MAD
Hyannis Port, MA 02647

Butterfield & Butterfield
220 San Bruno Avenue
San Francisco, CA 94103

Christie's Fine Art Auctioneers
502 Park Avenue
New York, NY 10022

William Doyle Galleries
175 East 87th Street
New York, NY 10128

Robert C. Eldred Co., Inc.
P.O. Box 796 M
East Dennis, MA 02641

Garth's Auctions, Inc.
2690 Stratford Road
P.O. Box 369
Delaware, OH 43015

Guernsey's
136 East 73rd Street
New York, NY 10021

Willis Henry Auction, Inc.
22 Main Street
Marshfield, MA 02050

James D. Julia
Route 201
Fairfield, ME 04937

Litchfield Auction Gallery
Route 202
Litchfield, CT 06759

Richard T. Oliver
Plaza 1, U.S. Route 1
P.O. Box 337
Kennebunk, ME 04043

Robert W. Skinner, Inc.
Route 117
Bolton, MA 01740

C.G. Sloan & Company, Inc.
919 East Street
Washington, D.C. 20004

Sotheby's
1334 York Avenue
New York, NY 10021

South Bay Auctions
Box 303
East Moriches, NY 11940

Adam A. Weschler & Son, Inc.
905 East Street, N.W.
Washington, D.C. 20004

Richard W. Withington, Inc.
Hillsboro, NH 03244

Dealers

Alexander Gallery
996 Madison Avenue
New York, NY 10021

All of Us Americans
Box 5943
Bethesda, MD 20814

American Hurrah Antiques
766 Madison Avenue
New York, NY 10021

The Ames Gallery of American
Folk Art
2661 Cedar Street
Berkeley, CA 94708

Marna Anderson
333 Rector Place
New York, NY 10280

Robert and Ann Anderson
Star Route, Box 16
Upper Black Eddy, PA 18972

Aarne Anton
American Primitive Gallery
242 West 30th Street
New York, NY 10001

Bari and Phil Axelband
109 Wood Terrace
Leonia, NJ 07605

Axtell Antiques
1 River Street
Deposit, NY 13754

Darwin D. Bearley
98 Beck Avenue
Akron, OH 44302

Beneduce & Lozell
388 Bleecker Street
New York, NY 10014

Ruth Bigel Antiques
743 Madison Avenue
New York, NY 10021

Bertha Black
80 Thompson Street
New York, NY 10012

Charles Brown & Co.
42 Trinity Pass
Pound Ridge, NY 10576

Robert Cargo
2314 Sixth Street
Tuscaloosa, AL 35401

Cherishables
1608 20th Street, NW
Washington, D.C. 20009

The Cobbs
83 Grove Street
Peterborough, NH 03458

The Cunninghams
(Contact: David and Sue
Cunningham)
RD #4, Box 481, Weaver Road
Denver, PA 17517

Allen Daniel
230 Central Park West
New York, NY 10024

Corey Daniels
P.O. Box 609
Wells, ME 04090

Marlin G. Denlinger
50 East Main Street
Box 698
Brownstown, PA 17508

Nikki and Tom Deupree
480 N. Main Street
Suffield, CT 06078

Diamant Gallery
37 West 72nd Street
New York, NY 10023

Ronald and Penny Dionne
Glass Factory, Schoolhouse Road
W. Willington, CT 06279

Jeannine Dobbs
P.O. Box 1076
Merrimack, NH 03054

Leslie Eisenberg
1187 Lexington Avenue
New York, NY 10028

Jim Elkind
Lost City Arts
339 Bleecker Street
New York, NY 10014

Epstein/Powell
22 Wooster Street
New York, NY 10013

M. Finkel & Daughter
936 Pine Street
Philadelphia, PA 19107

Gaglio and Molnar
Box 375
Wurtsboro, NY 12790

Pat and Rich Garthoeffner
436 South Cedar Street
Lititz, PA 17543

Gasperi Folk Art Gallery
831 St. Peter Street
New Orleans, LA 70116

Sid Gecker
226 West 21st Street
New York, NY 10001

Fred and Kathy Giampietro
153 ½ Bradley Street
New Haven, CT 06511

Jim and Nancy Glazer
2209 Delancy Place
Philadelphia, PA 19103

Greenwillow Farm Ltd.
Raup Road
Chatham, NY 12037

Guthman Americana
P.O. Box 392
Westport, CT 06881

Pat Guthman Antiques
342 Pequot Road
Southport, CT 06490

Gary Guyette
Box 522
W. Farmington, ME 04992

Phyllis Haders
Antique Quilts & Accessories
158 Water Street
Stonington, CT 06378

Fae B. Haight Antiques
P.O. Box 294
Lahaska, PA 18931

Haimowitz & Cloud Antiques
465 Broome Street
New York, NY 10013

Harry B. Hartman
452 East Front Street
Marietta, PA 17547

Harvey Antiques
1231 Chicago Avenue
Evanston, IL 60202

Nina Hellman
35 Harris Road
Katonah, NY 10536

Herrup & Wolfner
12 East 86th Street
New York, NY 10028

Pam and Tim Hill
56000 Ten Mile Road
South Lyon, MI 48178

Hillman Gemini Antiques
743 Madison Avenue
New York, NY 10021

Hirschl & Adler Folk
851 Madison Avenue
New York, NY 10021

Jim Hirsheimer
Carversville Road
Carversville, PA 18913

Stephen and Carol Huber
82 Plants Dam Road
East Lyme, CT 06333

Sharon Joel
2317 Segovia Avenue
Jacksonville, FL 32217

*Jay Johnson's America's Folk
Heritage Gallery*
1044 Madison Avenue
New York, NY 10021

R. Jorgensen Antiques
Route 1, Box 382
Wells, ME 04090

Kelter-Malce Antiques
361 Bleecker Street
New York, NY 10014

Kinnaman and Ramaekers
P.O. Box 1014
Wainscott, NY 11975

Jerry Kornblau
305 East 61st Street
New York, NY 10021

Deanne D. Levison
2995 Lookout Place
Atlanta, GA 30305

Zeke Liverant
Nathan Liverant and Son
Colchester, CT 06415

Main Street Antiques and Art
110 West Main
West Branch, IA 52538

Kenneth and Ida Manko
P.O. Box 20
Moody, ME 04054

Pam Martine
20 Bush Avenue
Greenwich, CT 06830

Millie McGehee
3009 Maple Avenue #310
Dallas, TX 75201

Grete Meilman
42 East 76th Street
New York, NY 10021

Roger Ricco–Frank Maresca
12 East 22nd Street
New York, NY 10010

Merican & Peskin Gallery
One Christopher Street
New York, NY 10014

Steve Miller American Folk Art
17 East 96th Street
New York, NY 10128

Sandy Mitchell
739 Mohawk
Columbus, OH 43206

Muleskinner Antiques
10626 Main Street
Clarence, NY 14031

John C. Newcomer
32 West Baltimore Street
Funkstown, MD 21734

Olde Hope Antiques
Box 209, Route 202
New Hope, PA 18938

Susan Parrish
390 Bleecker Street
New York, NY 10014

Pine Bough
Main Street
Northeast Harbor, ME 04662

Barbara and Frank Pollack
1214 Green Bay Road
Highland Park, IL 60035

Quilts and Country
(Contact: Darwin D. Bearley)
98 Beck Avenue
Akron, OH 44302

Susan and Sy Rapaport
51 Maple Drive
Great Neck, NY 11021

Richard and Betty Ann Rasso
Route 295
East Chatham, NY 12060

J.B. Richardson Gallery
362 Pequot Avenue
Southport, CT 06490

Sheila and Edwin Rideout
12 Summer Street
Wiscasset, ME 04578

Marguerite Riordan
Stonington, CT 06378

*Stella Rubin, Quilts and
Country Antiques*
12300 Glen Road
Potomac, MD 20854

John Keith Russell
Spring Street
South Salem, NY 10590

Bert and Gail Savage
Route 126 #11
Strafford, NH 03815

Kathy Schoemer
Route 116 at Keeler Lane
North Salem, NY 10560

David Schorsch
30 East 76th Street
New York, NY 10021

Stephen Score
Box 965
Essex, MA 01929

Shoot the Chute
34 Beacon Road
Bethany, CT 06525

Carol Shope
3828 Payne Koehler Road
New Albany, IN 47150

John and Jacqueline Sideli
Route 66
Malden Bridge, NY 12115

Smith Gallery
1045 Madison Avenue
New York, NY 10021

Elliot and Grace Snyder
Box 598
S. Egremont, MA 01258

Douglas Solliday
1705 High Road Drive
Columbia, MO 65203

Robin Starr
Duxbury, MA 02332

Sterling and Hunt
American Art & Antiques
Bridgehampton, NY 11932

Peter H. Tillou
Prospect Street
Litchfield, CT 06759

Joan Townsend
Gene Justice
4215 Utica Road
Lebanon, OH 45036

Don Walters
Goshen, IN 46526

Victor Weinblatt
Box 335
South Hadley, MA 01075

Brian and Lorraine Windsor
3599 Richmond Road
Staten Island, NY 10306

Thomas K. Woodard
835 Madison Avenue
New York, NY 10021

Shelly Zegart
12-Z River Hill Road
Louisville, KY 40207

Museums

CALIFORNIA

The Craft & Folk Art Museum
5914 Wilshire Boulevard
Los Angeles, CA 90036

CONNECTICUT

Mystic Seaport Museum, Inc.
Greenmanville Avenue
Mystic, CT 06355

Yale University, Garvan Collection
Box 2006 Yale Station
New Haven, CT 06520

DELAWARE

The Henry Francis duPont Winterthur Museum, Inc.
Winterthur, DE 19735

MASSACHUSETTS

Fruitlands Museums
R.R.2, Box 87
Prospect Hill Road
Harvard, MA 01451

Historic Deerfield, Inc.
The Street
Deerfield, MA 01342
Mailing address:
Box 321
Deerfield, MA 01342

Museum of Fine Arts, Boston
465 Huntington Avenue
Boston, MA 02115

Old Sturbridge Village
Sturbridge, MA 01566

MICHIGAN

Henry Ford Museum and Greenfield Village
20900 Oakwood Boulevard
Dearborn, MI 48121

NEW MEXICO

Museum of International Folk Art
Santa Fe, NM 87501

NEW YORK

Albany Institute of History and Art
125 Washington Avenue
Albany, NY 12210

New York State Historical Association
Fenimore House, Lake Road
Cooperstown, NY 13326

New York City

American Museum of Natural History
Central Park West and 79th Street
New York, NY 10024

Metropolitan Museum of Art
Fifth Avenue at 85th Street
New York, NY 10028

Museum of American Folk Art
49 West 53rd Street
New York, NY 10019
Mailing address:
444 Park Avenue South, 4th floor
New York, NY 10016

Museum of the American Indian
Broadway and 155th Street
New York, NY 10032

New York Historical Society
170 Central Park West
New York, NY 10024

NORTH CAROLINA

Museum of Early Southern Decorative Arts
924 South Main Street
Winston-Salem, NC 27108

PENNSYLVANIA

Historical Society of Pennsylvania
1300 Locust Street
Philadelphia, PA 19107

Landis Valley Farm Museum
230 North President
Lancaster, PA 17603

Mercer Museum of the Bucks County Historical Association
Pine and Ashland Streets
Doylestown, PA 18901

The Pennsylvania Academy of the Fine Arts
Broad and Cherry Streets
Philadelphia, PA 19102

Schwenkfelder Museum
Seminary Street
Pennsburg, PA 18073

TEXAS

The Bayou Bend Collection
#1 Westcott
Houston, TX 77007
Mailing address:
Box 13157
Houston, TX 77219

VERMONT

Shelburne Museum
U.S. Route 7
Shelburne, VT 05482

VIRGINIA

Abby Aldrich Rockerfeller Folk Art Museum
307 South England Street
Williamsburg, VA 23185
Mailing address:
Box C
Williamsburg, VA 23187

WASHINGTON, D.C.

Daughters of the American Revolution Museum
1776 D Street, N.W.
Washington, D.C. 20006

National Gallery of Art (Garbisch Collection)
4th Street and Constitution Avenue, N.W.
Washington, D.C. 20565

Smithsonian Institution
1000 Jefferson Drive, S.W.
Washington, D.C. 20560

Trade Publications

Antiquarian
Box 798
Huntington, NY 11743

Antique Gazette
929 Davidson Drive
Nashville, TN 37205

Antique Market Report
P.O. Box 12830
Wichita, KS 67277

Antique Market Tabloid
10822 Child's Court
Silver Spring, MD 20901

Antique Monthly
Drawer 2
Tuscaloosa, AL 35402

Antique Review
P.O. Box 538
Worthington, OH 43085

Antique Trader Weekly
P.O. Box 1050
Dubuque, IA 52001

Antiques & Auctions News
P.O. Box 500
Mt. Joy, PA 17552

Antiques & Fine Art
434 South First Street
San Jose, CA 95113

Antiques West
P.O. Box 2828
San Anselmo, CA 94960

Art & Antiques
89 Fifth Avenue
New York, NY 10003

Art & Antiques Weekly
The Newtown Bee
Newtown, CT 06470

Art & Auction
250 West 57th Street
Suite 215
New York, NY 10019

The Buckeye Marketeer
2256 1/2 Main Street
Columbus, OH 43209

Cape Cod Antiques & Arts
P.O. Box 400
Yarmouth Port, MA 02675

Cape Cod Antiques Monthly
P.O. Box 340
East Sandwich, MA 02537

Collectors News
Box 156
Grundy Center, IA 50638

Colonial Homes
1790 Broadway
New York, NY 10019

Country Home Magazine
1716 Locust Avenue
Des Moines, IA 50336

Country Living
224 West 57th Street
New York, NY 10019

Hobbies
1006 South Michigan Avenue
Chicago, IL 60605

The Magazine Antiques
980 Madison Avenue
New York, NY 10021

Maine Antiques Digest
Box 358
Waldoboro, ME 04572

Massachusetts Bay Antiques
9 Page Street
P.O. Box 293
Danvers, MA 01925

New England Antiques Journal
4 Church Street
Ware, MA 01082

*New Hampshire-Vermont
Antiques Gazette*
P.O. Box 40
Exeter, NH 03833

New York Antiques Almanac
Box 335
Lawrence, NY 11558

*The New York-Pennsylvania
Collector*
Drawer C
Fishers, NY 14453

Renninger's Antique Guide
P.O. Box 49
Lafayette Hill, PA 19444

Southern Antiques
P.O. Box 1550
Lake City, FL 32055

Southwest Antiques News
P.O. Box 66402
Houston, TX 77006

Tri-State Trader
Box 90
Knightstown, IN 46148

Bibliography and Suggested Readings

Andrews, Ruth, ed. *How to Know American Folk Art*. E.P. Dutton, New York, 1977.

Bishop, Robert. *American Folk Sculpture*. E.P. Dutton, New York, 1974.

———. *Folk Painters of America*. E.P. Dutton, New York, 1979.

——— and Coblentz, Patricia. *A Gallery of American Weathervanes and Whirligigs*. E.P. Dutton, New York, 1981.

——— and Safanda, Elizabeth. *Gallery of Amish Quilts*. E.P. Dutton, New York, 1976.

———, Secord, William; Weissman, Judith Reiter; Ketchum, William, Jr. *The Knopf Collectors' Guide to American Antique Quilts*. Alfred A. Knopf, Inc., New York, 1982.

———, Weissman, Judith Reiter; McManus, Michael; Niemann, Henry. *Folk Art: Paintings, Sculpture and Country Objects*. Alfred A. Knopf, Inc., New York, 1983.

Black, Mary D. *Erastrus Salisbury Field, 1805–1900*. Abby Aldrich Rockefeller Folk Art Collection, Williamsburg, Virginia, 1963.

——— and Lipman, Jean. *American Folk Painting*. Clarkson N. Potter, New York, 1966.

Boyd, E. *Popular Arts of Spanish New Mexico*. Museum of New Mexico Press, Santa Fe, New Mexico, 1974.

Brewington, M.V. *Shipcarvers of North America*. Dover Publications, New York, 1972.

Christensen, Erwin O. *The Index of American Design*. Macmillan Co., New York, 1959.

Chrysler, Walter P., Jr. *The Gift of American Naive Paintings from the Collection of Edgar William and Bernice Chrysler Garbisch: 48 Masterpieces*. Chrysler Museum, Norfolk, Virginia, 1974.

Coffin, Margaret. *American County Tin Ware, 1700–1900*. Galahad Books, New York, 1968.

Earnest, Adele. *The Art of the Decoy: American Bird Carvings*. Clarkson N. Potter, New York, 1965.

Fabian, Monroe H. *The Pennsylvania-German Decorated Chest*. Main Street Press, Universe Books, New York, 1978.

Fales, Dean A. *American Painted Furniture, 1660–1880*. E.P. Dutton, New York, 1972.

Fitzgerald, Ken. *Weathervanes and Whirligigs*. Clarkson N. Potter, New York, 1967.

Flayderman, E. Norman. *Scrimshaw and Scrimshanders, Whales and Whalemen*. N. Flayderman, New Milford, Connecticut, 1972.

Fried, Frederick. *Artists in Wood: American Carvers of Cigar-Store Indians, Show Figures, and Circus Wagons*. Clarkson N. Potter, New York, 1970.

Gould, Mary Earle. *Early American Wooden Ware and Other Kitchen Utensils*. C.E. Tuttle, Rutland, Vermont, 1962.

Guilland, Harold F. *Early American Folk Pottery*. Chilton Books, Philadelphia, Pennsylvania, 1971.

Heisey, John W.; Andrews, Gail C.; Walters, Donald R. *A Checklist of American Coverlet Weavers*. Colonial Williamsburg Foundation, Distributed by the University Press of Virginia, Williamsburg, Virginia, 1978.

Hemphill, Herbert W., Jr. *Folk Sculpture U.S.A.* Universe Books, New York, 1976.

————, and Weissman, Julia. *Twentieth Century American Folk Art and Artists*. E.P. Dutton, New York, 1974.

Holdridge, Barbara C. and Holdridge, Lawrence B. *Ammi Phillips: Portrait Painter, 1788–1865*. Crown, New York, 1969.

Janis, Sidney. *They Taught Themselves: American Primitive Painters of the 20th Century*. Dial Press, New York, 1942.

Johnson, Jay and Ketchum, William C., Jr. *Folk Art of the Twentieth Century*. Rizzoli, New York, 1983.

Kauffman, Henry J. *Early American Ironware, Cast and Wrought*. Weathervane Books, New York; C.E. Tuttle, Rutland, Vermont, 1966.

Kopp, Joel and Kopp, Kate. *American Hooked and Sewn Rugs: Folk Art Underfoot*. E.P. Dutton, New York, 1975.

Krueger, Glee F. *A Gallery of American Samplers: The Theodore H. Kapnek Collection*. E.P. Dutton, in association with the Museum of American Folk Art, New York, 1978.

Lichten, Frances. *Folk Art of Rural Pennsylvania*. Bonanza Books, New York, 1946.

Lipman, Jean. *American Folk Art in Wood, Metal, and Stone*. Pantheon, New York, 1948.

———— and Armstrong, Tom. *American Folk Painters of Three Centuries*. Hudson Hills Press in association with the Whitney Museum of American Art, distributed by Simon & Schuster, New York, 1980.

————, Warren, Elizabeth V.; Bishop, Robert. *Young America*. Hudson Hills Press, New York, 1986.

———— and Winchester, Alice. *The Flowering of American Folk Art, 1776–1876*. Viking Press, New York, 1974.

Little, Nina Fletcher. *American Decorative Wall Paintings, 1700–1850*. E.P. Dutton, New York, 1972.

————. *Floor Coverings in New England Before 1850*. Old Sturbridge Village, Sturbridge, Massachusetts, 1967.

————. *Neat and Tidy: Boxes and Their Contents Used in Early American Households*. E.P. Dutton, New York, 1980.

————. *Paintings by New England Provincial Artists, 1775–1800*. Museum of Fine Arts, Boston, Massachusetts, 1976.

Livingston, Jane and Beardsley, John. *Black Folk Art in America, 1930–1980*. University Press of Mississippi, Jackson, Mississippi, 1982.

Mackey, William F., Jr. *American Bird Decoys*. E.P. Dutton, New York, 1965.

Manns, William. *Painted Ponies*. Zon International Publishing Co., Millwood, New York, 1986.

Orlofsky, Patsy and Orlofsky, Myron. *Quilts in America*. McGraw-Hill, New York, 1974.

Peluso, A.J., Jr. *J. and J. Bard: Picture Painters*. Hudson River Press, New York, 1977.

Rifken, Blume J. *Silhouettes in America 1790–1840*. Paradigm Press, Inc., Burlington, Vermont, 1987.

Ring, Betty. *American Needlework Treasures*. E.P. Dutton, New York, 1987.

Rubin, Cynthia Elyce. *Southern Folk Art*. Oxmoor House, Birmingham, Alabama, 1985.

Safford, Carleton L. and Bishop, Robert. *America's Quilts and Coverlets*. Weathervane Books, New York, 1974.

Swan, Susan Burroughs. *Plain and Fancy: American Women and Their Needlework, 1700–1850*. Holt, Rinehart and Winston, New York, 1977.

Webster, Donald Blake. *Decorated Stoneware Pottery of North America*. C.E. Tuttle, Rutland, Vermont, 1971.

Weissman, Judith Reiter and Lavitt, Wendy. *Labors of Love*. Alfred A. Knopf, Inc., New York, 1987.

Index

About the Authors

Henry Niemann

Henry Niemann is a freelance curator of major exhibitions specializing in American folk art. He is also a member of the faculty at the Museum of American Folk Art Institute and The New School for Social Research.

Mr. Niemann has coauthored numerous scholarly texts on folk art and written several articles appearing in *The Encyclopedia of American Art and Artists, Artists of the Rockies and the Golden West,* and the *New England Antiques Journal.*

He has a wide variety of interests, especially in music, and has appeared as a singer in numerous concerts. He is also a member of the Actors' Equity Association, American Association of Museums, and the National Council for Geocosmic Research.

Mr. Niemann lives in New York City.

Helaine Fendelman

Helaine Fendelman, a graduate of Washington University, has been an appraiser, writer, and columnist for the past 15 years. A board member of the Appraisers Association of America from 1984 to 1986, Ms. Fendelman participated in the Winterthur Museum's prestigious American Decorative Arts summer program in 1980. Her previous books include *Tramp Art, Silent Companions,* and *Money in Your Attic* (with Jeri Schwartz). Her column, "What Is It? What Is It Worth?" (also written with Ms. Schwartz) has been a regular feature in *Country Living* magazine since 1984.

Ms. Fendelman lives with her family in Westchester County, New York.

The HOUSE OF COLLECTIBLES Series

☐ Please send me the following price guides—
☐ I would like the most current edition of the books listed below.

THE OFFICIAL PRICE GUIDES TO:

☐ 199-3	American Silver & Silver Plate 5th Ed.	$11.95
☐ 513-1	Antique Clocks 3rd Ed.	10.95
☐ 283-3	Antique & Modern Dolls 3rd Ed.	10.95
☐ 287-6	Antique & Modern Firearms 6th Ed.	11.95
☐ 755-X	Antiques & Collectibles 9th Ed.	11.95
☐ 289-2	Antique Jewelry 5th Ed.	11.95
☐ 447-X	Arts and Crafts: American Decorative Arts, 1894–1923 (ID) 1st Ed.	12.95
☐ 539-5	Beer Cans & Collectibles 4th Ed.	7.95
☐ 521-2	Bottles Old & New 10th Ed.	10.95
☐ 532-8	Carnival Glass 2nd Ed.	10.95
☐ 295-7	Collectible Cameras 2nd Ed.	10.95
☐ 548-4	Collectibles of the '50s & '60s 1st Ed.	9.95
☐ 740-1	Collectible Toys 4th Ed.	10.95
☐ 531-X	Collector Cars 7th Ed.	12.95
☐ 538-7	Collector Handguns 4th Ed.	14.95
☐ 748-7	Collector Knives 9th Ed.	12.95
☐ 361-9	Collector Plates 5th Ed.	11.95
☐ 296-5	Collector Prints 7th Ed.	12.95
☐ 001-6	Depression Glass 2nd Ed.	9.95
☐ 589-1	Fine Art 1st Ed.	19.95
☐ 311-2	Glassware 3rd Ed.	10.95
☐ 243-4	Hummel Figurines & Plates 6th Ed.	10.95
☐ 523-9	Kitchen Collectibles 2nd Ed.	10.95
☐ 291-4	Military Collectibles 5th Ed.	11.95
☐ 525-5	Music Collectibles 6th Ed.	11.95
☐ 313-9	Old Books & Autographs 7th Ed.	11.95
☐ 298-1	Oriental Collectibles 3rd Ed.	11.95
☐ 761-4	Overstreet Comic Book 18th Ed.	12.95
☐ 522-0	Paperbacks & Magazines 1st Ed.	10.95
☐ 297-3	Paper Collectibles 5th Ed.	10.95
☐ 744-4	Political Memorabilia 1st Ed.	10.95
☐ 529-8	Pottery & Porcelain 6th Ed.	11.95
☐ 524-7	Radio, TV & Movie Memorabilia 3rd Ed.	11.95
☐ 081-4	Records 8th Ed.	16.95
☐ 247-7	Royal Doulton 5th Ed.	11.95
☐ 280-9	Science Fiction & Fantasy Collectibles 2nd Ed.	10.95
☐ 747-9	Sewing Collectibles 1st Ed.	8.95
☐ 358-9	Star Trek/Star Wars Collectibles 2nd Ed.	8.95
☐ 086-5	Watches 8th Ed.	12.95
☐ 248-5	Wicker 3rd Ed.	10.95

THE OFFICIAL:

☐ 760-6	Directory to U.S. Flea Markets 2nd Ed.	5.95
☐ 365-1	Encyclopedia of Antiques 1st Ed.	9.95
☐ 369-4	Guide to Buying and Selling Antiques 1st Ed.	9.95
☐ 414-3	Identification Guide to Early American Furniture 1st Ed.	9.95
☐ 413-5	Identification Guide to Glassware 1st Ed.	9.95
☐ 448-8	Identification Guide to Gunmarks 2nd Ed.	9.95
☐ 412-7	Identification Guide to Pottery & Porcelain 1st Ed.	$9.95
☐ 415-1	Identification Guide to Victorian Furniture 1st Ed.	9.95

THE OFFICIAL (SMALL SIZE) PRICE GUIDES TO:

☐ 309-0	Antiques & Flea Markets 4th Ed.	4.95
☐ 269-8	Antique Jewelry 3rd Ed.	4.95
☐ 085-7	Baseball Cards 8th Ed.	4.95
☐ 647-2	Bottles 3rd Ed.	4.95
☐ 544-1	Cars & Trucks 3rd Ed.	5.95
☐ 519-0	Collectible Americana 2nd Ed.	4.95
☐ 294-9	Collectible Records 3rd Ed.	4.95
☐ 306-6	Dolls 4th Ed.	4.95
☐ 359-7	Football Cards 7th Ed.	4.95
☐ 540-9	Glassware 3rd Ed.	4.95
☐ 526-3	Hummels 4th Ed.	4.95
☐ 279-5	Military Collectibles 3rd Ed.	4.95
☐ 745-2	Overstreet Comic Book Companion 1st Ed.	4.95
☐ 278-7	Pocket Knives 3rd Ed.	4.95
☐ 527-1	Scouting Collectibles 4th Ed.	4.95
☐ 494-1	Star Trek/Star Wars Collectibles 3rd Ed.	3.95
☐ 088-1	Toys 5th Ed.	4.95

THE OFFICIAL BLACKBOOK PRICE GUIDES OF:

☐ 092-X	U.S. Coins 27th Ed.	4.95
☐ 095-4	U.S. Paper Money 21st Ed.	4.95
☐ 098-9	U.S. Postage Stamps 11th Ed.	4.95

THE OFFICIAL INVESTORS GUIDE TO BUYING & SELLING:

☐ 534-4	Gold, Silver & Diamonds 2nd Ed.	12.95
☐ 535-2	Gold Coins 2nd Ed.	12.95
☐ 536-0	Silver Coins 2nd Ed.	12.95
☐ 537-9	Silver Dollars 2nd Ed.	12.95

THE OFFICIAL NUMISMATIC GUIDE SERIES:

☐ 254-X	The Official Guide to Detecting Counterfeit Money 2nd Ed.	7.95
☐ 257-4	The Official Guide to Mint Errors 4th Ed.	7.95

SPECIAL INTEREST SERIES:

☐ 506-9	From Hearth to Cookstove 3rd Ed.	17.95
☐ 530-1	Lucky Number Lottery Guide 1st Ed.	4.95
☐ 504-2	On Method Acting 8th Printing	6.95

TOTAL

FOR IMMEDIATE DELIVERY

VISA & MASTER CARD CUSTOMERS

ORDER TOLL FREE!
1-800-638-6460

This number is for orders only; it is not tied into the customer service or business office. Customers not using charge cards must use mail for ordering since payment is required with the order—sorry, no C.O.D.'s.

OR SEND ORDERS TO

THE HOUSE OF COLLECTIBLES
201 East 50th Street
New York, New York 10022

___ POSTAGE & HANDLING RATES ___

First Book . $1.00
Each Additional Copy or Title $0.50

Total from columns on order form. Quantity_____$_____

☐ Check or money order enclosed $_____ (include postage and handling)

☐ Please charge $_____to my: ☐ MASTERCARD ☐ VISA

Charge Card Customers Not Using Our Toll Free Number Please Fill Out The Information Below

Account No. _____Expiration Date_____
(all digits)
Signature_____

NAME (please print)_____PHONE_____

ADDRESS_____APT. #_____

CITY_____STATE_____ZIP_____